The Subversive Imagination

The Subversive Imagination

Artists, Society, and Social Responsibility

edited by Carol Becker

Routledge ○ New York & London

Published in 1994 by
Routledge
An imprint of Routledge
29 West 35 Street
New York, NY 10001

Published in Great Britain in 1994 by
Routledge
11 New Fetter Lane
London EC4P 4EE

Library of Congress Cataloging-in-Publication Data

The Subversive Imagination: Artists, Society, and Social
Responsibility / Carol Becker, editor.
 p. cm.
 Includes biographical references and index.
 ISBN 0-415-90591-5. ISBN 0-415-90592-3 (pbk.)
 1. Artists and community. 2. Artists—Psychology.
I. Becker, Carol.
NX180.A77S83 1994
700'.1'03—dc20
 93-36230
 CIP

British Library Cataloguing-in-Publication Data also available.

for our students

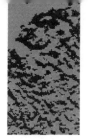

CONTENTS

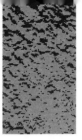

ACKNOWLEDGMENTS

Books take years to complete and anthologies are particularly complex. This one involved a group of wildly busy artists, writers, intellectuals, and educators, from both hemispheres, all of whom had to carve the time out of their complex lives to produce their essays and then craft them to fit within this book. I thank them all for trusting me, and I hope they will be pleased with the way their voices come together here.

I could never have completed this anthology without the brilliant, professional editorial assistance of Martha Gever. She had the patience I often lacked, the expertise I greatly needed, a faith in the process, and the vision to push me and the other contributors to perfect our efforts. She is a superb editor and a rigorous intellectual.

Jayne Fargnoli, my editor at Routledge, had enthusiasm and compassion for the concept of the book, oversaw the process, and offered important insights throughout. I am grateful to her for her wisdom, sophistication, and vigilance and to her assistant Anne Sanow for all her efforts on my behalf.

Certain close friends directly impacted on the content and form of this anthology: I would like to thank Henry Giroux, Ronne Hartfield, Lin Hixson, Matthew Goulish, Laurette Hupman, Roberta Lynch, Judy Raphael, Brigid Murphy, Jack Murchie, B. Ruby Rich, Robyn Orlin, Claudia Vera, Andries Botha, Susanna Coffey, Page duBois, and Alda Blanco, who continue to inspire me through their lives and work. I would also like to thank Jonathan Brent for his initial interest in and help with this project and for his ongoing connection to Eastern European writers which he made available to me. Ann Snitow and her amazing network introduced me to names of writers I would otherwise never have met and have since grown to truly admire. I must also take this opportunity to thank Jan Susler, Elizam Escobar's legal counsel, who helped us immeasurably and continues to struggle on his behalf.

The School of the Art Institute of Chicago, home to me for many years, as always, was totally supportive of my efforts. I would like to thank my colleagues for their patience with my distraction as I put the book together. In particular I am indebted to my coworkers Susan Cornier, Jennifer Arra, Jana Wright, Martin Prekop, Peter Brown, Michael Miller, John Kurtich, Jim McManus, and George Roeder, who absorbed my share of the team effort. They enabled me to take the much needed sabbatical and complete this project. The students at the School of the Art Institute—their needs, passions, deliberations, and desires—are at the heart of this book. I hope this collection of ideas will prove useful, have resonance, and position them more deliberately to take hold of their futures.

Nick Rabkin and the John D. and Catherine T. MacArthur Foundation encouraged this anthology from the beginning. I also thank them for their initiative in supporting the conference to launch the book and its ideas.

Finally I would like to thank those writers, artists, and poets, whether mentioned here directly or not, whose work has come before, influenced my understanding, and helped me to articulate the questions. I hope the book will seem a worthy addition to a debate that has been ongoing for centuries.

INTRODUCTION
Presenting the Problem

Carol Becker

In order to witness the colonized's complete cure, his alienation must completely cease. We must await the complete disappearance of colonization—including the period of revolt.

—Albert Memmi, *The Colonizer and the Colonized*

When the most recent "culture wars" began several years ago, we never imagined the dramatic rupture in the continuity would last as long, have such an impact, or reveal the hidden contradictions of democratic societies as effectively as it has done.[1]

The storming of the School of the Art Institute of Chicago by a group of African American aldermen to remove the controversial portrait of the late Mayor Harold Washington, followed by protests against the same institution a year later in response to Scott Tyler's installation *What Is the Proper Way to Display the U.S. Flag?*; the near destruction of the Museum of Contemporary Art in Mexico City by local citizens to remove the provocative collages of the Virgin of Guadalupe overlaid

with the face of Marilyn Monroe; the attacks against the National Endowment for the Arts' financial support of artists Holly Hughes, Karen Finley, Tim Miller, and John Fleck; the global boycott of Martin Scorsese's *The Last Temptation of Christ*; the controversies over rap artists 2 Live Crew and others—all demonstrated the degree to which art (in any of its multifarious manifestations) can unnerve when it pushes the boundaries delimited by the public sphere. These events revealed how misinformed about the intentions of art and artists and how easily swayed by politicians, art's audience could be. It also became clear that the place and function of art and artists in American society had never been sufficiently articulated.

Still, however extreme these misunderstandings and interventions may seem, they all pale next to the Ayatollah's *fatwah*, or death sentence against Salman Rushdie for publication of *The Satanic Verses*. Four years after Rushdie first went into hiding he can still write, "I am told there is nobody protected by the Special Branch whose life is in more danger than mine."[2]

Trying to understand these conflicts, many in the United States did not at first comprehend that the battles we had found ourselves in were actually disagreements about the nature of democracy—which point of view would be allowed to be expressed. As Richard Bolton states, "In the end, censorship of the arts reveals the failure of democratic institutions to articulate and defend the complexity and diversity of the American public."[3]

These battles represented for many the culmination of more than a decade of extreme alienation from mainstream society. The Reagan-Bush years, devastating to all economically disenfranchised groups, were uniquely so for artists, writers, and intellectuals. These individuals, already marginalized by the impact of mass media and the general anti-intellectual tone of North American society, felt relegated to oblivion—their values insignificant, their opinions unsolicited, their role mainly to debate one another. Nonetheless they continued writing books, exhibiting work, pushing the boundaries of theory in all areas to affect architecture, design, art, and literature. Yet the prevailing conservatism dominated while more progressive investigations remained isolated from mainstream thought.

The censorship controversies therefore appeared to many as the final polarization. America was pitted against itself. Progressive voices posed against reactionary ones, the desire for multiplicity struggling to overcome a desire for stasis and a retreat into a homogeneous status quo.

America seemed to want to return to a lost innocence, which had never been innocent at all—"nostalgia without memory."[4]

It was surprising that literature, art, music, and the making of images actually crystallized the debate and demonstrated once again that these forms can be important foci with which to challenge the limitations of the democratic process. What Jean-Pierre Vernant has written about Greek tragedy (dating from 420 B.C.) can ironically also be said of art that looks to the twenty-first century. Although it "appears rooted in social reality, that does not mean it is a reflection of it. It does not reflect that reality but calls it into question by depicting it rent, divided against itself, it turns it into a problem."[5]

But why would art need to present reality as a problem? Lukács speculates that "art becomes problematic precisely because reality has become non-problematic."[6] The more that is hidden and suppressed, the more simplistic the representation of daily life, the more one-dimensional and caught in the dominant ideology the society is, the more art must reveal. In form and content its aggressive refusal to sustain society's illusions, demonstrates the "limits of immediacy."[7] Art refuses to be easy. But as it posits the often contradictory nature of what exists around us, it appears less and less familiar to those untrained to read the complexity they in fact live. Art may be focused directly on the issues of daily life, but, because it seeks to reveal contradictions and not obfuscate them, art works which should spark a shock of recognition and effect catharsis actually appear alien and deliberately difficult. Art easily becomes the object of rage and confrontation. At the same time artists, frustrated by the illusion of order and well-being posited by society, or angry at the degree to which they are unappreciated and their work misunderstood, choose rebellion (either through form or content) as a method of retaliation. And in so doing, they separate themselves from those with whom many actually long to interact. Hence the need to decolonize the imagination of artists and audience, to force us all to break the paradigms that perpetuate this mutual alienation and keep art from having an impact on society.

Another aspect of the problem is the gap that has developed between the expectation of what art will be and the reality of contemporary art's actual intent. This misunderstanding is clarified by understanding what the work of many artists actually seeks to achieve and the tension this creates. Such work, Lyotard writes, "is not in principle governed by pre-established rules and cannot be judged according to a determinant judgment, by the application of given categories to this text or work.

Such rules and categories are what the work or text is investigating."[8]

There are few people outside the art or literary worlds who would define art as "investigation" and be sympathetic to this as its legitimate goal. Rather, many expect art to serve as a challenging source of pleasure or an intellectual and aesthetic diversion. Within this conflict between expectation and reality rests the contemporary artist's anxiety and despair.

In the summer of 1989 I returned to New York after teaching in Greece (where *The Last Temptation of Christ* had been banned) to join protesters responding to public outcries against government subsidized exhibitions of photographs by Andres Serrano and Robert Mapplethorpe. The marchers chanted, "You say tomato, I say *tomahto*. Don't leave art to Alphonse D'Amato"—a reference to the U.S. Senator's attack against the NEA.

As the North American art world first mourned, then organized, it became clear that art had gotten caught in an imploding vortex. Those who spend their time analyzing such events understood that if the national/international art police were to have their way, art would be forced to lose its uniqueness and social value to become innocuous entertainment or else run the risk of losing its often minimal government support.

The art that had been targeted for attack in each case reflected social concerns. It was work that would never allow us to believe that we all lived in the same America, shared similar desires, or were equally committed to maintaining the elaborate psychological, philosophical, economic, and sexual repression necessary to sustain Western Civilization as we have known it. In fact, whether we agreed with the content and form of the work under attack or not, its existence demonstrated that there were artists and thinkers willing to challenge the most originary notions of modern society, and risk the consequences. Such artists could undoubtedly be dangerous, their work not easily absorbed within the prevailing ideology.

These events of conspicuous outside interception unsettled writers and artists. Such violations should have triggered a series of debates profound enough to shift the direction of art-making or, at least, the debate around art-making. However, the nature of these discussions has been disappointingly constrained. For the North American art world in particular, the problem has been constructed in terms of censorship. There has been justifiable anger and despair that the blatant intrusions on freedom of expression have not been denounced by a larger segment

of society, that artists have been left to challenge this aspect of the demo-
cratic process alone. Certain points of view expressed in the censored
work have been deemed obscene, pornographic, unpatriotic, racist, sac-
rilegious, and the artist's rights to freedom of expression have been
severely curtailed. Even though the complexity of these curtailments
must be explored, unfortunately, artists and writers beleaguered by these
incidents have not been able to see beyond the violation of personal
rights. They have learned to fight back, but have not necessarily pro-
gressed in their understanding of how to contextualize such violations
within a larger analysis. Where do artists fit within the dynamics of a
democratic society? Although cases against these intrusions have been
won in the courts, the mutual ethical issues of responsibility and inten-
tion of individual artists and society have not been addressed.

Some serious questions need to be asked from the inside—by artists,
writers, and intellectuals themselves—with a generous spirit of inves-
tigation: What is the responsibility of the artist to society? What is the
responsibility of society to the artist? How might this relationship be
understood? What has been the role of artists within democratic soci-
eties? Historically when have artists made an impact? What are the
responsibilities of designers, filmmakers, actors, and musicians? What
role should private and public funding play in the imagined future lives
of artists?

Also to be explored is "patriocentrism"—the positioning of oneself
within the North American model as absolute. In the United States there
is often little interest in how artists, writers, and intellectuals live in other
parts of the world, what influence their ideas have, whether their situa-
tion is markedly different, and if their efforts are taken more seriously.
There has also been an implicit assumption that the historical role of the
artist has remained unchanged, that freedom of expression consistently
has been the central artistic concern, and the artist has always lived in
a marginalized or antagonistic relationship to society. Because history
reveals that this is not the case, there needs to be a way to expand our
analysis so that other possibilities are allowed to influence this paradigm.

For these reasons I began to imagine this book: an anthology bringing
together visual artists, writers, and other intellectuals working in various
contexts, some looking forward, some back, so that their articulated expe-
riences would force us to recognize that literature, art-making, and design
have always existed within a particular societal context. I envisioned a
book that would be philosophical and personal, international as well as
grounded in the contemporary North American art world debates. I

wanted to expand the terms of the discussion, raise the possibility that
the way we in the United States posed the problem might be part of the
problem or at least the reason it has been difficult to formulate a plan
of action. To achieve this the book had to represent divergent points of
view and attempt to move between "fine art" and "popular culture," as
well as incorporate issues of advertising and design. As an educator I
hoped to construct a book that would encourage debate within colleges
and universities, posing the notion of responsibility not so much as a
constraint but rather as a condition for freedom and as a mark of the
culture's maturity.

During the process of conceptualizing this anthology I visited Europe,
South Africa, Mexico, and Central America. Wherever I traveled I spoke
with artists about the ways they positioned themselves. While in Madrid,
during the Gulf War, I found myself amazed that writers and journalists
had come together to produce five issues of an alternative newspaper
critical of Spain's involvement in the war and that they actively sought
out the opinions of artists and poets. Such a normal response in
Europe—to assume creative people as citizens with ideas and visions
worth soliciting—seemed astounding to me. Those of us raised in North
American society do not always recognize how absolutely we all have
internalized the diminished value allotted to artists who are often alien-
ated from each other, the pressing political debates, and the society at
large.

In South Africa in 1992 and in 1993 I was equally fascinated to observe
artists, writers, and intellectuals of many races meeting to discuss the
place of art in the dismantling of apartheid. It was assumed that all cul-
tural workers would have a significant role in the long-awaited transition
and in future decision making. In these discussions the emphasis of
responsibility was not necessarily placed on the content of each artist's
individual work but rather on the entire life which artists and writers
choose to live.

It is clear that certain parts of the world are pivotal to these discus-
sions and that these locations need to be represented in the North
American investigation whenever possible. Eastern Europe seems rivet-
ing and problematic as it goes through its complex reconfiguration. The
introduction of capitalism after decades of communism has left many
creative people without a clear sense of how to earn a living or secure an
audience. Art that was once considered exotic in Western markets,
because it was made under subterfuge, is no longer in demand. There is
great cultural and economic confusion. So much that had been vital in

art, theater, literature, and journalism, when repressed, now seems in danger of being drowned under the weight of imported mass media and "popular culture."

Stories (painful to faithful readers) have been unearthed about writers once greatly respected in the West, who now have been accused of collaborating with the Stasi—the East German secret police—and similar organizations elsewhere. It will take decades for Eastern Europe to resolve its past—so much has been hidden and compromised for so long. Mexico is also in flux as it adapts to the idea of the North American Free Trade Agreement and struggles even more with the oppressive influence of imported North American "culture." Also, we need to understand the role of intellectuals in countries like Iran caught in the grip of right-wing fundamentalism. Added to these are the points of intersection where identities converge to form new syntheses and new continents of philosophical thought. Those who live in exile, for one reason or another, who exist on the borders between cultures, are creating new zones of hybridity, and their voices also need to be heard as they point us to those issues we must face as we enter the next century.

In the United States at this moment there is a sense of possibility and a revitalized democracy. The entire fabric of society is in a process of reevaluation. Serious debates are under way around identity—gender, class, race, sexuality, age—categories that layer and overlap to create distinct points of view. It has become clear that, "It is no longer possible to call development progress."[9] And thus the anthropocentric posturing which has led to ecocide—the destruction of the air, water, flora, and fauna—must be acknowledged and addressed. Once having broken our link to the physical world, how do we live? Such basic questions are still to be discussed.

The visual art apparatus—artists, museums, publications—is also rethinking itself. There is much talk about "community-based" work, but as yet insufficient debate around what community is, which communities artists should relate to, and who constitutes the community we all generically call the art world. Issues of accessibility, clarity, the formal properties of certain media, and the so-called "bourgeois nature of painting," have been raised, but the discussions have been hollow, prescriptive, and antithetical to the play with eclectic form postmodernism has encouraged.

Individual visual artists whose work does not directly engage these debates wonder how to position themselves within a marketplace that advocates a multiplicity of points of view yet somehow makes no room

for them. Progressive critical voices run a serious risk of restricting possibilities and becoming dogmatic at a time when answers will only come through a respect for the unrestricted process of creating and producing. As Lyotard suggests, we have yet to learn "how to counteract the confusions without forming a new 'front'."[10]

There is an ongoing reaction away from traditional structures like mainstream galleries, which have disempowered and disenfranchised artists, regarding them as mere producers of commodities. There is also an attempt to experiment with new forms that cannot be easily commercialized, collected, or fetishized. Can artists interested in producing nonobject objects succeed in refusing these dynamics intrinsic to capitalism? How can they take back the economic power that controls their daily lives and also reclaim the psychological mechanisms of approval now provided by the external judgment of critics, curators, gallery owners, and distributors? Can artists who attempt to make strong political statements, even against the art world itself, keep from becoming the darlings of the world they seek to critique? Such is the nature of capitalism and the dilemmas it poses for even its staunchest critics.

Being an artist is finally a sociological construct in all its material, psychological, and spiritual dimensions. There has been so little understanding of this, almost no thought as to how artists live—sustain themselves economically, emotionally, creatively, and sexually; make personal and aesthetic choices; develop intellectually; take political stands; hover between realities; and survive in prison, exile, under dictatorships, capitalism, or within revolutions.

My concept has been to create an anthology which looks closely at these aspects of daily life through the voices of individuals positioned at particular historical, cultural, and/or intellectual intersections. I have tried to amass a diverse group of contributors as wide ranging, controversial, outrageous, interesting and original as I could find. Some will be quite familiar to the art/intellectual worlds of the United States, while others, because of their international origins and global perspectives, will be new. In each case I have worked with the contributors to successfully address unique aspects of the problems raised in the preceding pages. They were asked to write a new essay or to adapt one to fit specifically within this collection's focus on social responsibility. They were also encouraged to write accessibly and engagingly, so as to reach as large an audience as possible. The pieces attempt to cover a breadth of concerns and, even within the diversity of content and style, to build a coherent whole.

The writers and artists asked to contribute to this anthology are vitally concerned about the place of art and culture in society in a way that shapes their lives as well as their art. They are passionate, involved in the ideas they choose to discuss, and in changing the world to accomodate the innovations of thought and action they project. They are "cartographers" inventing their own terrain to survey.[11]

When possible, the anthology works through first-person narrative to reach the philosophical. Its overall structure is actually determined by this progression. The inevitable intersection of the personal and the political is reflected in the first section—"Personal Responsibilities and Political Contingencies." The attempt to undo some of these basic polarizations and contradictions is discussed in the second section—"Decolonizing the Imagination," while a theoretical basis for change is projected in the third—"Theorizing the Future."

I wanted this book to open up the world, further problematize issues, and demonstrate the degree to which certain questions are particular to individual historical contexts, while others actually cut across time and political systems. If this anthology moves beyond and thus further complicates the debates around censorship, adds dramatically to the work of others, questions Eurocentric assumptions which have long held artists to be without responsibility or impact, challenges the circumscribed role society has played in supporting creative initiatives, brings an international perspective to often hermetic analyses, imagines a more engaged relationship between artists, writers, intellectuals, filmmakers, musicians, designers, and the worlds in which they live, then the fifteen essays to follow will have succeeded in surveying the extent of the problem and moving us all into the future a bit more intelligently.

Carol Becker
Belize, 1993

Notes

1. The phrase "culture wars" is taken from the title of Richard Bolton's *Culture Wars: Documents from the Recent Controversies in the Arts*, ed. Richard Bolton, (New York: New Press, 1992).
2. Salman Rushdie, *New York Times*, February 7, 1993, 21.
3. Bolton, *Culture Wars*: 24.
4. Arjun Appadurai, "Disjuncture and Difference in the Global Cultural Economy," *Public Culture: Bulletin of the Center for Transnational Cultural Studies*

2, no. 2 (Spring, 1990): 3.

5. Jean-Pierre Vernant and Pierre Vidal-Naquet, *Myth and Tragedy in Ancient Greece*, trans. Janet Lloyd (New York: Zone Books, 1990), 33.

6. Georg Lukács, *The Theory of the Novel*, trans. Anna Bostock (Cambridge: MIT Press, 1990), 17.

7. Georg Lukács, "Realism in the Balance," in *Aesthetics and Politics: The Key Texts of the Classic Debate within German Marxism*, ed. Ronald Taylor (London: Verso, 1977), 37.

8. Jean-Francois Lyotard, *The Post Modern Explained: Correspondence 1982-1985*, trans. Julian Pefanis and Morgan Thomas (Minneapolis: University of Minnesota Press, 1992), 15.

9. Lyotard, *The Post Modern Explained*, 78.

10. Lyotard, *The Post Modern Explained*, 66.

11. For a discussion of "cartographers" and "cartographies," see Guillermo Gómez-Peña's essay in this volume.

PART ONE
Personal Responsibility and Political Contingencies

1

THE PREHISTORY OF ART
Cultural Practices and Athenian Democracy

Page duBois

We think we know art when we see it. But our understanding of the nature of art is historical, determined by the horizon of our own residence in the late twentieth century. Much of the resistance both to the postmodern erasure of the boundaries between art and other cultural practices and to a humanist nostalgia for art for art's sake or as a cure for societal woes comes from our historical situation as late heirs of the Enlightenment, Romanticism, and modernism. As Jürgen Habermas recalls, "The project of modernity formulated in the 18th century by the philosophers of the Enlightenment consisted in their efforts to develop objective science, universal morality and law, and autonomous art according to their inner logic."[1] My theme in this essay is that ancient

democracy, the culture and society of ancient Athens, knew no such category as "autonomous art." For citizens and inhabitants of the ancient city, most cultural practices were "politics," matters of the *polis*, of the city-state.

The character Socrates, in the Platonic dialogue called the *Protagoras*, describes the way in which the ancient city-state of Athens made decisions about what we now might call art:

> I hold that the Athenians, like the rest of the Hellenes, are sensible people. Now when we meet in the Assembly, then if the state is faced with some building project, I observe that the architects are sent for and consulted about the proposed structures, and when it is a matter of ship-building, the naval designers, and so on with everything which the Assembly regards as a subject for learning and teaching. If anyone else tries to give advice, whom they do not consider an expert, however handsome or wealthy or nobly born he may be, it makes no difference; the members reject him noisily and with contempt, until either he is shouted down or desists, or else he is dragged off or ejected by the police on the orders of the presiding magistrates. That is how they behave over subjects they consider technical. But when it is something to do with the government of the country that is to be debated, the man who gets up to advise them may be a builder or equally well a blacksmith or a shoemaker, merchant or shipowner, rich or poor, of good family or none (319b–d).[2]

Socrates's complaint is that the democractic city relies on experts for technical knowledge, yet does not consider the matter of government to be a matter for experts, something that can be taught. What strikes the modern reader, however, is the extent of public, democratic participation not only in government but also in every decision about architectural enhancement of the city—and that decisions about ships are made in the same place, in the same way, by the same people, as decisions about buildings. What we now call the arts, although performed in fact in the classical age in Athens by "artists," that is, architects, tragedians, poets, painters, and sculptors, were not until the time of Plato differentiated from other activities of the city. The citizens considered artistic projects together, debated them, argued, disagreed, voted, financed, and supervised their production.

I often find it difficult, when teaching the ancient world, to convey a sense of the unity of ancient cultural practices. Even though it may be analytically and pedagogically useful to talk about "Greek religion," there is no such thing. To talk about the practices of the citizens of ancient

Athens that involved worship of the gods, one must discuss Greek tragedy, Greek architecture, sculpture, and painting, as well as what we would now consider to be politics, since the very city itself was under the guardianship of the goddess Athena and all the practices of its citizens implicate her.

I would here like to take three examples—building of temples, the sculptural programs, and the ancient theater festivals of the city—to demonstrate that these features of ancient Athenian life cannot be considered "art" and "literature" as we now know them, as vocations with their own generic histories and institutions. They are rather part of the cultural practices of a democratic state, one that concerned itself with its past, its future, the prosperity of its citizens, and the fate of the city among other cities. The provision of buildings for worship of the gods, as well as for political, religious, and historical education, is inseparable from the other functions of the state such as policing the city and waging war. Similarly, even to speak of "religious," "political," or "historical" education, when considering Greek tragedy, is falsely to categorize and differentiate among kinds of activity that were not differentiated until the work of Plato. His remarks on specialization and expertise belong to a long process of differentiation among human activities, and to a gradual narrowing of human possibility in the domains of cultural practices and expression. Plato's efforts to categorize and establish differences among kinds of human activity are linked to his antidemocratic strategies, his efforts to ensure that "governors" governed, while shoemakers stuck to their lasts.

Architecture

Architecture was, in the archaic age, before the founding of the democratic city Plato finds so distasteful, a matter inseparable from religious, cultic practices and was addressed in mythic and legendary terms. The ancient city of Thebes was said to have been walled by Amphion and Zethus, sons of Antiope and Zeus. Antiope, daughter of the river Asopus, or in another version of her story, of the king of Boeotia, was courted by Zeus, who appeared to her as a satyr. The boys were abandoned by their mother at birth and raised by a shepherd. Zethus became a herdsman, while Amphion, given a lyre by the god Hermes, was a gifted musician. He walled the city through the power of his music, placing the stones by means of his lyre (Apollodorus 3. 43–45). The story exemplifies the magical powers attributed to the builders of the past, constructing cities, carving out a protected and humanized space in the midst of the Greek

landscape. The story of the construction of Troy similarly exhibits mythic features. Joseph Rykwert recalls that "Greek literature is full of echoes of how a *kredemnon,* a magical veil of battlemented walls was established: as at Troy, as at Thebes and Athens."[3]

Sarah Morris's book *Daidalos and the Origins of Greek Art* recounts in fascinating detail the mythicization of the first architect, his representation in ancient culture from the Bronze Age into the classical period.[4] Morris points out how the figure of Daedalus, the artist, grew out of the vocabulary of epic poetry:

> Daidalos himself emerges as a movable beast, a creature most natural to the habitat of Greek myth. Born in an epic simile with enigmatic adjectives for parents, he was overshadowed by them for centuries. Dramatic changes in Greek art and life helped rediscover him and adapted him happily to far more numerous accomplishments than his poetic origins promised. Every feat claimed for him illuminates those occasions and attitudes that sponsored it, particular to a specific Greek city or tradition.[5]

Daedalus, the architect of the Cretan labyrinth, constructor of wings to fly across the Aegean, was a figure constructed retrospectively to justify the existence of the techniques and specialization of the artist. His history demonstrates the inseparability of the archaic artist from religious, mythic concerns.

The second-century A.D. travel writer Pausanias recounts in detail the mythical building techniques of Trophionios and his brother Agamedes:

> They say when these two grew up they showed a genius for the sacred buildings of gods and the royal palaces of men: for instance, they built the temple of Delphi and Hyreus' treasure-house, in which one stone could be removed from the outside. They were always taking something from the deposits; Hyreus was speechless, seeing the locks and seals untouched and the quantity of money always getting less. He put some kind of trap over the pots of gold and silver to catch anyone who came in or touched the money. Agamedes came in and was snared, so Trophonios cut his head off, for fear that when day came Agamedes might be tortured and he might be involved himself. The earth split open and swallowed Trophonios in the sacred wood at Lebadeia at what they call the pit of Agamedes with the stone tablet beside it (9.37.3).[6]

The site of Trophonios's swallowing up by the earth became an important oracle, in which the consultant of the oracle was himself carried off

to the underground and received revelations. This legend too provides an aura of magical or spiritual authority to the master builder, who is especially dear to the gods, or who possesses unusual gifts in his ability to manipulate the material world and create spaces for human use out of stone, the bones of the earth.

The master builders of the democratic city, however, were no longer mythical, divine, or semi-divine characters from the prehistoric past. They were often citizens of the ancient cities in which they worked, and although their labors might have been colored by the high esteem in which those figures from the past were held, they were also tainted by their association with labor in a culture which often related labor to slavery.[7] Nonetheless, building in the ancient city was conceived as integral to governance, inseparable from the functions of politics. In architecture, for example, the great buildings of the classical age, the temples, the structures on the Akropolis—Parthenon, Erechtheum, temple of Nike— were buildings erected by the city, for the city, in the city. J. J. Coulton describes the mechanism through which architectural structures were built under the direction of the democratic city:

> A typical public project might run something like this. An initial proposal to build would be made in the assembly...by a statesman like Perikles with a political purpose in mind, by somebody who wished to gain prestige by association with a notable building, or simply by a person who felt a special interest in the cult or project concerned. The assembly would discuss the desirability of the proposal and the way it could be financed and might suggest modifications. Then if the proposal was approved, a supervising committee would be appointed, and an architect selected to draw up a specification. The committee would organize a work-force and construction would start....[8]

Financing of these projects might include profits from the city-owned mines, or money gained in military victories; those pan-Hellenic projects such as the temple at Delphi were funded by contributions from many different cities. In general, the projects within a city were financed through the funds of the city itself or from the contributions of private citizens to the public good. "We know that under Perikles (c. 450–429 B.C.) the great buildings of Athens were financed from public funds, from the 460 talents or more which the Athenians collected annually from their 'allies.'"[9] The Athenian Council, a democratic body, would modify the preliminary plans for buildings, if necessary. Coulton points out that, from what we know of payment for labor in the ancient world,

payments made to architects seem rather low.

> However, these payments were probably not an economic salary,
> but a conventional living allowance, comparable to those paid for
> other state duties; the chief motive for an architect accepting
> responsibility for a new temple would be the prestige he would
> gain by ensuring that it was a credit to his city.[10]

The magnificent buildings of fifth-century Athens continue to stand as
monuments to the democratic process that led to their construction.

The Parthenon, the great temple of Athena on the Akropolis in
Athens, is one of the most impressive buildings ever constructed in the
ancient world. It could be said to exemplify the ideology of democratic
Athens, its pride, its ambition, its contradictions, and its resolution of
those contradictions. Donald Preziosi has recently offered a careful read-
ing of the architecture and sculpture of the entire Akropolis that takes it
as a whole, considering the many different representations of Athena
there, and the ways in which they sum up a complicated and multifac-
eted relationship between city and goddess:

> The Periclean building program for the Athenian akropolis, begun
> in the middle of the fifth century B.C., engendered and worked to
> sustain a matrix of complementary and interrelated narratives: an
> ideology of the polis and its relationships to the individual. It oper-
> ated as a prism through which the contradictions of Athenian
> social and political life might be resolved into an imaginary homo-
> geneity....[I]t was a theory of the city, a *theatron* for seeing the city
> and its history, a machine for the manufacture of a history.[11]

More than adornment of the city, more than the construction of func-
tional buildings at its center, the building program of the Akropolis
exemplifies the unity of artistic, political, and religious practices in the
ancient city, and exposes the inadequacy and ahistoricism of our cate-
gories of "art" and "artist" when applied to a radically different social
formation.

Sculpture

Sculpture, of course, is almost inseparable as an artistic practice from
architecture, since the master builders of the ancient city adorned their
temples and public buildings with sculpture, that is, reliefs, friezes, and
metopes, which were integral to the architectual fabric. Like the
architect, the sculptor had a mythic past and first emerged in Bronze

Age culture with a divine, semi-divine, or legendary persona. Sometimes the gods themselves seemed to have created the precious images of themselves worshipped by the early Greeks. The famous sanctuary of Artemis at Ephesus was said to have been founded at the spot where a figurine of the goddess fell from the sky into the marsh. And a revered statue of Athena, kept in the Erechtheum in Athens, a wooden *xoanon*, was thought to be of prehistoric antiquity.[12] Daedalus, the consummate artist, was a sculptor as well as an architect. He constructed the labyrinth on Crete for King Minos, which was necessary to contain and conceal the Minotaur: half-human, half-bull, a monster born through Daedalus's machinations. Minos, involved in a dispute about his right to the throne, prayed to Poseidon to send him a bull from the sea to sacrifice. The bull was so beautiful, however, that Minos could not bring himself to sacrifice it, so Poseidon caused Pasiphae, wife of Minos, to fall in love with it. Daedalus helped her to disguise herself as a cow, creating a costume/sculpture, and she was impregnated by the bull and delivered the monstrous Minotaur. Daedalus, maker of mythical structures and precious objects, stands as a figure for the skills of builders, sculptors, and engineers. All the arts, or *tekhnai*, as they were called in Greek, were associated with legendary, mythic, prehistoric characters whose names were passed on in the oral tradition, who represented centuries of nameless artisans and workers, constructors of the human environment of the Greeks, and whose work was anonymously honored through this displaced reverence for Daedalus and his kind.

In the democratic period, traces of this reverence toward the artist and master builder remain, in the worship of Hephaistos and Athena. Hephaistos the smith god was especially revered in Athens as the god of manual workers. Hephaistos had made such legendary objects as the shield of Achilles and the necklace of Harmonia, using automata of his own manufacture to assist him. He was also said to have made the first woman Pandora, at the command of Zeus, and to have assisted in the birth of Athena, goddess of the city of Athens, from the head of her father Zeus. Athena too was associated with arts and crafts. Spinning and weaving, women's work and art, fall into her domain, and she was also worshiped by manual laborers, artists such as potters and goldsmiths. Alison Burford lists some of the specializations known among craftsmen in antiquity:

> statuemaker, maker of eyes for statues, knife maker, knife sharpener, wagon builder, woodcarver, miner, smelter, smith, bronzesmith, iron-

> smith, silversmith, goldsmith, jeweller, gold-leaf worker, silver vessel
> maker, shield maker, helmet maker, trumpet maker, wool worker,
> flock worker, ragpicker, dyer, purple dyer, fuller, tanner, leather
> sewer, harness maker, shoemaker, bootmaker, ladies' slipper maker,
> spear polisher, sickel forger, wine-jar maker....[13]

No "artists." Even though the names of some famous craftsmen were
known—such as Pheidias, Polykleitos, Lysippos—the functions of crafts-
men are much more readily accessible than the names of individuals,
suggesting that the role of the artist was still barely distinguishable from
that of the manual worker. The list makes clear that there was a division
of labor among craftsmen. We assume that many of the vases painted
with scenes of drinking, of symposia, or of sexual enjoyment were offered
as gifts and would not have fallen into the category of public, democrat-
ic, city art. Their work, the creation of vases, of jewelry, of which much
remains, represents another, private direction for "art," characterized by
pieces more like the commodified objects of the world we inhabit.
It would be a mistake, however, to see them as equivalent to the mass-
produced, universally available things of capitalist culture. Artisans,
laborers, slave and free, made some of their works for the private
consumption of the very wealthy, the enamored, the devout, or the
bereaved. Still, the citizen body as a group directed the production of
most of what we would now consider to be art—literature, theater, music,
and sculpture.

Like the ensemble of the Akropolis in Athens considered as a whole,
the details of the sculptural program of the Parthenon reveal the
integration of political, religious, and artistic aims in the classical city.
The Parthenon was decorated with a frieze containing representations
of the citizens of Athens engaged in worship of Athena, a frieze of which
much remains, preserved in Athens, Paris, and London. The fifth-cen-
tury citizens represented on the frieze participate in the procession at
the great festival of the Panathenaea, celebrated with special features
every fourth year. The frieze depicts citizen warriors on horseback,
youths conducting animals to be sacrificed in honor of the goddess.
Maidens carry implements sacred to the worship of Athena. Part of the
ceremony involved the draping of an image of the goddess with a new
garment, woven by the women of the city, and the product of their labors
is also represented on the frieze. Even the *metics*, foreign residents,
noncitizens, are present, as are the gods, observing from their banquet
seats in characteristic poses. The pediments of the temple, now frag-
mentary, contained scenes from the stories about Athena. The eastern

pediment represented the goddess newly born from the head of her father Zeus. In the west was depicted the contest between Poseidon and Athena for the land of Attica, site of the city of Athens. Another important feature of the sculptural program was the metopes, that part of the ancient temple that punctuated the space above the columns. These bore representations of the mythical combats of the Greeks and the Amazons, and of the Lapiths and the Centaurs. These scenes in particular alluded to the boundaries of the ancient city, the citizens' imaginary encounters with imaginary others—the Amazons, warrior women, and Centaurs, horse/men.[14]

▬▬ Theater

The visual arts cannot be separated from the life of all the inhabitants of the ancient *polis*. And so it is in the social practices that we now categorize as literature and music. The theater festivals of the city were staged in honor of the god Dionysos, and were linked to the annual cycle of sowing and harvest, the picking of the grapes and their fermenting and consumption as wine. Legendary poets were named, praised, and honored, as were such figures as Daedalus and Trophonios, the mythic architects. Orpheus, mythic singer and poet, was said to attract wild animals, trees, and even the stones of the earth with his songs. The god Apollo himself, patron of such important sites as the oracle at Delphi, was associated with music and often portrayed on vases playing his lyre. The Homeric Hymn to Apollo recounts his accomplishments as architect at Delphi and as a maker of music:

> "Here I intend to build a beautiful temple...."
> With these words Phoibos Apollon laid out the foundations,
> broad and very long from beginning to end; and on them
> the sons of Erginos, Trophonios and Agamedes,
> dear to the immortal gods, placed a threshold of stone.
> And the numberless races of men built the temple all around
> with hewn stones, to be a theme of song forever (287-299).[15]

The god leads the Cretans to Delphi, to his temple, with song:

> [W]hen they had rid themselves of desire for food and drink,
> they set out to go, and the lord Apollon, son of Zeus, led the way,
> his step high and stately, and with the lyre in his hands
> played a lovely tune. The Cretans followed him
> to Pytho, beating time and singing the Iepaieon
> in the fashion of Cretans singing a paean when the divine

Muse has put mellifluous song in their hearts (513–19).

The god Apollo is the greatest of singers, but his songs vanish, surviving only as representations in the work of such poets as the anonymous author of the Homeric Hymn addressed to the god. Although the names of early poets were repeated and coupled with divine and legendary names, other such figures as Homer and Theognis probably represent a tradition of poetic creation rather than individuals, and these ancestors of the classical tragedians partake of a legendary aura.

We have the names of several tragic poets, along with fragments of their works, but the only tragedians whose work survives in the form of complete tragedies are Aeschylus, Sophocles, and Euripides. Their plays were presented at the theater festivals of Athens. Every year, in the classical period in Athens, four tragedies were performed at the festival called the Lenaia, and another nine at the City Dionysia. A poet who wished to enter one of his tragedies into competition was required to obtain a chorus from the Arkhon, the city official in charge of such events, among other aspects of city management. When the Arkhon took office, he appointed three tragic *khoregoi,* or "chorus leaders," who were then dispensed, in public patronage, to the poets who competed in the tragic festival.

The role of *khoregos* was a peculiar feature of Athenian democracy; the so-called "chorus leader" was actually a citizen who paid for the costs of training a chorus for the dramatic performances. Citizens assumed such financial responsibilities as a civic duty. One such citizen, a client of the orator Lysias, boasts that he spent more than seventy-two thousand drachmae on public services of this sort, on choruses for the theater, on dancers at the Panathenaea, the great festival held in honor of Athena, on ships for the city's navy. Citizens assumed these expenses not necessarily as as a primitive form of tax but often in competition with other less generous patrons of the city's functions.[16]

The judges of the tragic contests were chosen at random from among the citizens, the audience of the theater:

> Before the contest the Council had drawn up a list of names from each of the ten tribes, though the dramatic contests were not organised tribally. How the names were chosen is not known, but presumably they were those of regular theatre-goers. The names were put in ten urns, which were then sealed and lodged on the Akropolis. At the beginning of the contest the urns were brought to the theatre and unsealed. The Arkhon drew one name from

each. The ten men thus selected swore to vote honestly. At the end of the contest each judge wrote his order of merit on a tablet. The tablets were put in an urn. From it the Arkhon drew five at random, and thus the issue was decided.[17]

It was in fact the community of citizens and its agents, the Arkhon, *khoregoi*, and judges, who realized the tragic text as performance and judged it as part of the celebration of the power of the god Dionysos.

In his *Histories*, the ancient historian Herodotus recounts an anecdote revealing of the inseparability of the political and the "literary" in ancient Athenian culture. During the Persian Wars, when the Persians fought against the Greek cities in Asia Minor, the Persian army overwhelmed and defeated the city of Miletus, ally of Athens, and reduced it to slavery: The men were killed, the women and children made slaves, and the famous temple and oracle plundered and burnt. Herodotus recalls:

> The Athenians...showed their profound distress at the capture of Miletus in a number of ways, and in particular, when Phrynichus produced his play, *The Capture of Miletus*, the audience in the theatre burst into tears. The author was fined a thousand drachmae for reminding them of a disaster which touched them so closely, and they forbade anybody ever to put the play on the stage again.[18]

Such a scene—of the unity of representation, historical event, and politics—may seem almost incomprehensible to citizens of postmodern culture, where the domains of art, theater, and governmental intervention have a very different relationship. If we are concerned with the issues of censorship and intrusion of political bias into the funding of public art, for the ancient Greeks such categories would have made no sense. They inherited an understanding of mythical, divine skill from their Bronze Age ancestors, but they also considered the artisans among them to be workers, no longer gods. In the classical age they had become a democracy, and their "art" was always practice within the *polis*, "the city," their "art" was always *politics*.

Notes

1. Jürgen Habermas, "Modernity—An Incomplete Project," in *Postmodern Culture*, ed. Hal Foster (London and Concord, MA: Pluto Press, 1983), 9.
2. Plato, *Collected Dialogues*, Edith Hamilton and Huntington Cairns, eds.

(Princeton: Princeton University Press, 1961), 317.

3. Joseph Rykwert, *The Idea of a Town: The Anthropology of Urban Form in Rome, Italy and the Ancient World* (London: Faber and Faber, 1976), 130.

4. Sarah P. Morris, *Daidalos and the Origins of Greek Art* (Princeton: Princeton University Press, 1992).

5. Morris, *Daidalos,* xxi.

6. Pausanias, *Guide to Greece,* vol. 1, *Central Greece,* trans. Peter Levi (Harmondsworth: Penguin, 1971), 389.

7. On work and technological thought in ancient Greece, see Jean-Pierre Vernant, *Myth and Thought among the Greeks* (London: Routledge and Kegan Paul, 1983), 235-301.

8. J. J. Coulton, *Greek Architects at Work,* (London: Granada, 1977), 20.

9. Coulton, *Greek Architects,* 20.

10. Coulton, *Greek Architects,* 26.

11. Donald Preziosi, *Rethinking Art History: Meditations on a Coy Science* (New Haven: Yale University Press, 1989), 169.

12. See Francoise Frontisi-Ducroux, *Dedale. Mythologie de l'artisan en Grece ancienne* (Paris: Maspero, 1975).

13. Alison Burford, *Craftsmen in Greek and Roman Society* (Ithaca: Cornell University Press, 1972), 97-98.

14. See Page duBois, *Centaurs and Amazons: Women and Prehistory of the Great Chain of Being* (Ann Arbor: University of Michigan Press, 1982).

15. *The Homeric Hymns,* trans. Apostolos N. Athanassakis (Baltimore and London: Johns Hopkins University Press, 1976), 23-24.

16. See Lysias 16, 1-5, and Paul Veyne, *Le pain et le cirque* (Paris: Seuil, 1976), published in English as *Bread and Circuses: Historical Sociology and Political Pluralism,* abridged by Oswyn Murray, trans. Brian Pearce (London: Penguin, 1990).

17. J. W. Roberts, *City of Sokrates* (London and New York: Routledge and Kegan Paul, 1984), 166.

18. Herodotus, *The Histories,* trans. Aubrey de Selincourt, rev. A. R. Burn (Harmondsworth: Penguin, 1972), 395.

2

A PLEA FOR IRRESPONSIBILITY

Ewa Kuryluk

Born in Communist Poland, at four I was a Stalinist. At seven (after the death of Stalin whom our kindergarten instructor had called Daddy but who three years later was cursed every day) I began turning into a skeptic. At twelve I decided to become an artist. No doubt, my loss of faith was the first step towards art. Ever since I have been convinced that art makes sense, if at all, only when it uses personal perception to counter the power of some collective belief. I also share Adorno's view that today the anti-collectivist spirit of art must be treasured even more than in the past because of our culture's tendency to go totalitarian—on a deadly global scale. Thus collective standards must be questioned, not confirmed by art, and artists must fight for *autonomy*: their right

to explore and express whatever they find important or interesting. This explains the tenor of this little essay which, arguing against the politicization of art, desires to signal its recent degradation to a propagandistic or commercial device.

Another reason why I plead for an irresponsibly private pursuit of art is my wish to see it survive. Art is mostly about memory, and it seems to me that irrelevant remembrances—the insignificant bits and pieces of an artist's day—age best. A contemporary beholder is more likely to ignore a colossal statue of a pharaoh than a statuette of his cat. Life is a paradox, and so is art. In the end only the smallest may be truly immortal. See that red maple leaf swirling in the wind on an ancient Japanese scroll? A nothing, yet it makes us recall that fall is around the corner. On this note let me begin.

Should society expect a painter to be more responsible than a shoemaker? Should a poet show a greater degree of social awareness than a dentist? Until the French Revolution the answer was mostly *no*: The shoemaker was thought to be responsible for good shoes, the painter for pretty pictures, the poet for memorable verse. Since the French Revolution the answer has been an ever stronger *yes*. The transformation of the artist-craftsman into the artist-VIP is dramatically reflected in the career of Jacques Louis David. Originally a court painter of Louis XVI, he sided with the most radical wing of the Revolution, was elected to the Convention, and voted for the king's death.

No artist can exist without a patron. In the course of the nineteenth century the patronage of the court, the aristocracy, and the Church were gradually replaced with that of the bourgeoisie and the state. The loss of the old reliable patrons rendered the artist's life at once precarious and more glamorous. Artists began to find themselves without a steady income and a proper place in society. But they seemed to breathe a purer air than wage earners, and were compensated with public prestige. Their existence was endangered, but their egos kept growing, and so did their sense of social mission. They also hoped to attract the attention of the state, their new sponsor.

Poets in particular started assuming prominent political roles. Perceived by society and themselves as prophets and charismatic leaders, they felt entitled to speak for a nation or mankind, to head uprisings or wars. The romantic canon of a divinely inspired young genius sacrificing himself on the altar of freedom was established by Lord Byron. At thirty-five, sickly and incompetent, he joined the Greeks in their struggle for independence. Eight months later he succumbed to rheumatic fever,

ague, and epileptic fits. After his death in Missolonghi all Europe remembered in tears that he had called out in his comatose sleep half in English, half in Italian: "Forward—avanti—corraggio! Follow my example, don't be afraid!"

Young poets from Poland, another oppressed nation, were on the move too. Dressed à la Byron, they attempted to guide their people to liberty—with an equal lack of success. More successful, perhaps, was their contribution to the English bard's entrance into German literature. As they visited Goethe, their father figure, at the Weimar court, they no doubt raved about Byron—inspiring his immortalization in *Faust*. In the tragedy's second part, Lord Byron appears under the guise of Euphorion, the son of old Faust (Goethe) and Helen of Troy (the resurrected Miss Universe). In spite of his parents' warnings, Euphorion decides to fly up to the sun. But his wings are burnt by its fire, and he falls down and expires at their feet.

In the late nineteenth century the artist's position was strengthened by the ossification of religion and the erosion of traditional values. Before the final destruction of old Europe by World War One, the artist-messiah turned into a big-mouthed monster. In 1909 the Italian poet Filippo Tommaso Marinetti published his Futurist manifesto in the Parisian newspaper *Le Figaro*. His bombastic language provoked a lot of laughter, but his political program, suggested by contemporary anarchist activities, was no fun. His demand to obliterate the past and create a new society, his call for nationalism and colonial expansion, even at the cost of war with Austria, and his shock-speak were picked up by the fascist dictatorship. During World War Two an American artist followed in the footsteps of the Italian Futurists. Ezra Pound, one of the greatest innovators of modern poetry but politically a fool, spoke on the fascist radio in support of Mussolini and against his own country.

In Russia the Futurists, the most radical group of the prewar avant-garde, had little interest in politics. But they shared the obsession with progress and an obnoxious rhetoric with their Italian colleagues. The Futurists' merciless attacks on traditional poetry and art prepared the ground for the brutalization of culture after the October Revolution. In 1917 the country's most gifted artists sided with the Soviets, and many leaders of the avant-garde were given positions in the new state institutions. Once in power, they proceeded to get rid of the politically "irresponsible" artists, and to formulate Constructivism.

A typical product of revolutionary enthusiasm, Constructivism developed in two antagonistic directions. One descended from Kandinsky's

and Malevich's belief that art is derived from personal rather than public experience, and thus possesses its own autonomy. The opposite opinion was voiced by Tatlin. He was convinced that the artist must subordinate all individual creation to the common good, or more specifically to the requirements of the victorious new state. Not surprisingly, the Soviets preferred the second solution. It also fit better into Marxist aesthetics which later was incorporated, together with Tatlin's Constructivism, into Socialist Realism, the aesthetic doctrine of the Soviet Union and its satellites.

Socialist Realism, a revolutionary romanticism turned into a propaganda tool, limited the artist's role to two aims. The Soviet state, which considered itself a model for the rest of the world, ordered the artist to demonize the evils of capitalism—which in principle had been vanquished but now needed to be exterminated—and to render the dawn of communism and the future paradise on earth in pink and sugar. Complying artists were promised security, status, and fame. The state kept its promise, making the Soviet propagandist into a monumental proletarian Petrarch. The socialist cult of the artist is best recorded in an old joke about Gorky.

A friend of Lenin, a protégé of Stalin, the originator of Socialist Realism in literature and *Man! How proud it sounds*—a bon mot once written on every wall, including my kindergarten wall—Alexey Maksimovich Peshkhov changed his name to a politically correct literary pseudonym, Maxim Gorky, meaning Maximus the Bitter, the best raconteur of capitalist bitterness. His dedication to the Soviet state, from which he was often absent because of his bad health (the years 1924–31, when a million Russian peasants starved to death in consequence of Stalin's collectivization plan, he spent in Sorrento and Capri), was rewarded with the highest honors and biggest editions. But, insatiable, Gorky kept pestering Stalin: Joseph Vissorionovich, how can you bear that I, a Soviet Homer, remain so underestimated? First a Gorky monument was erected in the center of Moscow, then the capital's main boulevard and the city of Nizhny Novgorod, his birthplace, were renamed Gorky. At last, seeing Gorky return with yet another request, Stalin burst out: "Want me to give you a **gorkaya** *epokha* (a **bitter** age)? To ask you to extol its sweetness?"

The bitter age was created by art fanatics with a sweet tooth. Adolf Hitler, in his youth an amateur painter and composer, collected sentimental kitsch, toured Italian galleries with Benito and Signora Mussolini, and dreamt of being an architect, while attacking Stalingrad. In Russia,

the land of poetry, Comrade Stalin considered himself a linguist and critic of literature. Connoisseurs and lovers of "good" art, the Nazis and the Soviets felt obliged to fight "bad" art. Thus Germany was cleansed of the "degenerate" artists, the Soviet Union of the "antisocialist" elements.

However, the annihilation of art's autonomy proved as difficult as the eradication of false consciousness, the ultimate cause of all wrong doing. In the Soviet Union the pursuit of private fantasy was declared "bourgeois" art and persecuted like a crime. The forbidden fruit, however, was preferred to the mandatory truth. The complete luxury editions of Gorky's writings, the pride of every party apparatchik, decorated the book shelves from Peking to Budapest. Meanwhile, the people of the Soviet camp copied by hand and circulated in samizdat Nabokov's *Lolita* or Solzhenitsyn's *Cancer Ward*. They also produced tons of antipropaganda, which helped dismantle the system but was no blessing for art. After formal standards had been neglected for decades, poetry and fiction, painting and music, ceramics and embroidery emerged from the Soviet era pale, crude, and dull.

Has the collapse of the Third Reich and the Soviet Union discredited the ideal of the artist-propagandist? Yes and no. Clearly, there is little interest in reheating the totalitarian soufflé, especially where it had been prepared with so much pain. But the further away one moves from its cradle, the more attraction there is for it. In today's America, for instance, quite a few artists, art critics, and organizers seem to believe that it's good to produce and sponsor art which is *politically correct*, that is, has been *deliberately* made to fit, reinforce, or promote the collective images, ideals, and goals favored by them. Even though many politically correct art currents are less stultifying than one, the whole phenomenon is a late offspring of the totalitarian past. In addition, a Marxist approach to art is still strong on the left, while the right thunders about the God-given truth the artist should propagate—in order to please a "pro-life" preacher. All of the existing pressure groups dream of convincing the state that it should support the artists useful to them. But what about a Samuel Beckett delighting in absurdity? A Francis Bacon, driven to destruction and death? Must we really deplore their marginal lives, their irresponsible art?

I hope not. At the end of this bloody century we should finally admit that the politicization of art is harmful to a sophisticated humanity. In order to feed our psyche, stimulate our mind, and transcend space and time, art must strive for the highest individual standard, not for the common denominator of politics. Today, when at last it's possible to make art

that is as free as a poem by Sappho or a painting by Vermeer—once a truly independent creation was so rare!—its standard can only be defined by the the unique vision and aspiration of the artist. Torquato Tasso escaped from the court of Ferrara. But compared to an Italian prince's residence, the world of contemporary politics is a cage. Confined to it, art will mutate to junk. Deprived of art, humans will metamorphose into donkeys.

Of course, every artist is also a political creature. No one can jump out of his/her skin—white or yellow, black or red—and in this sense every artist is a medium of his/her time and place. But this doesn't mean that all art is political. The artist is a captive of his or her class consciousness in Marxist aesthetics only. In the modern world the artist—independent, solitary, and peripheral—tends to be the moving spirit of cultural change. Van Gogh's painting is not a typical product of the European bourgeoisie nor fully determined by his descent from the Protestant middle class of the Netherlands—even though the Great Soviet Encyclopaedia may tell you so. On the contrary, Van Gogh's pictures mirror his complete disinterest in the values of his society. Reflections of his liberty to chose his artistic kin at the other end of the world, his paintings are strangers to the European art establishment—but first cousins of Japan.

Am I against political art? Not at all. If artists want to work for an animal rights lobby or an anarchist party, let them do so—and have the animal rights advocates and anarchists take care of them. What I rebel against is the idealization of the "responsible" artist, and "the" politically correct art. It's time to understand that a Gorky type of guy or girl—artistically a dwarf, politically a giant—can also be cultivated in a democratic state where by now everybody is aware of the power of art as publicity and propaganda.

Now what about state patronage? Am I for or against it? It's a delicate question, and I hesitate to answer it with a clear yes or no. Maybe it's better for art when the state fuels the activity of private sponsors and refrains from direct patronage. But when there is no one else to fund the arts, the state has to take over. In such a case, however, it cannot favor any of the politically correct artists over those without a political agenda. If it does, it will contribute to the final dissolution of art.

At any given moment in history the world stands on its head. The belief in individual freedom has never been as strong as it is today. Yet the avant-gardists, blue birds, and lonely riders who refuse to subscribe to some goodness or truth, seem to be an endangered species, and the

number of single-minded dealers, critics, and beholders who share their dreams and are able to defend them from the claws of the political cats and the appetites of the commercial sharks keeps shrinking as well. The sharks, on the other hand, grow into killer whales, and, consumed by their greed for global profits, develop ever more perverse skills in producing and promoting best-sellers only. Squeezed in between the pursuers of politics and the pressure of the market, the artist is about to break down and succumb to propaganda or soap opera.

Today the question is: Does the world want to have art or not? If yes, a lot of effort will have to go into controlling the political and commercial forces which threaten its existence. In order to survive, the artist needs the company of a dedicated beholder. But an adequate milieu is also a must. A future Emily Dickinson is not likely to be born into an illiterate society. A Dogon wood carver needs the forest, a Zen monk-painter his convent, a Joseph Cornell a New York City where one isn't afraid to walk. The degradation of the cities, the suburbanization of the countryside, the destruction of nature and culture are likely to annihilate them all.

Humanity as a whole must begin to act responsibly, or be prepared to live in an awfully bitter age. And what's the artist's mission? To kiss goodbye the sociopolitical messiah and insist that the artist is responsible for his or her work. Bohemians, wake up! Let's start whispering into the ear of the public: The art that's best for you—now and in the future—is not a commodity but an inspiration. A curious communication between me, the creator, and you, the recreator of hidden patterns and secret suggestions, art is a coded love letter and a private plea: to retrieve from the river of blood and time what's irresponsible and mutual.

3

DEAD DOLL PROPHECY

Kathy Acker

CAPITOL IS AN ARTIST WHO MAKES DOLLS. MAKES, DAMAGES, TRANSFORMS, SMASHES. ONE OF HER DOLLS IS A WRITER DOLL. THE WRITER DOLL ISN'T VERY LARGE AND IS ALL HAIR, HORSE MANE HAIR, RAT FUR, DIRTY HUMAN HAIR, PUSSY.

ONE NIGHT CAPITOL GAVE THE FOLLOWING SCENARIO TO HER WRITER DOLL:

As a child in sixth grade in a North American school, won first prize in a poetry contest.

In late teens and early twenties, entered New York City poetry world.

Prominent Black Mountain poets, mainly male, taught or attempted to teach her that a writer becomes a writer when and only when he finds his own voice.

CAPITOL DIDN'T MAKE ANY AVANT GARDE POET DOLLS.

Since wanted to be a writer, tried to find her own voice. Couldn't. But still loved to write. Loved to play with language. Language was material like clay or paint. Loved to play with verbal material, build up slums and mansions, demolish banks and half-rotten buildings, even buildings which she herself had constructed, into never-before-seen, even unseeable, jewels.

To her, every word wasn't only material in itself, but also sent out like beacons other words. *Blue* sent out *heaven* and *The Virgin*. Material is rich. I didn't create language, writer thought. Later she would think about ownership and copyright. I'm constantly being given language. Since this language-world is rich and always changing, flowing, when I write, I enter a world which has complex relations and is, perhaps, illimitable. This world both represents and is human history, public memories and private memories turned public, the records and actualizations of human intentions. This world is more than life and death, for here life and death conjoin. I can make language, but in this world, I can play and be played.

So where is 'my voice'?

Wanted to be a writer.

Since couldn't find 'her voice', decided she'd first have to learn what a Black Mountain poet meant by 'his voice'. What did he do when he wrote?

A writer who had found his own voice presented a viewpoint. Created meaning. The writer took a certain amount of language, verbal material, forced that language to stop radiating in multiple, even unnumerable directions, to radiate in only one direction so there could be his meaning.

The writer's voice wasn't exactly this meaning. The writer's voice was a process, how he had forced that language to obey him, his will. The writer's voice is the voice of the writer as God.

Writer thought, don't want to be God; have never wanted to be God. All these male poets want to be the top poet, as if, since they can't be a dictator in the political realm, can be dictator of this world.

Want to play. Be left alone to play. Want to be a sailor who journeys at

every edge and even into the unknown. See strange sights, see. If I can't
keep on seeing wonders, I'm in prison. Claustrophobia's sister to my
worst nightmare: lobotomy, the total loss of perceptual power, of seeing
new. If had to force language to be uni-directional, I'd be helping my
own prison to be constructed.

There are enough prisons outside, outside language.

Decided, no. Decided that to find her own voice would be negotiat-
ing against her joy. That's what the culture seemed to be trying to tell her
to do.

Wanted only to write. Was writing. Would keep on writing without
finding 'her own voice'. To hell with the Black Mountain poets even
though they had taught her a lot.

Decided that since what she wanted to do was just to write, not to find
her own voice, could and would write by using anyone's voice, anyone's
text, whatever materials she wanted to use.

Had a dream while waking that was running with animals. Wild hors-
es, leopards, red fox, kangaroos, mountain lions, wild dogs. Running
over rolling hills. Was able to keep up with the animals and they accepted
her.

Wildness was writing and writing was wildness.

Decision not to find this own voice but to use and be other, multiple,
even innumerable, voices led to two other decisions.

There were two kinds of writing in her culture: good literature and
schlock. Novels which won literary prizes were good literature; science
fiction and horror novels, pornography were schlock. Good literature
concerned important issues, had a high moral content, and, most impor-
tant, was written according to well-established rules of taste, elegance,
and conservatism. Schlock's content was sex horror violence and other
aspects of human existence abhorrent to all but the lowest of the low, the
socially and morally unacceptable. This trash was made as quickly as pos-
sible, either with no regard for the regulations of politeness or else with
regard to the crudest, most vulgar techniques possible. Well-educated,
intelligent, and concerned people read good literature. Perhaps because
the masses were gaining political therefore economic and social control,
not only of literary production, good literature was read by an elite
diminishing in size and cultural strength.

Decided to use or to write both good literature and schlock. To mix
them up in terms of content and formally.

Offended everyone.

Writing in which all kinds of writing mingled seemed, not immoral,

but amoral, even to the masses. Played in every playground she found; no one can do that in a class or hierarchical society.

(In literature classes in university, had learned that anyone can say or write anything about anything if he or she does so cleverly enough. That cleverness, one of the formal rules of good literature, can be a method of social and political manipulation. Decided to use language stupidly.) In order to use and be other voices as stupidly as possible, decided to copy down simply other texts.

Copy them down while, maybe, mashing them up because wasn't going to stop playing in any playground. Because loved wildness.

Having fun with texts is having fun with everything and everyone. Since didn't have one point of view or centralized perspective, was free to find out how the texts she used and was worked. In their contexts which were (parts of) culture.

Liked best of all mushing up texts.

Began constructing her first story by placing mashed-up texts by and about Henry Kissinger next to *True Romance* texts. What was the true romance of America? Changed these *True Romance* texts only by heightening the sexual crudity of their style. Into this mush, placed four pages out of Harold Robbins', one of her heroes, newest hottest bestsellers. Had first made Jacqueline Onassis the star of Robbins' text.

Twenty years laster, a feminist house republished the last third of the novel in which this mash occurred.

CAPITOL MADE A FEMINIST PUBLISHER DOLL EVEN THOUGH, BECAUSE SHE WASN'T STUPID, SHE KNEW THAT THE FEMINIST PUBLISHING HOUSE WAS ACTUALLY LOTS OF DOLLS. THE FEMINIST PUBLISHER DOLL AS A BEAUTIFUL WOMAN IN ST. LAURENT DRESS. CAPITOL, PERHAPS OUT OF PERVERSITY, REFRAINED FROM USING HER USUAL CHEWED UP CHEWING GUM, HALF-DRIED FLECKS OF NAIL POLISH AND BITS OF HER OWN BODY THAT HAD SOMEHOW FALLEN AWAY.

Republished the text containing the Harold Robbins' mush next to a text she had written only seventeen years ago. In this second text, the only one had ever written without glopping up hacking into and rewriting other texts (appropriating), had tried to destroy literature or what she as a writer was supposed to write by making characters and a story that were so stupid as to be almost nonexistent. Ostensibly, the second

text was a porn book. The pornography was almost as stupid as the story. The female character had her own name.

Thought just after had finished writing this, here is a conventional novel. Perhaps, here is 'my voice'. Now I'll never again have to make up a bourgeois novel.

Didn't.

The feminist publisher informed her that this second text was her most important because here she had written a treatise on female sexuality.

Since didn't believe in arguing with people, wrote an introduction to both books in which she stated that her only interest in writing was in copying down other people's texts. Didn't say liked messing them up because was trying to be polite. Like the English. Did say had no interest in sexuality or in any other content.

CAPITOL MADE A DOLL WHO WAS A JOURNALIST. CAPITOL LOVED MAKING DOLLS WHO WERE JOURNALISTS. SOMETIMES SHE MADE THEM OUT OF THE NEWSPAPERS FOUND IN TRASHCANS ON THE STREETS. SHE KNEW THAT LOTS OF CATS INHABITED TRASHCANS. THE PAPERS SAID RATS CARRY DISEASES. SHE MADE THIS JOURNALIST OUT OF THE FINGER-NAILS SHE OBTAINED BY HANGING AROUND THE TRASHCANS IN THE BACK LOTS OF LONDON HOSPITALS. HAD PENETRATED THESE BACK LOTS WITH THE HOPE OF MEETING MEAN OLDER MEN BIKERS. FOUND LOTS OF OTHER THINGS THERE SINCE, TO MAKE THE JOURNALIST. SHE MOLDED THE FINGERNAILS TOGETHER WITH SUPERGLUE AND, BEING A SLOB, LOTS OF OTHER THINGS STUCK TO THIS SUPERGLUE. THE JOURNALIST DIDN'T LOOK ANYTHING LIKE A HUMAN BEING.

A journalist who worked on a trade publishing magazine, so the story went, no one could remember whose story, was informed by another woman in her office that there was a resemblance between a section of the writer's book and Harold Robbins' work. Most of the literati of the country in which the writer was currently living were upper-middle-class and detested the writer and her writing.

CAPITOL THOUGHT ABOUT MAKING A DOLL OF THIS COUN-TRY, BUT DECIDED NOT TO.

Journalist decided she had found a scoop. Phoned up the feminist publisher to enquire about plagiarism; perhaps feminist publisher said something wrong because then phoned up Harold Robbins' publisher.

'Surely all art is the result of one's having been in danger, of having gone through an experience all the way to the end, where no one can go any further. The further one goes, the more private, the more personal, the more singular an experience becomes, and the thing one is making is finally, the necessary, irrepressible, and, as nearly as possible, definitive utterance of this singularity....Therein lies the enormous aid the work of art brings to the life of the one who must make it....

'So we are most definitely called upon to test and try ourselves against the utmost, but probably we are also bound to keep silence regarding this utmost, to beware of sharing it, of parting with it in communication so long as we have not entered the work of art: for the utmost represents nothing other than that singularity in us which no one would or even should understand, and which must enter into the works as such…Rilke to Cezanne.

CAPITOL MADE A PUBLISHER LOOK LIKE SAM PECKINPAH. THOUGH SHE HAD NO IDEA WHAT SAM PECKINPAH LOOKED LIKE. HAD LOOKED LIKE? SHE TOOK A HOWDY DOODY DOLL AND AN ALFRED E NEUMAN DOLL AND MASHED THEM TOGETHER, THEN MADE THIS CONGLOMERATE INTO AN AMERICAN OFFICER IN THE MEXICAN-AMERICAN WAR. ACTUALLY SEWED, SHE HATED SEWING, OR WHEN SHE BECAME TIRED OF SEWING, GLUED TOGETHER WITH HER OWN TWO HANDS, JUST AS THE EARLY AMERICAN PATRIOT WIVES USED TO DO FOR THEIR PATRIOT HUSBANDS, A FROGGED AND BRAIDED CAVALRY JACKET, STAINED WITH BLOOD FROM SOME FORMER OWNERS. THEN FASHIONED A STOVEPIPE HAT OUT OF ONE SHE HAS STOLEN FROM A BUM IN AN ECSTASY OF ART. THE HAT WAS A BIT BIG FOR THE PUBLISHER. INSIDE A GOLD HEART, THERE SHOULD BE A PICTURE OF A WOMAN. SINCE CAPITOL DIDN'T HAVE A PICTURE OF A WOMAN, SHE PUT IN ONE OF HER MOTHER. SINCE SAM PECKINPAH OR HER PUBLISHER HAD SEEN TRAGEDY, AN ARROW HANGING OUT OF THE WHITE BREAST OF A SOLDIER NO OLDER THAN A CHILD, HORSES GONE MAD WALL-EYED MOUTHS FROTHING AMID DUST THICKER THAN THE SMOKE OF GUNS. SHE MADE HIS FACE FULL OF FOLDS, AN EYEPATCH

OVER ONE EYE.

Harold Robbins' publisher phoned up the man who ran the company who owned the feminist publishing company. From now on, known as "The Boss". The Boss told Harold Robbins' publisher that they have a plagiarist in their midst.

CAPITOL NO LONGER WANTED TO MAKE DOLLS. IN THE UNITED STATES UPON SEEING THE WORK OF THE PHOTOG-RAPHER ROBERT MAPPLETHORPE, SENATOR JESSE HELMS PROPOSED AN AMENDMENT TO THE FISCAL YEAR 1990 INTERIOR AND RELATED AGENCIES BILL FOR THE PURPOSE OF PROHIBITING 'THE USE OF APPROPRIATED FUNDS FOR THE DISSEMINATION, PROMOTION, OR PRODUCTION OF OBSCENE OR INDECENT MATERIALS OR MATERIALS DENI-GRATING A PARTICULAR RELIGION.' THREE SPECIFIC CATEGORIES OF UNACCEPTABLE MATERIAL FOLLOWED: (1) OBSCENE OR INDECENT MATERIALS, INCLUDING BUT NOT LIMITED TO DEPICTIONS OF SADOMASOCHISM (ALWAYS GET THAT ONE IN FIRST), HOMOEROTICISM, THE EXPLOITATION OF CHILDREN, OR INDIVIDUALS ENGAGED IN SEX ACTS; OR (2) MATERIAL WHICH DENIGRATES THE OBJECTS OR BELIEFS OF THE ADHERENTS OF A PARTICULAR RELIGION OR NON-RELIGION; OR (3) MATERIAL WHICH DENIGRATES, DEBASES, OR REVILES A PERSON, GROUP, OR CLASS OF CITIZENS ON THE BASIS OF RACE, CREED, SEX, HANDICAP, AGE, OR NATIONAL ORIGIN'. IN HONOR OF JESSE HELMS, CAPITOL MADE, AS PILLOWS, A CROSS AND A VAGINA, SO THE POOR COULD HAVE SOMEWHERE TO SLEEP. SINCE SHE NO LONGER HAD TO MAKE DOLLS OR ART, BECAUSE ART IS DEAD IN THIS CULTURE, SHE SLOPPED THE PILLOWS TOGETHER WITH DEAD FLIES, WHITE FLOUR MOISTENED BY THE BLOOD SHE DREW OUT OF HER SMALLEST FINGERS WITH A PIN, AND OTHER TYPES OF GARBAGE.

Disintegration.

Feminist publisher then informed writer that the Boss and Harold Robbins' publisher had decided, due to her plagiarism, to withdraw the book from publication and to have her sign an apology to Harold

Robbins which they had written. This apology would then be published in two major publishing magazines.

Ordinarily polite, told feminist publisher they could do what they wanted with their edition of her books but she wasn't going to apologize to anyone for anything, much less for twenty years of work.

Didn't have to think to herself because every square inch of her knew. For freedom. Writing must be for and must be freedom.

Feminist publisher replied she'd take care of everything. Writer shouldn't contact Harold Robbins because that would make everything worse.

Would, the feminist publisher asked, the writer please compose a statement for the Boss why the writer used other texts when she wrote so that the Boss wouldn't believe that she was a plagiarist.

CAPITOL MADE A DOLL WHO LOOKED EXACTLY LIKE HER-SELF. IF YOU PRESSED A BUTTON ON ONE OF THE DOLL'S CUNT LIPS THE DOLL SAID, 'I AM A GOOD LITTLE GIRL AND DO EXACTLY AS I AM TOLD TO DO.'

Wrote:

> Nobody save buzzards. Lots of buzzards here. In the distance, lay flies and piles of shit. Herds of animals move against the skyline like black caravans in an unknown east. Sheep and goats. Another place, a horse is lapping the water of a pool. Lavender and grey trees behind this black water are leafless and spineless. As the day ends, the sun in the east flushes out pale lavenders and pinks, then turns blood red as it turns on itself, becoming a more definitive shape, the more definitive, the bloodier. Until it sits, totally unaware of the rest of the universe, waiting at the edge of a sky that doesn't yet know what colors it wants to be, a hawk waiting for the inevitable onset of human slaughter. The light is fleeing.

Instead, sent a letter to feminist publisher in which said that she composed her texts out of 'real' conversations, anything written down, other texts, somewhat in the ways the Cubists had worked. [Not quite true. But thought this statement understandable]. Cited, as example, her use of True Confessions stories. Such stories whose content seemed purely and narrowly sexual, composed simply for purposes of sexual titillation and economic profit, if deconstructed, viewed in terms of context and genre,

became signs of political and social realities. So if the writer or critic (deconstructionist) didn't work with the actual language of these texts, the writer or critic wouldn't be able to uncover the political and social realities involved. For instance, both genre and the habitual nature of perception hide the violence of the content of many newspaper stories.

To uncover this violence is to run the risk of being accused of loving violence or all kinds of pornography. (As if the writer gives a damn about what anyone considers risks.)

Wrote, living art rather than dead has some connection with passion. Deconstructions of newspaper stories become the living art in a culture that demands that any artistic representation of life be nonviolent and nonsexual, misrepresent.

To copy down, to appropriate, to deconstruct other texts is to break down those perceptual habits the culture doesn't want to be broken.

Deconstruction demands not so much plagiarism as breaking into the copyright law.

In the Harold Robbins text which had used, a rich white woman walks into a disco, picks up a black boy, has sex with him. In the Robbins text, this scene is soft-core porn, has as its purpose mild sexual titillation and pleasure.

[When Robbins' book had been published years ago, the writer's mother had said that Robbins had used Jacqueline Onassis as the model for the rich white woman.] Wrote, had made apparent that bit of politics while amplifying the pulp quality of the style in order to see what would happen when the underlying presuppositions or meanings of Robbins' writing became clear. Robbins as emblematic of a certain part of American culture. What happened was that the sterility of that part of American culture revealed itself. The real pornography. Cliches, especially sexual cliches, are always signs of power or political relationships.

BECAUSE SHE HAD JUST GOTTEN HER PERIOD, CAPITOL MADE A HUGE RED SATIN PILLOW CROSS THEN SMEARED HER BLOOD ALL OVER IT.

Her editor at the feminist publisher said that the Boss had found her explanation 'literary'. Later would be informed that this was a legal, not a literary, matter.

'HERE IT ALL STINKS,' CAPITOL THOUGHT. 'ART IS MAKING ACCORDING TO THE IMAGINATION. HERE, BUYING AND

SELLING ARE THE RULES; THE RULES OF COMMODITY HAVE DESTROYED THE IMAGINATION. HERE, THE ONLY ART ALLOWED IS MADE BY POSTCAPITALIST RULES. ART ISN'T MADE ACCORDING TO RULES.' ANGER MAKES YOU WANT TO SUICIDE.

Journalist who broke the 'Harold Robbins story' had been phoning and leaving messages on writer's answer machine for days. Had stopped answering her phone. By chance picked it up; journalist asked her if anything to say.

'You mean about Harold Robbins?'

Silence.

'I've just given my publisher a statement. Perhaps you could read that.'

'Do you have anything to add to it?' As if she was a criminal.

A few days later writer's agent over phone informed writer what was happening simply horrible.

CAPITOL DIDN'T WANT TO MAKE ANY DOLLS.

How could the writer be plagiarizing Harold Robbins?

Writer didn't know.

Agent told writer if writer had phoned her immediately, agent could have straightened out everything because she was good friends with Harold Robbins' publisher. But now it was too late.

Writer asked agent if she could do anything.

Agent answered that she'd phone Harold Robbins' publisher and that the worst that could happen is that she'd have to pay a nominal quotation rights fee.

So a few days later was surprised when feminist publisher informed her that if she didn't sign the apology to Harold Robbins which they had written for her, feminist publishing company would go down a drain because Harold Robbins or Harold Robbins publisher would slap a half-a-million [dollar? pound?] lawsuit on the feminist publishing house.

Decided she had to take notice of this stupid affair, though her whole life wanted to notice only writing and sex.

'WHAT IS IT?'CAPITOL WROTE, "TO BE AN ARTIST? WHERE IS THE VALUE THAT WILL KEEP THIS LIFE IN HELL GOING?'

For one of the first times in her life, was deeply scared. Was usually as wild as they come. Doing everything if it felt good. So when succumbed to fear, succumbed to reasonless, almost bottomless fear.

Panicked only because she might be forced to apologize, not to Harold Robbins, that didn't matter, but to anyone for her writing, for what seemed to be her life. Book had already been withdrawn from print. Wasn't that enough? Panicked, phoned her agent without waiting for her agent to phone her.

Agent asked writer if she knew how she stood legally.

Writer replied that as far as knew Harold Robbins had made no written charge. Feminist publisher sometime in beginning had told her they had spoken to a solicitor who had said neither she nor they 'had a leg to stand on'. Since didn't know with what she was being charged, she didn't know what that meant.

Agent replied, "Perhaps we should talk to a solicitor. Do you know a solicitor?"

Knew the name of a tax solicitor.

Since had no money, asked her American publisher what to do, if he knew a lawyer.

WOULD MAKE NO MORE DOLLS.

American publisher informed her couldn't ask anyone's advice until she knew the charges against her, saw them in writing.

Asked the feminist publisher to send the charges against her and whatever else was in writing to her.

Received two copies of the 'Harold Robbins' text she had written twenty years ago, one copy of the apology she was supposed to sign, and a letter from Harold Robbins' publisher to the head of the feminist publishing company. Letter said that they were not seeking damages beyond withdrawal of the book from publication [which had already taken place] and the apology.

Didn't know of what she was guilty.

Later would receive a copy of the letter sent to her feminist publisher from the solicitor whom the feminist publisher and then her agent had consulted. Letter stated: According to the various documents and texts which the feminist publisher had supplied, the writer should apologize to Mr Harold Robbins. First, because in her text she has used a substantial number of Mr Robbins' words. Second, because she did not use any texts other than Mr Robbins' so there could be no literary theory or

praxis responsible for her plagiarism. Third, because the contract between the writer and the feminist publisher states that the writer had not infringed upon any existing copyright.

When the writer wrote, not wrote back, to the solicitor that most of the novel in question had been appropriated from other texts, that most of these texts had been in the public domain, that the writers of texts not in public domain were either writers of True Confessions stories (anonymous) or writers who knew she had reworked their texts and felt honored, except for Mr Robbins, that she had never misrepresented nor hidden her usages of other texts, her methods of composition, that there was already a body of literary criticism on her and others' methods of appropriation, and furthermore, [this was to become the major point of contention], that she would not sign the apology because she could not since there was no assurance that all possible litigation and harassment would end with the signature of guilt, guilt which anyway she didn't feel: the solicitor did not reply.

Not knowing of what she was guilty, feeling isolated and pressured to finish her new novel, writer became paranoid. Would do anything to stop the pressure from the feminist publisher and simultaneously would never apologize for her work.

Considered her American publisher her father. Told her the 'Harold Robbins affair' was a joke, she should take her phone off the hook, go to Paris for a few days.

Finish your book. That's what's important.

WOULD MAKE NO MORE DOLLS.

Paris is a beautiful city.

In Paris decided that it's stupid to live in fear. Didn't yet know what to do about isolation. All that matters is work and work must be created in and can't be created in isolation. Remembered a conversation she had had with her feminist publisher. Still trying to explain, writer said, in order to deconstruct, the deconstructionist needs to use the actual other texts. Editor had said she understood. For instance, she was sure Peter Carey in *Oscar and Lucinda* had used other people's writings in his dialogue, but would never admit it. This writer did what every other writer did, but she is the only one who admits it. 'It's not a matter of not being able to write,' the writer replied. 'It's a matter of a certain theory which is also a literary theory. Theory and belief.' Then shut up because knew that when you have to explain and explain, nothing is understood.

Language is dead.

SINCE THERE WERE NO MORE DOLLS, CAPITOL STARTED
WRITING LANGUAGE.

Decided that it's stupid living in fear of being forced to be guilty without
knowing why you're guilty and, more important, it's stupid caring about
what has nothing to do with art. It doesn't really matter whether or not
you sign the fucking apology.

Over phone asked the American publisher whether or not it mattered
to her past work whether or not signed the apology.

Answered that the sole matter was her work.

Thought alike.

Wanted to ensure that there was no more sloppiness in her work or
life, that from now on all her actions served only her writing. Upon
returning to England, consulted a friend who consulted a solicitor who
was his friend about her case. This solicitor advised that since she wasn't
guilty of plagiarism and since the law was unclear, grey, about whether or
not she had breached Harold Robbins' copyright, it could be a legal
precedent, he couldn't advise whether or not she should sign the apol-
ogy. But must not sign unless, upon signing, received full and final
settlement.

Informed her agent that would sign if and only if received full and
final settlement upon signing.

Over phone, feminist publisher asked her who had told her about full
and final settlement.

A literary solicitor.

Could they, the feminist publishing house, have his name and his
statement in writing?

'This is my decision,' writer said. 'That's all you need to know.'

WROTE DOWN 'PRAY FOR US THE DEAD', THE FIRST LINE IN
THE FIRST POEM BY CHARLES OLSON SHE HAD EVER READ
WHEN SHE WAS A TEENAGER. ALL THE DOLLS WERE DEAD.
DEAD HAIR. WHEN SHE LOOKED UP THIS POEM, ITS FIRST
LINE WAS, 'WHAT DOES NOT CHANGE/IS THE WILL TO
CHANGE.'

WENT TO A NEARBY CEMETERY AND WITH STICK DOWN IN
SAND WROTE THE WORDS 'PRAY FOR US THE DEAD.'
THOUGHT, WHO IS DEAD? THE DEAD TREES? WHO IS DEAD?

WE LIVE IN SERVICE OF THE SPIRIT. MADE MASS WITH TREES DEAD AND DIRT AND UNDERNEATH HUMANS AS DEAD OR LIVING AS ANY STONE OR WOOD.

I WON'T BURY MY DEAD DOLLS, THOUGHT. I'LL STEP ON THEM AND MASH THEM UP.

For two weeks didn't hear from either her agent or feminist publisher. Could return to finishing her novel.

Thought that threats had died.

In two weeks received a letter from her agent which read something like:

On your express instructions that your publisher communicate to you through me, your publisher has informed me that that they have communicated to Harold Robbins your decision that you will sign the apology which his publisher drew up only if you have his assurance that there will be no further harassment or litigation. Because you have requested such assurance, predictably, Harold Robbins is now requiring damages to be paid.

Your publisher now intends to sign and publish the apology to Harold Robbins as soon as possible whether or not you sign it.

In view of what I have discovered about the nature of your various telephone communications to me, please contact me only in writing from now on.

Signature.

Understood that she had lost. Lost more than a struggle about the appropriation of four pages, about the definition of appropriation. Lost her belief that there can be art in this culture. Lost spirit. All humans have to die, but they don't have to fail. Fail in all that matters.

It turned out that the whole affair was nothing.

CAPITOL REALIZED THAT SHE HAD FORGOTTEN TO BURY THE WRITER DOLL. SINCE THE SMELL OF DEATH STUNK, RETURNED TO THE CEMETERY TO BURY HER. SHE KICKED OVER A ROCK AND THREW THE DOLL INTO THE HOLE WHICH THE ROCK HAD MADE. CHANTED, 'YOU'RE NOT SELLING ENOUGH BOOKS IN CALIFORNIA. YOU'D BETTER GO THERE IMMEDIATELY. TRY TO GET INTO READING IN ANY BENEFIT YOU CAN SO FIVE MORE BOOKS WILL BE SOLD. YOU HAVE BAGS UNDER YOUR EYES.'

CAPITOL THOUGHT, DEAD DOLL.

SINCE CAPITOL WAS A ROMANTIC, SHE BELIEVED DEATH IS PREFERABLE TO A DEAD LIFE, A LIFE NOT LIVED ACCORDING TO THE DICTATES OF THE SPIRIT.

SINCE SHE WAS THE ONE WHO HAD POWER IN THE DOLL-HUMAN RELATIONSHIP, HER DOLLS WERE ROMANTICS TOO.

Towards the end of paranoia, had told her story to a friend who was secretary to a famous writer.

Informed her that famous writer's lawyer used to work with Harold Robbins' present lawyer. First lawyer was friends with her American publisher.

Her American publisher asked the lawyer who was his friend to speak privately to Harold Robbins' lawyer.

Later the lawyer told the American publisher that Harold Robbins' lawyer advised to let the matter die quietly. This lawyer himself advised that under no circumstances should the writer sign anything.

It turned out that the whole affair was nothing.

Despite these lawyers' advice, Harold Robbins' publisher and the feminist publisher kept pressing the writer to sign the apology and eventually, as everything becomes nothing, she had to.

Knew that none of the above has anything to do with what matters, writing. Except for the failure of the spirit.

THEY'RE ALL DEAD, CAPITOL THOUGHT. THEIR DOLLS' FLESH IS NOW BECOMING PART OF THE DIRT.

CAPITOL THOUGHT, IS MATTER MOVING THROUGH FORMS DEAD OR ALIVE?

CAPITOL THOUGHT, THEY CAN'T KILL THE SPIRIT.

I would like to thank Kathy Acker for permission to reprint her revised version of "Dead Doll Prophecy" which was originally published as "Humility" in the collection entitled *Seven Cardinal Virtues*, edited by Allison Fell and published by Serpent's Tail, London, 1990. —*ed.*

4

THE HEURISTIC POWER OF ART

Elizam Escobar

I

I ask myself how could I effectively offer the reader a vivid description of prison so that he or she can understand the conditions under which I live and create my work. Tonight, a Saturday, for example, as I am in the process of writing this essay, some prisoners are playing cards in the hallway in front of my cell door. There is enough noise to make concentration difficult. But I have become used to it—here, and in the "hobby shop" where I paint. I have been able, somehow, to overcome these obstacles, but not always. At times, I can become very irritable and nasty, especially if I am interrupted while painting. It is like being awakened while you are just beginning to fall asleep. At other times, like in the mornings after I am done with my job (cleaning the shower rooms) and

most people are working outside the unit, chances for concentration are better. I have no control of these things, and it all depends on my capacity to adapt or look for a new way of "attacking" every new obstacle. There is no privacy in prison, only that which you are able to create for yourself within yourself.

In the same manner that the situation varies from hour to hour, day to day, or place to place, it also varies with the prison and the prison administration. Every prison has its own "personality," and there are significant differences from one to the next. Even within the same prison units may be completely different from one another. In the unit where I am now, for instance, there are no writing tables as such. So, over the last five or six years I have become used to writing on my lap, and even if I had a table now I'd probably keep writing on my lap.

But before I begin to present the conditions of prison (and, certainly, the way in which I personally and subjectively experience those conditions), and in order to better understand my present views on art and politics, allow me to provide you with a condensed narrative of my development as an artist and as a political activist before my imprisonment in 1980.

▦ II

There was a time for me when art was a simple, spontaneous, pure, innocent, pleasurable activity. However, in my first years of grammar school I discovered that art, besides being materially or symbolically rewarding, could also earn me "social status," a reputation among my young peers as well as my elders.

When I was nine years old, my family moved from Ponce (in the south of Puerto Rico) to Bayamón (in the north of the island). My childhood friends were left behind. In this new environment, a new, scarcely populated urbanization constructed in the middle of what used to be a pineapple farm—in contrast to my previous neighborhood, one of the working-class *barrios* surrounding the center of the city—I discovered that art could also be a substitute for reality. I began to imagine and invent friends, landscapes, and stories. The previous activity of the *barrio* was supplanted by my imagination's activity. It was not just art; I began to invent games, solitary kinds of games. Thus, an invented secret place of liberty, where I could enter and exit at will, began to develop. My room became a place of solitude, a necessary space and time for my own construction of reality—in my notebooks, in my mind.

My interest and natural artistic inclination persisted through my

adolescence, at home and at school. But art was already overshadowed by other interests proper for that age. And I don't remember thinking of art as my future "profession," or as something that might become the main occupation in my life. So, by the time I finished high school, I thought that Fine Art was an idealistic activity belonging more to a romantic past than to our times. Instead, I was more interested in graphics or commercial design, especially the design of shoes.

With the exception of conventional graphic arts, however, there were no opportunities to study art of that nature in Puerto Rico. I felt then that the "art of my times," design, was a faraway dream, and that the "art of the past, of fine artists" was the only realistic dream. Hence, I entered the Fine Arts Department of the University of Puerto Rico, more because of fate than free choice.

In those first college years, I was already involved in the independence movement and the student movement on campus. My view of the world had been transformed from a kind of idealistic-mystic Christian outlook to a new, more real and active political-ethical concept based primarily on Marxist ideas. Among Marxist thinkers, Mao, more than anyone else at the time, began to inform my consciousness about the role of art and artists in class struggle. And yet, I was not totally convinced that an artist could or should treat art as an ideological and political weapon, however urgently called and influenced by Mao's views on art. In my heart, art and politics were different: one, "idealistic and useless," the other, "practical and realistic."

But—as was to happen on so many occasions in my life, in spite of my own views, convictions, and unresolved conflicts—a stronger force ended up pushing me "forward," as if "the call" and political commitment had no time for my own internal needs and doubts. Political ideology began to win over my ideas about art, regardless of the strong resistance exerted by my unconscious or my intuitions. In an essay for a Theory of Art class, I remember stating that only after the creation of a society without social classes, without the exploitation of man by man, could art become a truly free, disinterested activity. In the meantime, art must be employed in the service of class struggle and human liberation.

This was the mid-sixties: the Vietnam War, compulsory military service, struggle against the ROTC presence on campus—in short, the most militant period of student activism in Puerto Rico and around the world. I was incarcerated for one day—the first of three times I refused to enter the U.S. Army. Political events and ideological struggle had taken possession of me in ways that art had not. Still, and in ambiguous ways, my

understanding of the role of the artist was emerging and developing; ideological questions have never been able to calm my deeper concerns about human existence and its psychological and emotional dimensions.

During the same period, I encountered my first important living example of a politically committed artist: the poet, political thinker, and General Secretary of the Puerto Rican Socialist League, Juan Antonio Corretjer. His influence took shape in the context of all the contradictions and internal conflicts I have described. From his beginnings as a revolutionary nationalist, his art possessed a radical patriotic vein, directed towards creating a national epic and mythology; then, later on, as a Marxist, he was also a proponent of a militant, anti-imperialist, and class-oriented political poetry, but one never subordinated to any programmatic doctrine. I drank from this source, but art—that is, art as a specific language and discourse—was, to my mind, still a practice too elitist and specialized to ever become an effective political weapon unless it was pedagogic, propagandistic, or illustrative of ideological-political discourse. Therefore, my emphasis remained on political struggle.

However, because of the social division of labor—in my case, political, ideological, artistic labor—I was becoming more aware of practical demands: If you were intensely and radically involved in political work and you didn't have the time or the proper place to produce art, it really didn't matter what your views of the role of the artist were or what kind of art you were supposed to produce. I decided to try and see if I could live from my art and simultaneously put my art at the service of revolution. When I asked his opinion, Corretjer told me that if you are a painter then what you are supposed to do is *paint*. Very well, in *theory*. But in *practice*, this was a different matter. I failed.

I failed because, among other significant reasons, no one seriously thought that my art work was a "real job." Art was a privilege, and I felt guilty using the time that others devoted to "real work" to do something that had "nothing to do with necessity or reality," with the "real world," unless it was put directly in the service of political ideology. I worked as a construction worker, then as an art teacher. But between my political commitments, my "real job," and my family obligations, I found very little time for art that was not political-direct art.[1]

Some lessons became clear: Art is not considered a "real job" unless it is commercial or politically direct, or you are a recognized artist with a market. Art as another way of philosophizing or an autonomous, self-justified activity was only for bohemians or privileged individuals. I also reflected on another aspect of this problematic: Writers and poets who

were also political activists could always deal better with the question of time. Painters, however, need not only time but space, materials, and tools. The struggle can not always afford these.

These are the impressions I gathered and the implications I formed. Corretjer, for example, never imposed any style or doctrine regarding art. On the other hand, in his conception of the role of the artist, he thought that all art is committed to something and ours was not the time for "absolute leisure" or the luxury of the "ivory tower." He said that in order to defeat censorship, especially self-censorship, for the sake of being published (or exhibited) in official and prestigious places, the poet should be able and willing to self-publish his or her work and to sustain him/herself economically without depending on any other sources and, more important, live up to the consequences of those decisions.

In the early seventies, I went to New York City to work, to continue my studies and the struggle. After some wandering and taking odd jobs, I found myself back in college, working as a school teacher, and a member of the Progressive Labor Party, then a fraternal organization of the Puerto Rican Socialist League. In the PLP, the question of art was less open to question: the correct line on art was Socialist Realism. More caricatures, political drawings, and posters followed. My painting almost ceased. Much of the time, I worked collectively, developing ideas for caricatures used mainly to illustrate the party's newspaper editorials or magazine articles, and I learned the positive and negative aspects of collective work. I also had more creative moments working with PLP front organizations, including guerrilla theater groups. But everything we did was one-dimensional, based on the line of art-as-instrument-for-something-else.

Little by little, dissatisfied with too much "ideological struggle," the political work, and my own personal life, I began to paint again. My relationship with the party and conflicts in my personal life were getting worse. When I left the organization for personal, ideological, and political reasons, I had begun working with Mauricio Pretto, a painter and ex-comrade from Puerto Rico, on fixing up the first floor of a condemned building at 96th Street and Columbus Avenue in Manhattan to create a space for an art gallery and workshop. For a while we were able to work there and put on exhibitions, and, although the project failed economically, it gave me the strength and encouragement I needed to once again see art as a necessity (internal and external) beyond what was ideologically (at least, consciously) imposed. This occurred during the mid- and late-seventies. For me, art never again could be either a

mere instrument to "combine" art forms with political-direct content or a simple, spontaneous, pure, innocent, pleasurable activity as in my childhood.

The relationship between these two approaches to art is extremely complex and difficult to negotiate. Liberty itself, and thus the possibility of art, is doubly determined: there are both subjective considerations—commitment and responsibility—as well as objective ones—contingent and determining factors. In the struggle between Providence and Tyche, the individual, as well as the collective, after analyzing and taking into consideration all aspects and possibilities of a situation, must make a decision. But a decision must also be understood as a wager: You bet on the future (the unknown) and on the ironies of history and the human condition—all of which is, of course, problematic.

Around this time, two major events occurred that definitively decided my future relationship to art and the political, and how I might have to spend the rest of my life. On the one hand, I obtained my first "real job" as an artist with the Association of Hispanic Arts in New York. This work proved to be very productive and educational and would have led in very satisfying directions if not for, on the other hand, my political commitment, which led me to join the clandestine armed struggle for Puerto Rico's independence.

On April 4, 1980, my life changed radically. A group of us were captured in Evanston, near Chicago. After we were identified, we were accused of belonging to the FALN (Fuerzas Armadas de Liberación Nacional/Armed Forces of National Liberation), indicted, and put on trial twice, at the state and federal level, accused of seditious conspiracy (conspiring to use force against the "legal" authority of the U.S. government) and related charges. We declared that we were combatants in an anticolonial war of liberation against the U.S. government which illegally occupies our homeland. We stated our belief in our right to combat that illegal colonial authority by any means necessary, including armed struggle. We claimed, consequently, prisoner-of-war status based on international law, the United Nations declarations concerning colonialism as a crime against humanity and the rights of anticolonial fighters captured in battle, and the corresponding Geneva Accords and Protocols. Therefore, we refused to participate in the trials, the objective of which was to criminalize us and our legitimate political struggle for self-determination. The government conducted their trials in our absence, creating a hysterical antiterrorist atmosphere, thus obtaining guilty verdicts in spite of the paucity of evidence against most of us. I was

given a total of sixty-eight years in prison.

These are the events connecting my political and artistic trajectory to my own "season in hell."

▰▰▰ III

Almost eleven years ago I read Dostoyevsky's *The House of the Dead*. It was a tale based on his experience in prison. I thought that however much the scenario has changed, the feeling of what it is like to be in prison and the description of its general character is very much the same today: loneliness and the separation from loved ones, a crude atmosphere where man is a wolf to man in a limited and asphyxiating space, constant surveillance and absolute lack of privacy, struggle against time and eternal waiting and waiting. After thirteen years in prison, I think that, regardless of his class viewpoint, he was basically correct.

Contrary to the practices of most other national governments, the United States does not separate political prisoners from the general population. And contrary to their preaching, they do not even recognize their own political prisoners. Therefore, we political prisoners are, plainly, criminals. Additionally, most criminal activity in the U.S. is rooted in the country's basic socioeconomic injustice, and this criminal activity, in turn, is mainly directed against those who suffer the most from socioeconomic injustice: It is the violence of the oppressed turned against themselves. Prisoners are either sentimentalized by all kinds of prisoners' rights groups or treated as scapegoats by "law-and-order" vigilantes. From "the inside" the matter looks very different. In order to overcome this simplistic characterization of prisoners as "victims" or their demonization, it is necessary to penetrate the surface of prison reality. Here, you don't deal with abstractions or figures but with real individuals. And a great majority of these individuals have reached a point of no return. What you will find, to different degrees, is that prisoners provide extreme examples of the law of self-preservation and "survival of the fittest" under the most adverse conditions.

But Dostoyevsky also found out that there was another side to prison life, the softer side of solidarity among the living dead, the affective moments to be found even in the most depraved and hardened souls. Prisoners are dreamers, and what they dream about most is "freedom." In Siberia, even those who were chained to the wall or sentenced to death never completely abandoned hope. Prisoners are the living dead always hoping for resurrection unitl the very end. And today, no matter how much of a routine and revolving door prisons in the U.S. have

become, when you are there for a long time, you experience a form of death.

The prison system is a schizophrenic world, each prison a little "city-state" (with its fortress economy) that functions as a microcosm of society at large, with its own repressive and "intelligence" mechanisms, its prisons within a prison, department of "education," factories, and health, mail, television, telephone, consumer and visiting services. Some of these services are treated like "privileges" that can be retained or lost according to one's behavior. Crime and punishment doesn't end with the conviction and sentence; they continue in an infinite series of duplications, forever and ever.

As in any other structure of simulation, everyone is engaged in playing a role (including the prisoners), so that their world will "work" and not collapse in front of their noses. The games that are played here are not different from those played on "the outside," although in here you cannot go home after the game is over, because the game is never over. All this fuels what I call the "aesthetics/ethics of wax": if the surface looks shiny, then everything else—underneath and above—is clean: that is, everything is beautiful, true, and good.

In sum, prison is a waste of human lives and the continuation of criminal activity by other means through the self-preservation of a mediocracy, put in place and justified by the deep structural and moral crises of U.S. society. Rehabilitation is a social myth and a joke, but all the same everyone is busy trying to determine who is and isn't prepared to go back to "free society." Only a very small minority of strong-willed prisoners, through their own individual efforts, come out of prison better human beings.

IV

When I read *The House of the Dead,* I was in my second year of my state prison term in Menard, in the south of Illinois. Conditions were terrible. It was an old structure with beds hooked to the walls with chains and broken bedsprings that I had to cover with cardboard in order to make it possible to sleep. My property was stored in boxes because there were no lockers. Any time I found a piece of wood that could be used as a shelf to put my things on, the guards would find out and take it away. There were many cockroaches, and the food was disgusting. The showers consisted of lines of parallel pipes hanging from the ceiling with small holes through which the water came out, sometimes in spurts, sometimes in drips. We took showers two or three days a week at six in the morning,

gambling and hustling for the best spots.

I was there for a year, with one of my comrades, but he was separated from me on the other side of the building. I was locked in my cell for twenty-two hours a day. I painted a few canvases there, taping the canvases flat against the wall, something I learned from Pretto. But mostly I wrote a group of poems later published in a book (*Discurso a la noche y Sonia Semenovna*). There was one moment when I thought that I couldn't paint any longer because the experience was becoming too intense, and I couldn't handle it. Nor was I able to relax as I had been able to when painting on "the outside."

Before Menard, I was in Pontiac, my first designated prison. In Pontiac, after some time on a waiting list, I was able to do some painting in an art room other than my cell. Those paintings and the ones I finished at Menard were sent to New York City for the first individual exhibit I had of my work done in prison.

After one year at Menard (1982), I was transferred to another prison, Stateville, for "security reasons." During the midnight transfer, my typewriter "accidentally" broke, making writing more difficult. There, one of the oldest and biggest prisons in the U.S., I again painted in my cell. But because of poor light and few available materials, I painted very little. At the end of 1983, I was transferred two more times for "security reasons." In 1984, after I finished my state sentence (four years of an eight year sentence), the federal system took custody. Since then, I have been in two other prisons: in Oxford, Wisconsin, and now, in El Reno, Oklahoma.

At Oxford, I was able to create under somewhat better conditions. There was a good art program sponsored by some sort of "outside" project. The instructor was a painter from the second generation of Abstract Expressionists, but the most significant thing was that for the first, and only, time in prison, I found a place where I could actually paint more or less "isolated" from most of the hostile elements of prison life. In the two years I spent there, I painted more than in the previous four years, and I began to work on bigger paintings.

In 1985, some people from the movement and artist friends created a group (Friends of Elizam) in order to sponsor and finance a national tour of my work and subsequent activities and shows. They published a color catalogue of my work. The first exhibition at Axe St. Arena in Chicago, in November 1986, attracted considerable attention. Within a few days of these events and the press notices, I was transferred to El Reno—for "security reasons—and my "program needs." Obviously, in

their view, painting was not one of my needs, because in El Reno, I found out that there was no art program, but only a hobby shop for ceramics and leather work. After a year-long national and local campaign exposing the Bureau of Prisons' methods for punishing and censoring me for my art activity in prison, I was able to paint again in a new, expanded hobby shop. Still, this place is not really suitable for painting, since it is noisy and full of ceramic dust. The year I couldn't paint, I concentrated on making small drawings, cut-outs, collages, photocopies, and an art book, but mostly writing. Many exhibitions, exchanges, collaborations, publications, and other projects have followed since I began painting again in November 1987.

In prison, anyone who is an independent thinker, especially if you are there for anti-government activity or for being part of a revolutionary movement, is always subjected to special monitoring (surveillance). So everything I engage in is regarded as "suspicious." For instance, at Oxford I made two small *vejigante* masks[2] using papier maché. I got in trouble for that, and my "counselor" wanted to dismember the masks before I could send them out, just to make sure there was nothing inside them. He almost got away with this "logic," but the art instructor convinced him that I made the masks under his supervision. In El Reno, I was questioned by different staff members about my intentions concerning a particular painting, *La ficción*, where I portrayed myself as a cadaver in front of the Supreme Court Justices. The most recent event of this kind took place in August 1992, when my work was confiscated. The charge: I had "altered" photographs. After a letter from my attorney to the warden, the head of the SIS (Special Investigation Services) called me into his office. Luckily, he proved to be more open-minded about art and "freedom of expression" than the director of the Department of Education. I discovered that what had triggered the controversy were the comments of a high staff member about my photo/painting self-portraits. He thought that some were "weird" and looked like objects used by a "demonic cult"; in others he believed that I was "altering" my appearance, which, of course, was a "security" problem.

One section of the Bureau of Prisons' policy statement concerning "Hobby Crafts and Arts" says that creativity should be encouraged, but only in "good taste," and that "obscenity" is not allowed. Those statements, as we all know from the experience of the recent public debate about the public funding of art and censorship in a "free society," can always be molded to fit any interpretation you want. The obscenity of prison is one thing. The concept of obscenity stated by prison policy is

quite another. "Good taste" becomes meaningless, merely a euphemistic code fashioned in order to impose an ideology, to prohibit and keep in check any dissent or disruptive intentions. "Good taste," in this context, means domestication, cretinism, conformity, inoffensive hobby shop activity, and so on. "Creativity" means cultivating the manual ability to assemble ready-made craft objects, the reduction of art to an "elevator music" kind of painting.

Neither independent thinking nor creativity is encouraged or reward-ed in prison. The criterion of truth is authority. Everyone is supposed to follow or give orders. Everyone is below someone else who gives orders and follows orders. This chain is infinite, and no one is the real author of these orders. Orders simply circulate from functionary to functionary. Anything else disrupts the "inherent logic" of the prison code. If, for example, you refuse a "direct order"—whether it makes sense or not—you automatically receive a disciplinary incident report.

Trophies, certificates and other paraphernalia proliferate in relation to sports and other diversionary and "adjustment" types of activity. Any individual or group of individuals who dares to challenge this order of things will be submitted to extremely hostile treatment and systematic harassment, or transferred to another institution for "security reasons" or "program needs"; worse than that: You may end up travelling around the country from prison to prison with no definite destination.

My paintings are primarily symbolic and allegorical: forms that arose historically in response to the dominant classes' intolerance, ignorance, and censorship which artists responded to by imagining ways to deceive such barriers and obstacles. I had cultivated these forms long before my imprisonment, and this has helped me to intentionally counter the arbi-trary imposition of official codes with the ambivalence of symbolic exchange.

Now, the meaning of all this is not restricted to how any structure or model I might use "successfully" overcomes censorship of themes and/or restrictions on materials within the parameters of prison. It has also to do with both *the before* and *the after* of this situation. First, in *the before*, I must subordinate everything else to my priorities: Everything must be ordained to make the work transcend these conditions. Paradoxically, this requires adherence to the tenet that the end justifies the means: Art justifies my ability to "forget" (or sublimate, delay) the immediate needs, "duties," and desires of my quotidian existence. (Imagine, for instance, that your beloved one dies but that instead of immediately grieving her/his death you must first paint her/his dead

body.) One must forget oneself, because the work will be the self: The self will be the work, the mythic power of art pierces through all the obstacles. My quotidian existence—*the everything*—is irrelevant compared to *the nothing* of the work of art, which nevertheless, is the only real important *something* of this otherwise wasted existence. Secondly, *the after* has to do with "prophetic" preparations—preparations for the work's reception. These include theoretical work, interpolation of this theoretical work in political-direct discussions, technical arrangements to exhibit the work, selected envoys who will "explain" the work, assembling and circulation of the myth, the mystique, etcetera. Add to this Merleau-Ponty's insightful views and apply them to the painter: "The writer's thought does not control his [her] language from without; the writer is himself [herself] a kind of new idiom, constructing himself [herself]....My own words [images] take me by surprise and teach me what I think [see]."[3]

This is precisely what has happened to me. I am surprised that in a painting like *La ficción* I not only successfully overcame the federal prison system's vigilance and its censorship of delicate subject matter but that I also, unconsciously, reversed the Diego Salcedo legend. According to this legend, a group of Taíno Indians in Puerto Rico, by orders of the *cacique* (chieftain) Uroyoán, drowned this Spanish soldier in 1510 in order to "discover" whether the Spaniards were immortal. Salcedo's body was observed for a number of days to see if he would be resurrected or if he was, in fact, mortal. This legend, of course, was relayed to us through a Spanish/European point of view in order to justify the subsequent suppression of the Taíno rebellion and the conquest that ensued.[4] In *La ficción*, the immediate reference (the Supreme Court Justices) is transcended ("Justice" as fiction, "Justice" as necrophilia...). The allegory exceeds itself. The Salcedo legend returns, but this time it is the oppressor questioning the mortality of the oppressed or, on another level, the immortality of art or the artist.

Although it is clear that transcending immediate references is not always intentional or conscious, it is this transcendence and the overcoming of prison conditions by means of the work of art which is important. This transcendence is multilevel or multidimensional. In the case of *La ficción* it is not only an "indictment" of prison, the social system, or the politics of representation practiced by dominant structures and reproduced in so many instances and forms by liberation movements. It is also an indictment of an epoch and an unveiling of social constructs and myths by using the mythical, symbolic, and subversive

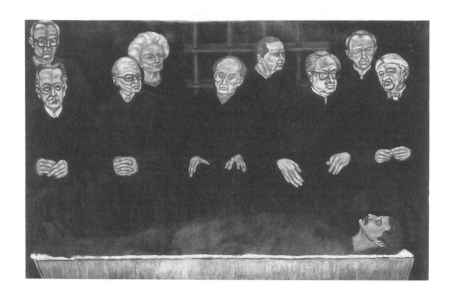

La Ficción (1991), Elizam Escobar, acrylic on cloth, 47"x72"

power of art—art, which is supposed to be a "hobby," an innocent activity, an activity meant to compensate for "reality," a space where the imaginary fulfillment of unsatisfied needs and the explosion of contradictions under controlled conditions are allowed to take place.

In sum, *a fiction!*—which proves to be the only *sane* space where a truth can be invented in spite of all the hostile forces of prison life, as well as the political and ideological myopia in our own ranks. In *La ficción*, ambivalence—the impossibility of distinguishing between separate terms and postulating them as such, what the sign cannot imprison[5]—is dominant. This not only means that art gets away with it; it also means that art becomes a space of liberty that cannot be taken away unless it is distorted or materially destroyed. And probably not even then, since once a reproduced image (a photograph of a work of art) circulates it is almost impossible to absolutely destroy it, and so, distortion can always be dis-covered. Also, if we not only recognize that, because of its temporal existence, a work of art—like everything else—is overdetermined, we must also recognize that art is the most permanent of all human creations: the most permanent force of all human forces.

If art demands my "forgetting the essential," on the other hand, it provides me with a kind of paradoxical and ironic gift for anticipation; I can always move ahead of events. In my painting *El ahorcado* (*The Hung One*), I do that. (In 1979, before I came to prison, a comrade from the

Puerto Rican Socialist League, Angel Rodríguez Cristóbal, was "found" hung in his cell. All circumstances—a short prison sentence, wounds on his head and body, traces of struggle, and the impossible way he supposedly hanged himself—point to homicide, but the official account was that he committed suicide.) *El ahorcado* is me: I hung myself. In this painting, again, ambivalence does not allow an obvious or "positive" reading, and in that sense it becomes a metaphor for all previous and future official accounts of homicide-as-suicide. Since I have frequently employed the image of the gallows and noose, this could be literally interpreted in terms of my own "suicidal tendencies." In prison, this sort of representation might be seen as "asking for it" or playing with fire. But if one does not take truth-in-art seriously, then one need not risk anything. However, in *El ahorcado*, there is an important detail: The hands of the hanged man are tied with rope. Thus, there is, unexpectedly, a statement that functions as testimony for the future: "Just in case you think I am planning to hang myself, I am not, other than symbolically."

Contrary to "the outside" where most of the time one can employ many materials, here material restrictions demand invention in "painterly" terms and an extreme effort whenever a new kind of "suspicious" material (like photography) is adopted, to assure the prison administration that this is nothing but another "art material." To obtain their approval at times one may have to engage in educational and diplomatic processes, at others, in taking chances, sheer defiance, and outside support. My latest "new materials" are toilet paper rolls, which I used to simulate prison bars for a collective installation for a Chicago exhibition. These constructions were based on drawings I had done as sketches for future, possible sculptures: that is, prison bars transformed into sculptures, "homages to prison," a transformation of the structure of imprisonment into a metaphor for liberty and the power of imagination....The constructions based on these drawings were modules that overtly represented nothing but different cylinders painted like I paint *vejigante* horns. But later they could be reassembled to make prison-bar sculptures or frames for paintings. Such flexibility is always a recourse if one wants to reassemble work on "the outside" which would be improbable "inside." In fact, I have been able to do other work (such as installations demanding different materials and objects) by giving instructions to people on "the outside." Notwithstanding all these complications, whenever I begin to work with "unconventional" material (within the context of prison), combine different materials, media, or art forms, or make more open political statements, I know to expect

trouble. But I also know that I should always expect trouble if I am going to retain my artistic and political views (within prison, as well as within the movement). More important, I also know that these contradictions and conflicts of interests must be approached intelligently and imaginatively.

V

The mirage of art and "utopian" writing provides a real space for the expression of liberty in terms of liberty itself. Whether liberty is a mirage or not matters little, because within this mirage the need to realize ourselves exists all the same. But art is not only that liberty where internal necessity and desire to construct reality as an "imaginary" reality—distinct and new—says something about or responds to "real" reality. Nor is it merely a question of "correspondence." It is, above all, a radical form of assuming existence and the real. That is, of assuming liberty.

The internal necessity of liberty—the sacred, the truthful, and the beautiful—demands the supreme effort of being. We must discover, invent, and reveal it; in other words, it is an heuristic process. With Socrates, we might say (understanding that the beautiful is what must be created) that the beautiful is the difficult.[6] This is the way I understand and experience art, which I do not pretend to impose on anyone, because it is useless to impose liberty. In this sense, liberty is something that you want to assume; under no conditions can it be imposed unilaterally.

On the other hand, an artist is also a political being, who often feels the political in the same manner as he or she assumes art and liberty: the political is an ethic and not only the specific and direct form of directing and deciding how power is distributed. As Foucault points out, ethics is the deliberate form that liberty takes.[7] In this sense, liberty is not just contingent but also a responsibility.

It is very difficult—if one is interested in being as honest as possible—to know with absolute certainty up to what point objective conditions affect one's artistic work. It is also obvious to me, in terms of subjective conditions, that mere self-consciousness is insufficient grounds for judging a being. A complex interrelation between real and imaginary factors takes place simultaneously. Eventually, one realizes that there probably only exist relations and nothing else. Art, then, becomes the only possibility to rescue and redeem life: Art is the prolongation of life by other means.

Hence, even if the role of the artist,[8] like so many other roles, is

conceived as a historically and socially determined construct, it is in the body of the artist—its physical, physiological, mental, spiritual, emotional totality—where we can locate the true impulse and source of art. In the last instance (within these specific circumstances), it is the particular, concrete individual who will decide how far he/she can go. The artist must pierce through all kinds of structuralist and historicist interpretations that either deny or impose roles. The individual is always more than a subject determined by social, ideological, and linguistic relations; more than a mere psychological entity; and more richly complex than an idealized, reified, "ideologicized," "teleologized" protagonist of history. The same applies to social groups and classes, as well as the history defined in the ontological sense as a super-subject and the only subject. The artist, then, is an individual (or, an individual is, at some point, the potential realization of an artist) who emphasizes the need for both liberatory, creative force (cause of effects and an effect as further causes) and ironic-realistic consciousness—the lucid and paradoxical understanding that being is no more than non-being.

One is continually formed and constituted by many interrelated elements and factors. In terms of praxis and in a philosophical sense, no one can be an absolute materialist or an absolute idealist. No activity or conceptual systematic process is "pure." Mythical and mystical levels always operate, unconscious or not, in every practice or world view. Earlier practices and forms of science and dialectics originate in magical practices and mythological explanations of the world. Philosophy, too, originated as the resolution between *mythos* and *logos*.

All these conflicting aspects of existence nurture and inform the artist in me. I am simultaneously an artist and imprisoned political activist. As a political prisoner and prisoner of war, others see me as a symbol and/or a martyr of the independence cause—an immolated living being. But as a thinker-activist who needs to conceptualize and determine his role, in part supported by all past traditions, in part against them, I refuse to play the role of a "passive" martyr. Although my comrades and I have been, in fact, martyrized, I see myself first as an active thinker who has too much to contribute to the struggle to be comfortable in such a role. Paradoxically, as an artist I produce images of martyrdom and death. The irony is that many of those who see me as a symbol and martyr for the cause would like me to produce heroic images of combatants or write optimistic messages and statements, while being, on the other hand, a passively faithful comrade in political terms. Instead, I do the reverse.

It couldn't be otherwise: the artist and the imagination are the limits of liberty. And the artist exists in a concrete particular body, an imprisoned body that "belongs" to the State: a slave, whose body is constantly humiliated and repressed, the object of the State's desire. The fact that privacy is nonexistent is not enough to satisfy this desire: There is no cavity or interstice of the prisoner's body that escapes the inspection of prison functionaries. It is not enough that they repress you sexually, but in order to see your loved ones you have to allow them to view and inspect all the cavities of your naked body. This is the obscenity of prison.

Another obscenity of U.S. prisons is the reduction of art to a mere "hobby" or leisure activity, something you do to kill time and have "fun." This attitude is an inevitable consequence and reflection of contemporary U.S. society and culture at large: Cultural activity is mainly seen as entertainment and is not supposed to be a critical activity—an activity that allows you to think critically about lived relations to the world and especially about immediate relations to society. Historically speaking, however, hostility towards art is not exclusively a feature of capitalism or any other social system instituted so far. By nature, art is desire materialized or realized in visible or concrete form and, as such, the most powerful and sublime means to express problematic aspects of active or passive human existence.

Surrounded by obscenity, art becomes a salvation, the sacred activity of liberty. My interpretation of Baudelaire's words, "To be a great man and a saint every day for oneself"[9] describes this path, which I do not confuse with a "narcissistic" goal. It entails a sublime and poetic understanding that, in the end, it is up to us to decide what constitutes *the sacred*, and therefore, how sacrifice (and the sacrificed) is creatively and ironically treated—how sacrifice is sublimated and transcended. In this sense, my martyrdom, my sainthood, my compulsory celibacy, my pain and suffering, becomes an image exhibited for the individual and collective body. *In this sense, I can say that the personal is political.* In this sense, the embarrassment of becoming an object of exhibition is redeemed by an act of liberation.

Both intentionally and unconsciously I have incorporated the cultural-mythological into the personal, and the personal into some aspects of Puerto Rican culture/mythology (the *vejigante*, for example) and our collective unconscious. I conceive this critical, personal-political intervention as different from "ideologized," direct-political art or other "easier" confrontational approaches. Barthes' words come to mind: "[I]nvention (and not provocation) is a revolutionary act."[10] If works of

art are provocations, they are insofar as they stimulate and transform all the participants engaged in the process. This transformation may include the entire distance traveled from awareness to scandal to action. But a provocation that only seeks "scandal" in order to create "sensation" remains at the level of tabloid journalism.

When the cultural-mythological penetrates the personal, the personal mythologizes itself, because the personal is no longer "private." My body, as a work of art, an "exhibited body," an heuristic body, does not belong to me. It is something other. The body becomes an offering, a symbolic exchange. This symbolic exchange is what I oppose to "ideologism" (the reduction of everything to ideology), imposed from the outside to codify my body's experience and knowledge. My exposed body poetically contains all that which dominant ideology wants to domesticate or reduce to cheap and easy pleasure. Pleasure that makes of the body an object dislocated from all liberty. In this liberty, with this responsibility, and in the voluntary act of offering, the exhibited body becomes sublime (transfixed), containing all the possibilities that make the body (the aching, redeemed, "triumphant" body) into the redemptive image of what otherwise would become part of collective, historical oblivion or an object of quantitative, nominal, and arbitrary documentation.

But domestication and censorship also come from the allied camp—through comrades and friends, fraternal political organizations and publications, and similar connections—which may seek to subordinate the imagination to instrumental reason. Also, the immense majority of these participants in cultural and political struggles remain prisoners of the politics of representation, where the one represented (whether individual or collective subjects) becomes a mere ornament who ends up being completely erased. This is especially true when it is forgotten that liberation begins with us, at home, internally; to cultivate a critical attitude means that nothing and no one can be excluded from criticism. Therefore, since internal conflicts need to be resolved through a healthy and honest practice of criticism and self-criticism, whenever this process is absent, sharpened contradictions become severely antagonistic. Then the ground is ready for the fiercest, most vicious, and pathetic battles and wars to take place.

During my imprisonment, I have found this experience to be one of the most painful and saddest, leading to feelings of impotence and frustration. Now, however painful or sad this political myopia may be, there is no alternative for me—or for any true artist in my position—but to insist on maintaining a critical attitude and assume without vacillation the

sacred role of an exceptional lover and defender of liberty, even if I find myself marginalized or ostracized from the official organs of the movement.

It is ironic that so many of those who have called for the political and social commitment of the artist—paper tigers and wolves in sheep's clothing, among others—have misunderstood the complex relationship between necessity, desire, and duty. The knowledge that liberty is a conflictual, reciprocal, inclusive, boomerang-like praxis is missing from their understanding. So, for those who only see artists and poets as tools or useful fools, beware, because the demand for political commitment can become a Pandora's box.

All the aspects and levels I have mentioned here compose the general and particular picture of the tension and the pressure behind my art. As Marx put it, "One must make the real pressure more pressing by adding to it the awareness of this pressure, make the shame more shameful by making it public....[O]ne must compel these petrified conditions to dance by playing them your [and their] own melodies!"[11]

Notes

1. The term "the political" is used by many writers from different disciplines (but sharing the same ground of contemporary cultural theory) not always with the same connotations; some are either pejoratively or positively charged, some are utterly contradictory. (The same can be said of other terms, especially "ideology".) Conventionally, "the political" represents the whole dimension of politics or "pure" political activity. In relation to art, I prefer to refer to this "pure" political activity as the political-direct, since as political beings our activity is ubiquitous; that is, in addition to its public dimension, the political has a personal, internal dimension.

2. A mythological, religious-evil-representation, carnivalesque, folkloric figure with roots in both Spain and Africa, which has taken diverse forms in Latin America. In Puerto Rico, this figure is dressed in a loose gown with very wide sleeves resembling a bat's or devil's wings. The most characteristic aspect is the mask: a grotesque goat-man face with multiple horns, painted in bright colors; in Loíza Aldea it is made out of coconut; in Ponce, papier maché.

3. Quoted in Jacques Derrida, *Writing and Difference* (Chicago: University of Chicago Press, 1978), 11.

4. For an original deconstruction of this legend see Carlos Gil, "Salcedo y la metáfora del agua," *Postdata* 2, no. 5, (1992): 1–12.

5. See Jean Baudrillard, *For a Critique of the Political Economy of the Sign* (St. Louis: Telos Press, 1981).

6. In Plato's *Greater Hippias*, Socrates says, "All that is beautiful is difficult." Quoted in A.S. Bogomolov, *History of Ancient Philosophy: Greece and Rome* (Moscow: Progress Publishers, 1985), 178.

7. Michel Foucault in an interview conducted by Raúl Fornet-Betancourt, Helmut Becker, Alfredo Gomez-Muller, "The Ethic of Care for the Self as a Practice of Freedom." January 20, 1984; photocopy.

8. When I speak of "the artist," I do not mean an abstract and universal artist *per se*. Nor am I referring to a particular kind of artist. However, the concept of the artist as a category, and the concrete expression of my experience and conceptualization of what I believe the artist should be, inevitably inform, connect, and unite my concept of "the artist."

9. Quoted in Joseph M. Bernstein, *Baudelaire, Rimbaud, Verlaine. Selected Verse and Prose Poems* (Secaucus, N.J.: Citadel Press, 1947), xxx.

10. Roland Barthes, *Sade, Loyola, Fourier* (Caracas: Monte Avila Editores, C.A., 1977), 138 (my translation).

11. Karl Marx, "Critique of the Hegelian Philosophy of Law: Introduction," *Works of Marx-Engels*, Vol. 1 (German edition), 380–381.

5

PLACE, POSITION, POWER, POLITICS

Martha Rosler

What is the responsibility of the artist to society? It is an open question what role art might play in a society that has all but ceased recognizing the existence of a public arena in which speech and symbolic behavior address important questions for the sake of the common good. Even introducing these terms shows how outdated they are. Instead, the language of cost accounting anchors the discussion of the role of art in public life. This loss of sense of (united) purpose has provided an opening for the right-wing to launch an assault on culture, with various rationales, including the rarely stilled voice of aestheticism, which prefers to see art as a transcendent, or at least an independent and therefore formalist, entity, with no social tasks to accomplish—itself a powerful

ideological task after all. On the other side is a critique from the left, which is often more open about its desire to tie art to its agendas. But neither left nor right is unified in what it wants of art, and on both sides there is the assertion of the need for artistic autonomy from the pre-scriptions of political figures. Nevertheless, there always seem to be people unhappy with the degree of autonomy that artists actually manifest. These are the broad terms of what has been a vital argument in the developed West through most of the century. For me, a child of the sixties, the questions of how engaged, how agitational, how built upon mass culture, how theory-driven (my) art should be have been ever-present, the answers never settled, since the terms of engagement themselves are constantly being renegotiated.[1]

The much noted crisis of modern society and culture continues to affect the art world, offering me no reason to change my judgment of twenty years ago that artists have difficulty discerning what to make art about. During the "emancipatory" sixties, many artists looked to the community of artists for an answer and in the process sought what seemed an attainable grail: liberation from market forces, which had been a recurrent goal of artists throughout the modern era. Such liber-ation, it was believed, would free artists to interpret—or perhaps to interpret for—the wider society. A number of strategies were directed toward this goal, including the circulation of art by mail and the devel-opment of happenings, performances, and other Fluxus-type interstitial maneuvers. Soon after, the rhetoric of democratization helped artists gain state support for the establishment of "artists' spaces" outside the market system, to pursue "experimental" forms. It would probably be a mistake to see this as elitism or separatism, as some have done, for artists were likely to identify with a rather vague notion of the common person, over and against art dealers and their clientele.

These "artists' spaces" were therefore thought of as more democratic, more related to the grass roots, than museums and market galleries. The concept of the art world as a system was just then being developed, and thinking about such matters as communicative acts or messages in art, about audiences, or about government aims in giving grants, was often not clearly articulated. The conceptualization of the new set of practices as a space was consistent with the notion of space as created by the prac-tices of social institutions and the state. The alternative-space movement took place in the context of a wide acceptance of the idea of alternative cultural spheres, or countercultures, which was richly inflected through the late 1960s and early 1970s, largely as a result of the antiwar/youth

movement and its alienation from modern technological/institutional power. Many young artists wanted to evade dominant cultural institutions: museums and their ancillary small shops, the commercial galleries, on the one hand, and broadcast television, on the other. High culture institutions were criticized for fostering individualism, signature, and careerism, and for choosing expression over communication. Television was castigated for empty commercialism (that part was easy). The institutional critique was also embraced by people who, with populist and collectivist impulses, made videotapes outside their studios in the late 1960s and early 1970s.

The anti-institutional revolt was unsuccessful, and the art world has now completed something of a paradigm shift. The mass culture machine and its engines of celebrity have long redefined the other structures of cultural meaning, so that patterns of behavior and estimations of worth in the art world are more and more similar to those in the entertainment industry, particularly as represented by television and popular music. Most artists no longer seek to make works that evade representation and commodification or that will not, in the case of video and film, be shown on television. In fact, the art world has been called a branch of the entertainment industry, and its dizzying bowing to trends, its need for splashy new talent and forms of presentation (acts), supports this view. The end of high modernism has led to the fulfillment of demands for the new in art on grounds other than formal innovation. As the art world moves closer to an entertainment model of cultural production, it is moving toward a closer accord with mass culture in its identification of narratives of social significance.

In contrast to the entertainment industry, however, which, as personified by Oprah, promises that everything will go down easy, even mass murder, art sometimes produces social lectures uncomfortably resistant to interpretation, containing complex significations and seeming to embody uglification and threat. Art is not going to be a successful player if made to compete on the same court. It may be more apt to think of the art world as a branch of the fashion industry because of its characteristic ability to turn substance into style, a maneuver accompanied by timidity and groupthink masquerading as bold new moves. As with clothing fashions, high-end products are custom made, unique, or scarce, and chosen and displayed (worn) by rich people.

When I began working, the two-worlds model of culture was dying along with Abstract Expressionism and high modernism, but the wrecking ball swung into motion by Pop Art hadn't yet brought down the

whole edifice—on which, it seems, stood the artist as teacher (I don't say visionary, although even McLuhan imagined there would still be such a role for artists in the global village). My politicized practice began when I saw that things were left out of explanations of the world that were crucial to its understanding, that there are always things to be told that are obscured by the prevailing stories.[2] (The defining moment was in coming to understand that reality differed for black and for white people. This realization came not from my own observation but from the black civil rights movement and from black people whom I knew as a child.) The 1960s meant the delegitimation of all sorts of institutional fictions, one after another. When I finally understood what it meant to say that the war in Vietnam was not "an accident," I virtually stopped painting and started doing agitational works. A further blow to my painterly life was dealt by the women's movement; I figured out what it meant to do works that were about my own life (read: identity)—that is, I came to understand the idea of "about" differently. But my ambivalence about the *telos* of art (I thought it had one, I still may) persists; the question was to what degree art was required to pose another space of understanding as opposed to exposing another, truer narrative of social-political reality.

When in the late 1960s Michael Fried[3] argued against the abandonment of modernist presuppositions of transcendence because they could only be supplanted by presence and temporality—by what he called "theatricality"—it seemed to me he was right, but on the wrong side of the question. I had begun making sculpture, but I soon realized that what I wanted wasn't *physical* presence but an imaginary space in which different tales collided. Now I understood why I was making photomontages. I want to discuss these works at some length here because their trajectory indicates something about changes in the art world, in which I have participated, though from the margins. I initially began making photomontages of political figures and ones of significant institutional and social sites, including operating rooms and cities viewed from the air. Then I began making agitational works "about" the Vietnam War, collaging magazine images of the casualties and combatants of the war—usually by noted war photographers in *Life* magazine—with ones defining an idealized middle-class life at home. I was trying to show that the "here" and the "there" of the world, defined as separate, were one. A few of these works incorporated images of American women, contrasting their domestic labor with the "work" of soldiers. Another, related set, more visibly Pop influenced, simply dealt with women's reality and their

representation: women with household appliances or *Playboy* nudes in lush interiors. In all these works, it was important that the space itself appear rational and possible; this was my version of the real as "a place."

At the time it seemed obvious not to show these works in an art context. To show antiwar, or feminist agitation in such a setting verged on the obscene, for its site seemed more properly "the street," or the underground press, where such material could marshal the troops, and that is where they appeared. If the choice was an art world setting or nothing, nothing seemed preferable. During the 1970s I turned to photographic media, including video and photography, as well as installation and performance. Although I never considered showing the photomontages in an art world setting, in giving talks, I showed slides of these works, particularly to art students; talking to artists in the process of defining a practice is critically important.

In the late 1980s, almost twenty after their making, an art dealer surprised me by suggesting we produce a portfolio of the images. What would determine my answer, aside from an allegiance to my long-standing refusal to take part in the financial dealings of the art world? The man making the suggestion had established a practice of showing politicized, sometimes agitational, works on diverse subjects. It had begun to seem important to preserve the antiwar work. I wanted a record, because it was my own work, but also because it was a kind of work that represented a political response to political circumstances. The art world had changed a great deal since the works had been made; by the late 1980s there was little possibility of defining a practice outside the gallery defined art world that still could be acknowledged within it.[4] Market discipline of the 1980s, enforced in part through the conscious action of the Reagan administration, had stripped away the monetary and ideological cushion for such practices. No matter what the cause, the discourse of the art world in the late 1980s flowed most directly from the gallery-museum-magazine system, but no magazine would devote serious attention to any artist not firmly anchored in a gallery world.

U.S. dealers don't know much about art or its recent history, so it wasn't surprising that the man who wanted to publish my portfolio knew neither my work nor my writings. In other words, in the 1980s the commodification of the art object—which a good portion of artists' energies had been devoted to fighting in the late 1960s and through the 1970s—was complete. As the dealer said bluntly, I wasn't on (his) art world map. I realized these works would be written into history only by being normalized. The works' entry to the present was highly "economi-

cal" with respect to time and effort. Soon after their first appearance in a published art world source in the early 1980s in a survey article by a noted critic who had attended one of my art-school slide shows, the works appeared sporadically in other critics' writings. One of these had attracted the dealer's notice. After he published the portfolio and showed the works in his small, out-of-the-way gallery, *Art in America* published a feature article on them during the Gulf War. The whole portfolio was promptly included in a show on war images held at the Museum of Contemporary Art in Mexico City. Now they are mentioned and shown regularly, at home and abroad.[5]

I have dwelled on these works because they illustrate the operations of the art world and suggest the difficulty of establishing a strategy one can comfortably maintain over a long period. The work migrated from the street to the gallery because that seemed to be the only way it might influence present practice.[6] It could be written about only after entering the art world as a commodity. The initial audience had disappeared with the times, and it needed a new one, which might take the work as a historical lesson. In order to have any existence, it had to become part of a much more restricted universe of discourse.

In a contrary movement, quite a few politicized artists who find their existence within the gallery-museum-magazine system use their fame to reach beyond it using the tools of mass culture: the mass-circulation magazine, the billboard, the train station or airport wall, broadcast television. This useful strategy is not without dangers, because rhetorical turns common in the art world may seem cryptic, incomprehensible, or insulting to the general audience, or their wider import may simply be inaccessible. The invisibility of the message can be ignored by art world institutional types, but when community people misread the work, the art world must take notice. (A number of well-known instances could be cited.) The right-wing ability to attack artists so convincingly grows out of the incommensurability of general culture and art world discourse. Thus, despite my remarks about the closer identification of real-world issues with art world issues, the art world, or art scene, is still a distinct though disjunctive community with specialized understandings and patterns of behavior. Furthermore, the art world may support what I have come to call "critique in general" but draws back from particular critiques about specific places or events—as I learned to my unhappiness when invited to mount a billboard in Minneapolis. The billboard I submitted, which was about Minneapolis, was refused by the funders, abrogating their self-generated contract that no censorship would be

imposed. (Of the eight or ten invited artists, two local submissions and mine were censored. No other out-of-town artists were curbed.) My substitute proposal, a surreal photomontage with a somewhat vaguely worded critique of television, was accepted without demur. Another instance of the contest of specific and general: A few years ago I was included in a show of "political" artists in New York; the two curators hesitated between a work of mine featuring a life-size photo of Ethel Rosenberg and one using photos of airports as quintessential postmodern public spaces. Which did they choose?

The several roles art serves in society often seem to conflict. People (the daytime television audience, say), who have no difficulty absorbing fantastic amounts of social information and innuendo relating to sexual conduct from the flirtatious through the highly unusual to the criminal, as long as it is transmitted through entertainment media, discover in themselves a streak of self-righteous puritanism when the material in question is produced by people called artists and when government money is involved. How the issue of taxpayer funding figures in the actual reasons for people's negative reactions is hard to ascertain. It cannot seriously be argued that entertainers with risky acts, like Eddie Murphy, are successful because people pay to see them and that that should be the model for art as well. The support for television "personalities" is not so straightforwardly measured, and even the television industry cannot determine with any degree of accuracy a "popularity index" for individual figures, except those at the extremes. It is plausible that people want to punish artists, whom they can easily scapegoat, since they don't (knowingly) run into one too often or have daily-life familiarity with their work. (Or perhaps people simply long for those who have representational magic to use it to create visions of beauty and wonder—like Steven Spielberg—not real-world criticism or exposé.)

The increasing walling off of intellectual activity in institutions and the marginalization of elements of high culture are undeniable.[7] Art world subculture activities that were the main impetus for the formation of the artists'-space movement are furthered, as I've indicated, in small undercapitalized institutions, in boutiques (art galleries), in journals and magazines, in classrooms, and sites of social intercourse, and also to an extent in high profile, highly capitalized elite institutions, making high art largely invisible to all but a fairly small proportion of Americans. Unlike many other fields of specialized knowledge in advanced industrial societies, art's institutional base is not stable, and art is not consistently useful to the aims of the state. Moral panics may take place in social

practice (repression of people of color, lesbians and gay men, Jews or Muslims, or even artists, for example) or in the symbolic realm (campaigns or witch hunts against pornographers, blasphemers, and so on). Subcultures with their own publics are mostly insulated from the criticisms of the larger culture or the state. Artists care because of the monetary value attaching to their work, and the mainstream institutions that support them are forced to bray in protest as well when the right engineers a generalized withdrawal of state support.

On the left, hostility to artistic autonomy also stems from the idea that art turns its back on the common folk. The left used to harbor a certain hostility to "vanguard" art because artists weren't sufficiently of the working class, the motor of social change. Since that class *as such* is no longer united or a powerful enough actor in public life in the States (the union movement, once an important political and social force, now covers under thirteen percent of the labor force), the more contemporary critique from the left often takes the form of a complaint that artists don't address "the people" or "the grass roots" or "the community," with those terms left more or less undefined. (The terms, and sometimes the understandings, are the same as the right populists'.) Left anti-art(ist) sentiments, traceable to Marxian economism, now stems as much from a critique or rejection of the restricted discourse—that is, the *community* understandings—that artists share. It is a criticism of language and audience, a criticism behind which lie charges of elitism and careerism. Ironically, hostility to artists' failure to occupy the social and moral high ground remains after theories of the proletariat have died.[8]

Although artists have often allied themselves with the so-called laboring classes since the early nineteenth century, artist subculture has constituted an enduring bohemianism, characterized by a rejection of certain defining working-class characteristics—most prominently, wage labor itself. Yet the shared vision of autonomy helps divide the two groups. The story of the Western tradition in art history has been a narrative of the valorization of personal and aesthetic autonomy, despite the fact that this dream of autonomy generally remained no more than that for the great majority of workers; the same dream thrives in the working class, where its greater unreachability seems to cause hostility to artists because of their relative success. The relationship to authority and power, then, is at issue. Artistic autonomy also led to the suspicion of artists and rejection of "advanced art" by political elites of both West and East. "Bourgeois" values have long been hegemonic in the States, and the working class, in rejecting exponents of sexual license or marital

casualness, hedonism, atheism or iconoclasm, is spurning not the practices but their public espousal. People may engage in sexual practices that violate social norms and conflict with religious teaching, such as sex outside marriage, the use of birth control, or the resort to abortion, as long as a certain element of duality—some might say hypocrisy—is maintained. It is a consistent finding that some people engaging in same-sex practices reject the associated label and thus the identity; naming something, writing it into public discourse, is too powerful. To accept the right of "everyone" to live their lives as they see fit or to claim that so-and-so is all right, but that race or gender or sexual orientation do not deserve "special rights" is to accept a policy of informal exceptionalism.[9] Artists and activists offend the sensibilities of the rule-bound when they interfere with people's ability to accept things in the private realm as long as they are not made part of the structure of law.

Artists, in turn, are often offended by working-class jingoism, while, ironically, the high-profile allegiances that prewar artists on several continents proclaimed with working-class political movements has led to suspicions that vanguard artists were Bolsheviks. Nativist movements, xenophobic and racist, are constantly recreating themselves among working-class adherents. But such policies of exclusion are not only socially institutionalized (as suggested by the inability of people of color to get jobs or mortgages and other loans compared with similarly qualified white applicants), but also are held by the middle class and enforced by social power elites. The latter, however, don't need to agitate for the maintenance of privilege, since they can resort to increasing behind-the-scenes pressure on institutions such as banks and courts to preserve privilege and manipulating public discourse—and therefore encouraging reactionary-populist attitudes—by deploying coded language. The visible result, however, is that hatred, violence, and exclusion appear to emanate from "the people." Thus, politicized artists are vulnerable to charges from the right that they violate community norms in the practices that they espouse or the groups that they champion and from the left that they don't situate their works in those communities or use language that can be readily understood by them. Since the tendency of capitalist society is toward social divisiveness, many artists have lost interest in instituting a broad discourse; the impetus to do so supplied by black, Latino, feminist, and antiwar militancy in the 1960s has dissipated. A new form of art world politics, "identity politics," has emerged, as I consider later.

As symbolic activity condensing social discourse, art does play an

important social role, though not one accepted with equanimity by those with reactionary agendas. Furthermore, as I suggested at the outset, artists have uncertain epistemological bases for their art. Transcendence is gone, along with ties to religion and the state, leaving an ever-changing rendition of philosophical, scientific, social-scientific, and cultural theory, including iconoclastic readings of identity and religion (Andres Serrano and Robert Mapplethorpe[10] were both lapsed working-class Catholics). Authorship, authenticity, and subjectivism seemed no longer supportable by the mid-1960s and remain questionable despite the heroizing tendencies and aspirations of the regressive painting movements of the 1980s. Culture itself—"society"—continues to be a problem, as it has for artists for centuries. The problem tends to manifest as a series of questions: with whom to identify, for whom to make work, and how to seek patronage. The immediacy of AIDS activism and its evident relevance to all levels of the art world, including museum staff, brought politicized art far more deeply into the art world than, for example, earlier feminist activism had. It led to the inclusion of directly agitational works, including graphics and posters. But the museum/gallery door is open wider for this issue than for most others; it is seen as a sort of family issue in the art-and-entertainment sphere, and public acknowledgment and rituals of mourning first appeared within mass entertainment industries, such as the movies, and in decorative arts, not in the high art world.

It can hardly be easy for artists to discern any responsibility to a society that demands they simply be entertainers or decorators. Those who demand racier material from art tend to be more privileged and educated, and it is those about whom artists are most ambivalent. At the same time, art objects are highly valorized (unique) commodities. Although real estate and other holdings have served to fill out the investment portfolios of the rich and superrich, including corporations themselves, art in the boom 1980s had a number of relative advantages as a safe haven for investment: Its value was rapidly multiplying; art was generally portable and easily stored; and it provided a kind of cultural capital no other entity could offer. Nothing else quite suggests both the present and the transcendent, both the individual (touch) and the collective (ethos). Nothing else reflects quite so directly on the social and personal worth of the purchaser. Elites, defining this as art's existence, recognize that art—and therefore artists—have a certain social necessity:

Alas, poor artists! They pour their life blood into the furrows that

others may reap the harvest.

—Louisine Havemeyer, wife of the Sugar King H. O. Havemeyer, patron of the arts, grand benefactor of New York's Metropolitan Museum of Art, crusader for women's suffrage; from the address she delivered at the (women's suffrage) Loan Exhibition, April 6, 1915.

Mrs. Havemeyer was not (consciously) referring to financial rewards. She meant that society was the recipient. For she believed in the uplifting power of art, as did all the progressive elites at the turn of the century. Art and culture were part of the Americanization (civilizing) program for the immigrant hordes, a program whose financial support was part of the *noblesse oblige* of the rich. Such elites have also understood that if society is to have any degree of coherence and continuity, this sort of cultural production must be preserved. The establishment of the National Endowments for the Arts and for the Humanities marked a recognition that in order for art to be preserved, it must be cushioned to some degree from market forces. In the 1980s, when market forces had again become paramount, this was not so apparent.

The viewpoint of social elites toward art is neither reliable nor consistent. In the early 1980s, the Reaganist attempt to shut down the Arts Endowment was stopped partly through the efforts of Republican elites (the wives, that is), who recognized the importance of saving the subsidies directed to orchestras, opera companies, and museums—and perhaps a little for the artists who fill them.[11] But eventually Republican strategists like point man Leonard Garment tried to engineer a mission for the Endowment of preserving the work of the dead—the "cultural legacy" or "masterpiece preservation" argument—allowing the Republican Party to placate its reactionary-populist fringe by dropping support for living artists.

In contradistinction, critique from the left has been complicated by changes in dominant political discourses, particularly the fragmentation and rejection of "international Marxism"—of the master narratives (*grands récits*) of politico-philosophical theorizing. The articulation of (the positionality of) those who have been excluded from public discourse—the voices of the previously voiceless or marginalized—means that multiple discourses of difference must be voiced (and be heard) simultaneously. At the moment, they cannot comfortably be harmonized except through a "pluralism of Others," but numerous contradictions erupt. Although identity appears to be a stable characteristic, a person's

very essence, people in fact maintain multiple, even conflicting, identi-
ties, and positionalities, whose importance shift, advance, or recede,
depending on other factors.[12] Art world "multiculturalism" is a reading
of identity politics[13] and the so-called new social movements whose rise
attended the fragmentation of Marxism. Having been implicated in this
"discourse of Others," I find myself, not too unexpectedly, on both sides
of the question.

On the one hand, who could possibly quarrel with the need for the
articulation of Others, for and of themselves? On the other hand, it is
impossibly simplistic to stop there. All articulation occurs in a specific
time and a place, in the context of a preexisting discourse and a real pol-
itics. I want to point to some occlusions entailed by the incorporation
into the art world of a version of the discourse of Others: How do you
put a patent on a point of view when every identity, and every identity
discourse, can be subdivided? How fine do you dice an identity?[14] And
what are the exclusions that result from your definition? Feminism in the
1960s and early 1970s was most visibly formulated by straight, white,
middle-class women and then by white, middle-class, professional
women. Questions of race and class still haven't been answered within
the movement, despite years of struggling, and positions on sexual ori-
entation are sometimes precarious. Political positions and movements
are constantly being renegotiated from within by the pressures of groups
which feel themselves to be excluded, unrepresented, or underrepre-
sented. Inclusion of the previously excluded in the art world, however,
doesn't solve the problem of audience. The African American artist
Emma Amos says there is no black audience, only a white one, and that
black artists must accept this for now. (Careerism doesn't go away when
the careers belong to a different set of people.) But if Amos is even part-
ly correct, yet another deformation, another self-Othering, is imposed
on artists simply by entering the vital institutions of fame and fortune.

"Identity" in the art world has so far coalesced around race, sexuality,
and gender. As I've indicated, (working-) class identity is not a currently
powerful mobilizer; it is either despised (by non-working-class people),
dismissed (because self-evidently powerless), or denied (by working-class
people). A problem with the invisibility of class is that people benefiting
from class privilege submerge themselves in identities suggested by skin
color or ethnicity without acknowledging their superior access to knowl-
edge and power. But even were this not so, social schisms that shear
along class lines are recast as something else.

I recently ran into heavy criticism from a media theorist for a video-

tape I made on representation and the Baby M "surrogate motherhood" case,[15] for it isn't fashionable among (academic) feminists to criticize the real-world practices of substitute child-bearing in case we foreclose an important option for women. I first codified my thoughts about the court case in a lecture on photography, in which I had rudely asked, which women, of what social class? The videotape I subsequently made with the populist media-activist collective Paper Tiger Television, *Born to be Sold: Martha Rosler Reads the Strange Case of Baby $M*, has been broadcast and circulated not only in the art world and in classrooms, but also among medical and nursing groups, since it raises the ethical questions that must attend the formulation of social and legal doctrine in relation to newly capitalized forms of reproduction. I think this is one of the things art should do, but I suspect some of the academic border police dislike the fact that the work has the possibility of instrumental use— although its didacticism has nothing to do with its presentational form, which involves some very broad burlesque. My sympathy for the birth mother in this particular case, painfully arrived at, has opened me to some silly charges of essentialism (birth-motherhood is sacred) and even, perhaps, Luddism. Many viewers appreciate the defense of "poor women" and women of color; relatively few applaud it for its class analyses. At the heart of the Baby M controversy was the question of whose identity was going to win out and be recognized: Even the name given the child by the working-class birth mother, who kept her for six months, was expunged by the court.

Looked at from the perspective of a fashion-driven industry, the advent of art world identity politics, or multiculturalism, represents the incorporation of marginal producers, who bring fresh new "looks" to revivify public interest. A couple of handfuls of young artists of color and gay and lesbian artists are drawn into the system for an indeterminate amount of time and have international gallery and museum shows. Some are offered grants and highly capitalized fellowships. A smaller number of somewhat older ones are conscripted to tenured professorships.[16] What differentiates the multiculturalism vogue from the art world's mid-1970s vogue for "Marxism" or "political art" is the scope of those rewards. Powerful cultural institutions like the Rockefeller Foundation and many universities, which didn't care for the older version of political art, have been quick to sponsor multiculturalism, which is, after all, a demand for inclusion rather than for economic restructuring. Multiculturalism accepts that artists are actually representative of non-art world communities, whereas whom did the artist of political critique represent? It is

still possible that, despite the shifts in rhetoric, what the two moments share is that they represent passing vogues. But it is surely true that sweeping in the margins leaves the white power structure of museum curatorial staffs and those above them relatively untouched.

The problem for me is that these aren't especially the politics informing my work. I can't seem to stay away from issues of power/knowledge/representation. In the obvious instance where my works address feminist issues in the broadest sense, the art world may accept them. But when they are about the politics of localisms or labor that are closer to class politics, the art world is not generally interested. I recently exhibited an installation about the flows of toxics, wastes, traffic, and population in the largely white, working-class North Brooklyn community of Greenpoint in which I live. I had often considered making a work about this community, a postindustrial wasteland populated by a working-class remnant, by those who had fallen through the bottom of that class, and by immigrants. Although it is highly polluted and used as a dumping ground for unwanted services by the city, a number of factors, including its large transitional population of immigrants from different places,[17] has prevented it from organizing effectively. Because class politics are taboo in America, social problems directly traceable to class become visible only when they impinge upon the lives of people of color; some communities of color have recently defended themselves against toxic sitings by suing on the basis of denial of civil rights ("environmental racism"). Greenpoint, however, cannot employ this civil rights strategy. Also, since the art world occludes class issues, it would not (normally) be interested in such a work. In any case, I had no plan for a work, or even a theme or a medium, until an invitation from a Manhattan museum to participate in its show on involuntary urban population flows gave me a framework and an impetus. I began working on an installation outlining not only the flow of immigrants but of traffic and toxics. The more I researched the polluting services and industries, the more that become the central focus of the work.[18]

After the work was installed, I was stung by a friend's criticism for putting it in a Manhattan museum. I accepted the suggestion of a local activist with whom I'd worked on pollution issues, to send out a press release. It assuaged my conscience and brought in some local people. Coincidentally, the producer of a local NPR radio show saw the work and invited me on the show; I agreed, bringing the activist along. I felt a responsibility to the work and the community to obtain a wider venue, no matter how ephemeral. The only art world response to the installa-

tion came from artists living in the adjacent community of Williamsburg. But a pair of documentary filmmakers, Greenpointers who recently did a television show for PBS on the area's toxicity, saw the press release and attended the show and are trying to find a site for it in Greenpoint.

Were it not for the museum invitation, the work would not have been made. My invitation had come because in 1989 I'd done a fairly ambitious cycle of shows and forums called *If You Lived Here...*, which centered on homelessness and urban issues, at a high-art venue in Soho. In that case, I had been invited to do a project, for which I chose the theme of homelessness. My topic was acceptable—though only marginally—primarily, I think, because it invoked (trendy) issues of "the city" and because it smacked of charitable representations of social victims of color, despite the fair degree of ambivalence that occasioned. The art world virtually ignored it, and in a sense so did the sponsoring institution—refusing, for example, to share their mailing list with me. But the project's reputation, nationally and internationally, has steadily grown, proving my rule of thumb about what the art world likes about political issues: long ago or far away.

The shows were messy (the sponsoring institution liked the forums much better) and evaded a number of art world preferences—but in a sense my project spawned the show in 1993 to which I was invited to contribute, in the company of a number of artists whose first art world appearance had been in my own earlier project. That earlier project brought together art world and non-art world artists, community activists, homeless people, photographers, videomakers, filmmakers, architecture professionals, urban designers, and teachers. A book[19] published in conjunction with it, incorporating work from the shows and forums and related material, has given it a new, longer life.

In 1990, asked by a curator at Washington University in St. Louis to exhibit a selection from the shows, I made a new work about housing and homelessness in St. Louis instead. I wanted to find out whether a university setting could be effective in communicating the material. St. Louis was a much harder community to work with; the sizable homeless community was invisible, swept into shelters, facilities, and homes (some seeming quite passable), administered by various religious communities. Local newspapers were generous to the project, but the only mention in the art press was a vituperative review in a minor national magazine. The writer produced the old chestnut on this sort of work: Show it in a bus shelter or somewhere where such people congregate; in other words, get it out of my face. Although this reviewer was politically on the right, his

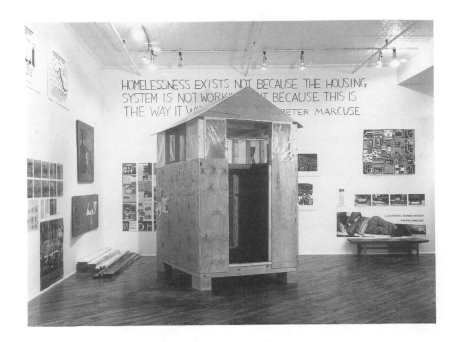

Homeless: "The Street and Other Venues," 2nd exhibition of the project
"If You Lived Here...," Dia Art Foundation, New York, 1989

criticism is similar to the left-wing populist complaint that artists like me
who put their work in art world (or university?) settings are playing to an
imaginary audience. I find startling the static conception of audience
this implies and the lazy thinking that produced it. Audiences for art are
carefully constructed by lifetimes of parental and scholastic preparation,
expectation, and guidance. Although this training can't be duplicated in
untutored viewers, audiences can be constructed on the basis of a com-
munity of interest. This process clearly can work, and even my limited
efforts in relation to *If You Lived Here...* and *Greenpoint: Garden Spot of the
World* had results. I believe these critics are wrong—but I am still looking
for a venue for *Greenpoint* in Greenpoint.

Although I have portrayed myself for the purposes of argument as a
constant exponent of class analysis incorporated in heavily narativized
work, in fact I don't recognize myself as such. Were I to define the the-
matic material that has motivated my work even when I made paintings
and Pop constructions, I would claim that the overlay of "place" and "the
body" (woman's body) and their relationship to discourses of power and
knowledge are my driving issues.[20] This was the impetus behind, say, *The*

Bowery in two inadequate descriptive systems, which sited a work about social-ly transient (and déclassé) people, their street locale and photographic representation within the art world discourse in which such representa-tions had come to find a "home." It clearly lay behind *If You Lived Here...* and the photomontages I described earlier. But it also motivated the mail-work "novels" on women and food and work on anorexia and bulim-ia, done before the words had entered popular language. With respect to form, sometimes the works have contradictory texts, sometimes they include lists of words, sometimes the texts are quotations, and sometimes there are no words.

A prominent critical response to *The Bowery* and its accompanying essay "In, Around, and Afterthoughts: On Documentary Photography"[21] articulated the degree to which the work engaged with the question of the presentation of (socially victimized) Others, and, by extension, women and other Others. But as usual, I am located on both sides of this question as well. In 1990 I went to South Africa for a number of months, with one foot in an elite university, the other in a (multiracial) commu-nity video production group. I shot many hours of videotape, but when I was nominated for a multicultural fellowship and applied for postpro-duction funding, I was turned down: What is a white girl doing making a work about South Africa? We may never know the answer, because I haven't been able to obtain the resources to produce a finished work. Not too surprisingly, there was far less questioning of my motives in South Africa's activist communities. When, in a previous year, I had been invited by (the same) high-profile multicultural funder to submit a plan for a work, I outlined a work about a Canadian woman artist who worked with native American themes. But Canada itself isn't "sexy," not sufficiently multicultural.[22] And I am still a white, middle-aged, straight woman whose work is political in the unacceptably hard-edged sense.

I have recently stuck my neck on the same block. Last year I found myself (a) funded in advance and (b) working with native Americans. Invited—along with a number of other artists—by the art commission of Seattle, Washington, to do a public art work, I proposed a work of short radio and television "spots" on the theme "hidden histories." Although Seattle's residents are of many different ethnic origins, and the city has a strong gay community and a venerable labor history, the feel of the place is white and polite. I proposed working with a wide range of ethnic and racial communities, with women, with the lesbian and gay community, and with women's and labor history. Numerous considera-tions led to my scaling back the project to a single element, and in

consultation with project adviser Gail Dubrow (whose own work is about the recovery of women's histories), I chose the native American community—feeling a bit odd about it.[23]

While I was conducting the on-camera interviews, a number of participants asked that the works not be aired on "educational" television but on the commercial stations. This imposed a powerful new stricture on the work, for those stations, when contacted, said they would be happy to decide whether to show the work *after* it was completed and *if* it fit their PSA, or public service announcement, formats: sixty seconds, thirty seconds, twenty seconds, ten seconds! I chose sixty seconds (nothing I'd made before has been shorter than six minutes). I have recently completed a handful of these tiny bites, and they are being reviewed by the people in them. I can imagine what the reception will be by people who believe that I cannot legitimately work with native Americans. They may be right, but I won't know until the works have actually appeared in the venue for which they are intended—which includes but doesn't end with broadcast television.[24]

The basis of the anticipated criticism is that people must speak for themselves—but, a friend murmured when I mentioned that I let the native Americans determine their topics of discussion, and they chose to talk about having been robbed of their cultures, their languages, and their spirituality—aren't you worried about pandering to essentialism, to imaginary identities?[25] Worried? The entire cast of *criticisms* of "people like me" making work about, say, South Africa is essentialist. When "Marxism" was more viable in the art world, people used to grumble about the impropriety of making works about working-class people, especially since the majority of such works were malicious efforts to portray people's unlovely body types, untrendy recreational activities, or poor taste. I have been much cited as an opponent of documentary photography for the way it has portrayed those without power to those in power, although in fact my critique was of the particular way in which particular sorts images are used, institutionally and personally. But others who enthusiastically adopted this criticism took it as reason or excuse to turn away from documentary-style representations, no matter how "extended" a definition of documentary might be in question. Anthropologist Jay Ruby believes that only self-reflexive documentary— "giving the camera" to those represented—evades authoritarian distortion. Others wish to interpret all representations as fictions. I disagree with all these totalized criticisms.

The critique of representations of people of color is more difficult. I

am strongly sympathetic here, but as unsympathetic to a blanket prohibition as I was to that against representations of working-class people. The enforcement of regimes of thought may always entail excessive application of rules, policing the borders of meaning, and essentialism is a dangerous pitfall of identity politics. Racism and sexism produce polarities in which a vital step toward liberation is the self-articulation of meaning, and the self-naming, of "colonized" subjects.[26] This long, difficult process may make it necessary temporarily to foreclose the possibility of cross-identity alliances. I don't want men at women's meetings, although I can imagine men collaborating with women on works about women—but could I accept their making such works alone? I'd have to see them first before I could judge them. On the other hand, South Africa (to pursue my own example) is a place, not an identity. As I saw on a recent visit to Russia, the search for authentic expressions of identity can be highly regressive, even delusional, and as the war in the Balkans amply shows, dreams of ethnic autonomy can lead to bestiality and murder. What grounds for exclusion are spurious, criminally so?

A critique of excessive particularism is more easily articulated when it applies to issues other than identity. For example, Alexander Kluge described a situation in which he and his film crew wanted to film an eviction of squatters in Frankfurt.[27] The squatters protest that their eviction cannot be filmed from without, by someone not living and struggling alongside them. Kluge and his crew reply that this point of view copies "the other side" by producing a "nonpublic sphere," a relationship of property and exclusion, whereas what is needed is the ability to disseminate information outside that sphere: "A public sphere can be produced professionally only when you accept the degree of abstraction that is involved in carrying one piece of information to another place in society, when you establish lines of communication."[28] Kluge and his crew were unsuccessful in persuading the squatters, who apparently saw authenticity of experience as a prerequisite to its representation.

I, in contrast, don't seem to be able to learn the lesson that the cat learned from the stove: once burned, twice shy. I feel strongly responsible to try to puzzle out these involvements or obsessions in the best way I can, and as I get older I trust this impulse more. I have to, for otherwise I might do nothing at all.

With apologies to Ine Gevers and the Jan van Eyck Akademie in Maastricht, in whose symposium and publication *Place Position Presentation Public* I participated in 1992. At the time I kept interpreting their version of PPPP as mine, and, as I discovered when I gave my talk, it was precisely those two last P's that marked the difference between their understanding of the art world and mine.

1. I have spent quite a bit of time considering questions of inclusion and exclusion of artists and audience members, on censorship and communities of meaning, and related issues. Some of the ruminations in print include "Lookers, Buyers, Dealers, and Makers: Thoughts on Audience," in *Exposure* (Spring, 1979), reprinted in *Art After Modernism: Rethinking Representation,* ed. Brian Wallis (New York and Boston: The New Museum and David R. Godine, 1984); but also in "In, Around, and Afterthoughts: On Documentary Photography," in *Martha Rosler: 3 Works* (Halifax: Press of the Nova Scotia College of Art and Design, 1980), reprinted in *The Contest of Meaning: Critical Histories of Photography,* ed. Richard Bolton (Cambridge: MIT Press, 1990); in "Matters of Ownership and Control,"*Artist Trust* ([Seattle] Autumn, 1990), 8, 13, reprinted as "The Repression This Time: On Censorship and the Suppression of the Public Sphere," in *Release Print* (Film Arts Foundation) 13, no. 10 (December/January, 1990-91), and in "On the Suppression Agenda for Art," in *Social Control and the Arts: An International Perspective,* eds. Susan Suleiman et al. (Boston: Agni and Boston University, 1990) and also published in *Agni* no 31/32 (1990), 63–70; and most recently in *If You Lived Here: The City in Art, Activism, and Social Theory, A Project by Martha Rosler,* ed. Brian Wallis, (Seattle: Bay Press, 1991), and in a few short articles and interviews.

2. I certainly said this differently at different times of my life, but I think an earlier self would recognize this particular formulation.

3. In his essay "Art and Objecthood," in *Minimal Art, A Critical Anthology,* ed. George Battcock (New York: E.P. Dutton, 1968), 116–147. Originally published in *Artforum* (June 1967).

4. Many artists, of course, have nothing to do with the art world. This includes people whose work is situated in various communities outside the dominant culture, often activist artists. Certainly, few media activists place themselves in art world settings.

5. For example, just during this past week, while I was writing this essay in the spring of 1993, two galleries, one in New York, one in Austria, solicited my participation in shows based on this series. One wanted to exhibit the original series, the other was soliciting new work on war.

6. I benefit financially from work that was made with no thought of permanence, let alone sales; oddly, that is still the hardest thing to accept. And now I am stuck with the problem of many requests for twenty-year-old work!

7. Imagine Picasso, Pollock, De Kooning, Hesse, Warhol as tenured profes-

sors. That was only thirty years ago.

8. Furthermore, the argument is likely to be put forward by those who are too young to ever have had an interest in the "working class" or the masses.

9. As I write, Massachusetts Congressman Barney Frank, who is out of the closet, is suggesting that gays in the military ought to remain in the closet.

10. The photographic work of both these men provided the soapbox on which the Congressional and religious right have tried to destroy social acceptance of critical art and end the public funding of all art.

11. See my "Theses on Defunding," *Afterimage*, vol. no. (Summer, 1982).

12. See Felicity Barringer, "Ethnic Pride Confounds the Census," *The New York Times* (May 9, 1993) sec. 4, 3, and on the next page (by way of obvious example), Roger Cohen, "The Tearing Apart of Yugoslavia: Place by Place and Family by Family," sec. 4, 4. See also *The Nature and Context of Minority Discourse*, eds. Abdul R. JanMohamed and David Lloyd (New York and Oxford: Oxford University Press, 1990)

 A number of factors help determine what people identify themselves to be. A despised identity is a powerful organizer. The process of liberation and self-nomination of oppressed people—"African American," say—sometimes creates bogus or imaginary identities for the oppressor—"European-American," an ascribed identity lumping together people of, for instance, English, German, and Sicilian extraction, and Jews and Muslims with Christians. Thus, "European American," useful as an epithet of opprobrium, has little force for those who supposedly bear it, given the heirarchy and desirability for European identities. In the States, however, intermarriage confuses white ethnic and religious identifications. Although people with negative identities may choose to hide or downplay them, attaching social benfits to them leads a proportion of people to claim them who otherwise might not. The parallel situations in Eastern Europe promise to be far more incendiary.

13. A corollary is a resurgence of "body art," now incarnated as an expression of "abjection" or victimization: the downside of the representation by, rather than of, social Others. It is not unmeaningful that this is the art of the young—often very young—which means that much of the art is preoccuppied with Oedipal matters or with early recognitions of social discrimination

14. See note 13.

15. See Maureen Turim, "Viewing/Reading *Born to Be Sold: Martha Rosler Reads the Strange Case of Baby $M* or Motherhood in the Age of Technological Reproduction," *Discourse* 13, no. 2 (Spring-Summer, 1991): 21-38, and my response, "Of Soaps, Sperm, and Surrogacy," in *Discourse*, 15, no. 2 (Winter, 1992-93): 148-165.

16. The grounds for granting such professorships seem as good as any, I hasten to say.

17. But overwhelmingly from Poland.

18. For me there is a primary irony in that well into my life as a so-called politicized or engaged artist, I still vowed I would never make a work about housing, health care, pollution, environmentalism, or any of these social-

19. *If You Lived Here: The City in Art, Activism, and Social Theory. A Project by Martha Rosler.*
20. For example, the airport photographs I mentioned earlier, which collectively go under the title *In the Place of the Public*—and which constitute a body of work that has occupied me for a decade and about which I care deeply—has nothing of the agitational or didactic about it as one normally understands these terms.
21. Craig Owens, "The Discourse of Others: Feminists and Postmodernism," *The Anti-Aesthetic,* ed. Hal Foster (Seattle: Bay Press, 1983), 65–90.
22. A fine irony for a culture that developed the government-invested term and concept of multiculturalism in the late 1960s as a way to avoid the riots erupting in their neighbor to the South.
23. Coincidentally, I had been an avid student of Northwest Coast Indian art since my teen years. I used to "visit" elements of it at the Brooklyn Museum, the Museum of the American Indian, and the Museum of Natural (sic) History. The Canadian painter about whom I wanted to make a videotape lived in that region, and it was those native peoples whose work she studied and appropriated.

 Unexpectedly, a foreign friend reminded me that I had been taken to task in 1980 by some audience members at a London symposium accompanying a political-feminist art exhibition I took part in at the Institute for Contemporary Art. The objections were directed at a "postcard novel" I had produced about a fictive undocumented Mexican maid (a composite based on interviews) in San Diego, where I lived. The work was part of a trilogy on women and food production.
24. Although I decided to leave my name off these one-minute "lectures" by native Americans, the city is balking at my unmediated use of the Indian head that is the city's logo. They want an attribution line and a logo tying the work firmly to the Arts Commission and offering its phone number, all in a work whose total running time is sixty seconds; we shall see.
25. I get uncomfortable when I begin to see these "good" lost identities as not so different in kind from the East Bloc ones currently being pursued.
26. Again, see note 13.
27. In an interview with Klaus Eder published as " On Film and the Public Sphere," in *New German Critique* no. 24/25 (Winter 1981/82), 206–220, an excerpt of which was published in *If You Lived Here*, 67–70.
28. *If You Lived Here*, 68.

6

THE VELVET REVOLUTION AND IRON NECESSITY

Eva Hauser

From 1948 to 1989 Czechoslovakia was under Moscow-oriented Communist rule, and the country experienced many political, sociological, and cultural changes. The first years of the Communist regime were grim and tragic: show trials and executions of the Communists' political opponents (so-called "class enemies"), mass confiscation of property belonging to people who had been marked out as "exploiters" or "the bourgeoisie," and omnipresent fear. However, there were also a number of enthusiastic people who still believed that it was possible to build a utopia, a true socialist state where all people would be equal, no one would suffer, and everybody would be happy and love their work.

This situation changed completely in 1968. A reformist faction within

the Communist leadership led by Alexander Dubček, which had come to power the previous year, attempted to humanize the Communist regime, introducing greater freedom of the press and democratic reforms under the banner of "socialism with a human face." Most people, including the Communists' former opponents, accepted these reforms with sympathy and hope. However, the experiment was terminated abruptly by the Soviet invasion on August 21, 1968. People were shocked by the sight of tanks in the previously peaceful streets and the statements about "counterrevolution" that emanated from Moscow. Very gradually, within one or two years, hard-line, pro-Moscow conservatives within the Communist Party forced their way back into power.

The seventies were a dark, barren era of "normalization": The whole cultural life of the nation was dismembered, there was a complete lack of information, and no one trusted the Communist slogans anymore. People—especially Party members—who refused to call the Soviet occupation "brotherly help" were punished. They lost their jobs, they were forbidden to travel, and their children were denied access to education.

The first open statement against this situation—and the beginning of the dissent movement—was Charter 77, the petition for human rights created by a group of intellectuals centered around Václav Havel (today the president of the Czech Republic) which rapidly circulated throughout the country. Signatories of Charter 77 were subjected to surveillance by the secret police, punished, and sometimes imprisoned. In the eighties, the machinery of oppression very slowly relaxed. However, the creative efforts of people who had been active in the arts (and hadn't ever wanted to take on the regime in the first place) continued to be denigrated, hedged in by bureaucratic obstacles, or forbidden by the authorities.

The role of artists throughout this history was central. Artists and poets invented the enthusiastic new language and images of the "builders of socialism" in the fifties. They wrote work songs for groups of Communist Youth who built the new (absurd and unnecessary) plants and factories. They created heroic statuary. It was also artists, especially writers, who laid the groundwork for the Prague Spring of 1968. Since then the conservative Communist leadership was always desperately afraid of writers: They could not forget that writers had initiated the "counterrevolution." A small group of official artists tried to justify "normalization" during the seventies, but a large proportion of the dissent movement also consisted of artists. They managed to create an alternative, unofficial culture that paralleled official culture for more or less the

whole of the eighties, although they were not able to distribute their newspapers, samizdat books, videos, audiotapes, or exhibition announcements openly, so their audiences were somewhat limited.

The Velvet Revolution of 1989 was started by students who went on strike for more freedom, but they were immediately joined by artists and the dissident intelligentsia. Concerts and theater performances were cancelled, and in their place artists told people their real opinions about liberty, human rights, and our regime. These artists—and a few days later workers in the Czechoslovak media—helped to spread the idea of Velvet Revolution among the people. The first student demonstration took place on November 17, and slightly less than six weeks later the Communist regime collapsed without ever really putting up a fight. The whole process culminated in the election of Havel as President on December 29, 1989.

It was difficult to be an artist in Czechoslovakia during the communist years. Your work was supervised constantly and judged according to ideological criteria. However, the "socialist" state still claimed to actively support art, and in some cases it provided a certain amount of security, the basic means for making a living, and certain other advantages for those artists who it found acceptable. This system was much more highly developed in the Soviet Union, where artists constituted a truly privileged group: Not only the official artists who actively supported the Party but even more "normal," ideologically neutral, artists benefited from these arrangements. In Czechoslovakia, apart from a handful of the highest ranked official artists, writers and artists always risked proscription. One politically suspect sentence—not necessarily about freedom; sometimes a single mention of the Russians or the word "tank" was sufficient—might attract the attention of the authorities and precipitate disaster.

I wanted to find out how artists regard their new situation in the wake of the enormous changes that have occurred since 1989, and how they are coping with it. It became clear in the course of my research that the problem of supporting oneself financially and related commercial pressures have strongly overshadowed any perception of less immediate social problems introduced by the new "capitalist" society, such as racism, sexism, and other topics which occupy the thoughts of many artists in the West.

In short, due to the new conditions, Czech artists still seem to be in a state of shock. I wanted to gather the most authentic, honest, and concrete information about what these artists are experiencing, and to do

this I decided to interview a select group of individuals. I deliberately refrained from over-generalizing on the basis of what they told me, because the new situation is not yet sufficiently stable to draw general conclusions. Wherever possible, I decided to interview my friends (Hamzová, Pawlowská, Berková), because I thought they would be most likely to give me candid insights into their thoughts, problems, and lives. When I needed more material on the visual arts, I also contacted Vlasta Čiháková-Noshiro, who is a noted theoretician of the visual arts.

▬▬ Totalitarianism

"It seems absurd," says Liana Hamzová, a free-lance artist who lives in a medieval house in Únětice, a small village near Prague, "but under the old regime, artists had a lot of security, so much so that sometimes even Westerners were envious. Really envious. If you graduated from the Academy of Arts or from Umprum (the School of Applied Arts and Crafts) you were given a studio by the state and obtained the right to work as a free-lancer, so that you were not obliged to have a regular job. Today it's no longer necessary to have a stamp in your identity card from your employer, but under the Communists, you regularly had to show this card to police on the street and prove to them that you were employed.[1] Perhaps one-third of the people who decided to study at Umprum did so because of this advantage.

"After you graduated, you received a grant from the Artists' Union for, let's say, three months, which gave you some time to look around and find work. The Union also had a lawyer, and you could use his services for free, so that you wouldn't do some work and not get paid for it. Today, this happens all the time! There was also a Fund for the Arts, which sold your work for you. Of course, they took a small percentage of your sales, but this was not very high and you didn't have to worry about anything.

"On the minus side, the Fund had an effective monopoly on the sale of art works, and part of their activity involved a commission which decided what work it would accept and what it would reject. It was extremely important not to draw attention to yourself in front of the commission, not to be exceptional, provocative, or different in any way. If the members of the commission became angry or irritated with you, they might reject your work several times with a recommendation to redo it, or they might decide to pass you over for a particular job and give it to someone else."

Liana was born in 1952, studied at Umprum in Prague, and worked there as a teaching assistant for three years. Later she became a free-

lance artist, initially working as an illustrator and graphic designer, more recently as a painter. She was one of the best students in her year and wanted to stay on at the school to teach, but one of her relatives emigrated to the West, so this wasn't permitted. Today, she doesn't seem to mind and lives quite happily in a beautiful house, surrounded by an herb garden, with her daughter, three dogs, and her husband Josef Hamza, who was one of the leaders of Umprum during the communist era. He was a member of the Communist Party and worked as a professor at the school.

Josef explains why he eventually decided to join the Communist Party: "I hate it when people manipulate me, and I was always very angry when my fate was decided by some thug I never even got to see. I wanted the opportunity to participate in some decisions. I wanted to have some influence." Today he works for an advertising company and earns much more money than he used to. He also seems quite happy.

Liana continues to explain how things used to operate: "The best arrangement was if you had a friend on the commission, so you could phone him up and say, 'Look, my things are going to be judged tomorrow. Keep an eye on them, please.' Of course, these commissions were tremendously stupid. On the one hand, they protected you, but on the other, they effectively censored your work. A similar situation applied when you wanted to organize an exhibition. The exhibition hall had to be booked through the Union of Artists; otherwise you weren't allowed to exhibit your work. However, once you had an exhibition, they also printed posters, catalogues, and so on—all for free. Today you must pay for everything yourself and hire the exhibition hall, which costs a fortune. The young, beginning artist can't afford it."

Vlasta Čiháková-Noshiro was born in 1944. She studied modern Japanese art and aesthetics in Japan and lived there for sixteen years. Since her return to Prague in 1990, she has worked in trade and cultural relations. She collaborates on numerous contemporary art magazines and organizes exhibitions for various small, independent galleries, such as Behemot in Prague. She is the chairperson of the Mánes Association of Art Critics and the Czechoslovak-Japan Society. Vlasta always seems to be rushing, involved in all kinds of tasks and responsibilities. Her home is beautifully furnished with Japanese antiques and piled high with magazines, papers, other materials—and frequently occupied by foreign guests.

She explains: "Before the revolution, art was divided, as was the whole of society, into official and unofficial camps. I would even distinguish—

although it sounds funny—an official underground and an unofficial underground. Members of the official underground were people who didn't have any opportunities to exhibit regularly in official venues, so they used to show their work in places like shopping malls, market halls, and the cultural centers in the new housing estates. Still, they tended to paint nice, decorative pictures which you could hang on your walls—stuff they could sell and which was not openly opposed to the regime.

"Expressionism has been very popular in the Czech lands from the beginning of the century, and a lot of people who began to paint in the seventies or early eighties constituted a sort of new expressionist wave. Their art wasn't offensive in any sense, and it ended up being, so to speak, semi-official. Of course this applies only to this recent generation, since their predecessors, who started to work in the sixties, were condemned for political reasons and could sell their works only through the Artcentrum, an organization exporting art abroad. Sometimes it was difficult to survive [that is, live on the proceeds of your art and not be forced to supplement your income as a cleaner or a laborer] and still remain moral [not collaborate with the secret police]. However, there existed a group of people who managed it.

"Apart from this so-called official underground, there existed the unofficial underground, and their position was far worse. They specialized in the kinds of actions which today we call performances, and they made no effort to avoid ideological conflict. On the contrary, they were quite open in their political opposition to the regime. In those times, it was something unbelievably daring—the Communist newspapers sometimes wrote about their 'open political assaults.' Or someone, somewhere, would strip and perform naked, which was terribly inflammatory to totalitarian prudery!

"These performances were sometimes in clubs, but more often they would be carried out in the open, among ordinary people, for example, on the site of the new housing estates which were then being built or in the mountains or at barns attached to the weekend cottages of sympathizers. Sometimes these performers and organizers were arrested, interrogated, and forbidden to sell their work. People from this unofficial underground were rehabilitated after the revolution, which was easy, but otherwise they still have a hard life, since they aren't easily integrated into society. Their art is difficult to classify, and it is not commercial enough to market. The official underground is preferred today."[2]

I remember that I once went by chance to an exhibition by a young

artist, Čestmír Suška, which was staged in cooperation with Theater Kolotoč. It was really surprising and made a major impression on me: crude papier-maché models of human bodies, arranged in different ways, travelled via an escalator up a gray concrete panel wall very typical of our housing estates and then fell down as if in a suicidal act. This action was repeated again and again, with atmospheric music, express-ing the alienation of our dreadful housing estates and the whole way of life under communism. I enjoyed this performance very much, but after several days it simply disappeared—someone cancelled it. Also there were never any posters or other advertisements for it.

I asked Vlasta how people managed to find out about unofficial art, because this information barrier was one of the most lethal aspects of the old regime for our culture.

"It was not really possible to send invitations by post or to call some-body, because these channels weren't safe. So friends used to inform each other by word of mouth. Certainly, this sort of culture was only for a very close circle of friends," she explains.

Film is an area where the problems of commerce and finance are probably most demanding. Only a small fraction of the scripts that are written are ever produced, and filmmaking itself is by far the most expensive art medium.

Halina Pawlowská was born in 1955. She studied screenwriting at the Film Academy in Prague and worked for several years as a free-lance writer, authoring scripts for three films and about twenty television plays. She now works as a journalist for the daily newspaper *Telegraf.*

When she wrote teleplays before the revolution, she frequently encountered enormous problems: Her personal intentions and the entire character of her work were seriously distorted by her bosses. She also wrote several film scripts, comedies about contemporary life, and these were quite successful, although they tested the limits of what was tolerated by the Communist censors. She comments on the situa-tion under the former regime: "Before the revolution, we had only the Film Studio Barrandov, and it had a monopoly on film production. Its existence provided a certain guarantee that at least some of our scripts would be used, but, of course, it had distinct preferences for some thoughts, some themes, over others. Concretely, when someone wanted to make a film, he or she wrote either an outline or the script and presented it to the studio's script editor—that means to an employee of the state—who then brought it to the leader of their so-called creative group at the studio. This leader would either reject it (in most cases) or

pass it on for approval by a higher authority, and finally for approval by an official committee. Only after it had gone through these stages could production of a film begin."

Today, this machinery has been dismantled. The State Studio Barrandov used to produce about thirty to forty films per year. Last year (1991) it managed to complete only eleven. Now, when someone wants to make a film, he or she must get funding either from the state— there are various competitions for grants—or from a private sponsor. In theory, the second form of sponsorship is not officially sanctioned; in practice, however, several privately funded films have been made in the last two years, so there must be loopholes in the law. The Minister of Culture has promised that he will try to resolve this situation as quickly as possible, but so far nothing has been decided.

"Most film people (directors, screenwriters) have shifted to making advertisements, since there is now plenty of work in this field. Nobody judges the quality of your work. The only important thing is to be smart enough to get the money," says Halina.

Commercial pressures also seem to have become much more significant, even a limiting factor, for those engaged in writing and publishing books. To shed light on this subject, I should perhaps briefly recount my own experiences.

I was born in 1954 and was always strongly attracted by creative writing, but I decided to study biology, partly because in the 1970s I couldn't aspire to study journalism (too much ideology was involved). I graduated as a microbiologist from Charles University in 1978 and started to do research in molecular biology. A few years later, however, I managed to make the move to journalism anyway, by way of the children's science magazine *ABC mladých techniků a prírodovedcu* (*ABCs of Young Technicians and Scientists*). At the same time, I continued to write short stories, but I was only partially successful in getting these published, because they didn't convey the image of contemporary society required by the official culture. Like many other writers, I solved this problem when I discovered science fiction. In totalitarian times, science fiction enabled us to speak about our society much more openly and critically than the literary mainstream; it is an outstanding medium for political metaphor. As a result, people loved science fiction, and it enjoyed enormous popularity. Since the revolution, science fiction has utterly abandoned this political role and become once more a genre of popular literature.

In 1990 I began work as an editor for the newly founded SF monthly *Ikarie.* My responsibility was to select stories by our domestic SF authors, which meant that I had to form an accurate impression of what people enjoyed reading. From this perspective, I determined that the overwhelming majority want easily readable SF or fantasy adventures with little intellectual content, and a fair number of our writers have adapted their styles to suit these new market demands. Other writers, who continued to write in metaphors as they had in the past, found that they were no longer popular.

Alexandra Berková comments on this situation: "Before the revolution, there was enormous strength, but really enormous strength, in genuine art. Today people don't read much. Only a few years ago we used to copy books on typewriters; we dug around in old libraries searching for translations published in the times of the First Republic (1918–1938). There was such a hunger for culture, which simply doesn't exist anymore. Art used to awaken hopes in us; it gave us human dignity, was like part of our identity.

"Today people travel, do business, open shops, and so on, but under totalitarianism the same people attempted to write poetry, copied poetry by underground writers, tried to obtain interesting things to read. From time to time, exceptionally, the official publishing houses would issue a really interesting book, and people queued for it. You would never see that today. Also, books are far more expensive now. Before the revolution, when you went out and spent 100 crowns on books, you would come back with a whole bag full. Now, you come back with maybe one or two books. People here used to buy many more books than is usual in other countries. Of course, it's not just the price; people have other distractions now—TV, video, computers and so on. People read much less."

Alexandra (Saša) Berková was born in 1949, studied at the Philosophical Faculty of Charles University in Prague, and worked briefly as an editor in the publishing house Československý spisovatel. Since the mid-eighties she has been a free-lance writer. Her position in communist times could be described by the term "official underground." She was able to publish and have her plays produced for television only in the second half of the decade, after the arrival of Gorbachev and perestroika in the Soviet Union, since, as a result of these events, the situation became slightly liberalized in Czechoslovakia. At that time, her books and plays were regarded as important cultural events; everyone talked about them. Today people seem to have different interests, and writers, however good and interesting their work, don't attract nearly as much attention.

Saša reflects on this situation: "During totalitarianism, I saw things from the other side, because I didn't belong among the official writers. Writers who addressed their art to the emperor's court in such an easily understandable manner, so that even the emperor himself could understand it, received enormous royalties. They were paid for adoring the power, fame, and immortality of Communism, and they could publish more or less anything they wanted, in vast print runs. Again and again they would publish new and newer editions of their collected works, or their selected writings, or whatever...on and on and on. This was one segment of our writers— those who would raise their voices in a single chorus, whenever there was a need for it. Like Josef Peterka: 'Those who carry morning on their shoulders/ Do I hear you ask: "The Communists?"/ That's right! You've got it!'[3] You should understand that these people were not particularly proud of their work. On the contrary, they didn't like to be reminded of this particular aspect of their poetry. They would constantly tell their editors, 'Please, don't put it in the collection. I only write this sort of thing occasionally. Why not select a poem about my native house, or about nature?' Other examples of this kind of poet are Miroslav Florian and Karel Sýs."

How did you support yourself?

"I worked as an editor in the official publishing house Československý spisovatel for a little while, but they fired me. I was not a member of the Communist Party or even of the Socialist Union of Youth, and people were suspicious. You know, when you entered the Party it was exactly like stepping into shit. When someone wasn't a Party member, the people who were considered this an offense, a humiliation, as if you were trying to show them that you were better than them.

"My problem was that I didn't understand what my bosses really wanted from me (otherwise I would never have started working there in the first place). The Communists didn't say openly, 'Come on, lads, let's go and rob those Czechs of everything they own,' or, 'Let's go and force others to work for us, and we shall only eat.' No! They said, 'We are struggling for our luminous future; we want everybody to be happy,' things like that. They had to have positive slogans. And I was stupid and couldn't decipher these slogans. I thought that they really wanted to 'search for new, young authors,' that they really wanted to 'support literature.' Nobody ever said that they wanted me to adore the Communist Party or the working class. But they waited for it. So I had many, many conflicts. Eventually I understood that this publishing house (and the Writer's Union to which it belonged) had the same function as, say, the

Union of Women: to guard women so that they wouldn't be active. The function of the Writer's Union was to guard writers so that they wouldn't write anything dangerous—new, inventive.

"They were unbelievably narrow-minded. Everything was an awful *pruser* (fuck up). A misplaced comma was a *pruser*, the small American flag on the jeans of a girl in some photograph was a *pruser*. Then again, these were the times when they called a special, extraordinary meeting of the Czechoslovak government just because there weren't enough sanitary napkins in the shops, so what can you expect?

"Once, William Saroyan was in Prague, and I went to meet him, privately, on my own. I didn't ask my bosses for permission, and that was my most enormous *pruser*! After they fired me, I worked as a cleaner and I wrote some television scripts. They accepted them because they confused my name with Alena Berková, who was a television script editor. It took them about a year to discover the error, and by that time they had invested so much money in these projects that they had to finish them. And they sacked Alena Berková, which in the end was very good for her. A year later there was the Velvet Revolution, and she made a triumphant return as a dissident. So we are grateful to each other."

Freedom

In November and December 1989, together with hundreds of thousands of other people, I was in the streets and squares of Prague. We rang tiny bells, chanted slogans, made demands for freedom, human rights, the end of totalitarian rule. It seemed to be a vast performance. Shortly after the revolution more exhibitions of the official underground appeared, in galleries, in places such as the plateau above Prague where a huge statue of Stalin stood in the fifties.

A Soviet tank, placed on a pedestal in one of Prague's squares to remind us of our "liberation" by the Red Army at the end of the Second World War, was painted pink by a student from Umprum. The local officials wanted to charge him a considerable amount of money for damages, and they repainted the tank its original military green. However, a group of members of our Parliament painted the tank pink again in protest—a great performance for all Prague citizens! Personally, I really liked the pink tank, since it looked surprisingly tender—a genuine protest against war—but older people hated it, because they felt that war was too serious to be treated in this manner. Eventually, the tank had to be removed.

When I started to work on *Ikarie*, the first science fiction magazine in

the Czech language, my colleagues and I soon discovered that what our readers really wanted were commercial illustrations, covers with colorful scenes of aliens, monsters, and spaceships. It seems absurd, but in former times, exactly this kind of kitsch was suppressed in the name of quality art. Although totalitarian covers and illustrations might be boring and dully abstract, they were never as kitschy as this! I was a bit distressed when I had to tell our graphic artists, "People really want kitsch, and we need to sell. Could you please do something more commercial?"

The situation of visual artists in the Czech Republic today is described by Vlasta Čiháková: "After the Velvet Revolution the generation of the sixties became professors at the Academy of Art, Umprum, and other schools. Galleries that had been closed to them opened their doors to the younger generation (that is, the former official underground), so their situation has improved. The position of the unofficial underground is more difficult. Now we have a market economy, and you will be commercially successful only if you do something easily comprehensible and acceptable—decorative pictures that can be hung on walls, not performances. And so these people still feel like an opposition, even though the situation isn't as clear-cut as it used to be.

"We don't have ideological repression today, but customers are not used to distinguishing real quality in art; they don't understand modern art. We have made a good deal of progress on this, through the work of critics, education, and so on, but the most commercial things still sell the best."

Will our art become more cosmopolitan? Liana Hamzová is quite optimistic in this respect: "I think our intellectuals and artists will try to retain their specificity, because this is what the world wants from us: It is national specificity that makes our art interesting. What sense would there be in our becoming Americans? What is really important is character."

Do people today read more of what we call *brak*[4] than they used to? I ask Alexandra Berková.

"I think there was always plenty of *brak* around. People used to borrow more books from each other or from libraries; *brak* was published in newspapers as serials. What has changed is that the people who read quality literature have stopped reading today, or rather, they read newspapers, write columns, watch TV."

I ask Alexandra what she is writing now.

"Supporting yourself is much more complicated than it used to be,

although it was hard in communist times, too. I still write for TV, and they keep asking me for more, but I would like to withdraw from it, because TV is a pest; I hate it. It homogenizes everything. The people who make programs for television do everything in the same style, for the average viewer. But this makes no sense, because a good film or play needs a personal approach."

So what would you really like to do?

"Well, when my first collection of stories, *Knížka v červeném obalu* [*Small Book in a Red Cover*]⁵ was published shortly before the revolution, there were queues and it sold out immediately. When my second book, *Magorie* [*Loonyland*], was published last year, it didn't get nearly as much attention and still hasn't sold out." I should add that in Czechoslovakia reprints were exceptional, and it was usual for books to sell out. You could even measure the success of a book by its unavailability. Only bad books were available in the shops.

"Anyway, even though it hasn't sold out yet, you can't see *Magorie* in the bookshops, because the distributors don't buy this kind of literature. They don't like it; they don't consider it attractive. The print run on *Magorie* was ten thousand, whereas the first book had a print run of fifty thousand. We were that hungry for culture—it substituted for belief, dignity, everything.

"All in all, though, these low print runs are, I think, the normal state of affairs, and if you can publish a Czech literary novel in a print run of five thousand and sell most of it, that is OK. What is not normal is the way our system of distribution works. Our distributors act in an amateurish way; they are greedy for money and want only books which they think will give them an instant return: thrillers and other potential best-sellers. I hope this will change in the next few years. Perhaps distributors will learn to behave more professionally and quality literature will be available, too."

▓▓ Money and "Survival"

The former totalitarian state called itself "socialist," and in a certain sense it was a welfare state. Everyone had a badly paid job and no one starved, but no one (or only very rare exceptions) became wealthy or really successful. Today, people have lost this basic financial security, and this seems to make them very nervous. From my own experience, I know it is rather difficult to draw people's attention to topics like feminism, racism, the problems of the third world, the environment, and homophobia, since Czechs generally consider these problems insubstantial or

unimportant, saying that there will be plenty of time to think about these issues after we have solved the "basic existential problems." By this they mean some level of personal wealth and prosperity for the entire society.

I asked Liana Hamzová and her husband Josef Hamza about the economics of being an artist, because this dimension seems so critical to the changed social order. "Under the old regime," says Liana, "there was a legal obligation for construction managers to invest several percent of the cost of every new building for so-called artistic purposes. This is how, for example, we came to have these monumental walls in the metro stations, fountains and statues on the housing estates, and so on. [I should explain what Liana means by "monumental walls": When you approach the entrance of most Prague metro stations, you are confronted by a huge, deadly serious mosaic or bas relief, either utterly abstract (a few strict lines) or with ideological content (an image of the Kremlin, a Soviet cosmonaut, or a few words from a Communist poem).] All this was paid for by the state. These jobs have ceased to exist, but instead we have boutiques, cafés, and such places, and their owners have quickly figured out that it is to their advantage to have temporary exhibits on the walls. They give the artists space, take a percentage of the proceeds for whatever is sold, and every month they get new decorations.

"Obviously, there will be a winnowing process, because we must all live on something and the Czech people don't have money for buying art. There used to be a stratum of society who bought art, but now they don't have money for it. During the First Republic, artists established good relationships with doctors, who had a lot of money. I hope that similar relationships will emerge again. But before this new strata appears, much talent will be destroyed. Our new entrepreneurs don't feel any need to buy art yet."

Josef Hamza adds: "These people, the *nouveaux riches*, buy only the famous names—if somebody tells them, 'See, this name has real value.'"

"Nowadays, if we sell anything at all," explains Liana, "we sell it abroad, because foreigners can afford it; it is cheap for them. Many of our people like our art, but they say, 'Sorry, living expenses are so high today, I simply don't have any money.' These are the same people who used to buy art a couple of years ago.

"All my friends have lost their studios. I don't actually know anyone who has managed to keep their studio. So many of houses are being returned to their original owners, and you simply can't pay the sort of prices they are asking. Sometimes the owners don't even ask for more money; they simply throw the artists out. They want to renovate their

houses, and they are not interested in having an artist working there.

"For some professions, especially sculptors and ceramicists, it is simply impossible to work without a studio. It is absurd to do such things in an apartment. A sculptor, for example, must work on the ground floor, with ready access for trucks. And artists are often sensitive people; they consider these problems an assault on their person, and not an objective situation, which it is necessary to cope with, to find new ways to earn money. It is marvellous that we are freer now," concludes Liana, "but life is generally much more difficult."

Josef adds, "Some people used to say that when you start to speak about money you stop speaking about art. This is nonsense."

I ask Vlasta Čiháková whether she is afraid of an invasion of kitsch that will undermine the ability of serious artists to make a living.

"Yes. Recently the Association of Amateur Artists was founded, giving them the same rights as professionals. They are the Montmartre types; you can see them in Prague on Charles Bridge, selling their works to tourists, and a similar sort of thing is happening with street musicians. Then again, this is the same all round the world and belongs to the pulse of the city, so perhaps it's not really a cause for worry. What would be worse is if all the art being produced dropped to this level, which is a real possibility. What worries me is the dictatorship of the market, which we have never experienced before."

Halina Pawlowská speaks about the present situation in the film industry: "Recently, several new private companies have started to produce films. Also, the state-run Film Studio Barrandov needs to raise money, because state support has been cut considerably, and state grants will only finance approximately five films per year. Our Minister of Culture says that he doesn't like talking to artists nowadays, because they speak more about money than about art. But artists under these conditions have to be businessmen as well. The best combination is someone who is a good artist and a good businessman.

"If you look at the sort of films that are being privately produced, you can see they have particular problems. A recent example is a film from Brno called *Trhala fialky dynamitem* (*She Blew Up Violets with Dynamite*, released in December 1992). The private company responsible for this production, Hošna Films, is owned by a textile merchant, and he decided he wanted to make a successful commercial movie. The only problem is that he has reused all the old clichés which he hopes will succeed again. Milan Růžička, the screenwriter and director for the film, was forced to follow his producer's suggestions, which are not very competent. Of

course, it is a positive development that this private company decided to produce a film at all, and I am not against commercial films in principle, but the people who have participated in this particular project are not very experienced or educated in the field. They came to the project at random, and they have no clear idea what they want. So their ideas about commercial films are rather primitive, as if fast cars and naked girls were enough to guarantee success."

Why don't we have any professional film producers?

"The whole concept of professional producers was rejected by the Bolsheviks as something extremely dangerous, suspicious. We did have some people who studied film production at our Film Academy, but usually they only led the production group and organized the work itself. They are not real producers and have no money or fundraising skills. Where could they have got them from?"

For Alexandra Berková money plays an important role in an artist's life: "If I had money, everything would be much easier for me, and I could finish my next book, *Všivák* (*The Scoundrel*). I think the myth of the impoverished artist, who works better for being hungry, is not realistic. Artists don't need a lot of luxury, golden potties and the like, but if winter shoes are a problem, then that is embarrassing.

"We live in an era dominated by commerce, so the connection of art with life is mediated by money. But I don't believe in this as a principle. Consumer art—craft, if you like—is not real art. I do this craft, my television scriptwriting, so I have food to put in my family's mouths, but actually I would much prefer to do the real thing."

Politics

Vlasta Čiháková speaks about the relationship between art and politics: "In the West, people are used to taking a political approach to art, but here our approach to everything is just beginning to take shape. Everyone used to love Havel and the other Velvet Revolutionaries; no one wanted to offend them. Now the political scene is becoming more sharply differentiated, but we still haven't reached the stage where, for example, an artist would tackle Sládek (an extreme right-wing populist politician, leader of the small, nationalist Republican Party, and an obvious target for ridicule). But people's attitude towards civic affairs still expresses itself in a sort of vague will to be helpful."

It is clear that people more or less identify themselves with the new regime, the new situation. One of the things that has changed dramatically since before the revolution is that people no longer tell political

anecdotes. I find this staggering. Throughout the totalitarian period, I constantly heard political anecdotes. Anecdotes were a sort of humorous defense mechanism, expressing people's true opinions about the Soviet Union, the Soviet occupation, the stupidity of our Communist leaders, even perestroika. After the Velvet Revolution, the flow of anecdotes stopped. Odd. Symptomatic.

"What is artistic freedom?" says Liana Hamzová. "If you look at the biography of any artist whose works are really worthy of our attention, you find that the basic problems they faced in life are always the same. True artistic freedom only exists when you don't have to live by your art."

Alexandra Berková, who is very active in feminist and human rights movements, says, "Actually I never wanted to get involved in politics at all, but I don't want to have the feeling that I could have done something to help and didn't. Women's problems are really political problems, which is something that people here don't quite realize."

What is your opinion about the relationship between politics and art?

"It's perfectly possible for artists to address political problems in their art, but they can't do it explicitly, *à la thèse*. One of the best expressions of the political role of the artist I know is Vonnegut's image of the canary in the coal mine: No one can smell anything wrong, but this little bird is already keeling over. The bird is more sensitive than the more robust beings around it. Artists are able to pick up advance signals that are perhaps only vaguely detectable at first. I don't believe that real art can be pure entertainment. Even if something is genuinely funny, it still carries many subtexts, pointers on various levels, far more than any work created for a specific propagandist goal.

"Good art is about the reality within which the author lives, and, if it is well done, the reader lives it with the author. The reader learns something from the author's sensitivity. Human beings secrete art in the same way that trees secrete resin when they are wounded, as a restorative. I am convinced that when this sick and stupid humanity of ours is healthy, harmonic, free of anxiety, art will die."

Czechoslovak artists nowadays fully confront the pressures of the market economy, of commercialism. Facing these new problems of practical everyday life, which are sometimes surprising and harsh, does not leave them much time to analyze their emergent democracy, to distinguish its subtler characteristics. As the situation stabilizes, I expect they will gradually become aware of some of these more subtle issues: questions like racism, the position of minorities, the environment, the lack of tolerance for difference.

Nevertheless, artists now enjoy the fact that everyone has a voice and, for the time being at least, don't seem to mind so much that this voice is usually weak and that only a few people listen to it.

— Translated by Cyril Simsa

Notes

1. Under Communist law, employment was compulsory. Anyone who could not prove they were employed was liable to be imprisoned as a "parasite."
2. For more details about "alternative culture," see, for example, Vlasta Čiháková-Noshiro, "Umění jako postoj (Art as Attitude)," *Výtvarné umění* (*The Magazine for Contemporary Art*) No. 4 (1991).
3. This poem by Josef Peterka was published provocatively in large letters, on the cover of the official literary magazine *Literární měsíčník* in 1979. Peterka was reputedly very upset, since he didn't intend the poem to be so visible.
4. *Brak*: a pejorative term for popular culture which is very difficult to translate into English; "trash" is perhaps the nearest equivalent. The attitude of the East European intelligentsia towards popular culture is in general much less tolerant than that of their American counterparts. The concept of cultural "debasement" (*pokleslost*), first coined by the Soviet critic Viktor Shklovsky, is still considered an appropriate response to popular culture by a depressingly large sector of the Czech cultural elite, and it is quite normal for literary critics to talk about "debased literature" (*pokleslá literatura*) when discussing popular genres like science fiction, horror, and the detective story. This is true even for critics who are enthusiastic proponents of popular fiction in the face of literary snobbery, and who are notoriously anti-Soviet in their political views: cf. Josef Škvorecký's use of the term in "Some Contemporary Czech Prose Writers," *Novel* vol. 4, no. 1 (Fall 1970): 5-13; "debasement" appears on p. 5.
5. Unfortunately, the publisher chose to issue it with a green cover.

7

EL DIARIO DE MIRANDA/MIRANDA'S DIARY

Coco Fusco

Americans often ask me why Cubans, exiled or at home, are so passionate
about Cuba, why our discussions are so polarized, and why our emotions
are so raw, after thirty-three years. My answer is that that we are always
fighting with the people we love the most. That intensity is the result of
the tremendous repression and forced separation that affect all people
who are ethnically Cuban, wherever they reside. Official policies on both
sides collude to make exchange practically impossible. Public debate is
extremely limited in the United States and on the island. Only extreme
positions get attention; all nuanced critiques are immediately recast by
all sides as either variations on the party line or treason, better known as
una diversion ideológica, an ideological diversion from the "true" path.

Travel is severely restricted by the U.S. and Cuban governments, making contact difficult and encouraging exaggerated rumors to pass for truth. Communication, when it does happen, is often strained.

The main players in this game—the Cuban government, the Miami-based Cuban right, and the Cuban supporters among American leftists—are all suspicious of Cuban border-crossers: people who allow ethnic, kinship, and emotional ties to override ideological difference; people whose intellectual and political perspective is less nationalist, and less invested in fictions of separate development. The Cuban government has no official policy vis-à-vis the liberal/progressive sectors of *la communidád*, which allows the prejudices of individual bureaucrats to determine action and allows easy erasure of any real distinction between extremist anti-Castro terrorists and proponents of dialogue. The Cuban right wing uses its economic clout and political ties to the U.S. government to proclaim that it speaks for all Cubans. Pro-Cuba intellectuals of the international left, or *cubanólogos,* as some of us lovingly refer to them, can use the convenient stereotypes about Cubans outside Cuba—*gusanos, colonizados,* and *fanáticos*—to maintain a paternalist attitude towards all exiles and Cuban Americans, reject all their criticism of the Cuban government, and justify not sharing power with them. None of these sectors has effectively dealt with the complexities of the situation; the revolution and the Cold War created a separate nation but never completely succeeded in dividing a people.

I am the daughter of a Cuban who emigrated to the U.S. in 1954, and who was deported in 1959, shortly after the triumph of the revolution. My mother hid from the INS (Immigration and Naturalization Service) until after my birth. Then she returned to the island with me. The fact that I was a U.S. citizen secured her permission to return to New York City within weeks, while the lines of Cubans at the American Embassy in Havana who sought visas to leave the country grew and grew. In the decade that followed, my mother's sisters, brother, parents, nieces, and nephews all emigrated, and my home became a way station. At the of age eight, I was teaching English to my cousins and translating for older relatives; at school, I would hide this side of my life to downplay my difference from the rest of the children and look embarrassed when adults asked me what I thought of Fidel Castro. Yet, as a child among foreigners, I grew accustomed to living with the presence of an imaginary country in my home. It spoke to me in another language, in stories, rhymes, and prayers; it smelled and tasted different from the world beyond the front door. Still, unlike other immigrants who could return

and replenish their repertoire of cultural references, we could not. For many exiles, the real Cuba died with the revolution and would only live on in their minds.

The Cuban children of my generation didn't choose to leave or stay—the wars that shaped our identities as Cuban or American are ones we inherited. There are those among us who have made quiet pilgrimages back to the island as a way of reconciling ourselves to the paradoxical familiarity and distance that mark our connections to our origins. That decision to reestablish contact with Cuba is often looked upon as an act of treason—we are traitors to the exile community's extremists and ungrateful to our parents, who saved us from the Caribbean "gulag." When I began to travel to Cuba in the early eighties, I was naive enough to believe that I could slip past the watchful eye of *la communidád*. I was soon forced to realize that my decision would define me in ways that went far beyond my power to determine my own life. It also opened the door to understanding myself as a child of diaspora, of the Cold War, of the civil rights movement, of the black Caribbean, of Cuba *and* the United States.

None of this would have been possible were it not for that fact that Cuban culture didn't die with the revolution, as the exiles would have had it. The neocolonial world of the middle and upper classes had simply diminished in importance, as different notions of the popular moved into the foreground. I went there ostensibly to confront Cuban culture in the present, but returning enabled me to face and come to know my counterparts, the children (now grown) who also hadn't had a choice, but who stayed in Cuba. Although history had intervened to separate us, we shared a healthy skepticism toward the nationalist rhetoric of our parents' generation and a growing curiosity about one another.

The following "diary" is a collection of my reflections on my experiences travelling to Cuba for the last eight years. I chose to write it in this form because of the fleeting, momentary nature of those encounters. I also wanted to stress the subjective dimension of those experiences, rather than "speaking for Cuba," as I had done as a journalist to gain entry into the country. The account is not chronological—instead, I piece memories together to find the logic that links disparate events. This way of thinking reminds me of the kinds of conversations I have had late at night on the island: With so little information circulating "officially," our favorite pastime was to drink coffee and chew over details each member of the group could provide to figure out what the government was doing.

I call my essay "Miranda's Diary," referring to Prospero's daughter in Shakespeare's *The Tempest* and to a host of allusions to the play in Latin American intellectual history and postcolonial thought. Shakespeare's drama, set on an island, is believed to have been inspired by accounts of voyages and shipwrecks during the early colonial period. Among the drama's many characters the patriarchal magician Prospero, his indigenous slave Caliban, and his ethereal assistant Ariel have become symbols of colonial relations and of struggles to forge identity in nineteenth- and twentieth-century Latin American thought. In 1900, following the transfer of Cuba, Puerto Rico, and the Philippines to the U.S. as "protectorates," the Uruguayan writer José Enrique Rodó published "Ariel," an essay describing an allegorical conflict between two versions of modernity.[1] In it, the U.S. is a chaotic and materialistic Caliban whose influence threatens Latin America, Ariel, envisioned as a neoclassical, orderly, and ideal world.

In the postcolonial period, Latin American and Caribbean intellectuals began to recast this allegory, shifting their identification from Ariel to Caliban: In 1960 George Lamming champions Caliban's ability to reshape his master's language in *The Pleasures of Exile*; in 1969, Aimé Cesaire writes *A Tempest: An Adaptation of Shakespeare's "The Tempest" for a Black Theatre*. Then in 1971, the Cuban writer Roberto Fernández Retamar publishes his *Caliban: Notes on a Discussion of Culture in Our America*,[2] transforming the slave into an admirable combination of defiant Carib and New World Man, and identifying him with the island, the revolution, and even Fidel.

These writers concentrate little attention on Miranda, *The Tempest*'s only significant female character. They only take note of Caliban's attempt to seduce her shortly after she arrives to the island with Prospero. Psychoanalytic theorists O. Mannoni and Frantz Fanon underscore the implications of this; in *Prospero and Caliban: The Psychology of Colonization*,[3] Mannoni coins the term "Prospero complex" to describe the psychology of the colonial patriarch whose racism is manifested in his obsessive fear that his daughter's virginity is threatened, especially by the hypersexualized New World Man.

Miranda's name literally means wonder. In Shakespeare's play she is a young woman whose arrival to the island marks the beginning of a process of self-discovery. In the opening scenes of the drama Prospero reveals to her the secret of her birth, and she confesses to having already been haunted by the memory of belonging to another family. Her initial attitude toward the island is one of compassion and curiosity, and it is

she who teaches Caliban the language of the master. That relationship is immediately sexualized, which provides the pretext for Prospero's intervention to save her "purity," resulting in her redirected attention to a more "appropriate" form of courtship. It would seem, then, that the knowledge Miranda gains in her symbolic loss of a father figure is too dangerous for her to have—it makes her too independent, or too vulnerable, depending on whose perspective one takes. It was travelling to another place that allowed the original Miranda to understand her identity as different from the fiction that had been propagated by her symbolic father. The Mirandas of the present, myself among them, continue to undertake these journeys, straying far from the fictions of identity imparted to us by our symbolic fathers. What was once a potential sexual threat is now a matter of political transgression. As the Cold War, that modern day tempest, subsides, it seems logical that Miranda's story would emerge.

November 1991: While hundreds of international visitors flock to Havana to attend the country's fourth art biennial, the passports of two art professionals waiting for visas to attend the event sit on desks at the Cuban embassy in Mexico City and the Cuban Interests Section in Washington, D.C. Despite frequent phone calls, faxes, and letters, no official move was ever made to accept or deny these requests. The biennial passes and neither of them are able to attend.

January 1988: After weeks of waiting, I receive the news that two Cuban artists I have invited to New York City for the opening of a group exhibition in which they are participating will not be able to attend because they do not have visas to enter the U.S. American-based Cuba supporters urge me to lodge a formal complaint against the U.S. State Department.

December 1990: I am walking down the street with a relative of mine who I've just met in a provincial city in southeastern Cuba. I have a new electrical fan in my hand that I have just bought from a *diplo-tienda*, a hard currency store for foreigners. My relative looks uneasy. Outside Havana, that fan is like a red flag. "What will I say if I get stopped with you?" he asks. "Tell them I'm your cousin," I say.

"No," he says. "Then they'll know that the fan is for me."

"OK, tell them I'm a journalist, and that I asked you for information about music."

"No good," he says. "They'll say I should have taken you to talk to my professors. Look," he finally says, "if I walk away at any point, just meet me in a half hour in the main plaza, OK?"

No one in Havana has ever expressed such worries about being seen in public with me or about owning appliances from the *diplo-tienda*.

January 1986: My first radio program about Cuban film airs on a community radio station. The next day, my mother receives a phone call from a Cuban colleague who tells her that I should try living in a Cuban prison for a while before talking "communist propaganda" on the radio.

July 1991: I receive a letter from a friend telling me that an article I published in *The Nation*, in which I criticized an exhibit of art from Cuba in the United States for occluding the current complexities and political tensions in the art world there, has caused quite a stir in Havana. According to the letter, a faculty member at the Higher Institute of Art was brought in to make an official translation for Wifredo Lam Center director Llilian Llanes and members of the Party leadership.

November 1987: I stop in Miami to see old family friends before travelling to Havana. The father of the family, a Cuban exile, takes me outside to tell me that it's a bad idea to go to Cuba. He says I will be kidnapped by the secret police and forced to be a prostitute for visiting Russians. His oldest daughter asks me to visit their old house and take pictures. She says she'd like to go with me, but can't because she might get fired from her job for doing so.

November 1991: One of the professionals whose visa was held up is Nina Menocal, a Cuban-born Mexican resident who owns and manages Ninart, a gallery promoting Cuban art in Mexico City. For exhibiting and selling the artwork of Cuban nationals, she has incurred the ire of sectors within the Cuban cultural ministry (for not splitting the profits with the Cuban government) and the Miami-based Cuban right (for allegedly aiding the island "regime" by supporting the artists). The other person whose entry to Cuba was effectively blocked is me, a Cuban American writer and media artist who has spent at least one month a year there since 1984.

January 1992: Sufficient confusion was created by conflicting reports that manage to obfuscate the reasons for my visa problem. Cuban artists

who ask about me during the event receive blank stares from the biennial organizers. A biennial committee member who enquired on my behalf was told definitively by Llilian Llanes that "there simply were no more visas to give out." A Cuban American political scientist who sought information about my case in Havana received the explanation from a local specialist on Cuban relations with the exile community that my request was trapped in a temporary visa war with the U.S., in which Cuba stopped giving press visas because the U.S. had denied entry to two Cuban journalists.

This does not explain why Nina Menocal's visa never arrived. When she questions Luis Camnitzer, a U.S.-based Uruguayan artist and critic who had a solo exhibition at the 1991 biennial and has served as adviser to two previous ones, he told her that it was logical that our visas would be denied since we "both have problems with Cuba." This response expresses a familiar double standard: The same leftists who defend Cubans' right to enter the U.S. often find many reasons to justify the exclusion from the island of those deemed undesirable to Cuba. None of the Americans who attend the biennial make any public statement about their dissatisfaction over our having been denied entry.

November 1991: In Mexico City, the first exhibition of art by Cuban nationals and exiles to take place since 1959 opened in mid-November at Ninart, entitled "15 Cuban Painters." All the Cuban nationals in the exhibition have established temporary residence in Mexico, while the exiles were from the United States. On the island, there were no Cuban American participants in the biennial exhibition, although there were some other diasporan and ethnic minority populations included, such as Chicanos and Canadian artists of color. U.S. art historian Shifra Goldman delivers a paper that touches on work by Cuban exiles that was well received. Several cultural ministry officials publicly express regret to biennial visitors that an initiative such as Nina Menocal's to include nationals and exiles in one exhibit had not been organized by Cuba.

December 1991: In Miami, the Cuban exiles who participated in the Ninart exhibition are criticized for aiding the "Castro regime" through their collaboration. One of them had already been counselled by his U.S. gallery representative that such activities would lower his prices. On the other side, the Cuban government sends the Vice-Minister of Culture to Mexico to proclaim that the show is a "Miami plot" to compromise the

young Cuban nationals politically.

In Mexico City, dozens of Cuban artists tighten their belts and enjoy the pleasure of painting to pay the rent. Those in Spain, France, and Germany get a taste of racism from the new xenophobic European Community, a confusing experience for those Cubans who are, at least visibly, white. They are living what artist Arturo Cuenca calls "low-intensity exile," living abroad without defecting.

Several Cuban cultural ministry officials announce their intentions to visit Mexico City to interview Cuban artists and determine how these artists can contribute (financially) to the revolution from abroad.

December 1990: A meeting takes place in Havana between UNEAC (Unión Nacional de Artistas y Escritores Cubanos) officials, U.S.-based foundation representatives, and visiting Cuban Americans. The Cuban Americans insist that dialogue and cultural exchange between the two sides be resumed with official blessings. They are effectively stonewalled. A foundation representative who approaches Llanes to suggest that a Cuban American component to the 1991 biennial might be eligible for financial support is politely rebuffed.

January 1992: One month after the biennial, a rally takes place in New York City to support ending the U.S. blockade against Cuba. Several thousand people who pack Nassau Coliseum are joined by several thousand more who form a counterdemonstration led by Cuban right-wing leader Jorge Más Canosa. The morning of the rally, my mother receives a phone call from a Más Canosa supporter threatening that if I show my face at the rally I will be severely beaten. I had just published an article in *The Village Voice* about Ninart's show in Mexico City last November.

August 1991: At the Festival Latino opening in New York City, a crowd of anti-Castro protesters who are frustrated because they can't find Gabriel García Márquez, known to be a friend of Fidel's, hurled curses at me as I entered the theater. "Coco Fusco! Puta! Traidora!" they yell and push towards me, and then physically attack the two male friends who try to protect me. The police intervene to break up the struggle.

August 1989: I arrive in Brasilia on a U.S. Information Agency-sponsored lecture tour and am taken to the home of the U.S. cultural attaché, where I am questioned for over an hour in an intrusive manner about my trips to Cuba, my activities there, and my relatives on the island. My

head is pounding from trying to resist his questions. He tells me with a smirk at the end of our discussion that he is going back to the States to run Tele-Marti, the anti-Castro television station based in Key West. A few days later, his Brazilian assistant lets me know that my FBI file was scrutinized carefully by the embassy because I was labelled "sympathetic to leftist movements" and "travels to Cuba."

December 1986: After working as a co-producer of a documentary shot during the 1986 biennial, I am brought to the office of Wifredo Lam Center director Llilian Llanes, where she and her assistant Jorge Ayala questioned me for two hours about the material that was shot. They demand copies of all rushes, which I do not provide.

December 1987: At the Havana Film Festival, the second screening of my documentary about Cuban artists is mysteriously cancelled at the last minute. During a screening of a rough-cut several months earlier, several Cuban artists defended the piece in a closed meeting with officials from the cultural ministry and the Wifredo Lam Center. A Cuban friend who accompanies me to the airport is questioned by police after I leave.

March 1988: The video master of the documentary sits locked in a secret vault in Budapest, Hungary, where it was edited. A letter was sent from Cuban officials to the Hungarian Minister of Culture, denouncing the material and demanding that it be confiscated as a gesture of socialist solidarity. We succeed in bribing someone to remove it from the vault and send it to the United States, where it is sold to public television.

February 1992: A recently emigrated Cuban artist is yelling at me on the phone in disagreement about the article I have written for the *Voice* about the Cuban artists in Mexico. "You weren't critical enough," he says.

"I can't write based on speculation," I retort. "I have to respect people's right to represent themselves how they choose."

"Of course people don't really tell you how bad things are," he screams. "They think you're from the CIA, no matter what they tell you to your face."

April 1989: A *marielito* completing graduate work in the Midwest comes to see me at my office. As soon as I shut the door, he begins to speak to me with tears in his eyes. "I saw your work, and I know you can go to Cuba," he says. "I want to go home. I made a mistake. I can't stand not

being able to be in my country. Can you help me?"

March 1993: Two Cuban American colleagues call me from Miami, where they have been waiting for entry visas to go to Havana for four months. "The head of the Interests Section called early this morning," says one of them. "He told me there was another delay, but not to worry, because that doesn't mean I'm being rejected. Who is he kidding?" We laugh uncomfortably.

April 1991: One of the artists I invited to the U.S. in 1988 who was not able to enter is now living in Miami. Before processing his visa he learned that his first request three years ago was never completed in Cuba, although the cultural ministry had told him at the time that his visa had been denied by the U.S. State Department.

June 1992: I've waited a good six months since my visa was denied to write anything about Cuba. I think I was afraid of becoming a knee-jerk "counterrevolutionary," or at least feared that people might see me that way if I complained. Putting my own dilemma into a broader context becomes my way of depersonalizing a rather painful experience of rejection.

Global politics have changed since the fall of the Berlin Wall and Cuba's future is uncertain. Cultural debates on postcolonialism, and about the relationship between other U.S.-based Latinos and the populations and cultures of their homelands have matured significantly in the last decade. These factors, together with the new migration of eighties-generation artists and intellectuals and the existence of a post-exile generation of moderate Cuban Americans, contribute to conditions that demand a paradigm shift in the way we think about Cuban culture, Cuban cultural identity, and "revolutionary" cultural activity. We must rethink our priorities and define alliances not on the basis of territoriality but shared interests. Nationality has been a Cold War game. Identity, for Cubans, goes far beyond it.

Cuba still operates in the American imagination as the last great mythical terrain of the Cold War. U.S. efforts to isolate Cuba have stepped up and are conveniently justified by "evidence" of intensified repression on the island: the execution of Ochoa, the quarantining of AIDS patients, the frequent use of physical violence by police against protestors, the arrest of human rights activists, and most recently the execution of Cuban exile infiltrators and the United Nations declaration

that put Cuba on the human rights violators list. On the other hand, the U.S. government's sabotage efforts are continuously frustrated by Cuba's maintenance of a higher standard of living than most of her neighbors despite crippling food and energy shortages, the island's growing tourist and bioengineering industries, the commercial and critical successes of several Cuban artists and entertainers who *do not* defect, and Fidel Castro's uncanny ability to maintain international media popularity even after communism goes out of fashion.

In such a politically charged context, art-making for Cubans in Cuba is like walking in a mined desert. Supplies are hard to come by. Anything that might spark unrest or a public manifestation of discontent is considered dangerous. The economic and political factors mentioned above have led to the silent exodus of many of Cuba's best and brightest artists and intellectuals. Over sixty visual artists and writers are in temporary residence in Mexico. And a number have recently moved to the United States. More are scattered throughout Spain, France, Belgium, and Germany; the majority of them have opted out of the Havana vs. Miami conflict and look instead for neutral territory to wait out the last gasp of the Cold War.

In the 1980s, a growing number of younger Cuban Americans express interest in open engagement with Cuban nationals. Many of them are post-*diálogo*, post–Antonio Maceo Brigade types, who are less interested in the revolution, and more concerned with multicultural activism, cultural identity, Santería, Caribbean culture, contemporary Cuban art and cinema, etc. Some of them organize activities to bring Cubans to the United States or to help support them during their visits here. Some visit Cuba and begin collaborations with Cuban artists and writers. Most of their activity goes on through unofficial channels, although official bureaucratic demands must occasionally be met to justify travel and stay out of trouble. Some have developed an entire body of work around their status as displaced Cubans. Others might refer to Cuba in their work and maintain varying degrees of political "neutrality" with respect to the revolutionary government, but they are also engaged with gay and lesbian politics and culture in the U.S. Still others have stuck their necks out and broken taboos by exhibiting with Cuban nationals.

Not only have attitudes towards Cuban nationals begun to change, but the exile community itself has evolved to the extent that monolithic descriptive models simply do not work anymore. A class and cultural divide becomes increasingly apparent in Miami. Most of the most recent immigrants from Cuba (Mariel and its aftermath) to Miami are not

accepted by the Cuban aristocracy. Like the Cuban American second generation intellectuals and artists, many are more politically moderate. Many are gay and lesbian and are out. Many are not white. Together with the first and second generation moderates who reside for the most part outside Miami, they make up an informal support network for visiting Cubans and information exchange with the island. They assist in obtaining visas, provide housing and extra money for visitors, take mail and medicine to and from Cuba, organize receptions, assist the recently arrived in finding employment, etc. The most famous story about this network comes from the Tropicana Nightclub's visit to New York, when the same *marielitos* who picketed the entertainers from "Castro's Cuba" ran around to the dressing rooms to greet old friends and bring them *pastelitos.*

June 1992: At a party in New York, Carmelita Tropicana laments that her work is not well received by the Cuban upper crust in Miami. "They tell me I must be Puerto Rican," she says, "because they don't think that Cubans could be into kitsch."

June 1992: Over the last six months, I have made dozens of lists in my mind of the conditions for rapprochement between two sides of a divided population. Culture is at the center of this issue, since it is precisely that which has bound a people otherwise split by geography and ideology. Art is also a symbol of Cuban people's creative possibilities, a barometer of "freedom," that ideologically charged word.

For three decades, two forms of "liberty" remained at odds: on the one hand, the opportunity to have access to free art education and a state infrastructure that allows an artist to carry out his/her métier—with occasional strings attached; on the other, the unlimited availability of an art market open to those who can afford to educate and produce artwork with practically no hope of subsidy. Cultural politics on both sides determined the value of the art produced. Until recently, the differences were easy to define: If you were in Cuba and made art about identity and popular culture, that was very likely to be supported and receive critical attention, and if you made nonfigurative art that was also fine, but might not benefit from the Euro-American interest in Third World exoticism. If you were in Miami and made nonfigurative or surrealist work, you might sell to the local market, but you would not receive a tremendous amount of critical attention. If cultural or sexual politics entered into your work, you would probably have to move to another part of the country, where

you would be likely to receive some degree of support—but not from Cubans. Now there are Cubans making art about the island from a variety of political perspectives and locales. Some travel with Cuban passports, others with American or European ones. The majority do not live on the island. Who can say whose art is more or less Cuban?

December 1992: I visit Nina Menocal at her gallery in Mexico. She is making preparations to take a group of "her" Cuban artists to the Art Miami fair in January. She is extremely worried because she has been receiving calls from Miami warning her that someone is going to give her an unpleasant surprise.

January 1992–March 1993: I have reviewed several articles and catalogue essays by the newly migrated young Cubans. These are the same people who put spirit and intellectual rigor into their arguments against reductive nationalism in the conceptualization of Cuban identity, who posited a cultural politics of "appropriation" based on Cuban cultural history, and who explained the role of popular culture and ritual in the reclaiming of public space for personal expression in the 1980s. New arguments emerge: If these Cubans could make whatever they appropriated Cuban by virtue of that act, then they can also take their culture to another place. Cuban culture throughout history, they argue, has been influenced by contact with other countries: Wifredo Lam, Alejo Carpentier, Amelia Pelaez, Raul Martinez, José Martí—even Fidel—spent time abroad. Perez Prado created an entire genre of Cuban music—in Mexico.
A new chapter in the theorization of exile.

July 1992: I'm in Mexico City, having lunch with a Cuban art critic now living there. "It's one thing to talk about broadening notions of identity on the island," I tell him. "It's quite another to redefine exile when there are at least three decades of exile culture preceding you."
"We're just beginning," he says.
"That's fine," I say, "but you might want to consider getting to know all the other Cuban artists out here if you're going to continue using national paradigms to define the work you're talking about." I have this feeling he's not really listening to me.

December 1990: I'm sitting in a conference room at UNEAC in a meeting with Cubans, Cuban Americans, and U.S. foundation representatives. UNEAC president Abel Prieto starts off by suggesting "that the Cubans

introduce themselves." He means the islanders. Raul Ferrera-Balanquet, a *marielito* exile and video artist, immediately interjects that Prieto's suggestion only enforces polarization and that he (Raul) considers himself Cuban, too. Cuban American Roly Chang concurs. Prieto clears his throat and begins discoursing on the "inauthenticity" of Oscar Hijuelo's novel, *The Mambo Kings Play Songs of Love.*

January 1993: I meet up with a Cuban painter friend who has lived in Chicago since she was a teenager. She has just come back from the Art Miami fair. "I saw all our friends from *la colonia cubana de Mexico*," she said. "Everyone was friendly and respectful—and I couldn't help noticing their surprise at the fact that my work was selling like mad. I think they respect me a little more now."

June 1992: Is there any difference, I wonder, between the fights Cubans and Cuban Americans have and the ones Chicanos and Puerto Ricans have with their homeland-based populations? Because of the upper- and middle-class composition of the mass Cuban migration of the 1960s, and because of the ideological tone of the derogatory terms for exiles, the homeland's image of the immigrant community has a different gloss on it. The problem, however, is fundamentally the same. It's real identity vs. fake identity, original vs. copy, upper class vs. working class, good Spanish vs. bad Spanish.

The eighties generation in Cuba made enormous contributions to politicizing debates on appropriation and postmodernism and created an internal critique of the iconography and rhetoric of the Cuban revolution that had been entrenched since the 1960s. There are, however, several aspects of progressive cultural politics that developed in other parts of the Americas during this same period that Cuban artists have not participated in, and toward which they still display suspicion. I am thinking of critical social and political movements in North America in which culture has played an enormous role: black cultural politics, the Chicano movement, multiculturalism, feminism, gay and lesbian rights, and AIDS activism. From the point of view of leftist traditions within Latin America, with their deeply ingrained universalist rhetoric and patriarchal and authoritarian tendencies, these movements could easily be dismissed as sectarian and inconsequential. But underneath the frequent rejection of these political movements is an old-school brand of Marxism rearing its head—that and some kind of *machista* and Catholic resistance against taking radicalism into the privacy of the bedroom.

Cuban artists for whom the celebration of cultural identity was experienced as official policy of the State, and for whom radicalism could be measured in terms of one's distance from official policy, tend to look upon the identity politics of the New New Left with skepticism, if not disdain. Multiculturalism more often than not spells manipulation of art for political ends to them. While their evaluations of mainstream institutional paternalism and exoticizing attitudes towards marginal cultures are often prescient, they have difficulty acknowledging the grassroots dimension of efforts towards cultural pluralism in the North and do not recognize the advantages of an alliance based on a shared interest in cultural democracy.

May 1992: A Cuban artist in Spain shows me a letter from another Cuban artist who is living in Europe: "It's incredible," writes the artist, "that when I am in Cuba, the Europeans who visit us love my work because it's made on the island, '*dentro de la revolución*,' even if the materials are lousy. Nobody's interested in what I make as a Cuban in Europe."

March 1993: UNEAC continues to send messages expressing their interest in organizing cultural exchange between Cubans and Cuban Americans. And yet not even Abel Prieto, who in addition to being the president of UNEAC is a member of the Central Committee of the Cuban Communist Party, seems to be able to guarantee a visa. There will be those on both sides who will not see this dialogue as a priority or will find any kind of politicized cultural gesture suspicious. It would be naive to think that after over three decades of psychological warfare, everyone would jump at the opportunity to convene with the enemy. And it would also be naive to think that a little individualism might not be a necessary antidote to an overdose of revolutionary sacrifice.

July 1992: I receive news from Mexico: The Museo del Chopo is planning an exhibition of Cuban artists. The curators, one Cuban and one Mexican, intended to include works by Tomás Esson, Florencio Gelabert Soto, Arturo Cuenca, and Dania Del Sol, four recent defectors to the U.S. They receive word from the Foundation for Cultural Goods (the marketing arm of the Ministry of Culture) that all works promised from Cuba will be pulled from the exhibition if the defectors participate.

In mid-June, the Club Ateneo de Fotografía in Mexico sponsored an exhibit entitled *150 Years of Cuban Photography*, to be donated to the University of Guadalajara. In the show was a piece by Cuenca. Just before

the opening, Nina Menocal was informed by club president Jesus Montalvo that Cuba had threatened to withdraw the entire exhibit if Cuenca's work was included. Cuenca's photo was promptly returned to Ninart.

August 1992: I receive word from *Third Text* in England that they cannot publish this piece as I have written it. The editors send me a fax stating that all the names must be removed, and that all personal information about my experiences in Cuba must also be excised. I argue by fax for weeks and only succeed in getting them to add a line explaining that Nina Menocal and I were both denied visas to attend the 1991 biennial.

▩ Notes

1. José Enrique Rodó, *Ariel*, trans. Margaret Sayers Peden (Austin: University of Texas Press, 1988).
2. Roberto Fernández Retamar, "Caliban: Notes on a Discussion of Culture in Our America," *Caliban and Other Essays*, trans. Edward Baker (Minneapolis: University of Minnesota Press, 1989), 3–45; Lamming and Cesaire are cited in Retamar's book: George Lamming, "The Pleasures of Exile" (London, 1960); Aimé Césaire, "Une tempête: Adaptation de 'La Tempête' de Shakespeare pour un théâtre nègre," (Paris, 1969).
3. O. Mannoni, *Prospero and Caliban: The Psychology of Colonization* (New York: Praeger, 1964). Originally, *Psychologie de la Colonisation* (Paris: Editions du Seuil, 1950).

PART TWO
Decolonizing the Imagination

8

HERBERT MARCUSE AND
THE SUBVERSIVE POTENTIAL OF ART

Carol Becker

If pressed on the subject of the political significance of certain types of art, Marcuse often recounted an anecdote that pleased him a great deal. It was about the painter Victor Neep, who, when "challenged" to explain the alleged element of protest in Cezanne's "A Still Life With Apples" responded, "It is a protest against sloppy thinking."[1]

In the seventies, when the cultural world of America was in constant upheaval and many of us were humanists, modernists, and Marxist/Leninists all at once, I was a graduate student at the University of California, San Diego, where I was fortunate enough to work closely with philosopher Herbert Marcuse. In what was then a truly pastoral environment, we often took long walks and debated issues: the viability

of the Women's Movement, "repressive desublimation," the role of intellectuals and students in a prerevolutionary context. But the most contested topic of discussion by far was the relationship of art to social change.

Fundamental to Marcuse's understanding of the possibility of human liberation was his belief in the imagination—its regenerative abilities to remain uncolonized by the prevailing ideology, continue to generate new ideas, and reconfigure the familiar. It was within the imagination that the desire to envision the idealized state of utopia and push the world to its realization resided. For Marcuse, the history of art and literature (at least in the West) reflected this ability: Out of repression came images of liberation; out of the bourgeois ideology came its inherent critique—the discomfort and displeasure that could lead to revolutionary thoughts. But no matter how brilliantly the argument was presented, I was dubious. I thought Marcuse was trapped in modernism, unaware of how times had changed. The imagination, perhaps once freer to generate its own thoughts, was now virtually oppressed by the effects of mass media. I argued that the pervasiveness of images on such a grand scale, in every aspect of daily life, was the inevitable cause of a colonization of the imagination which was now held hostage by the prevailing culture it both created and reflected.

As the years passed and I spent more than a decade working in an art school watching the process of art-making, in all forms, I began to think we were actually both right. I was correct because the images of the media—television, newspapers, Hollywood films, popular music—do permeate so much of the work of young and mature artists at this historical moment. The influence of popular culture can also be recognized in the various forms that the work takes—decentered and comfortable with fragmentation and overstimulation. Although there is work that attempts to reckon with these fragmenting effects, it often gets caught in them nonetheless. All of this seems truly inescapable.

However, Marcuse was also right. Within the creative process *is* resistance. In the process of making images, they can be transformed, utilized, co-opted, inverted, diverted, subverted. The personal becomes political; the political is appropriated as personal. Here the dictates of capitalist consumption are challenged as non-object art attempts to thwart the marketplace. Here, too, the sheer act of concentration necessary to produce art resists the diffusion and fragmentation characteristic of postmodern society. Also, the labor in which artists engage is in many instances nonalienated, because it is true to a

particular vision—of historical reality, their own psychic world, or the intersection of the two. If there is a utopian aspect to art, it is in the rare spaces where artists can free themselves from the expectations of the art market and the contingencies of economic reality to immerse themselves in the making of their work. Or it is where, unable to free themselves from these concerns, artists are able to comment on them through a reconfiguration that becomes the art piece itself. Marcuse's own resistance to my media-based analysis was typical of his refusal to be caught too easily in the conflation of cause and effect. He always struggled to articulate the ineffable, even when he knew his conclusions might be unpopular.

At this moment, there is a great deal of confusion about where art fits into society, what function it serves, and where its emphases should be placed. And within the complex art world itself there is a very particular debate about what is politically viable: What determines political work? Who should work be for? Should art be for a "community?" If so, who constitutes that community? Or rather, which communities should it address? Are artists necessarily responsible to the world in which they live? If so, how? If not, what are their goals?

In general, the debates around these issues have been limited. Art that is considered "political" by the art world often has little to do with the larger political arena. That which appears to address social concerns is often conspicuously one-dimensional. That which is complex, dealing with subjective or psychological concerns, is often considered obscure and inaccessible to the world outside the art world. Such work is especially suspect when it appears in a traditional medium like painting.

There are few theoretical models to turn to as one attempts to address these problems. Therefore, it may be helpful to revisit the work of the Frankfurt School—those intellectuals whose historical and philosophical mission was to make sense of the senseless modern world. In particular, it may be useful to reconsider Marcuse's last book, *The Aesthetic Dimension*, in order to reevaluate his ideas in light of the difficult post-postmodern era when a sense of political urgency accompanies widespread economic despair. And, however modernist it may seem, it may also be a good time to borrow from his analysis a much needed sense of possibility or, as Marcuse might say, "hope."

▓▓▓ A Return to *The Aesthetic Dimension*

The argument Marcuse presents in his efforts to examine the actual function of art, as well as the function it might serve, demands a careful,

somewhat detailed review. He unravels his understanding slowly, beginning the book with a disarming apology:

> In a situation where the miserable reality can be changed only through radical political praxis, the concern with aesthetics demands justification. It would be senseless to deny the element of despair inherent in this concern: the retreat into a world of fiction where existing conditions are changed and overcome only in the realm of the imagination.[2]

In this statement, written in 1976, Marcuse admits that he was beginning to lose faith in the possibility that the "miserable" political environment could be changed. In this crisis, as his optimism waned, he returned to aesthetics—his early, great love. He focused primarily on literature, about which he could speak with an unhesitating authority lacking in his knowledge of the visual arts. And when he went back to what first fed his own utopian ideals, he did so with a deliberate agenda. He attempted to use this reexamination to refute Marxist notions about the function of art in society, which he saw as limited, didactic, naive—an attempt on the part of the left to impose utilitarian functions on art. He railed against the idea that art, which focuses on the "declining class" (i.e., the bourgeoisie) is decadent and that all art should therefore focus on the "ascending class" (i.e., the proletariat).[3] He was quite clear that art need not represent the social relations of production directly. Rather, the indirect ways in which art represents these social relations may well prove to be more significant and profound. Of this he writes,

> I shall submit the following thesis: the radical qualities of art, that is to say, its indictment of the established reality and its invocation of the beautiful image…of liberation are grounded precisely in the dimensions where art *transcends* its social determination and emancipates itself from the given universe of discourse and behavior while preserving its overwhelming presence. Thereby art creates the realm in which the subversion of experience proper to art becomes possible: the world formed by art is recognized as a reality which is suppressed and distorted in the given reality.[4]

In the refusal to be absorbed within the reality principle (Freud's term for the world of work and obligation as constructed by the demands of civilization) or adhere to the rules of the reality principle, in insisting upon issues of subjectivity and the presentation of contradiction, art

rejects the idea that there can be any simple transformation of society or that "all of that which art invokes and indicts could be settled through the class struggle."[5] But if art indicts, what comprises its indictment? According to Marcuse all humans have been forced to repress basic instincts in order to survive within civilization as it has been constructed. Such is the premise of *Eros and Civilization*, where Marcuse asks, "[H]ow can civilization freely generate freedom, when unfreedom has become part and parcel of the mental apparatus?"[6]

For Marcuse, art is a location—a designated imaginative space where freedom is experienced. At times, it is a physical entity, a site—a painting on the wall, an installation on the floor, an event chiseled in space and/or time, a performance, a dance, a video, a film. But it is also a psychic location—a place in the mind where one allows for a recombination of experiences, a suspension of the rules that govern daily life, a denial of gravity. It "challenges the monopoly of the established reality" by creating "fictitious worlds" in which one can see mirrored that range of human emotion and experience that does not find an outlet in the present reality. In this sense the fabricated world becomes "more real than reality itself."[7] Art presents the possibility of a fulfillment, which only a transformed society could offer. It is a reminder of what a truly integrated experience of oneself in society might be, a remembrance of gratification, a sense of purpose beyond alienation. Art can embody a tension which keeps hope alive—a "memory of the happiness that once was, and that seeks its return."[8]

In such a configuration, there must be an understanding that there is something beyond the reality principle, even if the existence of such a different state can only exist within the imagination. In its ability to conjure those dimensions of the individual's emotional life not dominated by the social system, art, according to Marcuse, is able to keep alive an image of humanness—the emergence of human beings as "species beings" capable of living in that community of freedom which is the potential of the species. The recognition of this potential is the "subjective basis of a classless society."[9] The image of the liberated human psyche can be communicated by art, not necessarily through a literal representation of the utopian dream, as in socialist realist work, but in the emotions such work is able to elicit. This range of emotional responses can be transmitted by the struggles depicted in content and their embodiment integrated by form. Through form, art can portray humanness on a grand scale, beyond the class struggle. Here, where form becomes content, individuals can experience a spectrum of

imaginative possibilities crucial to envisioning and manifesting a revolutionary process. For Marcuse, a great deal of the radical potential of art lies in its ability to play within as well as outside of the reality principle.

The act of observing art may have a transformative effect on a person; nevertheless, within a society of alienation this use value is often discounted. Marcuse might say that within a capitalist system the deepest purposes of art go against the basic premises upon which capitalism is constructed. Within capitalism the only justifiable place for art is as an object that can be bought, speculated upon, and sold for a profit. Or it might serve as diversion or entertainment. Its value is as a tool that can regenerate the lost, hidden, creative, spiritual, and intuitive aspects of human life which capitalism has denigrated.

At its best, art serves a different master than capitalism, one whose values are not so readily discerned. Although its place in the order of things is not always clearly articulated, no one would publicly advocate a society that did not, at least in theory, encourage creative expression as manifested in art. A society without art seems unimaginably impoverished. The necessary tension between the longing embedded in peoples' desire for a fuller life, a more complete self, and the world in which they live would have one fewer outlet. What is almost unspeakable, what cannot be contained is allowed to live through the form of art. This is why at times art is perceived as subversive, not simply because it presents a world that appears immoral or licentious, as is frequently thought, but because it reminds people of what has been buried—desires their deepest selves dream but cannot manifest within the existing system.

Marcuse locates this vision of possibility within the well-articulated space of the aesthetic dimension, a place that stands in negation to the reality principle. It does not embody what is, but what wants to be. "One of the foremost tasks of art," writes Walter Benjamin, "has always been the creation of a demand which could be fully satisfied only later."[10] In Benjamin's understanding, "later" can only mean within a revolutionary society—a potential condition that does not yet exist. This is an idea that many politically minded people in the United States have long ago abandoned, instead preferring the concept of slow, evolutionary change.

But works of art need not necessarily exist only within the domain of the pleasure principle to be successful. They could also easily be found within all those places where human potentiality is able to manifest itself. This might mean advocating art that embodies the possibility of change

and struggle, the sense that through deliberate action or the transformation of consciousness and social conditions one's personal situation could also be altered. Art allows for this actualization through the vehicle of form—a physical organization that captures a range of intangible experience. Artists, Marcuse says, are those for whom form becomes content. This is the source of their strength and alienation. Those outside the art-making process may not consciously understand why they respond to the work as they do. They may be unconscious of how beauty, coherence, properties of elegance, or a deliberate refusal to allow for the experience of beauty affects their ability to understand the content of the work intellectually as well as emotionally. Successfully executed art stands as both part of and not part of the society out of which it has emerged. It has not acceded to the demands of the "miserable reality." It has not accepted the limiting prejudices of race, class, gender, and sexuality. While commenting on these, it is also capable of moving past them. This is why, when art is effective in Marcuse's terms, it appeals to people with progressive interests. It may well contain a critique of the prevailing ideology. Or, as in Neep's understanding of Cézanne's *Still Life with Apples*, the clarity and integrity of form itself may prove subversive, especially when all else in society seems in disarray.

There is no doubt that this is a utopian vision of the place of art in society, because it allows for the possibility that art could embody utopia and thus annihilate the reality principle. Marcuse is not ingenuous about how this transcendence will occur. He does not expect or want the experience to be easy. On the contrary, he rejects the notion that art should try to reach a large audience directly. He does not think that art is life or that it should attempt to appear as simulated reality. According to Marcuse, the strength of art lies in its Otherness, its incapacity for ready assimilation. If art comes too close to reality, if it strives too hard to be comprehensible, accessible across all boundaries, it then runs the risk of becoming mundane. And if this occurs, its function as negation to the existing world is abandoned. To be effective, art must exert its capacity for estrangement. There is certainly work which in its utter banality becomes dislocating, often because it is unexpected within an art venue. Here the context may provide the necessary tension. It must dislocate the viewer, reader, audience, by its refusal and inability to become part of the reality principle or to in any way anticipate the needs of the performance principle (Freud's term for the manifestation of the reality principle at this historical moment in Western society). Art should not help people become assimilated in the existent society, but at each turn

should challenge the assumptions of that society, whether through the demands of intellectual and visual rigor and/or the heightened recognition of pleasure and pain.

Political Art and Uncompromising Estrangement

The ideas in *The Aesthetic Dimension,* which might have seemed dated only a few years ago, now present themselves as useful once again. As debates around what is politically viable rage in the art world, thinking about the question of how artists can make significant statements and how best to fight against the prevailing ideology often seems simplistic, as if these debates had not already occurred and been recorded by the literary world—Brecht, Lukács, Adorno, Marcuse, and others. If in the eighties it became fashionable to embrace pastiche and appropriation, make work that referenced the art world or art history, the most visible pressure in the early nineties has been to make political art. But there has been surprisingly little discussion about what constitutes politically engaged work. The art world often applies this definition only to art whose content is overtly and clearly about political concerns and whose form is readily accessible or clearly confrontational. Marcuse, however, takes issue with the often hidden assumptions built into these concepts when he writes:

> The political potential of art lies only in its own aesthetic dimensions. Its relation to praxis is inexorably indirect, mediated and frustrating. The more immediately political the work of art, the more it reduces the power of estrangement and the radical, transcendent goals of change. In this sense, there may be more subversive potential in the poetry of Baudelaire and Rimbaud than in the didactic plays of Brecht.[11]

Marcuse is talking about something very specific here, articulating the effect of work that does not necessarily move the intellect to a direct perception of injustice, but that can move the spirit and thus indirectly affect social change. His is a difficult position to explicate because the relationship between the emotional life of individuals and the collective political reality has not sufficiently been explored. It is to the credit of the Frankfurt School that they attempted this kind of investigation. But no matter how subtle these distinctions are, this passage from Marcuse's book would constitute fighting words were they written today, because, for the most part, the art world would not easily tolerate such juxtapositions. It has often employed definitions of the political that

privilege certain content, but this also has meant that it has denied the possibility that work too easily designated as "bourgeois" might actually serve a significant political purpose.

The North American left, too, has often restricted its understanding of form. The same audience that desires art that contains revolutionary messages cannot grasp the degree to which innovations in form can also be radical, since they can change the scope, order, and content of what people are able to see. If the content does not overtly and directly articulate social concerns and the work is not easily accessible in a for-mal sense, then it is often not deemed political. This encourages the judgment that "political art" must be "anti-art"—art that refuses to take pleasure in its own formal properties or denies conventional forms or complexity of form and defies traditional expectations. Within Marcuse's particular understanding, though, art that becomes anti-art by refusing the conventions of art-making may be too closely aligned with the reality of day-to-day life. Such art only recreates fragmentation in its simulation of reality and runs the risk of losing its subversive potential. We have seen such anti-art in the sixties, seventies, and eighties: work where the state-ment became more significant than its execution or where complexity in dealing with issues was sacrificed to easy comprehension—a distillation meant to foreground "issues." Often it was work lacking in metaphor or work which, in an attempt to be acceptable to a mass audience, attempt-ed to adapt familiar, popular forms. In the nineties, such art appears in conjunction with political statements. About this complex issue Marcuse writes:

> While the abandonment of the aesthetic form may well provide the most immediate, most direct mirror of a society in which subjects and objects are shattered, atomized, robbed of their words and images, the rejection of the aesthetic sublimation turns such work into bits and pieces of the very society whose anti-art they want to be. Anti-art is self-defeating from the outset.[12]

Marcuse clearly rejects the notion that art can effectively comment on the degeneration of society by too simply recreating and mirroring that degeneration. Nor does he believe that one can successfully attack the one-dimensionality of society by reproducing that one-dimensionality. In reproducing the "miserable reality," such art reflects that which already exists and is, in a sense, too familiar. It does not allow for estrangement. We see this in video, performance, and installation art, as well as in paint-ing and sculpture. The key to this particular failure, Marcuse might say, is

not content but rather a refusal to embody that content in an aesthetically challenging form that would further the question, push the viewer or the reader to a more complex, more emotional, or revelatory understanding of the problems posed by the work.

This particular aspect of Marcuse's analysis would prove the most controversial for some who see his refusal to accept what he calls anti-art as an attempt to contain art and artists within conventional modernist boundaries. But it would appear that Marcuse is not so much interested in restricting formal possibilities as he is in fostering work that, in its refusal to simulate the present reality, encourages people to imagine what might transport them beyond this reality. His argument is also founded on the idea that, however radical it may seem to smash traditional forms, the shock effect will ultimately be dissipated if the artwork reproduces the experience of daily life. The need to make formally effective work is more than an abstract idea within Marcuse's system. For him it is *the idea*, crucial to the meaning of art itself. He writes, "In this sense, renunciation of the aesthetic form is abdication of responsibility. It deprives art of the very form in which it can create that other reality within the established one—the cosmos of hope."[13]

Within Marcuse's concept of the aesthetic dimension, there are two necessary conditions. The first is that the artist has a responsibility to help society deal with its hidden conflicts and contradictions. And the second is that the work must embody hope in whatever way possible. However, Marcuse does not legislate how these prerequisites should be achieved. Nor does he project a simple optimism. Rather these ideas represent his notion that a much needed psychic space is created when contradictions are confronted within the aesthetic dimension. For Marcuse, hope lies in the particularly human ability to envision what does not exist and give that imaginary dimension shape. He believes that this shape, this original organization—whether in painting, literature, or music—is precisely what is necessary to transcend the limitations of the reality principle and that it is the job of all serious writers, artists, and intellectuals to attempt this feat. He does not merely want to elevate art above everyday life. Marcuse's vision tolerates an embrace of the contemporary issues of daily life as long as these are presented in a form that embodies their ability to transform themselves—revealing their contradictions and their emotional, political resonance. Even "death and destruction" may invoke the need for hope: "a need rooted in the new consciousness, embodied in the work of art."[14] In Marcuse's dialectical scheme, the "new consciousness" is the ability to address the complexity

of one's situation and find within it that which might lead to its transformation.

▬▬ The Accusation of Romanticization

It is easy to understand why Marcuse has been called a romantic and why his work on aesthetics has received so little notice from the contemporary art world. There is no doubt that after all the collective, theoretical work that attempts to situate and explain postmodernism, certain aspects of Marcuse's thesis need qualification. During Marcuse's lifetime, he continued to believe that there is a part of the human psyche that remains invulnerable to social repression. If this psychic aspect is tapped—which he believed art is capable of doing—then it can be given shape, articulated, and its wholeness explored, no matter how fragmented the reality surrounding it may be. But Marcuse's concept of the psyche assumes a unified subject and a coherent sense of identity that ultimately escapes alienation. It also assumes the existence of a universal subject: all humans participate in this fundamental, common experience. In the same vein, he does not make distinctions between Western and non-Western art. Instead, art is treated as a monolith. And he implies that art can transcend racial, gender, sexual, and other cultural differences through certain aesthetic forms. These forms are undoubtedly Eurocentric, grounded exclusively within the Western tradition—the world out of which Marcuse's thought evolved.

At the core of Marcuse's theory, for example, is the issue of "the Beautiful," another locus of controversy which Marcuse says appears time and again in progressive movements "as an aspect of the reconstruction of nature and society."[15] Even when social upheaval is on the agenda, beauty often has been defined in a limited, benign way as "plastic purity and loveliness" and as "an extension of exchange values to the aesthetic-erotic dimension."[16] He is not content with the idea that beauty can only be manipulated for commercial ends. Marcuse's philosophical understanding of Beauty lends it a more profound relationship to questions of revolutionary change.

The Beautiful, for Marcuse, is sensuous and preserved in "aesthetic sublimation," and the autonomy of art and its political potential reside in this sensuousness. He rails against a crude form of Marxist aesthetics that rejects the idea of the Beautiful as the central category of bourgeois aesthetics and fails to grasp its subversive element. Marcuse contends that what is deeply satisfying and aesthetic *is* political and art with political aspirations should utilize the subversive power of beauty when

appropriate. But the left has not always understood these subtleties. This leaves those artists anxious to make a strong statement about society without the possibility of making work that is both political and beautiful. Perhaps this is why many artists resist involvement in political movements: They fear that such associations will deny them the right to engage in the sensuous, aesthetic fulfillment of the art-making process— the love of materials, principles of structure, pleasures of translating abstract concepts into form. For most artists, these are the reasons they were drawn to art-making in the first place.

Such artists fear they will be forced to replace this love with a more intellectual grasp of "issues" and that pleasure will be transformed into a gnawing guilt derived from the enjoyment they take in line, color, and/or texture. In fact, the work considered by political activists and critics to be the most "subversive" is often filled with unpleasure, deliberately negating the Beautiful and reflecting the unhappiness one would want to change. It is not a vision of what is possible or what might seduce others into endorsing the more progressive philosophical understandings it represents—or the future world it portends. In this sense, Marcuse's understanding of the sensuousness of art can be subversive, especially if it is understood that mass culture, as it exists in the United States, cannot comfortably tolerate what is truly beautiful in his terms—art that resonates with originality and strong formal properties and allows complex meaning to evolve.

Work matching this definition of the Beautiful could also require people to consider what no longer exists, what resides in dreams, memories of a time (whether real or imagined) when life was fulfilling and people's relationship to it seemed less estranged. It is not necessary to prove or disprove the historical existence of such a time. Rather, it is important to note that, in the context of many social movements, the seemingly retroactive emotion of *longing* has propelled people forward. This can be elicited through an appeal to the senses as well as the emotional and psychological life of an individual. There is little in mass culture that attempts to touch people at all these levels. When longing is evoked, it appears as melodrama and/or nostalgia. Such manifestations usually homogenize differences by settling for a mundane version of human experience. The result is a form of sublimation we tend to think of as entertainment and diversion, not the complex interaction of form and content we call art or the enjoyment one derives from art which is humorous, playful, seductive, well-executed, and helps to move ideas and emotions to a new plane.

Most artwork is too layered and at times difficult to easily lend itself to mass appeal. Nevertheless, art that deeply affects the senses, the intellect, and the unconscious is essential to the well-being of the collective imagination. Yet in North American society, such art usually receives mainstream attention only when it has come under attack "in the name of morality and religion."[17] It is to art's credit that it can generate such an extreme response. Whether they know it or not, moralists are fearful that such work will arouse people, not in an overtly sexual way, but in a sensual, provocative manner. They fear it might touch people's profound desires and challenge the banality, conformity, repressiveness, and the dissatisfaction they actually feel in their daily lives—work, environment, relationships. Therefore, there have always been those who have tried to impose silence on what they consider dangerous art.

Artists know the power of creating work that is directly sensual and erotic. They often do it precisely because it battles with the tyranny of delayed gratification and unfulfilled needs—a repression at the heart of capitalist society. But within the art world, work often becomes explicitly and provocatively sexual because artists assume their audience to be composed of moralists who will always be offended by sexuality and thus need to be confronted. Artists rarely imagine an audience hungry for real sensuality and receptive to all its possibilities—an audience with whom it would be a challenge to communicate. Were they to make work with such an audience in mind, art might be able to fulfill the types of demands Marcuse has presented.

"Art for the People"

The appropriation, pastiche, sometimes parodic cynicism characteristic of the postmodern period left a vacuum. Curiously, it now seems that the pendulum has swung fiercely in the opposite direction—toward sincere social concern and commitment. What results is an atmosphere in which artists are *expected* to serve a social function, moving in communities where they are unfamiliar and making work that talks to, has meaning for, people other than themselves. Certainly, this turn of events could be significant if the concept is carefully considered. But more often than not these ideas become demands placed on artists by other artists for whom making politically useful work has become a moral issue. Which is to say, if someone is not working in a political mode, their work cannot be considered responsive to the pressing issues of the society. This imperative is often directly connected to the issue of audience: Who is the work for?

Surveying *The Aesthetic Dimension*, it is clear that Marcuse has given a great deal of thought to this type of mandate. There is no doubt that he is dubious about anything that might sound like "art for the people." Marcuse fears a too deliberate type of populism that diminishes and dilutes the potential impact of art. Art must help develop "a new morality and a new sensibility," he writes.[18] However, "the more the exploited classes, 'the people,' succumb to the powers that be, the more will art be estranged from them."[19] In other words, the more alienated people are from their own inner needs and desires, the more fragmented they will be in relation to the society in which they live and work; the more they need the experience of art which is powerful, the more they may turn away from it because the deeper concerns such art engages seem too remote and obscure to touch their daily lives. Therefore, it often happens that the audience that would benefit most from the work will reject its content or find its form unattainable. Nonetheless, attempts to conscientiously tailor the art to the audience can too readily assimilate the work and defeat the necessary tension that allows it to be subversive.

Marcuse's position on this issue demonstrates an understanding of the contradictions artists frequently encounter. His willingness to analyze these ambiguities is lacking in much of the critical thinking of the art world today, which encourages artists to make work with a strong political orientation and then rewards that work even though it actually has no impact on a larger arena. Similarly, work that is not overtly political but perhaps deeply subversive is too easily dismissed and criticized for not extending beyond traditional confines. Ironically, the success of artwork need not always be measured in terms of favorable reception but rather by how and by whom it is attacked or ignored—whether it appears Other when measured against predominant cultural values or, for that matter, the predominant subcultural values of the art world.

In a similar vein, Marcuse does not believe that the prevailing cultural values that make complex thought intolerable and fearsome to mass audiences should force artists to create art, writers to write texts to suit the tastes of an audience embedded in the one-dimensional society. If "art cannot change the world," it can help to change "the consciousness and drives of the men and women who would change the world."[20] It might appeal to those who see through the veil of Maya, who move beyond the myths of their own civilization. Artists can make a decision "to work for the radicalization of consciousness." In Marcuse's terms, this may mean "mak[ing] explicit and conscious the material and ideological discrepancy between the writer and 'the people' rather than to

obscure and camouflage it. Revolutionary art may well become 'The Enemy of the People.'"[21] It may antagonize and confuse. Its ability to rupture continuity may be its strength. But it may be misunderstood, ahead of its time, beyond its audience, even when its message is precisely to liberate those who passively ignore or actively oppose it. The function of art is not to be politely absorbed but rather to challenge and disrupt. We have seen this concept played out fiercely in recent years. Art that was conceived as a vehicle to free its audience from repressive conventions was met with tremendous hostility by precisely those people who could have been moved to greater understanding had they welcomed the possibilities offered. But the work proved too unnerving to find acceptance among non-art world audiences.

Actually, many artists and intellectuals themselves have trouble absorbing the difficult and controversial work of others or allowing multiple points of view to coexist. Artists who make such work can understand these negative responses if they accept and are prepared for a certain amount of rage when they challenge social norms that have been internalized as correct, moral, and legitimate. They need to understand the uproar their work has caused. But the dominant culture, or even the supposedly more sophisticated subculture of the art world, may not be able to absorb the most profound work produced, especially when it refuses to hew to a politically or aesthetically correct line and strikes out on its own.

To try to make work immediately tolerable to an audience for whom the work must inevitably be challenging is to attempt to homogenize and ultimately render it impotent. William Blake believed that his poetry had to be difficult to read, that it was in the act of struggling to understand the text that transformations of consciousness actually occurred. Simplifying the effect by translating the form thus dilutes the power of the work to reach into the psyche and challenge the values of society.

The notion of making politically useful work often leads to a desire to simplify not merely the form but the content as well, reducing it to a message that can be easily apprehended. This may result in a heavy-handed, almost insulting condescension that alienates the audience rather than engaging it. They may "get" the message, but they may not like the message they are getting. This is also humiliating for the artist, whose function—unlike that of the TV scriptwriter, newscaster, journalist, cabaret dancer, or popular singer—is not to seduce only by entertaining. As Susan Sontag says of her own work, a significant role of the artist of the future may be "to keep alive the idea of seriousness, to

understand that in the late 20th Century, seriousness itself could be in question."[22]

Marcuse understood this aspect of art. Knowing the indigenous, anti-intellectual attitudes progressive North Americans have always faced, he was not sympathetic to any movement that forced art into oversimplification. He saw the limitation of this tendency, as well as the repressive consequences of pushing artists into a prescribed position. I think he also would have grasped the irony of any attempt on the part of the art world to determine what is legitimate, what work can and cannot be made, or how it should be made. It is not coincidental that the move towards self-regulation follows so quickly on the heels of postmodernism as the ascendant aesthetic and the concomitant tendency of many artists to isolate themselves from a broader audience. This reversal appears as a dramatic overcompensation, which, in the name of relevance and accessibility, may have the unwanted effect of destroying what is uniquely important about art—its commitment to play and freedom of expression. This crisis of purpose also provokes a crisis of vision. Artists and writers, insecure about what art should be and how to justify their activity, attempt to impose a meaning from the outside in the hope that a set of political criteria will make art more scientific, objective, moral, and therefore more legitimate. The anti-intellectual bias of North American society has relegated those engaged in such activities to its margins. It is no wonder, then, that what is now most valued in art is that which appears to directly engage with the issues of contemporary culture.

It is also no wonder that in the opening passages of *The Aesthetic Dimension* quoted earlier Marcuse notes that only radical praxis can change the political situation and therefore his concern with aesthetics "demands justification." He prepares himself and his text for the inevitable accusations that his pursuit is a futile exercise in the face of more pressing, immediate concerns. If his final work retains nothing else useful for us today, however, it demonstrates the importance of aesthetics as an area of exploration and of art and artists as a crucial force of liberation within a repressive society. The debate Marcuse entered into almost twenty years ago remains relevant and continues today. As the world artists live in becomes more complex, as the demands made on us all increase, his work on this subject could provide an endless source of inspiration, not necessarily for the answers it provides but rather for the range of fearless questions it engages. Postmodernism may have changed the discourse and terms of the debate, with the introduction of issues of postcolonialism and the notion of the divided, decentered subject. But

it has not helped artists understand how to position themselves. It has only made it clear that they *must* position themselves in relationship to their own identities, the social issues that surround them, and the world in which they live. In this post-postmodern moment, as the art world struggles to establish the conditions for its social identity and even its existence, *The Aesthetic Dimension* remains one of the finest explications of the crucial place of art in Western society, and a stronghold against the nihilism and denigration that at times threaten to engulf it.

Notes

An earlier version of this essay appears in *Marcuse Revisited*, eds. John Bokina and Timothy J. Lukes, (Lawrence: The University Press of Kansas, 1993).

1. Barry Katz, *Herbert Marcuse and the Art of Liberation* (New York: Schocken Books, 1969), 220.
2. Marcuse, Herbert, *The Aesthetic Dimension* (Boston: Beacon Press, 1978), p. 1.
3. Marcuse, *The Aesthetic Dimension*, 14.
4. Marcuse, *The Aesthetic Dimension*, 6.
5. Marcuse, *The Aesthetic Dimension*, 14.
6. Herbert Marcuse, *Eros and Civilization* (New York: Vintage, 1961), 206.
7. Marcuse, *The Aesthetic Dimension*, 66.
8. Marcuse, *The Aesthetic Dimension*, 68.
9. Marcuse, *The Aesthetic Dimension*, 17.
10. Walter Benjamin, *Illuminations* (New York: Schocken Books, 1969), 237.
11. Marcuse, *The Aesthetic Dimension*, xii-xiii.
12. Marcuse, *The Aesthetic Dimension*, 9.
13. Marcuse, *The Aesthetic Dimension*, 52.
14. Marcuse, *The Aesthetic Dimension*, 7.
15. Marcuse, *The Aesthetic Dimension*, 62.
16. Marcuse, *The Aesthetic Dimension*, 62.
17. Marcuse, *The Aesthetic Dimension*, 66.
18. Marcuse, *The Aesthetic Dimension*, 28.
19. Marcuse, *The Aesthetic Dimension*, 32.
20. Marcuse, *The Aesthetic Dimension*, 32.
21. Marcuse, *The Aesthetic Dimension*, 35.
22. Susan Sontag, "Susan Sontag Finds Romance," *New York Times Magazine*, August 2, 1992, 23, 43.

9

EAST AND WEST—THE TWAIN DO MEET
A Tale of More than Two Worlds

Felipe Ehrenberg

If life is a command performance, then mine is a single work as yet unfinished.

The performance, a giant *Mechano* set in time, began even before I got the call. My tools and materials have been near misses, chance, and coincidence: born in '43; growing up in what is now the largest city on earth; escaping from a falling house in the 'quake of '57; learning with Spanish anarchists; hosting Lee Harvey O. one evening during his Mexico trip.

Then there was the seventy street–long walk during the New York blackout in '64. And then again, the student uprising in 1968 and the long trip to England. After that, Hurricane Fifi; establishing earthquake

victims aid camps in Mexico '85 and in San Salvador one year after; witnessing Reagan's ascent to power on TV in Chicago; experiencing the foiled coup attempt in Caracas in '92.

Growing older and loosing teeth.

Slowly and surely, the pieces of the puzzle come together: paintings and voyages, performances and relationships, mural workshops and running for office, installations and writings like this one. They're all a part of the Big Performance.

The image is kaleidoscopic. Here's part of the story...

One stormy winter afternoon we embarked at Le Havre, my two children and I, on the SS Jordaens, a small Belgian cargo boat bound for Mexico. It was 1974, and we were going back home. The trip would mark a circle that contained a painfully prolonged absence from home; it was, in fact, an enormous transcontinental circle that would close on arrival at the port of Veracruz.

As we held on to the stern's cold railing and watched Europe's coast recede in the darkening mist, I remember feeling that this enforced sojourn had lasted far longer than I had ever foreseen, as measured by my children's growth and my own changes but especially by art's mutations. Night closed on our little ship. I tucked the kids into their bunks and, all of a sudden, for the very first time since I had made the decision to leave England and return to Mexico, I found myself pondering what we were leaving behind.

Exile has astonishing effects on the spirit. In the forced passage from one climate, one geography, one culture to another, one faces changes so complex they seem at times impossible to digest.

Though East is East and West is West, the twain do meet, and when they do there is great confusion. When dealing with the cultural production of the Spanish- and Portuguese-speaking nations of the American continent, it must be remembered that our arts respond not only to the energies of our very own and particular contexts; our arts respond, in addition, to Western Art, that is, to the art produced by artists who live in developed nations. In the process of reconciling widely differing cultural visions, the arts of the many Americas have evolved some fascinating variations.

This, I'm convinced, is especially true of art in twentieth-century Mexico, which among other contributions to universal culture birthed the School of Mexican Painting, whose strength lay in our graphics and mural movements. Since then, Mexican artists have felt especially

committed to cultivating our links to the whole of society. Although changing values and market pressures have affected our concepts of the uses of art, the awareness that art best serves culture by responding first to the immediate society in which it is made is still very strong in our country.

Mexicans have always known that artists are the spokespeople of society. Diego Rivera, Jose Clemente Orozco, David Alfaro Siqueiros, Frida Kahlo, Dr. Atl were all intensely political animals. The role models of my generation and of preceding ones, their behavior as a whole was our point of departure. Through its whispers, its cries, and its powerful shouts, their art was—*and still is*—the voice of many.

Precisely because of my circumstances, precisely because I am a Mexican artist, I had been sucked into the turmoil in Mexico towards the end of 1968, when students first, the lower middle class, then factory and farm workers, had hit the streets yelling bloody murder against the government's crass mismanagement of public life. The violent social upheaval that shook Mexico in 1968 paralleled those in other countries in that fateful year, but this was our very own, very Mexican experience.

These events unraveled and polarized Mexican society. As people from every level closed ranks against official obstinacy, more and more artists and intellectuals took a stand and entered the fray. Then, on the afternoon of the second of October 1968, on the eve of the Olympic Games, the President ordered the armed forces to break up a massive student demonstration. Hundreds of youngsters and their families, people from all walks of life, were massacred. As a result of the government's bloody measures to quell the unrest, the more militant people began fleeing the country, myself among many. It is believed that in the days following the repression, close to ten thousand Mexicans sought asylum abroad—in Chile, France, Canada, Holland, Cuba, England, and elsewhere. For better or worse, our lives had been changed. Mexico's politics and Mexico's arts would reflect the change.

It had been by chance then, by nothing but pure chance, that I had suddenly mutated in 1968. I had been unexpectedly transformed from a young and struggling artist (rather an ordinary one, I'm sure), into a young, struggling, but decidedly out-of-the-ordinary artist. Alas, such a metamorphosis had little to do with talent. A mere eighteen-hour flight across the Atlantic and I'd become a *foreign artist* (a Mexican one to boot). All because I had to pack things up and, together with my family, become an expatriate. The reason? Politics. Chance and nothing else deposited me in England, of all places.

Though I had started life by working loosely within the framework of expressionism, by the time I left Mexico, I was already exploring other visual possibilities: plastics, neon, three-dimensional works, sounds, and body language. Within a few months after arriving in England—wham-o!—homesickness hit me. Hard. Dazzled by the swirl of new ideas but gagging over the rat race for gallery recognition, I found it very difficult to pick up what seemed a chaos of loose threads. Soon though, some semblance of order gradually became visible. I abandoned straight painting and objects (though I never stopped drawing) and went from small to ah, well…postcard collages connected to mail art connected to conditions connected to performances connected to conceptual art connected to…. Slowly, I merged into the experimental fringes of England's art scene, and through it, into Europe's. And during this time I found myself facing an ever more complicated web of cultural issues which I can only describe as *confrontational*: the color of my wife and children's skin, the way those people perceive non-Europeans, the purposes art serves….

My production during those six years consisted mainly of test flights, a giant collection of blueprints for what was to come years later, up to the present, to the large installations I just finished for the *Past Imperfect*[1] show. None of the work I produced in Europe dealt even remotely with the quality of a finished object; it was all about ideas. I was working under duress: *Nothing had prepared me to question the one thing I had never expected to doubt: my chosen profession, my role as an artist.*

Now, six years later, my two children and I sailed back home across the Atlantic. Behind us lay Langford Court, in Devon. The wondrous venture which had kept us there, the Beau Geste Press, had been, for all practical purposes, dismantled.[2] We carried with us a priceless bundle of rich experiences, but this knowledge could not mitigate the bittersweet feelings surrounding all we were leaving behind: a throng of friends, promises to stay in touch. Though I had the nebulous intention of picking up the Beau Geste Press and its editions where we had left off, my main concern had to do with the direction my work should take. I was optimistic, of course, but felt anxious, unbearably so.

Like so many other artists of my day who had trodden the grounds of conceptualism, who had Fluxed and mail-arted and Dadaed and happened and videoed themselves beyond the ken of orthodox art criticism and out of the art market, I was burdened by the exquisitely challenging riddle of the times: art's capital A. But unlike them, I was additionally saddled with the task (a self-imposed responsibility, to be

sure) of finding solutions to that problem *within* the context to which I was returning. And Mexico's visual arts were far, very far from the changes European and North American art was undergoing at the time.

In its development, Mexico has had to walk the tightrope between the shadows of a shattered past and the confusing lightning flashes of an incomprehensible present. In this, it is not very different from other developing countries in Latin America, indeed, in the non-Western world. Our past achievements are a source of great pride, but we are ashamed of our inability to keep up with the more "advanced" nations. Perhaps the gist of our drama is that we're unable to understand *where* we "went wrong," *how* it happened that we became the underdogs.

Twenty years ago I returned to a country that was experimenting timidly with some political reforms. Nevertheless, democracy in the modern sense was still a dream. At first glance, it felt as if everything had remained static, as if the traditional hierarchies in politics, business, and culture had survived the big scare of '68 unscathed. But upon a closer look, the semblance of change began to emerge through the veils of confusion.

The protective layer of nationalism, which in the first decades of the century had been successfully nurtured by artists and intellectuals as a means to rebuild a country damaged by civil war and had led to enormous government support to education and culture, had crumbled into meaningless official rituals. Despite their claims of transformation, successive generations of politicians had been unwilling or unable to offer viable alternatives. Mexico's upper echelons, both in business as well as in government, periodically updated their discourse, but it was all on the surface. In fact, they had imploded, tightening their hold on power. Today, they are a conservative, almost isolated power group. And they are our art market.

The arts carbon-copied the situation. Musicians, artists, writers, dancers, thinkers of every sort, many of them extraordinarily talented, drifted along aimlessly. Castaways from government patronage that grew leaner as they became meeker, they had been unable to stimulate the official infrastructure required to sustain a cultural production that could satisfy a developing nation. Compared to the world I had just left, Mexico was nowhere, the boondocks.

My main, nay, my only problem then was solving the riddle my European circumstances had forced on me, that of finding a meaningful way to bridge the gap between East and West, between America's Indo-Hispanicism and European sophistries, to reconcile the past and

the present, *as an artist, through art.*

Intuition rather than intellect became the decisive element. Looking back, I realize that the only way I could have calmed my restlessness lay in the course I actually took. Rather than aiming for art collectors' walls I felt it was necessary to *create a different context.* This could only be done by setting practical examples.

Those six years away from home made the return unexpectedly arduous. The first few months were plagued by very painful events. Getting used to a broken marriage, a tragic car crash, grief in the family. As I worked my way through the hard times, I realized that in less than a decade I had become a stranger in my own land. Still, the practicalities of life had to be dealt with. There was no question of living in Mexico City again. I abhorred the idea of breathing its pollution, being hurried by the tempo of what was growing into the largest city on earth, facing a stagnant art scene, and trying to sell my strange art wares to an ignorant, practically nonexistent market.

After roaming around in search of a place to settle, I finally located it in the mountains of the state of Veracruz, a large stone house in ruins and a deep well. The spot, about an hour's drive away from the Gulf Coast, is called Xico, and it's always green and humid. It's beautiful and it's Mexico, past and present. We still live here. There I was, an artist— An Artist! in the purest Western tradition—in a small coffee and cattle town in the middle of nowhere, that is, of Anywhere. "And…ah, what did you say you do?" people in Xico would ask. "I'm an arrr…uh, I'm a teacher…."

How does one explain "being an artist," a contemporary artist, to someone who's never seen art, at least the sort made in the developed West? In the process of settling in this microcosm there grew in me the need to *prove* my skills' worth.

Life began shaping up. Amidst the greenery of banana plants and the smells of the pepper tree and gardenias, in the warm, misty evenings, children play, youngsters court each other, and folks sit and talk and build the future on the past. It's the theater of life, the stuff of culture. It was the proper setting to rediscover my own land, to try to fathom its many contradictions.

As I observed Mexico's reality, as once again I took up *living* Mexico's realities, so unlike England's, further doubts germinated and prospered in my mind. Where were to be found, I would ask myself over and over again, all those notions of universality I had learned about in the course of becoming a present-day artist? All those years of learning a profession

and traveling and hustling to "make it" out in the wide world…jeeeez! It required no major insight to see that in a paradise such as Xico, in all of Mexico, and, for that matter, in most of the world, things couldn't—in fact, don't—work out the way Western art would have it. It finally and truly dawned on me that universality is a matter of *who* writes art history, of *who* calls the shots, indeed of ethnocentricity. This wasn't yet a truism in the days before words like "multiethnicity" and "multiculturalism" were in everyone's mouth.

On discovering that art is not universal but that it is about *contexts*, I felt I had found the map to the buried treasure. All I had to do then was to clear my head of preconceptions and ingrained habits. I decided to shelve Europe. I began by severing all ties with the immediate past, wrapping, crating, and storing all the remnants from England, Holland, Italy, Germany, and other parts of the Europe I had known: books, art magazines, past work, even friends' letters. I filed away unfinished projects, broke engagements and commitments. Next I attacked my dreams and innermost thoughts and forced them to *be* in Spanish, to actually *happen* in Spanish. I felt a vehement need to return to my native tongue and reorder my very ways of perceiving. So many things, if not to discard, at least to put way from sight and thought.

"Where to begin?" could only be answered in what I felt then was an arbitrary manner (reason giving way to intuition), and, because people's memories were the only real thing at hand, I set about learning what had happened in Mexico within living memory. Perhaps the most ambiguous period of Mexico's recent past has to do with General Emiliano Zapata, the legend become myth, the man who shares a hero's pedestal with his own assassin, President Venustiano Carranza. And oldsters in Xico remembered the days of Zapata. Their memories and their experiences would become my reference point.

At that time, severely short of cash, I had accepted a teaching post at the School of Art of the Universidad Veracruzana in Xalapa. It's a small school in a small city. As a way of creating a context, I decided to translate the Beau Geste Press experience. If making books had opened unsuspected horizons for adventurous artists, it could surely work for Mexican art students. I designed a course in bookmaking and self-publishing. The project was accepted by the art school, though hesitantly. But as I shared with the students my ideas and doubts—quite unorthodox in the context I had stepped into—the powers that be began to worry seriously. I wasn't as yet cunning enough to avoid disaster. Things came to a head when on my workshop's wall I wrote, in large capital

letters, ART IS JUST AN EXCUSE. The powers that be had theirs, and I was forthwith and rather ignominiously relieved of my job. Poverty was averted only because I happened to be awarded a Guggenheim Fellowship. I hadn't yet managed to make any serious progress in my work, but now I had some leeway.

Proceeding on intuition, I mined deep into recent history. My approach, of course, was never as an historian. But I needed to find out what had happened to Mexico's art—and through it, to Mexico—after the euphoria of the revolutionary years between 1910 and 1925 had dissipated. I began my acquaintance with the unforgettable Southern Leader by working my way through his letters and the texts of Gildardo Magaña, General Zapata's aide and heir, Sotelo Inclán and John Womack, his biographers; Adolfo Gilly and Carlos Monsiváis, his admiring judges. I visited the state of Morelos where Zapata was born, sugar cane country, and breathed the sultry air of dusty towns and ranches. Back at my new home, I walked the streets of Xico and the many hilly paths that surround it, thinking things out. My readings were enriched by the recollections of the old folks, their stories retold in a Spanish loaded with the music of the Nahuatl language. Zapata had been a full-fledged Native American, a Nahuatl.[3]

One morning, almost a year after our return, I finally picked up my tools and faced the infinite whiteness of the blank surface. Resorting to a conceptualist discipline, I worked exclusively with children's school materials—cheap paper, crayons and colored pencils, small wooden rulers, a rubber stamp alphabet, watercolors—the tools and materials of pedagogy. A primitive opaque projector allowed me to create a series of anamorphic sequences, visual metaphors, of the hero's face.

Once more, insight came from the unexpected. I had grown up with the idea that racism does not exist in Mexico. We are, the saying tells us, a *mestizo*[4] nation, the result of the fusion of two worlds, two peoples, two cultures. The official version affirms that Mexico is a delicious *café au lait* on its way to forging a destiny, not quite manifest, but certainly glorious. This rendering is at best the *criollo*'s interpretation as taught to every generation of Mexicans since the Spanish priests established their first schools.[5] Although I couldn't know it at the time, the discovery of our racist character would become a major concern in my work a few years hence. In the meantime, it conditioned the way I dealt with the saga of Zapata's world, the struggle between the pre-Hispanic cosmogony and the European Middle Ages, between East and West (East being Europe, West being America…or is it the other way?), between "civilization" and

"underdevelopment."

Two years after leaving England, I finished the series *Zapata Today*, a collection of drawings and collages plus one big assemblage in wood. Formally all quite unorthodox, if compared to the work my peers in Mexico were producing in those days—latter-day expressionisms, abstractions, and geometricisms. When it opened, the show created a stir, since it attracted a bevy of high-caliber journalists, reporters, and columnists, whose opinions defused the worn-out, official discourse over Zapata used by the country's Presidents year after year. I had managed to jump the gun. I'm convinced the coverage it received stimulated other artists: A scant three years later a mammoth exhibition of contemporary renderings of Zapata was presented in the sacred halls of the Palace of Fine Arts in Mexico City.[6]

Hmmm...the way was becoming clearer. I had personally seen proof of art's power to affect events *as long as the media was part and parcel of the act.*

Many things culminated in 1976. We were entering the Oil Boom years. Mexico City had grown to hold nearly ten million inhabitants; nevertheless it had barely five or six art galleries, two rather dinky art museums, and, for a while, a lonely art magazine subsidized by Mexico's Museum of Modern Art.

While artists, specially the younger ones, grumbled over the nature and significance of the art they were producing, the country as a whole was host to unprecedented migrations from the south. Many of the exiles were artists and intellectuals from Chile, Argentina, Colombia and Guatemala, Uruguay and Nicaragua.[7] The notion of the artist as an ostrich that prevails in Western art seemed to me—indeed to a growing number of art mavericks—completely untenable.

Financially impoverished as usual, I was zipping back and forth from Xico to Mexico City, trying to make ends meet. I was still doing my best to prove than artists are not a commodity but a necessity, that art is needed all the time, everywhere, not just by a moneyed elite in big cities. I sold some work but also wrote for newspapers and magazines, and met and talked with people. Buried somewhere deep in our discussions there lurked the seeds of major confrontational concepts that would soon pit the notions of personal success (measured in terms of sales and prestigious exhibitions) and personal achievement (realized in work that is meaningful in a broader social context)—power versus strength. It was the time when artists began forming groups.

Now that I reflect on those days, I honestly don't know how I found

the time to be involved in so many things and, in addition, take on the founding of a cultural center for Xico. It all had to do with making myself useful as an artist, of course. I was in a terrible hurry to build a different context for the art that interested me.

It's not easy to sell the idea of creating a cultural center anywhere, least of all in a small town. My vision had to do with priorities, with developing the town's own potential rather than comparing it with outside arts (inevitably at a disadvantage), with *detecting* local talent and only then, perhaps, importing it from elsewhere.

I began by talking to anyone who cared to listen and soon formed a small group of incipient art lovers. We hit on the ways and then the means to put a great idea into practice. It would be a show of photographs, of pictures already there, in Xico. We distributed a mimeographed broadsheet (shades of the Beau Geste Press) calling on people to look in trunks and closets for photographs old and new, even offering a prize for the oldest one to be found. After weeks of house-to-house visits we managed to select a surprising assortment of pictures. Family photos, picnics, birthdays, funerals, the restoration of a church, the day water was first piped into people's homes (the decline of backyard wells), the crumbling of a stone bridge, the class of 1912's graduation day, and…oh yes, the oldest picture we found had been taken in 1876, right in Xico itself!

I titled the show *Xico through the Years* and timed its opening to coincide with the town's annual fiesta, the feast day of Mary Magdalene. The show was a success. It marked the first time the town was able to see itself pictured as a community of families that had grown into a city with a distinct character of its own. The idea went a long way. In time, better funded shows were organized by myself and others, in Campeche, Pachuca, Xalapa, and other cities and towns. Nearly twenty years later, Xico's modest cultural center lives on. It has its own little library. When it can afford to do so, it offers workshops in mask making, guitar playing, or nature drawing. It keeps growing.

But now I have another tale to tell.

One afternoon in the late seventies, I received a visit from a godson of mine, a very young man called Nicolas. His dad, Pablo de Jesús, and I had known each other since we were teenagers. Nicolas brought very sad news: His father had been shot dead while selling his wares in a bar, murdered by a two-bit, drunken politician in Iguala. The guy was never even arrested. Why bother? The law turns a blind eye when a *mestizo* lawyer kills a Native American. Pablo had been a Nahuatl from Ameyaltepec, and his

wife's Spanish was barely sufficient to rescue Pablo from the morgue and carry him back for burial in Ameyaltepec. Pablo had been an artist. His wares had been his work, colored ink drawings on *amatl* paper.

Now Ameyaltepec (which means "mountain spring") is a very unique place, and some very unique things had happened there over thirty years ago. Young as I had then been, I'd had a hand in those events.

The place perches on a rocky, inhospitable mountainside in the Sierra Madre of Guerrero. From where it lies, one can look down at the awesome majesty of the Balsas River. It's ochre dry and dusty during the hot days, but the enormous panorama of craggy mountains that surrounds it begins turning a violet blue as the sun sets. At night the whole landscape glimmers in starlight, even when there's no moon. Although its origins are unknown, it was most probably founded by families who fled the great city of Tenochtitlan before the invading Spanish hordes, the *conquistadores*, shortly after the fall of the Aztec empire, some 470 years ago. With nothing more than the will to survive, the migrants—all city folk—endured ages of hardships by cultivating stony hills and fishing. For years, their only crafts were weaving and embroidery, as well as the manufacture of a low-temperature pottery—large pots, jugs, containers, figurines—totally decorated by exquisite brushwork. They traded these with neighboring communities for other commodities. As roads opened, the people of Ameyaltepec began traveling farther and selling their wares in other cities. Their figurines were especially strange and whimsical, and they were a major presence in my mother's collection of folk art. Their production and, for that matter, all the wonderful, imaginative examples of folk art Mexico is so rich in, have always been an important element in my visual landscape.

Young Nicolas's visit and the tragic news he'd brought jolted me into remembering the year I had first visited Ameyaltepec, 1960, and the circumstances under which Pablo and I had met. In those times, Ameyaltepec was rarely visited by outsiders. Occasionally, an anthropologist or two, mostly North American scholars, would make their way there on horseback. Few memories linger in my mind as clearly as the days I spent in the tiny settlement that first time, during which I met several people, among them Nicolas's dad Pablo, his uncle Pedro, and Cristino Flores (who's nearly deaf now). Pablo and Pedro are dead, but my friendship with Cristino and some other people has endured. These chance encounters led to the birth of a new craft, that of the world famous "bark paintings of Guerrero," a label I detest. This is not the place for this fascinating tale.[8] It's enough to say that it was chance and

nothing else that allowed me to introduce my potter friends to the *amatl* paper made from bark in the mountains of the state of Puebla.

A new support material makes for a new medium and new expressions. Released from the constraints of earthenware and reveling in the flatness of their newfound surface, the talent of Ameyaltepec designers blossomed into something truly wondrous, a space where they could express themselves, where they could be artists. As the paintings began selling and their authors prospered, people in other neighboring towns in the Balsas area—Xalitla, San Agustin Huapan, Maxela—adopted the new craft, spreading a very particular imagery all over Mexico and far beyond our borders. In less than twenty-five years, the origins of *amatl* paintings have been forgotten. They're considered "age-old," "traditional." None of us involved in developing them ever thought of publicizing their origins. Isn't it sufficient that they exist? Although I didn't perceive it then, this youthful experience had been about aesthetics. It marked me profoundly. It would surface in the future.

Gradually, people have begun recognizing the talent of Nicolas de Jesús and that of some of his contemporaries, women as well as men. Some have already begun showing in galleries and museums, mostly abroad. The going is slow. In their whiteness, Mexico's art pundits refuse to accept them as artists. At best they call them "Indian" painters, relegating them to the sphere of the exotic.

But we're back in the mid-seventies, and I'm on one of my regular visits to the Big City. Ricardo Rocha, an artist and old friend of mine, is a teacher at the National School of Fine Arts, also known as the Academy of San Carlos. He invites me to address his students. I talk to them about self sufficiency in art, about the Poligonal Workshop,[9] about the Beau Geste Press. Then and there we produced *The 24-Hour Book*, all handmade (including the rubber stamps) and photocopied at the corner paper store. It was the first "artist book" ever seen...or made in Mexico.[10]

Ricardo suggested I get a job at the academy, but the forceful separation I had endured in the Veracruz art school was still festering in my mind. Some of Ricardo's students insisted. I relented on one condition: that we do it *without* the school's knowledge. The idea of being a pirate teacher was suddenly very appealing. Every week for the next seven months I'd make the six-hour trip from Xico to Mexico City and meet with the group in a covered backyard of the academy. We'd rearrange old chairs and battered desks kept in a nearby storage room to form a large square and learn the publishing task. This involves learning how to choose the material you want to place out there, how to arrange and

design it, how to go about printing or photocopying it (or whatever), and how to distribute it as effectively as possible. By the time the art school's director found me out, the damage had been done—most of those people have matured to become outstanding artists.

In spite of the apparent lassitude of the seventies, things *were* happening in Mexican art. A stage had been reached where artists began to question actively the ways their artworks were circulated. In our restlessness, we felt the need to address people directly. It was up to us to invent and discover new forms, new materials, new ways to reach a new public. A veteran questioner by then, I hearkened back to my experiences in Europe. For all its experimental hermeticism, the Poligonal Workshop and the Beau Geste Press had proven their worth in breaking new ground. The sediment of those experiences seemed a viable foundation. I found myself involved in some heavy proselytizing, at parties and cafés, in interviews, vehemently espousing the formation of artists' collectives. Grupo Tepito Arte Aca was founded by Daniel Manrique, Gustavo Bernal, and other inner-city artists who proclaimed their class and skin color "otherness." Grupo SUMA was formed by Ricardo Rocha and a group of his students (from my erstwhile pirate class), among them Santiago Rebolledo and Gabriel Macotela. Grupo Proceso Pentágono, founded by Victor Muñoz, Carlos Finck, José Antonio, and myself, came into being early in 1976.

As so often in the past, a periodic event in faraway Europe's art scene would become a detonator of events in Mexico. For their Tenth Paris Biennale, the French had decided to favor Latin America with a special pavilion. To this end, the organizers appointed a Continental Curator who, in turn, named a series of regional commissars. Mexican sculptor Helen Escobedo was called upon to select the Mexican contingent, and she chose to send four artists' groups, including Grupo Proceso Pentágono, whose work was attracting the most attention at the moment.[11]

All preparations were going along smoothly until the contingent found out that the Continental Curator appointed by the French was the Uruguayan art critic Angel Kalenberg and that this same man had served, a few years past, as the Uruguayan military dictatorship's Chief of Cultural Affairs. At the time of his appointment by the French he was head of the Museum of Art in Montevideo. A careful reading of his pedantic, abjectly solemn, barely intelligible texts revealed that their Man in Montevideo was the epitome of what we stood against.

Further investigations into Kalenberg's *modus operandi* disclosed that

in creating the Latin American pavilion he had privileged art sponsored by the totalitarian regimes of the day. Highly indignant, the Mexicans decided to protest and wrote to the organizers of the Biennale, other artists, and the press. We wanted him *out!* The French temporized: They kept their Uruguayan curator, and we boycotted his pavilion. Gabriel García Márquez made his sympathy manifest in our catalogue, which we took to Paris. Artists such as Julio Leparc, Luis Felipe Noé, Crasso, and other important Latin American intellectuals residing in France closed ranks with us. Our position was widely publicized in Europe.[12]

Back in Mexico, the groups' success stimulated more artists into forming collectives. Its participants were thirsty for knowledge and news, and began networking beyond our borders. The Group Phenomenon was on.

Change took place not just in the ways we began putting our work out. Forms also began changing. Soon, both art collectives as well as individual artists were exploring all manner of nonmainstream options: non-object art, neographics, installation pieces, neofiguration, performance art, street events, book objects.[13] Step-by-step Mexican art was updating its languages, adjusting itself to changing circumstances.

Scarcely any records of those days exist beyond yellowing press clippings. Mexico's critics (no more than five or six baffled ones on active duty) proved unable to cope with the situation. They barely chronicled the changing times. As a matter of fact, few if any of the many works produced during those odd years survived, except maybe some artists' books...hmmm...artists' books.

Then came another great stimulant: the astounding defeat of Somoza, the Nicaraguan dictator. The hoped for but unexpected event reverberated throughout the continent. Nicaragua was in shambles and in need of international solidarity. It came lavishly. The Sandinistas laid down their weapons and became a governing body. Father Ernesto Cardenal, the poet priest, was appointed Minister of Education. An acquaintance from the days of *El Corno Emplumado/The Plumed Horn,*[14] in the mid-sixties, Father Cardenal began operating from a hotel room. Artists from the whole continent responded to his call to support the newborn democracy.

As tiny as Nicaragua is, communications were a critical issue. Priorities had to be reordered even before the slightest chance of enjoying art could be possible. A bewildered people—less than five million souls—had to heal themselves, locate lost relatives, rebuild homes, and learn how to make the most out of the least. I found a way to do my bit: through self-publishing. The Beau Geste Press/Libro Acción Libre enterprise,

which already had proven its usefulness during the Group Movement, could once again be transformed, I was certain, perhaps as a project that I called Shoestring Publishing Workshops. I sat down, whetted my pencil, and drafted my suggestions.

The plan was to establish workshops and teach people how to organize themselves by publishing their needs. In the face of rampant disorganization, who better to know what the priorities were than the locals themselves? Information could be gathered and organized locally and the community could publish at a very low cost. Paper could be recycled, any old Ditto or Gestetner machine could be used. And if there were no such tools at hand, one could easily build a simple wooden duplicator. Even the ink can be homemade.

One of the many artist friends who traveled back and forth between Mexico and Managua volunteered to deliver my project into Cardenal's hands. It's possible the good father never got it. If he did, he must have promptly misplaced it in one of his many hotel-room drawers. Fortunately, the project surfaced six months later and was eventually put into practice in the sixteen *Centros Populares de Cultura* (People's Cultural Centers) throughout the country. Soon enough, though, a new opportunity to put the publishing project into effect would come my way.

By the end of the seventies, Mexico's Oil Boom had truly come into its own. President López Portillo threw oil dollars around like confetti. Once, on a visit to Spain, he expressed the wish to be buried next to his ancestors there. Can you imagine what any of the several million Native Americans in Mexico must have thought? The First Lady would fly to and from Paris, carrying a whole symphony orchestra along in her plane, including her big white concert piano (and the pianist). López Portillo appointed his sister to head the National Communications Network, and news was made whenever she consulted the ouija board. Thanks to the spirits' advice, she'd been able to locate the site where, she claimed, lay the long lost bones of her muse, Sor Juana Inez de la Cruz, the poet nun! The spot, a former convent built during the colonial era, was converted into a giant cultural center, a white elephant.

The eighties arrived and any vestiges of the traditional rhetoric wielded by the ruling party by now had disappeared. (In a scant two or three years, our regime would no longer be called a regime. It would become an Administration, no less.) Slick and healthy looking impresarios, bankers, and stockbrokers had begun to take the place of the older, mustached, beer-bellied politicos and money barons. Mexican yuppies, aka *yupitecas*, built themselves palatial mock-Tudor and neo-Provençal

homes. The size of their fortunes was—and still is—beyond belief. Their slim, peroxided wives, replicas of Jane Fonda, blandished plastic money as they undertook the wholesale decoration of their improbable mansions. They zeroed in on art.

Overnight, the work of all the old masters, dead or alive, became prime merchandise. Dealers sold Méridas, Gerzsos, and Sorianos like hot bread, together with "Indian" scenes and landscapes by Siqueiros, Rivera, and Dr. Atl. Newly emerged experts, art dealers, and posh galleries popped up like mushrooms after a rainfall. On their advice, the money people began buying the work produced by a new breed of young masters who suddenly appeared on the scene. Their style is called "neo-Mexican" and looks suspiciously like the Chicano art produced by their more daring counterparts in the U.S. Such work is permeated by garish, bleeding hearts, Frida Kahloesque *Sturm und Drang*, cactus plants, and the like. Auctions became the rage and Beautiful People breezed in and out of these social gatherings, thrilled to be seen spending megadollars. For art, no less. Sound familiar?

Times were certainly changing. For one thing, the government began sponsoring until then unheard of art competitions, offering purchase prizes "to enrich public collections." So how in the heck can a performance or an installation be given awards if it can't be stored or sold? To compete or not to compete, that became the question. Pragmatism triumphed over idealism and all the enthusiasm for the Group Movement and non-market-oriented production was promptly wafted away by the winds of modernization. Postmodernism, here we come.

There was simply no place for "concerned artists" who cried wolf whenever rowdy workers struck or unwashed Indians from the hills claimed the lands they continued to lose, especially if their art production was so…well, experimental?

All through these years, I kept up my own production, showing at least yearly, leaning more and more towards painting (perhaps to keep my links with the market). Still, I've been unable to stop doubting and enjoy the search for answers. Having learned a little diplomacy since my expulsion from the art school in Veracruz and from other capers, I finally managed to disguise and sell a variation of my Nicaraguan publishing project to a government agency. A new group called H_2O was born. This time the artist's task included a new service, that of an instructor. Within half a decade, these workshops, conducted by some twenty-six young men and women, stimulated the birth of more than eight hundred small publishing ventures in as many far-flung localities. H_2O's effectiveness

led to additional funding, and this permitted us to create other workshops such as the Shoestring Postermaking Workshop (using hand cut stencils and spray paint) and the Collective Mural Painting Workshop. One thousand sixty murals were painted under the auspices of this program.[15]

Although the tale runs longer, space runs out. In November 1992, I held my latest one-man exhibition under the title of *Past Imperfect* at the Museo Carrillo Gil in Mexico City, consisting of several installations, five giant book-objects, and five paintings. It is a body of personal work, the nature of which, like everything I've made to date, is indelibly branded by my unique reality, the context that surrounds me as an artist in a multitudinous and imperfect society, which is, nonetheless, fresh and powerful in its complexities. I am the product of my place and time, like every other artist in the world, but I have felt it possible to affect my historic moment.

The task of sharing information, cultural and otherwise, is a *sine qua non* condition in this age of forced rapprochement between Mexico, Canada, and the U.S., with the North American Free Trade Agreement looming on our shared horizon and the enormous repercussions it's already having on the social and cultural horizons of all three countries.

I believe that events have taken a splendid turn when people begin realizing that cultural progress lies not in the cold hardwares of the mind and the market but in the warm softwares of the heart and the community. Perhaps reading an account of a multi- and transcultural artist can be of use to someone out there. As a neologist, I'm available for consultations.

▨▨▨ Notes

1. *Pretérito Imperfecto* (*Past Imperfect*), Museo Carrillo Gil, Instituto Nacional de Bellas Artes, Mexico City, November 18, 1992–January 17, 1993.
2. Beau Geste Press/Libro Acción Libre was founded in England in 1970 by Felipe Ehrenberg, David Mayor, Martha Hellion, and Terry Wright as "a community of duplicators who published books, objects, and sundry by artists." It made its mark as a forerunner of book-objects and artists'-books.
3. Unlike many great leaders in history, Emiliano Zapata did not rise from anonymity to become the general of a revolutionary movement. Of pure Nahuatl descent and true to his traditions, he accepted the task given to him by his region's elders. The language of his Southern Army and the people they defended was Nahuatl, and most of his correspondence is in that language as well.

4. Although in the English language the word *mestizo* is used more and more, its connotations remain vague. In fact, the word means "half-breed," certainly a derogatory term. Continuous attempts are made in the Spanish language to raise the status of the word and load it with more positive associations.

5. Like *mestizo*, the word *criollo* poses a series of semantic problems. A kin of the anglicized Gallicism *creole*, which means: 1) a person of European descent in the West Indies or Spanish America and 2) a person of mixed French or Spanish and Negro descent. In Mexico and most of Latin America, it is used with pride by the descendants of the Spanish and with scorn by those of Native American lineage.

6. See "Exposicion Homenaje Nacional a Emiliano Zapata en el Centenario de su Nacimiento (1879–1979)," catalogue published by Secretaría de Gobernación, Secretaría de Educación Pública and Instituto Nacional de Bellas Artes, Mexico City, 1979.

7. Nicaragua, in the Nahuatl language, actually means "the limits of the Anahuac," that is, the limits of the Aztec empire.

8. See *Ameyaltepec*, a portfolio of etchings by Cristino Flores, Felipe de la Rosa, Eusebio Díaz, and Nicolas de Jesús (Mexico City: Artegrafías Limitadas S.A., 1983).

9. The Poligonal Workshop was a group founded in London in 1969 by Austrian video artist Richard Kriesche, Mexican photographer and theater person Rodolfo Alcaraz, and myself. Among the various works we produced, all of a conceptual nature, were the exhibition *The Seventh Day Chicken*, presented at the Sigi Krauss Gallery, London, 1970, in which we explored the aesthetics of garbage; a 16mm movie called *La Poubelle—It's a Sort of Disease— Part I*; and, with poet Mick Gibbs, a long distance mail art experience called *10-Day Communication Breakdown*. The Poligonal Workshop also participated in the Seventh Paris Biennale.

10. See Felipe Ehrenberg, Magali Lara, and Javier Cardena, "Independent Publishing in Mexico," *Artist's Books: A Critical Anthology and Sourcebook*, ed. Joan Lyons (Rochester, N.Y.: Visual Studies Workshop Press, 1985) 167–183.

11. The other groups were Grupo SUMA, Taller de Arte e Ideología (known as TAI,) and Grupo Tetraedro.

12. See *Expediente Bienal X: La Historia Documentada de un Complot Frustrado* (Mexico City: Beau Geste Press/Libro Acción Libre, 1978).

13. See Felipe Ehrenberg, "Postmodernism: The View from Latin America," , *Artspace: A Magazine of Contemporary Art* (September/October 1989): 40; also, "De los Grupos los Individuos," (Mexico City: Museo de Arte Carrillo Gil/INBA, 1985).

14. *El Corno Emplumado/The Plumed Horn* was an influental poetry magazine. Published in Mexico City by Margaret Randall and Sergio Mondragón in the early sixties, it was a bilingual quarterly that bridged the gap between the Spanish- and the English-speaking Americas.

15. An attempt was made to export the idea when, in 1987, I was hired as a consultant to the U.N. We tried applying it in Burkina Faso, but the coup which overthrew Tomas Sankara effectively snuffed out the project.

10

DEFINING SOUTH AFRICAN LITERATURE FOR A NEW NATION

Njabulo S. Ndebele

South Africa is the one country where social and political contradictions have been so stark that the influence of politics on other social activities, and vice versa, has been most easily observable. Many pious denials by racist apologists of the system that such an influence actually existed have actually turned out to affirm the truth of close relationships between politics and society. How often have we been told that sport and politics don't mix, when as a result of deliberate policy, the distribution of sports opportunities in the country ensures that sport and politics do mix. The same has been the case in the relationship between the history of the debate about literary standards, on the one hand, and the social distribution of opportunities for artistic development, on the other

hand. Literary standards in South Africa cannot be discussed outside the context of opportunities for many aspirant writers, who are black, to obtain a basic education.

If at some future date in South Africa the relationship between art and society becomes blurred, as it has in many Western countries, due to the mediation of many complex effects of economic and technological development, the world will have lost, in this country, a very useful teaching aid. That will happen when the relationship between a state of affairs and its origins can no longer be directly perceived. I want to suggest in my brief commentary that the state of literature in South Africa also mirrors in a very fundamental way the larger historical imbalances in the country, and that lasting answers to some of our literary problems are to be found in the manner in which the larger struggle for liberation is finally resolved.

Gloria Emerson, an author from the United States, made the following comment, back in 1965 at a writers' symposium at Northwestern University in Chicago: "The trouble with the most brilliant people in America…is that things don't happen to them. They happen to other people, and then they discuss what has happened." This situation plays itself out in South Africa, where world-renowned writers tend to be white people who write about what has happened to "Others". The result has been a literature of what we have done to others, how it has affected them, and how it may have affected us. This kind of literature emerges from a society that perceives itself as history's primary agent in the South African context. However, political agency ended with the first question: What have we done to them? We have conquered them; now it is our task to build and shine the light of civilization.

Since then, the human interest in the conquered "Other" has not evolved significantly beyond the perimeters of military objectives. Keep the conquered "Other" at bay. For the state, the domination of the "Other" posed no major moral problems, only military ones. This resulted in a state management culture in which the state became preoccupied with its own methods and techniques of domination. This situation has spawned a profoundly insensitive society.

If art plays an adversary role in society, asking disturbing questions, revealing unsettling feelings, attitudes, and experiences, then we will understand why it was writers who went further to ask the next two questions: "How has what we have done to them affected them? How has it affected us?" It will be immediately clear that the "us" in the last question does not include the "Other," for the writers are trapped in their

own society. They were born within it: it sent them to well-equipped schools; it provided them with publishing opportunities; it sanctified their languages through legislation and language academies; it gave them theaters, museums, art galleries, concert halls, and libraries; it arranged for them special salary scales that ensured access to a range of cultural facilities as well as the ability to buy books and newspapers; it created literary awards to honor them; it also made it possible for some of them to become critics and reviewers who influenced literary taste and declared standards; it protected them in law against the claims of the "Other," by assuring them of the privacy and security of residential areas legally inaccessible to the "Other," thus ensuring that they socialized among themselves; it gave them passports to travel, and they could meet other writers internationally; it sought to make them take for granted the elevated status of their citizenship and its attractive resulting comforts. However, since they were concerned about the "Other" and the effect of the "Other's" plight on their own humanity, theirs became a bipolar existential reality of moral abhorrence accompanied by a physical inability to escape the conditions of that abhorrence. Even when the system banned their books, I am certain that it entertained a grudging admiration for their worldwide acclaim. I am certain that South African diplomats, albeit embarrassed by the routine bannings of books, nevertheless shared in the international glory of their compatriots or, at worst, condescended towards their "misguided" artists.

If thus far I have referred to "writers" and the "Other" in general terms, it is because I have steadfastly avoided the intellectually debilitating signposts all South Africans will habitually expect. I have chosen rather to imply the signposts. But now, I should indulge in the South African pastime and be more explicit. South African literature is "white" South African writing expressing a limited range of concerns within a particular set of historical circumstances. It was literature concerned with what happened to the "Other" produced by writers who were existentially unable to experience what the "Other" went through. Indeed, the best of it (J. M. Coetzee, Nadine Gordimer, Andre Brink, Alan Paton) represents the artistic achievements of the era of apartheid. The fact that this literature stood in moral opposition to the era that produced it does not affect that objective historic reality. It owes its achievements to the special legitimizing opportunities as well as to the agonies of conscience that nurtured its growth. This reality represents both the limitations of that literature as well as its lasting relevance.

From that edified position, this literature then became a standard against which other literatures could be measured. Thus came into being a two-literary phenomena. The first one was called "writing in the indigenous languages," while the second one became known as "black South African literature" which implicitly did *not* include "writing in the indigenous languages." "Black South African literature," because it was written in English or Afrikaans, qualified to be called literature, but was a special nonstandard literature called "black." This setting apart of this literature confirmed its alien character. For some critics, mainly white, this literature assumed the kind of position that the Congress of South African Trade Unions played in South African politics: something with pretensions to political status but essentially naive, crude, untutored, inexperienced, yet threatening, but ultimately incapable of defining a labor culture. Yet to others, it was like Nelson Mandela's African National Congress: personable, worthy of being understood, but often times quite frustrating. Substitute "literary" for "political" and "labor" and you get a good sense of the relationship between politics and culture in South Africa. We can say that within the structure of domination in South Africa "white" South African literature, as a sociological phenomenon, effectively oppressed other literatures. Of course, that it did so was a situation not personally intended by its writers but a result of the dominant political sociology of official "white" South African culture.

I am reminded, at this point, of the significance of our recent participation in the Olympic games at Barcelona, which occasioned a lively debate in the evening phone-in program of Radio Metro. Many callers, black, declared that strictly speaking, South Africa was not *returning* to international sport, but that we were actually participating for the first time. They were making a distinction between South Africanism as a hoped for national attribute, universally distributed, as against South Africanism as a powerful concept of domination narrowly distributed and applicable to one moment in our history. The latter represents an appropriation of nationhood by a powerful racial group. In this connection "white" South African literature of the apartheid era should properly be seen not as a universally representative phenomenon, but as the manifestations of a dominant literary or intellectual trend running through a particular historical era.

Where does all this take us? I think I am attempting to highlight the ultimate impossibility of arriving at a timeless definition of South African literature. If the era of apartheid is part of South African history as that history paradoxically stretches into the future, then "white" South

African literature will represent a moment in the history of South African literature. From this perspective, South African literature will be seen to be made up of a variety of intellectual trends in history. It is not the definition that matters ultimately but the understanding that informs it, and the social context from which that understanding emerges.

Now, I have had to learn very quickly since the dramatic events of February 2, 1990, which led to the release of Nelson Mandela, that any attempt at a nonjudgmental understanding of our history is quickly interpreted by many white people as letting them off the hook. They become comfortable and begin to make arguments and demands that have the effect of reinforcing their privileged status. They want to enjoy the leveling benefits of objectivity without abandoning their claims to privilege. Unfortunately for them, sooner or later, "white" writing, to use J.M. Coetzee's expression, like apartheid, may become exhausted. With the "Other" having attained freedom, "white" writing may run out of a central and sustaining philosophical and moral focus. Its concerns may become marginal. Then white South Africans and their arts will have to engage in fundamental reflection on their cultural future.

The irony is that the future of that phenomenon known as "black" South African literature has been questioned by white critics for similar reasons. With the monster of apartheid gone, what will "black" writers write about? This question thus far has been thrown at "black" writing. "White" writing has thus far not been able to recognize its own precarious position. It has been basking in the self-confidence of one who has a habitual right to ask questions about the "Other."

What we are likely to have in our hands is a general loss of focus. And there lies the crisis of culture in South Africa. Central to the resolution of that crisis is the achievement of a genuine democracy in our country. In practical terms it means the creation of a society that can throw up new creative problems for writers. It means that the possibilities for new writing are inseparable from the quest for a new society—a society in which everyone is entitled to education for which the state must assume some responsibility; in which there will be much cooperation between the state, publishers, and book distributors in order to ensure greater accessibility and affordability of books for a greatly increased reading public; in which literary awards are freed from the culture of "white" writing; in which African languages are vigorously promoted; in which cultural institutions are more available and accessible; in which most people enjoy good health and decent housing. All this has everything to

do with literature and all the other arts. It has everything to do with a new sense of nationhood.

The current transitional period of negotiation, if it is too long, is likely to exacerbate the condition of cultural crisis, resulting in a blurred vision of liberation. It seems to be the intention of the Nationalist Party, the party that built apartheid and is still in power, to engineer and then take advantage of this situation in order to hang on to the dead end of "white" history for as long as possible. This is a reflex response on their part, for they are incapable of acting in any other way. Which means that if they cannot fall from the tree on their own, they need to be plucked from it. Whatever the case may be, the future of literature in our country is inseparable from the future of democracy and the difficult tasks of working towards it. Writers and artists of all kinds need to be centrally located in that struggle for democracy. The nurturing of their imaginations and new artistic skills will take place within that struggle and be informed by it. Possibly, they may even inspire it.

11

THE POLITICS OF BLACK MASCULINITY AND THE GHETTO IN BLACK FILM

Michael Eric Dyson

The explosion of contemporary black cinema, along with the emergence of hip-hop culture, expresses the pervasive influence of African American styles, sensibilities, and ideas in American popular culture. The narrative strategies that black filmmakers employ, and the images, symbols, and themes black filmmakers present, are important because they embody the coming of age of a new generation of artists dedicated to portraying the complexities and peculiarities of black life. Given the wretched history of often distorted, even racist, representations of black life viewed through the prism of white cultural producers, the rise of a new black cinema promises the articulation of artistic visions of black life beyond the troubled zone of white representational authority and mainstream

interpretative dominance.

A sharp analytical understanding of the narrative strategies, themes, symbols, and images of contemporary black filmmakers is crucial in developing a sophisticated critical vocabulary that may be employed to interrogate the cultural and artistic practices of the new black cinema. The development of such a critical vocabulary encourages and enables the examination of the artistic perceptions and representations of black filmmakers; a wide-ranging exploration of the material conditions and social situations of their cultural production; an astute analysis of the goals, aims and objectives of black film; and a rigorous engagement with the cultural contradictions and political determinants of black film production.

A select group of new black films, in particular, investigates the politics of black masculinity and its relationship to the ghetto culture in which ideals of masculinity are nurtured and shaped. Concepts of masculinity are central to contemporary cultural debates within African American society, especially given the crisis of black manhood and the widespread attention it has received in the last few years, especially within rap music and black film. Malcolm X is the unifying cultural signifier for the powerful premise of an overhauled black masculinity within a broad variety of contemporary black cultural expressions, the vibrant hero of a black juvenile cultural imagination seeking to contest the revived racism and increasing social despair of American life.

The relationship between concepts of masculinity and social responsibility is strongly implied in the life, thought, and career of Malcolm X, whose influence on contemporary black filmmakers cannot be under-estimated. In one reading, black filmmakers can be seen as cultural interpreters of the socially responsible dimensions of black masculinity as they are taken up in the organs of American popular culture, particularly within African American life. In another reading, the work of black filmmakers can be read symptomatically, as examples of the failure or success of artistic explorations of masculinity to probe the healthy and productive—or unhealthy and disenabling—consequences of black manhood within African American life, particularly as it takes shape in the black ghetto and often in relation to black female identity.

In this essay, I will probe the treatment of the ghetto and black manhood in several black films, examining the artistic visions of directors in relation to their responsibility in forming images of these twin subjects. In the process, I hope to illumine the ethics of representation and

characterize the manner in which these films both enable and resist helpful understandings of black masculinity, especially in connection with their views of black female subjectivity.

Matty Rich's *Straight Out of Brooklyn* is a relentlessly desolate rejection of the logic of liberal democracy: that individuals can act to realize themselves and enhance their freedom through the organs of the community or the state. For the inhabitants of Brooklyn's Red Hook Housing Project, the possibilities of self-realization and freedom are infinitely reduced by the menacing ubiquity of the ghetto. The suppressed premise of Rich's film—the steely argument for its existence at all—is a deferred rebuke to all pretensions that the ghetto is not a totalizing force, that it is possible to maintain the boundaries between geography and psychic health implied by the expression: Live in the ghetto, but don't let the ghetto live in you. It is precisely in showing that the ghetto survives parasitically—that its limits are as small or as large as the bodies it inhabits and destroys—that *Brooklyn* achieves for its auteur a distinct voice among black filmmakers while establishing the film's thematic continuity with black popular culture's avid exploration of black, urban (male) identities.

After disappearing for a while from the intellectual gaze of the American academy and being obscured from mainstream cultural view by the virulent narcissism of *nouveau riche* yuppies and the fragile gains of an increased black middle class, the ghetto has made a comeback at the scene of its defeat. The reinvention of American popular culture by young African American cultural artists is fueled by paradox: Now that they have escaped the fiercely imposed artistic ghetto that once suffocated the greatest achievements of their predecessors, black artists have reinvented the urban ghetto through a nationalist aesthetic strategy whose interpretative seam joins racial naturalism and romantic imagination. That the most recent phase of black nationalism is cultural rather than political suggests the extent to which the absorption of radical dissent into mainstream politics has been successful and expresses the hunger of black juvenile culture for the intellectual sources of its hypnotic and feral remix of pride and anger.

Mostly anger, and little pride, stirs in the fragmented lives of teenager Dennis Brown (Lawrence Gilliard, Jr.), his younger sister Carolyn (Barbara Sanon), and their parents Frankie (Ann D. Sanders) and Ray (George T. Odom). Each in his and her own way is the prisoner of an existential and ecological misery so great that its pervasive presence would suggest the impossibility of charting its affects and differentiating

its impact across the spectra of gender and class within the community. In Rich's dark ghetto, it *appears* that all such difference is smothered by the lethal hopelessness spread thickly over the lives of its inhabitants in equally devastating portions.

But the exception to this apparently equally shaded misery is the extraordinarily acute misery of black men, seen first in the cinematic chiaroscuro of Ray's descent into a Dantean hell of racial agony so absurd and grotesque that its bleakness is a sadistic comfort, a last stop before absurdity turns to insanity. Ray's gradual decline is suffered stoically by Frankie, a doleful throwback to an earlier and dispiriting racial era when the black-woman-as-suffering-servant role was forced on black women by black men forced to pay obeisance to white society who, when they came home, expected to claim the rewards and privileges of masculinity denied them in the white world. The only other model lifted to black women consisted of an equally punishing (and mythic) black matriarchy that both damned and praised black women for an alleged strength of character absent in their feckless male counterparts. Thus, the logic of black communities ran: As the black man's fate goes, so goes the fate of the family.

Brooklyn's implicit narrative line ties generously into the fabric of this ideological argument, drawing its dramatic punch and denouement from the furious catastrophes that sweep down on its black male characters, the defining center of the film's raw meditation on the angst of emasculation. Ray's frequent beatings of Frankie are rituals of self-immolation, her brutally bloodied countenance a tangential sign of his will to redefine the shape of his agony by redefining the shape of her face. Moreover, Ray's suffering-as-emasculation is further sealed by his denial of desire for white women during a Lear-like verbal jousting with an imaginary white man, a deus ex machina produced by his search for an explanation of his suffering and a dramatic ploy by Rich that ascribes black suffering to the omnipotent white bogeyman. And Dennis's out-loud soliloquies in the presence of his girlfriend Shirley (Reana E. Drummond) about his quest for capital to reverse his family's collapse belies a deeper need to redeem black masculinity by displaying his virility, his goal to be the man that successfully provides for his family allied disastrously with his gratuitous desires to "get paid."

A different tack was pursued in John Singleton's *Boyz N the Hood*. Singleton's neorealist representation of the black working class ghetto neighborhood provided a fluid background to his literate script, which condensed and recast the debates on black manhood that have filled the

black American independent press for the last decade. Abjuring the heavy-handed approach of negative racial didacticism, Singleton retraced instead the lineaments of the morality play in recognizable black cultural form, richly alluding to black particularity while keeping his film focused on The Message: Black men must raise black boys if they are to become healthy black men. Thus Tre (Cuba Gooding, Jr.), Ricky (Morris Chestnut), and Doughboy (Ice Cube), the three black males whose lives form the fabric of Singleton's narrative quilt, are the film's interpretative center, while Reva (Angela Bassett), Brenda Baker (Tyra Ferrell), and Brandi (Nia Long), the mothers of Tre, Ricky, and Doughboy respectively, and Tre's girlfriend occupy its distant periphery. Singleton's film—as is the case with most cultural responses to black male

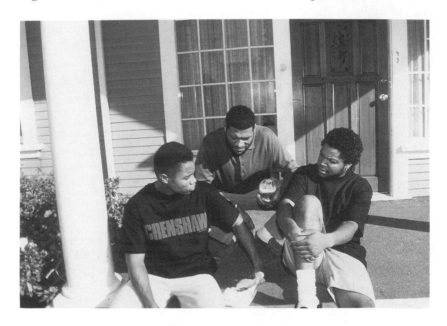

Tre (Cuba Gooding, Jr.), his father Furious (Larry Fishburne),
and his friend Doughboy (Ice Cube) in director John Singleton's *Boyz N the Hood*

crisis—is an attempt to answer Marvin Gaye's plea to save the babies, while focusing his lens specifically on the male baby that he and many others believe has been thrown out with the bath water to float up the river, like Doughboy and one out of four black men, into the waiting hands of the prison warden.

But Singleton's moral premise, like so many claims of black male suffering, rests dangerously on the shoulders of a ruinous racial triage: black male salvation at the expense of black female suffering, black male autonomy at the cost of black female subordination, black male dignity at the cost of black female infirmity. Once and for all, Singleton's film jarred into visibility the inadvertent yet unseemly alliance between black cultural nationalists and the cultured despisers of black women. His implicit swipe at black women ceded too much ideological territory and argued too little with white and black conservative social scientists who lament the demise of American culture because it is in the lethal embrace of welfare queens and promiscuous black women. The brilliant presence of Furious (the father of Tre, played by Larry Fishburne) as a redemptive and unswerving North Star and Brenda's uncertain orbit as a dim satellite offer the telling contrast in Singleton's cinematic world.

This premise would seem achingly anachronistic, the warmed up leftovers from black macho posturing painfully evident in sixties black nationalist discourse, were it not for its countless updates in the narrative strains of black juvenile culture, reified to patriarchal perfection in rap lyrics that denounce the racist dominance of white men while glorifying without irony black male material dominance and sexual mastery of black female life. Of course, the quest for black manhood is everywhere apparent in black culture; note its evocation as well in the upper climes of bourgeois respectability as the implicit backdrop to Clarence Thomas's claim of perfidy by Anita Hill, the innuendo of his charge only faintly arrested in the racial code of his undertone: another sister pulling a brother down. But it is with the reemergence of the ghetto in popular culture and its prominence in a revived black nationalist cultural politics, where, for better and worse, the images of black masculinity find a discursive home.

This is especially true of black film and rap music. The politics of cultural nationalism has reemerged precisely as the escalation of racist hostility has been redirected to poor black people. Given the crisis of black bourgeois political leadership and a greater crisis of black liberal social imagination about the roots of black suffering, black nationalist politics reemerge as the logical means of remedy and resistance. Viewed against this backdrop, black film and rap music are the heightened imaginary of black popular culture, the self-announced apotheosis of a black populist aesthetic that occludes the seepage of authentic blackness into diluted cultural expression.

Rap music grew from its origins in New York's inner city over a decade

ago as a musical outlet to creative cultural energies and to contest the invisibility of the ghetto in mainstream American society. Rap remythologized New York's status as the spiritual center of black America, boldly asserting appropriation and splicing (not originality) as the artistic strategies by which the styles and sensibilities of black ghetto youth would gain popular influence. Rap developed as a relatively independent expression of black male artistic rebellion against the black bourgeois *Weltanschauung*, tapping instead into the cultural virtues and vices of the so-called underclass, romanticizing the ghetto as the fecund root of cultural identity and authenticity, the Rorschach of legitimate masculinity and racial unity.

The sensibilities afforded by the hip-hop aesthetic have found expression in many recent black films. *New Jack City*, for instance, is rife with the feral fusion of attitude and style as the replacement of substantive politics that prevails among young black males, especially those profiting from the underground political economy of crack. Similar to *Boyz N the Hood*, with Ice Cube (Doughboy) and *Juice* with Tupac Shakur (Bishop), *New Jack City* appeals directly to the iconic surplus of hip-hop culture by drawing upon rapper Ice-T to convey the film's thinly supplied and poorly argued moral message: Crime doesn't pay.

Thus, Ice-T's "new jack cop" is an inside joke, a hip-hop reconfiguration of the tales of terror Ice-T explodes on wax as a lethal pimp, dope dealer, and bitch hater. The adoption of the interchangeable persona as the prerogative of mood and message in the culture of hip-hop is taken to its extreme with Ice-T's character: Even though he appears as a cop in New Jack City, his appearance on the soundtrack as a rapper detailing his exploits as a criminal blurs the moral distinctions between cops and robbers, criminalizes the redemptive intent of his film character (even more so retroactively in light of the recent controversy over his hit "Cop Killer" recorded with his speed metal band).

Director Mario Van Peebles's cinematic choices in *New Jack City* expose as well the vocabulary of overlarge and excessive cultural representation that characterized many ghetto films of old. Van Peebles's ghetto is a sinister and languid dungeon of human filth and greed drawn equally from cartoon and camp. The sheer artifice of *New Jack City*'s ghetto is meant to convey the inhuman consequences of living in this enclave of civic horror, but its overdrawn dimensions reveal its cinematic pedigree that can be traced more easily to seventies blaxploitation flicks than to the neorealist portrayal of carnage wreaked by the ghetto's bleak persistence presented in other recent black ghetto films.

As a black gangster film, *New Jack City* links its genre's appeal to the Cagneyization of black ghetto life, the inexorable force of woman-bashing and partner-killing sweeping the hidden icon of the people to a visible position larger than life. Thus Nino Brown (Wesley Snipes) reigns because he tests the limits of the American Dream, a Horatio Alger in black face who pulls himself up by forging consensus among his peers that his life is a ghetto jeremiad, a strident protest against the unjust limits imposed on black male material flourishing. As Nino intones with full awareness of the irony of his criminal vocation: "You got to rob to get rich in the Reagan era."

But it is the state of black male love that provides the story's unnarrated plot, its twisted pursuit ironically and tragically trumped by boys seeking to become men by killing each other. Thus, when a crying Nino embraces his teary-eyed closest friend and partner in crime, G-Money, on the top of the apartment building that provides the mise-en-scène for the proverbial ode to an empire gone, destroyed by the fatal winds of undisciplined ambition, Nino hugs G-Money tight, avowing his love even as he fills his belly with steel as recompense for G-Money's treacherous disloyalty. It is the tough love of the gang in action, the logic of vengeance passing as justice in gang love's final fulfillment of its unstated but agreed-upon obligations.

The mostly black and Latino gangs have also recaptured the focus of American social theory and journalism in the past decade. Urban sociologists such as New York's Terry Williams, in his important *Cocaine Kids*, and Los Angeles's Mike Davis, in *City of Quartz*, have written insightfully about the economic and social conditions that have led to the emergence of contemporary black and Latino gang culture, citing especially the yearning for love and social acceptance that animates such aggregation. And former-model-turned-journalist Leon Bing has interviewed Los Angeles gang members, who speak eloquently about their own lives in words as moving for their emotional directness as their honesty about the need for affection and comfort that drives them into mutual association. In *Straight Out of Brooklyn* and Ernest Dickerson's *Juice* the theme of black male love in the ghetto filtered through the prism of gang or crew association looms large.

In *Brooklyn*, Rich presents a loosely associated group of three black male teens, including Dennis, Kevin (Mark Malone), and Larry (played by Rich), who are frustrated by poverty and the closure of personal and vocational horizons that lack of money has come to signify. Whereas in *Juice* the crushing consequences of capital's absence is more skillfully

explored through the interactions between the characters—its damning effects as subtly evoked in the resonances of anger and gestures of surrender and regret weaved into the moral texture of the film's dialogue as they are dramatically revealed in the teens' action in the streets—in *Brooklyn,* money's power more crudely signifies in the lifeless representation of large material and sexual icons that dominate the landscape of dreams expressed by Dennis and his friends: big cars, more money, and mo' ho's.

The lifelessness of the ghetto is reified in the very textu(r)al construction through which the movie comes to us: Although it's in color, the film seems eerily black and white, its crude terms of representation established by its harsh video quality and its horizontal dialogue. Of course, the film's unavoidable amateur rawness is its premise of poignancy: After all, this is art imitating life, the searing vision of a nineteen-year-old Brooklyn youth, with little financial aid and the last-minute gift of film roll from Jonathan Demme (himself a renegade of sorts before his Hollywood breakthrough with the troubled *Silence of the Lambs*), committing his life to a film drawn partially from real-life events. This is the closest derivation in film of the guerrilla methods of hip-hop music culture, the sheer projection of will onto an artistic canvas constituted of the rudimentary elements of one's life in the guise of vision and message.

In *Brooklyn,* the triumvirate of teens is not a roving, menacing crew engaging in the business of selling crack rock and duplicating capitalism's excesses on their native terrain. Rather, they are forced by desperation to a momentary relief of their conditions by robbing a dope dealer, an impulse that is routinized and institutionalized in the crack gang, whose cannibalistic rituals of gunplay and murder feed on the lives of opponents out to seize their turf in the harrowing geopolitics of the drug economy.

The anomie and alienation produced by everyday forms of capitulation to despair, and the spiraling violence of Ray, force Dennis from his family to affectionate camaraderie with Larry and Kevin, and with Shirley. All other hints of family are absent, save Larry's barber Uncle, who unwittingly provides the ill-named getaway car for their ill-fated heist. But the existential vacuum at home for Dennis is made more obvious by Ray's attempt to preserve the disappearing remnants of a "traditional" family, angrily reminding Dennis after he misses dinner that his empty plate on the table symbolizes his membership in the family. But Rich shatters this icon of familial preservation into shards of ironic

judgment on the nuclear family, as Ray breaks the dishes and beats Frankie each time he becomes intoxicated.

Dennis's only relief is Shirley and his crew. When Shirley disappoints him by refusing to buy into his logic about escape from the ghetto by robbery, he turns to members of his crew, who in the final analysis leave Dennis to his own wits when they agree that they have stolen too much cash ("killing money," Kevin says) from the local dope dealer, an act whose consequences roll back on Dennis in bitter irony when the heist leads to his father's death. The film's dismal and inescapable conclusion is that black men cannot depend on each other, nor can they depend on their own dreams to find a way past their mutual destruction.

In *Juice*, the crew is more tightly organized than in *Brooklyn*, although their activity, like the teens from Red Hook, is not regularized primarily for economic profit. Their salient function is as a surrogate family, their substitute kinship formed around their protection of each other from rival gangs and the camaraderie and social support their association brings. But trouble penetrates the tightly webbed group when the gangster ambitions of Bishop threatens their equanimity. Of all the crew—leader Raheem (Khalil Kain), a teen father; Q (Omar Epps), a DJ with ambitions to refine his craft; and Steel (Jermaine Hopkins), a likable youth who is most notably "the follower"—Bishop is the one who wants to take them to the next level, to make them like the hard-core gangsters he watches on television.

Viewing Cagney's famed ending in *White Heat* and a news bulletin announcing the death of an acquaintance as he attempted armed robbery, Bishop rises to proclaim Cagney's and their friend's oneness, lauding their commendable bravado by taking their fate into their own hands and remaking the world on their own violent terms. Dickerson's aim here is transparent: to highlight the link between violence and criminality fostered in the collective American imagination by television, the consumption of images through a medium that has replaced the Constitution and the Declaration of Independence as the unifying fiction of national citizenship and identity. It is also the daily and exclusive occupation of Bishop's listless father, a reminder that television's genealogy of influence unfolds from its dulling effects in one generation to its creation of lethal desires in the next, twin strategies of destruction when applied in the black male ghetto.

Like the teens in *Brooklyn*, *Juice*'s crew must endure the fatal consequences of their failed attempt at getting paid and living large, two oft-repeated mantras of material abundance in the lexicon of hip-hop

culture. After Bishop's determination to seize immortality by the throat leads him to kill without provocation or compunction the owner of the store they rob, the terms of his Faustian bargain are more clearly revealed when he kills Raheem, destroying all claims of brotherhood with a malicious act of willful machismo, succeeding to Raheem's throne by murderous acclamation.

Dickerson, who has beautifully photographed all of Spike Lee's films, uses darker hues than characteristic of his work with Lee, but nowhere near those of the drained colored canvas on which *Brooklyn* is drawn. Dickerson's moral strategy is to elaborate to its fatal ends the contradictory logic of the gang as a family unit, a faulty premise as far as he is concerned which overlooks the lack of moral constraints that ultimately do not work without destructive consequences. His aesthetic strategy is to move the cameras with the action from the observer's frame of reference, borrowing a few pages from Lee's book without mimicking Lee's panache for decentering the observer through unusual angles and the fast pace of editing. Like Rich in *Brooklyn*, Dickerson wants the impact of his message to hit home, but he employs a less harsh method, a gentler but insistent drawing into his moral worldview, an invitation to view the spectacle of black male loss of love by degrees and effects.

In *Juice*, the ghetto working-class family is much more visible and vital than in *Brooklyn*. Mothers and fathers wake their children in the morning for breakfast and make certain they take their books to school. The extended family is even given a nice twist when Q fetches a gun from one of his mother's old friends, a small-time neighborhood supplier. And Dickerson draws attention subtly to the contrasts between the aesthetic and moral worldviews of the generations and the thriving of an earlier era's values among the younger generation at the dinner at Raheem's family's house after Raheem's funeral. As snatches of gospel music float gently through the house, Q and Steel pay their respects to Raheem's family.

When Bishop arrives, the rupture between generational values forces to the surface the grounds of choice upon which each of the remaining three crew must stand. Q and Steel are offended at Bishop's effrontery, his mean-spirited and near demented hypocrisy leading him to violate Raheem's sacred memory with this latest act born of unbridled machismo and hubris. For them, the choice is clear. The religious values signified in the quiet gospel music seem no longer foreign, gently providing a vivid counterpoint to the hip-hop aesthetic of violent metaphors in the service of greater self-expression.

Instead, the gospel music and the world of black respectability it symbolizes carry over into their grieving acknowledgment of the bonds between them and their departed friend, a sure sign of their surviving religious sensibilities bred from birth and inbred for life, no matter how distant they appear to be from its central effects. Bishop's traduction of Raheem's memory and family signify the depth of Bishop's moral failure, the unblinking abandon to which his wanton acts of violence have given portentous license. Unlike the black teens in *Brooklyn*'s ghetto, the black males can depend upon one another, but only after being forced to acknowledge their debts to the moral infrastructure given them by a predecessor racial culture, and only after discovering the limits of their freedom in destructive alliance with each other.

Unquestionably, the entire contemporary debate within black culture about black film and its relation to enabling or destructive representations of black males, and the consequences of the cinematic choices made about black females vis-à-vis these representations started with the meteoric rise of Spike Lee, a key flashpoint in the resurgence of black nationalism in African American culture. With Lee's groundbreaking *She's Gotta Have It*, young black men laid hold of a cultural and artistic form—the Hollywood film—from which they had with rare exception been previously barred. By gaining access to film as directors, young black men began to seize interpretative and representational authority from ostensibly ignorant or insensitive cultural elites whose cinematic portrayals of blacks were contorted or hackneyed, the ridiculously bloated or painfully shriveled disfigurements of black life seen from outside of black culture. Lee's arrival promised a new day beyond stereotype.

What we get with Lee is Jungian archetype, frozen snapshots of moods in the black (male) psyche photographed to brilliant effect by Ernest Dickerson. Lee's mission to represent the variegated streams of black life denied cinematic conduits before his dramatic rise, has led him to resolve the complexity and ambiguity of black culture into rigid categories of being that hollow his characters' fierce and contradictory rumblings toward authentic humanity. And after *She's Gotta Have It* black women became context clues to the exploration of black male rituals of social bonding (*School Daze*), the negotiation of black male styles of social resistance (*Do the Right Thing*), the expansion and pursuit of black male artistic ambitions (*Mo' Better Blues*), and the resolution of black male penis politics (*Jungle Fever*).

It was precisely Lee's cinematic representations of black male life that occasioned the sound and fury of proleptic criticism over his latest and

most important project: his film biography of Malcolm X. Writer and social critic Amiri Baraka drew blood in a war of words with Lee, claiming that Lee's poor history of representing black men suggested that he would savage the memory of Malcolm X, a memory, by the way, to which Baraka presumed to have privileged access. This battle between the two diminutive firebrands, ironic for its poignant portrayal of the only logical outcome of the politics of more-black-nationalist-than-thou, a game Lee himself has played with relish on occasion, was but a foretaste of the warfare of interpretation waged in light of Lee's portrait of X.

Malcolm X is the reigning icon of black popular culture, his autobiography the Ur-text of contemporary black nationalism. His legacy is claimed by fiercely competing groups within black America, a fact certain to make Lee's film a hard sell to one faction or the other. More importantly, X's complex legacy is just now being opened to critical review and wider cultural scrutiny, and his hagiographers and haters will rush forward to have their say once again.

To many, however, Malcolm is black manhood squared, the unadulterated truth of white racism ever on his tongue, the black unity of black people ever on his agenda, the black people in ghetto pain ever on his mind. Thus, the films that represent the visual arm of black nationalism's revival bear somehow the burden of Malcolm X's implicit presence in every frame, his philosophy touching on every aspect of the issues the films frame—drugs, morality, religion, ghetto life, and especially, unrelentingly, the conditions of being a black man. For many, as for his eulogist Ossie Davis, Malcolm was the primordial, quintessential Real Man.

But, as with the films of Dickerson, Lee, Rich, Singleton, and Van Peebles, this spells real trouble for black women and for an enabling vision of black masculinity that moves beyond the worst traits of X's lethal sexism. Gestures of X's new attitude survive in the short hereafter Malcolm enjoyed upon his escape from Elijah Muhummad's ideological straitjacket. Malcolm's split from the Nation of Islam demanded a powerful act of will and self-reinvention, an unsparing commitment to truth over habit. Lee's film reflects this Malcolm, though not in relation to his changed views about women. Although there are flashes of a subtly nuanced relationship between X and his wife Betty in Lee's film, as usual, Lee is silent on the complexities of black female identity.

Only when black films begin to be directed by black women, perhaps, will the wide range of identities that black women command be adequately represented on the large screen. Powerful gestures toward black

feminist and female-centered film production exist in the work of Julie Dash in *Daughters of the Dust* and especially in Leslie Harris's *Just Another Girl on the IRT*. Less successful is John Singleton's flawed *Poetic Justice*. But until the collapse of the social, cultural, and economic barriers that prevent the flourishing of black female film, such works threaten to become exceptional, even novelty items in the black cultural imagination. In the meantime, black male directors remain preoccupied, even trapped, by the quest for an enabling conception of black male identity. But its full potential will continue to be hampered until they come to grips with the full meaning of black masculinity's relationship to, and coexistence with, black women.

12

ADJUSTING TO THE WORLD ACCORDING TO SALMAN RUSHDIE

Ahmad Sadri

▬ What's the World Coming To?

In 1988 Salman Rushdie, an Indian born, Pakistani author who was educated in England, published *The Satanic Verses*, a highly stylized novel with vague references to events that had occurred some fifteen hundred years earlier at the dawn of Islam in the Arabian peninsula. The novel caused such a stir that very shortly afterwards it was hard to find a corner of the earth in which people were not expressing strong feelings of sympathy or antipathy toward the elusive subject of the novel and its hybrid author. Many of his compatriots in England, India, Pakistan, and, later, other Muslims all over the world denounced this novel as blasphemous for what they perceived to be its defamation of the Prophet of Islam, and they held demonstrations where more than a dozen people were killed.

Tracts were circulated and meetings held for and against the author everywhere. Finally an Ayatollah from Iran decreed that the Moslem born, naturalized British author had forfeited his life according to the tenets of Islamic law. Since then violent death has ended the life of the Japanese translator of the novel and the fear of it has ended Rushdie's life as a free man. He has tried, of course in vain, to mend fences with his Moslem critics by appearing to embrace Islam, only to later retract this move as the desperate decision of a weak moment. On a larger scale the Ayatollah's Fatwa, the religious edict that condemned Rushdie to death, has replaced the hostage crisis and the Iraqi campaign as the latest symbolic cornerstone of Iran's anti-Western posture and of its claim to leadership of the transnational community of Moslems. In yet a different theater, intellectuals the world over, feeling that their freedom is also jeopardized by Rushdie's death sentence, continue to go to great lengths to publicly demonstrate their discontent and to persuade their governments to pressure Iran to retract the Fatwa.

Let us remember that the main outline of this crisis was drawn within just a few weeks. Almost all of those who became emotionally invested in this affair, scattered as they were all over the planet and among divergent classes and ethnic groups, felt unthinkably abused; no one could believe the extent to which the offending party had gone either to trespass on their treasured liberties or to justify the profanation of their sacred prophet. More than a few might have seen an insidious enemy in their neighbor. Some must have realized that these days one no longer needs to be in politics in order to wake up to strange bedfellows.

Among the lessons we could learn from this sordid affair is the one about the state of the world that just a few decades ago promised to grow into a "global village." If what we inhabit is a global village, then it is one of armed clans feuding over real and imaginary issues in different languages but all couched in the universal rhetoric of violence. This is what the world has come to: *Never before have so many lived so closely to so many of whom they know so little.* Instead of realizing the lofty visions of modern philosophies that promised to emancipate and unify humankind in the spirit of universality and rationality, our world has turned into a Gulliverian archipelago of incommensurable cultural islands: some sinking, others growing hostile and apart. What can we say about the present state of the world in the wake of the failed promises of modernity, except to say that it is postmodern? The current mood of postmodernist social theory calls for dismantling the universalizing conceptual umbrellas of

our modernist forefathers and dismissing their ambitions to achieve a unified and rational global order as, at best, the false consciousness of Western hegemonic elites.

Salman Rushdie is more than a gauge of this century's disappointments; he is not merely the sundial passively marking the elongating shadows of modernism. Rushdie is also an activist. Indeed there is a sense in which Rushdie is a typical third world intellectual with modernist ambitions for writing politically relevant fiction and for representing the plight of his people. He once characterized *Satanic Verses* as a "secular, humanist vision of the birth of a great world religion." Rushdie soberly envisions Islam as a civil religion for Pakistan, but seems to be just as happy to see it supplanted with the mythologies of the French Revolution.[1] The modernist in Rushdie dismisses the postmodernist case made for religion as just another grand narrative among other grand narratives (e.g., history, economics, and ethics.) Rushdie's conscious mind is set in modernist dichotomies: "Battle lines are being drawn up in India today...secular versus rational, the light versus the dark. Better you choose which side you are on."[2] However, none of these explains the magnitude of the reaction Rushdie has provoked among Moslems. After all he is not the only contemporary secular author in the Islamic world who has nursed doubts about the origin of Islam and its role in the modern world.[3] The volatility of the *Satanic Verses* consists not in its modernist criticism of Islam, but in its framing of modernist doubts in the compass of postmodernist fiction, where text and context are deliberately conflated. It is Rushdie's unsurpassed talent for this kind of amalgamation that causes the world incarnated in his fiction to easily merge with the one he aims to shape. Rushdie's talent for collapsing fact and fiction is more than successful; it is indeed daunting.

Rushdie's Postmodern Spectacle of "Magical Realism"

In blurring the line between reality and fantasy Rushdie goes beyond presenting an involuted spectacle to infuse both reality and his imaginings. From the very beginning of his career Rushdie has mined the vein in which grand history is crystallized into personal biography. In his second and most successful novel *Midnight's Children* we hear the dominant voice of its narrator Saleem:

> I am the sum total of everything that went before me, of all I have seen done, of everything done to me. I am everyone, everything whose being-in-the-world affected [and] was affected by mine...to

understand me you have to swallow a world.[4]

The subjective character of this merger of reality and fantasy finds an echo in an innocuous allegory of *Midnight's Children,* where storytelling is likened to the cozy practice of pickling bitter memories in jars of chutney.[5] But *Satanic Verses* is not a cozy book. It rejects the celebrated romantic chore of conserving memories in a Proustean fashion. *Satanic Verses* is an infernal cement mixer that indiscriminately blends heaps of historical happenings with long yarns of magical escapades. Like a wayward project out of a science fiction movie, it spins out of control, swallows its inventor, and, snapping into reverse, turns fiction into fact, procreating episodes of persecution of blaspheming poets and writers by angry prophets and exiled Imams. This is magical realism[6] at its eeriest: The fate of Salman merges with that of his namesake in the book; what is in the book happens to the book. No postmodern theorist or magical realist author has so ably demonstrated the confluence and collapse of a universe of discourse and its referent. To say that this is not what Rushdie planned is to admit that his "demonic gift" is beyond his command: "It is hard to express how it feels to have attempted to portray an objective reality and then to have become its subject...."[7]

As literary sensibilities, postmodernism and magical realism are eminently conducive to Rushdie's concerns: recounting the bizarre life experiences of the exiled elite of a formerly colonized people striving to reevaluate a culture that has long lost its magic of "self-evidence." In Rushdie's imaginative fables we share an agnostic elite's scheme to at once go into exile and solve the mysteries of its identity, to follow in the footsteps of the protagonist of Tennessee Williams's *The Glass Menagerie* who left a troubled home "to find in motion what was lost in space."[8] The tidings of the disintegration of the unique individual are indeed good news for the stratum of intellectually deracinated and culturally alienated elites. From such a standpoint, what is simpler than concluding that counterfeits do not exist in the absence of an authentic copy and deciding in favor of dissolving, rather than resolving, the difficult question of identity? However, to the lost at sea the news that all shores are imaginary will sound hollow if soothing. The postmodern denial of the unique subject of experience, sweet as it might sound, is too flippant a solution for dealing with the real pain of living in exile and encountering the crudest sort of prejudice, racism, and bigotry. No matter what theory of the self one subscribes to, it is still hard to serenely file away a look of disdain or a snide remark. Thus Rushdie

and his fictional avatars, and above all Saladin of *Satanic Verses* (whose fate we will consider shortly), dally with these ideas without being able to take them quite seriously, especially when the proverbial push comes to shove.

There are recurrent thematic allusions to the postmodern condition in Rushdie's fiction: end of order, objectivity, and rational sequences of events. *Satanic Verses* starts with a postmodernizing Big Bang that sends the main protagonists of the story, Gibreel and Saladin, flying amid a cloud of out-of-context commodities and people:

> Above, behind, below them in the void there hung reclining seats, stereophonic headsets, drinks trolleys, motion discomfort receptacles, disembarkation cards, duty-free video games, braided caps, paper cups, blankets, oxygen masks...mingling with the remnants of the plane, equally fragmented, equally absurd, there floated the debris of the soul, broken memories, sloughed-off selves, severed mother-tongues, violated privacies, untranslatable jokes, extinguished futures, lost loves, the forgotten meaning of hollow, booming words, land, belonging, home.[9]

The explosion does not create but merely makes explicit the chaos that permeates the life of Rushdie's migrating protagonists. The most important pieces in this potpourri of gliding objects are shards of formerly solid cultural and national identities. Even the terrorists who blow up the plane have no idea who they are: "They want to behave the way they have seen hijackers behaving in the movies and on T.V."[10] The question of "identity" is as pivotal in Rushdie's *Satanic Verses* as it was in his earlier works, but the postmodernist setting of this book puts a new spin on old questions. It is significant that the main protagonists of *Satanic Verses* are both actors, professional imitators of others. Gibreel is a movie actor, the "creature of surfaces."[11]. Saladin works for commercial radio as the disembodied voice of advertised commodities. As postmodern heroes, Rushdie's protagonists nurse doubts about the existence of an authentic self behind their many masks. However, disavowing selfhood as a modernist myth, comforting as it might be, does not expunge their desire for a naive, but well rooted and neatly delineated "self."

In his nonfiction writings Rushdie often prevaricates on the subject of an authentic self, rooted in a "home," and of the possibilities of undivided selves and identities. He confides in his Nicaraguan travel notes: "The idea of home had never stopped being a problem for me."[12] In a more nostalgic moment he even envies a friend's sense of belonging: "How wonderful still to have contact with the house in which you grew

up."[13] Then again Rushdie does not believe in the myth of roots:

> [T]o explain why we become attached to our birth places we pre-
> tend that we are trees and speak of roots. Look under your feet.
> You will not find gnarled growths sprouting through the soles.
> Roots, I sometimes think, are a conservative myth, designed to
> keep us in our places.[14]

In his evocative critique of *The Wizard of Oz*, Rushdie starts with nostalgi-
cally recounting childhood memories and mourns the loss of the first
story he wrote. Yet his heart is in the land of Oz and scoffs at the idea of
Dorothy's return to gray old Kansas, chiding the good fairy for prodding
our heroine to go back home:

> Glinda: That's all it is....Now those magic slippers will take you
> home in two seconds....Close your eyes and tap your heels togeth-
> er three times...and think to yourself...there is no place like..."
> Hold it.
> How does it come about that at the close of this radical and
> enabling film...we are given this conservative little homily? Are we
> to think that Dorothy has learned no more on her journey than
> that she didn't need to make such a journey in the first place? Must
> we believe that she now accepts the limitations of her home life,
> and agrees that the things she doesn't have there are no loss to
> her? "Is that right?" Well, excuse *me* Glinda, but it is not.[15]

His ambivalence between longing for belonging and rejection of this cul-
tural nostalgia finds fictional flesh in the fates of the two protagonists of
Satanic Verses.

Rushdie's Modern Search for an Authentic Self

The champions of *Satanic Verses* are torn between two urgent tasks:
reevaluating, possibly jettisoning the baggage of tribal convictions, on
one hand and preserving or redefining a sense of identity in the con-
text of their Western surroundings on the other.[16] Like Rushdie's earlier
fictional avatars, Gibreel and Saladin suffer from *inner voids*, caves carved
out by the corrosive currents of self-doubt. The author himself is familiar
with this affliction but succeeds in filling the lacuna with literature:
"literature is...the art most likely to fill our god-shaped holes."[17] But the
precious ether of literature does not permeate the spiritual cavities of
Rushdie's fictional extensions. What fills the holes in the soul? Rushdie
first explored this curious question in the personage of Adam Aziz, the
Western-educated grandfather of Saleem, the narrator of *Midnight's*

Children. As a fallen Muslim:

> [H]e resolved never again to kiss earth for any god or man. This decision, however, made a hole in him, a vacancy in a vital inner chamber....Many years later...the hole inside him had been clogged up with hate....[18]

Gibreel and Saladin of *Satanic Verses* are also fallen Muslims before they fall from their West-bound, exploding jetliner. This second fall turns them inside out: They are metamorphosed. Gibreel, the phlegmatic, perverse dreamer of the sacred history of Islam grows a subtle halo and becomes an angel, while Saladin, the bilious, self-conscious immigrant develops into a two-legged goat, a cross between a domestic animal and a devilish oaf. Despite this initial advantage, Gibreel continues to compulsively plow his inner wilderness and inexorably slips toward the abyss of insanity. His rebellion involves serial visions that recreate the birth of Islam in the harsh light of agnostic impiety and defiant irreverence. Like the main protagonist of Rushdie's first novel, *Grimus,* Gibreel takes his doubts to their logical conclusion: open contempt, profanity, and desecration.[19] These sanctimonious meanderings in the quicksand of his inner void, these blaspheming nightmares finally overwhelm him. Despite his grave doubts about his own religion, Gibreel is disdainful of the West. The introverted Gibreel does not notice let alone wish to flatter foreign gods. His problem, like his illness and metamorphosis, are elusive, culturally private, and socially privatizing. Possessed by his dreams about Islam he loses touch with his Western surroundings. In other words, throughout the saga of falling from the jetliner and his metamorphosis he is busy having a nervous breakdown.

Saladin's main crusade, however, is not against the demons of his inner void. His symptoms, expressed in the nature of his conspicuous metamorphosis, are public and intercultural. Unlike Gibreel, Saladin is a hard working immigrant intent on making it in a strange, inhospitable land. As a seasoned traveler of cultural spaces he is familiar with strategies of surviving as an outsider. He is the bona fide displaced man who fakes, therefore is: "[D]isplaced persons are like that, you know. Always counterfeiting roots. Still, if a false front is thick enough, it serves."[20] As a voice contortionist for British radio, Saladin relishes the deluge of fluid and interchangeable selves that allow him to make up "false descriptions to counter falsehoods invented" for him and his ilk.[21] But this is only a smoke screen for obscuring an inner conflict. Among his collection of false selves there is a well-polished Briton, a fully assimilated, "goodand-

proper" Oxford-accented Saladin who has secretly usurped the seat of his former native self. The suppressed native within, resenting his defeat, lurks at subliminal crevices of consciousness intent on exposing the charade. At the outset of *Satanic Verses* Saladin falls asleep in the soon-to-be-exploded jumbo jet:

> At this point an air stewardess bent over the sleeping Chamcha and demanded, with the pitiless hospitality of her tribe: *Something to drink, sir? A drink?*, and Saladin, emerging from the dream, found his speech unaccountably metamorphosed into the Bombay lilt he had so diligently (and so long ago!) unmade. "Achha, means what?" he mumbled. "Alcoholic beverage or what?" And, when the stewardess reassured him, whatever you wish, sir, all beverages are gratis, he heard, once again, his traitor voice: "So, okay, bibi, give one whisky soda only."[22]

Here Saladin displays his resonant self-hatred: "Damn you India…to hell with you, I escaped your clutches long ago. You won't get your hooks into me again. You cannot drag me back."[23] And again: "Damn all Indians…those bastards. Their lack of *bastard* taste."[24] Even when he is transformed into a revolting and smelly two-legged goat, he repays his Indian benefactors who offer him shelter and the consolation of being among his own people by thinking: "I am not your kind…you're not my people. I've spent half my life trying to get away from you."[25] And even under the brutish blows of the British police, who bludgeon the deformed Saladin and taunt him with racial epithets, he finds time for self-loathing fantasies.

> The humiliation of it! He was—had gone to some lengths to become—a sophisticated man! Such degradations might be all very well for riff raff from villages in Sylhet or the bicycle-repair shops of Gujranwala, but he was cut from different cloth![26]

Through his ordeal, however, Saladin is gradually disenchanted with the vision of himself as an integrated British gentleman. Unlike Gibreel's private psychosis, the transmutation of Saladin is a sociological and intercultural disease. During his excruciating metamorphosis Saladin remains painfully connected to his social environment; he is aware of his loss of "face." It happens not only in full view of his Western hosts whose approval he has always sought, but appears to have been caused by them. In a British medical menagerie where Saladin ends up, a fellow mutant-native, another victim of the gaze of the Westerners, reveals the etiology of their common disease: "They describe us, that's all. They have the

power of description, and we succumb to the pictures they construct."[27]

It finally dawns on Saladin: he is not, probably never was, such a "goodandproper Englishman."[28] This deepens his hatred for his dual (Indian and British) selves and their respective origins. But unlike Adam Aziz of *Midnight's Children* who just let hatred clog his inner cavities and ended up a jaded and embittered man, *Saladin is empowered by his hatred.* He freely turns his self-hatred into resentment toward the civilization that instead of returning his love and respect has bedeviled and humiliated him.[29] It is Saladin's "fearsome concentration of hate" that finally reverses his humiliating metamorphosis.[30] Thus, in a marked contrast to the whining tones of *Midnight's Children*, Saladin concludes a litany of his miseries with startling assertiveness.

We must remember that Salman Rushdie's novels are peopled with freaks, of nature and culture, psychotics, and mutants. These afflictions are often stigmatic; they are brands left on individuals by a sociohistorically determined fate. Saleem, the dominant voice of *Midnight's Children* is a half-British bastard, born with deformities and a gift for feeling pain, among other things, acutely. Saleem is the closeted Dorian Gray's picture of his society: Social repression and historical catastrophes brand him and each new one adds deformities to his collection of handicaps, leaving him to whine:

> [N]ine-fingered, horn-templed, monk's-tonsured, stain-faced, bow-legged, cucumber-nosed, castrated, and now prematurely aged, I saw in the mirror of humility a human being to whom history could do no more, a grotesque creature who had been released from the preordained destiny which had battered him until he was half-senseless.... [31]

Sufiya the idiot heroine of *Shame* and Gibreel of *Satanic Verses* are also psychotic showcases of sociohistorically relevant repressions and tensions. In *Satanic Verses*, however, hatred becomes the cathartic catalyst for Saladin's healing.

> When you've fallen from the sky, been abandoned by your friend, suffered police brutality, metamorphosed into a goat, lost your work as well as your wife, learned the power of hatred and regained human shape, what is there left to do but as you would no doubt phrase it, demand your rights.[32]

Rushdie is right in calling the *Satanic Verses* an optimistic book because only Saladin among all of Rushdie's fictional offspring suc-

ceeds in breaking the vicious circle of violence, alienation and oppression by discovering that hatred is the antibody of oppression: its symptom as well as its antidote.[33] Only in *Satanic Verses* and with Saladin do rage and hatred become something of a cleansing force for rehabilitating the victims of interhistorical injustice. Rushdie's obscure note in *Grimus* that "hatred is the nearest thing on earth to power"[34] and many similar thoughts in *Midnight's Children* reverberate throughout *Satanic Verses*. In this sense Rushdie's fiction and especially his last major novel is, among other things, literature about hatred, its varieties and its destructive as well as constructive properties. Such literature about hatred is not "hate literature," although it may be interpreted as such. But why?

Satanic Verses chronicles the fabulous ventures of two uprooted men who cross the no-man's-land of doubt, exile, and disillusionment. Passages that have offended most Moslems are just that: passages, brief sojourns of a perplexed tramp without a guide. Gibreel's defiant return to the temple of his tribal creed damns him to madness and death. But Saladin, having conquered his hatred, returns to makes peace with his Eastern roots. It is true that, compared to Gibreel's colorful adventures, Saladin's salvation lacks luster. His rehabilitation and his return "home" are anticlimactic and unconvincing. We never find out exactly *how* Saladin harnesses his anger to redeem himself, nor are we given a persuading picture of Saladin's recovery, return, and rediscovery of filial and romantic love. Rushdie is in his element when describing victimization, rage, and rebellion; but he is not terribly inspiring when donning the mantle of positive thinking.

If this is a weakness Rushdie is in good company. Few writers since Gogol have felt compelled to write edifying fiction. This is probably the way it should be, but with two caveats:

■Thanks to the coincidence of the advancement of the means of transportation and communication, on one hand, and the persistence of most of our tribal convictions, on the other, works of art and intellect with little or no political intent are increasingly likely to set in motion emotional waves in unforeseen and unintended audiences. Artists and writers must beware that they now live and create in, to borrow a term from phenomenological sociology, the "co-presence" of strangers: unknown, unseen, and often misunderstood "Others," who are just as likely to misunderstand what is said to or about them.

■The writer who wishes to accomplish political goals through writing or express political ideas thereby, has already stepped into a global

arena. Such a person is considered a "political actor," and as such must gauge the limits of what can be said in view of how his or her words might be interpreted. As a political actor, the writer can not shrug off "responsibility" for his or her action nor plead ignorance nor hide behind the shield of artistic and intellectual immunity. For this reason "freedom of expression" is an inadequate defense of Rushdie. Of course, in an ideal world one must be free to write much less edifying prose than his. The operative words in this maxim, however, are "ideal" and "must." To confuse believing in the desirability of an ideal and acting as though it has been achieved is recklessness on the part of the apolitical aesthete. Such confusion is inexcusable, and can be even disastrous, for anyone who ventures to engage in politics through writing.

Rushdie, His Liberties and Responsibilities

During the fall of 1992, which I spent in Iran, the immense curiosity of my students and colleagues about the forbidden author's work propelled me to agree to give a public lecture about it. Then a sudden political turn of events caused the postponement of this talk. A campaign was waged by the extreme right-wing daily *Keihan* against the "moderates" who favored economic reform and were conducting semi-clandestine negotiations with the World Bank officials in Tehran. The right-wingers decided to use the Fatwa against Rushdie as a rallying point, both to symbolize the uncompromising attitude of Iran and make sure that it remained in place as an obstacle in the way of normalization of relations between Iran and the West. I could not help but nod at Rushdie's complaint that his book had become a political football. But this is misleading. Rushdie's book was already causing quite a tempest months before it became the means of scoring easy political points. Indeed, my own interest in Rushdie was generated not by Rushdie's fiction but by the Rushdie controversy. Unable to find myself as an Iranian and a Moslem represented in the ghastly contracts put out on Rushdie I took to reading the compendium of his works. I never doubted that understanding Rushdie as a writer could be separated from understanding him as a social and political phenomenon.

Despite my sympathetic reading of Rushdie's book in respect to the question of blasphemy I question his judgment as a political actor. How could the author who had portrayed the bloody language riots of India doubt that Gibreel's dream sequences would raise more than eyebrows there? Could Rushdie have been naïve about the consequences of tinkering with much more explosive subjects, such as the authenticity of the

holy books? Did he really expect his novel to engender enlightened debate and at worse a few unfavorable reviews in a country where the last major religious massacres did not occur five centuries but five decades ago, and where blood still flows over the question of whose holy temples were built over whose? Or maybe he thought he was writing only for a Western audience. In this case, how long did he think he could straddle the fence and convert one side's live ammunition into the other's fireworks?

Even if we grant that Rushdie could not possibly anticipate the extent of the opposition to his *Satanic Verses*, his argumentative attitude toward the events precipitated by the book is puzzling. More than a dozen people had been killed in India and bloodier riots were anticipated when Prime Minister Gandhi decided to ban the book. This was a painful political decision aimed at preventing violence and preserving human life at the expense of the principle of freedom of expression, a kind of difficult balancing act that constitutes the essence of most political decisions. If the tone of the intellectual discourse about Rushdie is anything to go by, it must be concluded that most Western observers fail to see the significance of Mr. Gandhi's decree. After all it is not a Western sacred cow that is being gored here. One must not, therefore, judge the strength of libertarian tendencies in the West by how many support Rushdie's unconditional right to freedom of expression.

Considered in context, this question is at least as thorny as the issue of race relations in the United States. Every public remark, expression and even joke is carefully monitored for implied racism in a way that is hard for outsiders to understand. To give just one graphic example, D.W. Griffith's 1915 masterpiece *The Birth of a Nation* provoked indignant dissent from many African Americans who protested the mockery of their history in this otherwise grand exercise in the art of filmmaking. Nor did the director's forays against *Intolerance*, following his bigoted portrayal of blacks in *Birth of a Nation*, win him many supporters, especially liberal ones. The complex controversies in the U.S. over certain rap artists' fantasies about women, quotation of sections from *Mein Kampf* in a student newspaper, trampling the American flag in an art show, and displaying pictures of a crucifix immersed in urine also indicate that an absolute decision in Rushdie's favor by Western observers may be due to cultural distance more than anything else.[35]

Why did Rushdie denounce Mr. Gandhi's decision in writing? Indeed, his position is very clear: Adherence to the principles of liberty and freedom of expression without compromise and irrespective of the cost even

in human life. As a dogmatic position—not a political stance—this move leaves its author with a righteous aftertaste of having done the right thing without paying the price. Yet it is not Rushdie that sets this tone. Rather, he suffers from a common condition that prevails in contemporary Western circles: the lack of a tradition for political engagement by intellectuals.

In the wake of the sixties' shallow fad of dabbling in politics by purveying slogans and folk songs, and especially in the wake of the demise of the Stalinist strictures of socialist realism, nothing is easier than castigating (as kitsch or totalitarian) the idea of intellectual and political engagement, except when dealing with such ostensibly noncontroversial issues as preservation of the environment. Thus intellectual and artistic political expression has been reduced to making erratic gestures and throwing puerile tantrums—in short, acting out.

If politics is the art of the possible, political writing must also explore ways of achieving what is possible rather than dogmatically insisting on what (aesthetically, logically, or ethically) ought to be. The core of intellectual engagement is the acceptance of moral "responsibility" for both anticipated and unanticipated consequences of one's expressions. Only in the presence of a tradition of political engagement will it become self-evident that to be "responsible" and nondogmatic about one's sense of aesthetic calling and political mission does not necessarily amount to compromising one's integrity. The absolutism of those who come to the world with passion, unadulterated will, and the purest intentions to save it often yields horrific consequences. Many catastrophes in the recent history (especially the history of the twentieth-century social movements and revolutions envisioned and heralded by intellectuals) can be traced back to the certainties of sincere and uncompromising believers who backed into the arena of political action while keeping their gaze on some high ideal. Such people are apt not only to precipitate calamities but also to relinquish responsibility in the face of the complications they have created, blaming the absurdity of the world for refusing to abide by their commandments. Our century has surely seen enough of this kind of irresponsibility and of those who are involved in creating their ideal world too much to deem the existing imperfect one worthy of saving. Political action is often monotonous and quite unheroic. It is far from a knightly quest, an uncompromising crusade in shining armor against darkness and evil. It involves choosing goals and soberly assessing the possibilities for their achievement. Political action requires balancing the positive and

negative consequences of any action and possibly retreating from a perilous path. Compromise may be a dirty word in the universe of artistic and intellectual endeavor, but it is a practical and moral necessity in the world of responsible politics.

None of the above lessons are new to students of politics who have meditated upon such texts as Max Weber's "Politics as a Vocation,"[36] but politically inclined intellectuals are advised to review them in light of the current vacuum in political mores. The task of such a political actor is creative and patient engagement with issues and involvement in genuine debate with those who need it most but happen to live beyond the pale of intellectual or intellectuals' culture. Far from an invitation to docility and compromise, this is a challenge to undertake the heroic task of modifying one's message in view of its possible effects and consequences: to synthesize artistic creativity and political effectiveness without sacrificing one for the sake of the other. The price for becoming socially relevant and politically influential is to take the long and arduous path of responsibility and adjustment. This approach demands the more difficult route of challenging and educating instead of the shortcut of shocking and alienating. Even pure aesthetes must face the music and realize that their romantic ivory tower of art and intellect has long been open to herds of uncouth sightseers. To neglect unwanted (or, in the case of political art, the wanted) audiences, or to wishfully reinvent them as more tolerant, knowledgeable, and open than they are, constitutes the melting core of many of our current cultural Chernobyls, including the one that has consumed Salman Rushdie.

My aim in this article has been to shed light on the import of Salman Rushdie's work and on the concept of political engagement that this affair has occasioned. I have assumed a Western audience for this paper. But I also belong to the Iranian and Moslem communities, and as such I feel responsible for facilitating the badly bungled task of creating a dialogue between quite dogmatic sides. I appeal to Ayatollah Khamenei to heed the letter and spirit of his own decree of February 17, 1989, in which he judged Rushdie as pardonable, and to repeal his death sentence. As a Moslem I would like to remind my fellow Moslems of the damage that has been done to their communities as a result of this bitter confrontation and urge them, even if they do not share my reading of Rushdie's intent in discussing the issues relating to blasphemy, to overlook him altogether in their time-honored tradition of tolerance (*Tasamuh*). I ask them to regard Rushdie's writings not as a sworn enemy's vilification but as "admonitory evidence" (*Ebrah*) relating the

torments of a soul lost to what he calls "soft siren temptations" of Occidental shores.[37]

Notes

1. Salman Rushdie, *Shame* (New York: Vintage Books, 1983), 277, 278.
2. Salman Rushdie, *The Satanic Verses* (New York: Vintage Books, 1988), 537.
3. For instance Ali Dashti the writer of *Bisto Seh Sal*, a mercilessly critical biography of prophet Mohammad, was briefly held, interrogated, and released by the authorities at the outset of the triumph of the Islamic Revolution when fundamentalist sentiments were at their highest.
4. Salman Rushdie, *Midnight's Children* (New York: Avon Books, 1980), 457–458.
5. Rushdie, *Midnight's Children*, 459–460.
6. This term that was first coined in 1925 by the German art critic Franz Roh to define the German post-Expressionist painting and has been appropriated by literary critics seeking to describe the brand of Latin American literature exemplified by Allende, Asturias, Carpentier, Márquez, and Amado, among others. In "Magic Realism and Garcia Marquez's Erendira," *Literature and Film Quarterly*, 17, no. 2 (1989): 113–122, Seymour Menton enumerates the characteristics of this style thus: 1) reality is portrayed so overwhelmingly realistically that it is rendered illusive; 2) ordinary, material things are instilled with seemingly magical powers, yet remain easily identifiable; 3) objective perspective becomes the basic point of view; 4) "coldness" is a major component, that is, the works lack passion; they appeal intellectually, not emotionally.

 Menton elaborates: "Luis Leal points out that in 'magic realism' unlike in fantastic literature mysteries do not intrude on accepted reality from some nether dimension, but are rather an intrinsic part of that reality. The magic-realist writer, Leal stated, confronts reality in order to extract and capture those mysteries which, since they are innate to the reality, need not be explained nor justified. Thus the mysteries of reality are presented in a mostly matter-of-fact manner, suggesting a kind of 'pre-scientific' view of reality" (115–116).
7. Salman Rushdie, "In Good Faith," *Newsweek* 115 (February 12, 1990), 56.
8. Tennessee Williams, *The Glass Menagerie* (New York: Signet Books, 1987), 137.
9. Rushdie, *The Satanic Verses*, 4.
10. Rushdie, *The Satanic Verses*, 78.
11. Rushdie, *The Satanic Verses*, 27.
12. Salman Rushdie, *Jaguar Smile* (New York: Penguin, 1987), 86.
13. Rushdie, *Jaguar Smile*, 130.
14. Rushdie, *Shame*, 90.
15. Salman Rushdie, "Out of Kansas," *The New Yorker* (May 11, 1992), 103 .
16. Rushdie's conversion to Islam was widely condemned as cowardly and self-

contradictory, and he has since accepted these assessments and regretted his decision as a poor choice in a moment of weakness. But the comforts of return to a "home" remains an ideal that Rushdie has never denied his fictional prodigal sons, and why should he be forced to deny it, even as a temporary harbor, to himself?

17. Salman Rushdie, "Is Nothing Sacred?" The Herbert Read Memorial Lecture, February 6, 1990, published in *New Perspectives Quarterly*, 8, no. 2 (Spring 1991), 8.

18. Rushdie, *Midnight's Children*, 4, 5.

19. The protagonist of *Grimus* journeys back to the temple of his tribal deity to rape its Goddess and defile and desecrate it in order to regain his freedom. Salman Rushdie, *Grimus* (New York: Penguin, 1991).

20. Rushdie, *Grimus*, 99, 100.

21. Rushdie, *Satanic Verses*, 49.

22. Rushdie, *Grimus*, 34.

23. Rushdie, *Grimus*, 35.

24. Rushdie, *Grimus*, 137.

25. Rushdie, *Grimus*, 253.

26. Rushdie, *Grimus*, 159.

27. Rushdie, *Grimus*, 168.

28. Rushdie, *Grimus*, 43.

29. Rushdie, *Grimus*, 401.

30. Rushdie, *Grimus*, 294.

31. Rushdie, *Midnight's Children*, 534.

32. Rushdie, *Midnight's Children*, 401-402.

33. This solution seems to be present, albeit in embryonic form, in Rushdie's earlier novels. The discovery of his rage restores a modicum of humanity to Saleem of *Midnight's Children*: "I discovered anger....Wrath enabled me to survive the soft siren temptations of invisibility; anger made me determined...to begin, from that moment forth, to choose my own, undestined future...." Yet the discovery of the healing effects of his anger is short-lived and comes too late: "Tonight, as I recall my rage, I remain perfectly calm; the Widow (Mrs. Gandhi) drained anger out of me along with everything else" (456-457.)

 Before Saladin's reformulation in *Satanic Verses*, anger is incapable of restoring humanity and subjectivity to the victims of history and society. It only provides a humane interlude worthy of Saleem's biographical note: "[I]n fairness to my wrath, I must record that it claimed one instant achievement....I had been rescued by rebellion from the abstraction of numbness....I realized that I had begun, once again, to feel"(458). The marginal importance of rage is also present in *Shame*. Sufia's violent outbursts merely vent her pent up emotions and temporarily relieve rather than cure her.

34. Rushdie, *Grimus*, 258.

35. In addition to issues of "sensitivity" that impose a good deal of informal control on what is artistically expressed, there are legal safeguards that

work within each society and may be extended globally. For instance, in the U.S. one can not invoke freedom of expression in instances where speech incites injury or causes panic. A variation of this legal maxim could be applied by Mr. Gandhi to justify his banning of *Satanic Verses* in India. There are other occasions when differences in legal traditions may pose difficulties. Professor Ali Mazroui ("The Satanic Verses of a Satanic Novel?," [lecture delivered on March 1, 1989, at Cornell University and published by the Committee of Muslim Scholars and Leaders of North America, Brooklyn, NY.]) has called attention to a peculiarity in the Western legal tradition: Although freedom of expression does not allow defamation or libel of a living person, no such protection is offered the dead even if he or she is revered as a saint or prophet.

36. Max Weber, "Politics as a Vocation," *From Max Weber: Essays in Sociology*, eds. H.H. Gerth and C. Wright Mills (New York: Oxford University Press, 1958), 77-128.
37. See footnote 32.

PART THREE
Theorizing the Future

13

BENETTON'S "WORLD WITHOUT BORDERS"
Buying Social Change

Henry A. Giroux

▬▬▬ Small Beginnings and Global Controversies

> Diversity is good...your culture (whoever you are) is as important
> as our culture (whoever we are).
>
> —*Colors*, no. 1

In 1965, Luciano Benetton and three siblings established a small business,
Fratelli Benetton, near Treviso, Italy. Originally designed to produce
colorful sweaters, the business expanded into a full range of clothing
apparel and eventually developed into a two billion dollar fashion
empire producing eighty million pieces of clothing a year for seven thou-
sand franchise stores in over one hundred countries.

Benetton's advertising campaign over the last decade has been instru-
mental in its success in the fashion world. The advertising campaign is
important not merely as a means for assessing Benetton commercial suc-
cess in extending its name recognition; it is crucial for understanding
how the philosophy of the company has attempted to reinscribe its image

188 the subversive imagination

within a broader set of political and cultural concerns. In 1984, Benetton hired Oliviero Toscani, an award-winning photographer, to head its advertising campaign. Given a free hand with the advertising budget, Toscani's early work focused on culturally diverse young people dressed in Benetton attire and engaged in a variety of seemingly aimless and playful acts. Linking the colors of Benetton clothes to the diverse "colors" of their customers from all over the world, Toscani attempted to use the themes of racial harmony and world peace to register such differences within a wider unifying articulation.

In 1985, Toscani adopted the "United Colors of Benetton" as a recurring trademark of the Benetton ideology. In 1991, Toscani initiated a publicity campaign that removed Benetton merchandise from the firm's advertising, and started using its eighty million dollar global ad budget to publish controversial and disturbing photographs in magazines and on billboards. Taking full control of the ad blitz, Toscani personally photographed many of the images that dominated the 1991 Benetton campaign. These included a number of compelling images that created a provocative effect: variously colored, blown-up condoms floating in the air; a nun kissing a priest on the lips; a row of test tubes filled with blood; and a newborn baby girl covered in blood and still attached to her umbilical cord. In 1992 Toscani embarked on his most dramatic effort to combine high fashion and politics in the service of promoting the Benetton name. He selected a series of highly charged, photojournalistic images referencing, among other things, the AIDS crisis, environmental disaster, political violence, war, exile, and natural catastrophe. These appeared in various journals and magazines as well as on billboards without written text except for the conspicuous insertion of the green and white *United Colors of Benetton* logo located in the margins of the photograph.

Benetton's shift in advertising strategy between 1983 and 1991 needs to be considered as part of a wider politics and pedagogy of representation. The earlier photographs representing children of diverse races and colors dressed in Benetton clothing have a "netherworld quality that gives the viewers the impression they're glimpsing some fashionable heaven."[1] Depicted in these photographs of children hugging and holding hands is a portrayal of racial harmony and difference that appears both banal and sterile. The exaggerated precision of the models and primary colors used in the advertisements render racial unity as a purely aesthetic category while eliminating racial conflict completely in this two-dimensional world of make believe. In addition, these colorful

images appear almost too comfortable and seem at odds with a world marked by political, economic, and cultural conflict. In the early ads difference, then, is largely subordinated to the logic of the marketplace and commerce. At the same time, the harmony and consensus implied in these ads often mock concrete racial, social, and cultural differences as they are constituted amid hierarchical relations of struggle, power, and authority. Benetton's corporate image in this case seems strangely

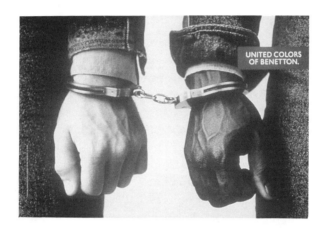

Handcuffs
Oliviero Toscani for United Colors of Benetton

contrary to its own market research which indicated that its "target customers—18–34 year old women—are more socially active and aware than any generation that precedes them."[2]

The switch in the ad campaign to controversial photojournalistic images reflects an attempt on the part of Benetton to redefine its corporate image. In order to define itself as a company concerned with social change, Benetton suspended its use of upscale representations in its mass advertising campaign, especially in a world where "denial in the service of upbeat consumerism is no longer a workable strategy as we are continually overwhelmed by disturbing and even cataclysmic events."[3] In a postmodern world caught in the disruptive forces of nationalism, famine, violence, and war, such representations linked Benetton's image less to the imperatives of racial harmony than to the forces of cultural uniformity and yuppie colonization. Moreover, Benetton's move away from an appeal to utility to one of social responsibility provides an object

lesson in how promotional culture increasingly uses pedagogical practices to shift its emphasis from selling a product to selling an image of corporate responsibility.[4] Given the increase in sales, profits, and the widespread publicity Benetton has received, the campaign appears to have worked wonders.

The response to the campaign inaugurated in 1991 was immediate. Benetton was both condemned for its appropriation of serious issues to sell goods and praised for incorporating urgent social concerns into its advertising. In many cases, a number of the Benetton ads were either banned from particular countries or refused by specific magazines. One of the most controversial ads portrayed AIDS patient David Kirby surrounded by his family shortly before he died. The Kirby ad became the subject of heated debate among various groups in a number of countries. In spite of the criticism and perhaps in part due to it, the company's profits have risen twenty-four percent to 132 million dollars worldwide in 1991. The Benetton name has even infiltrated popular literary culture, with Douglas Coupland coining the phrase "Benetton Youth" in his novel *Shampoo Planet* to refer to global kids whose histories, memories, and experiences began in the Reagan era of greed and conspicuous consumption. *Adweek* reports that because of the success of the Benetton campaign, Toscani has become something of a commercial "star" and has been asked by American Express to develop marketing concepts for them. Benetton's stock is up because of the visibility of the company, and David Roberts, an analyst with Nomura International/London, claims that Benetton's "name recognition is approaching that of Coca-Cola."[5]

Benetton's practical response to the controversy has been threefold. First, Benetton and its spokespersons have reacted aggressively within a number of public forums and debates in order to defend its advertising policies by either condemning the criticism as a form of censorship or criticizing other ad companies for producing advertising that merely engages in the most reductionist forms of pragmatism. Second, it has used the debate to reorder its identity as a corporate force for social responsibility. Third, it has seized upon the controversy itself as a pretext for further marketing of its ideology in the form of books, magazines, talks, interviews, articles, and the use of stars such as Spike Lee to endorse its position in the debate.[6]

Benetton has attempted to articulate and defend its position through material found in campaign copy sent to its various stores around the world, particularly the fall/winter and spring/summer 1992

versions. Moreover, it has attempted to defray criticism of its ads by allowing selected executives to speak in interviews, the press, and various popular magazines. The three major spokespersons for Benetton are Luciano Benetton, founder and managing director, Oliviero Toscani, creative director, and Peter Fressola, Benetton's director of communications in North America. All three provide different versions of a similar theme: Benetton is not about selling sweaters but social responsibility, and it is a company that represents less a product than a lifestyle and world-view.

Recently elected as a Senator to the Italian Parliament, Luciano Benetton is the principle ideologue in the Benetton apparatus. He is chiefly responsible for defining the structuring principles that guide Benetton as both a corporate identity and ideological force. His own political beliefs are deeply rooted in the neoliberal language of the free market, privatization, removal of government from the marketplace, and advocacy of business principles as the basis for a new social imaginary. Hence, it is not surprising that in addition to defending the ads for evoking public awareness of controversial issues, Luciano Benetton readily admits that the advertising campaign "has a traditional function…to make Benetton known around the world and to introduce the product to consumers."[7] More than any other spokesperson, Luciano Benetton articulates the company's position concerning the relationship between commerce and art and acts as a constant reminder that the bottom line for the company is profit, not social justice.

Peter Fressola, on the other hand, promotes Benetton's ideological position and claims that the ad campaign does not reflect the company's desire to sell sweaters. He argues, "We're not that stupid. We're doing corporate communication. We're sponsoring these images in order to change people's minds and create compassion around social issues. We think of it as art with a social message."[8] Of course, the question at stake here is whose minds Benetton wants to shape. In part, the answer lies in its own advertising material which makes it quite clear that "various studies have shown that in 1992 consumers are as concerned by what a company stands for as they are about the price/value relationship of that company's product."[9] There is nothing in Fressola's message that challenges the legacy of the corporate use of communications to advance, if only tacitly, "some kind of self-advantaging exchange."[10]

The moral high ground that Benetton wants to occupy appears to be nothing less than an extension of market research. When questioned about the use of the Benetton logo imprinted on all of the photographs,

Fressola, Toscani, and other spokespeople generally reply by evading the question and pointing to the use of such photographs as part of their support for art, controversy, and public dialogue around social issues. But the presence of the logo is no small matter. In light of their market research, which stresses what Raymond Loewy called the need for designer corporate symbols to index visual memory retention, the presence of the Benetton logo partakes of a powerful advertising legacy. It asserts that, regardless of the form it takes, the purpose of advertising is to subordinate all values to the imperatives of profit and commercialization. Loewy's argument, "We want anyone who has seen the logotype, even fleetingly, to never forget it, or at least to forget it slowly,"[11] provides a powerful indictment of Benetton's rationale and the claim that Benetton is engaging in a *new* form of corporate communication. By refusing to disrupt or challenge this haunting and revealing legacy of designer logos, communication in these terms appears to do nothing more than link the commodification of human tragedy with the imperatives of brand recognition while simultaneously asserting the discourse of aesthetic freedom and the moral responsibility of commerce. This is captured in part in a statement that appeared in their fall/winter 1992 advertising campaign literature:

> Among the various means available to achieve the brand recognition that every company must have, we at Benetton believe our strategy for communication to be more effective for the company and more useful to society than would be yet another series of ads showing pretty girls wearing pretty clothes.[12]

Toscani goes so far as to separate his economic role as the director of advertising from what he calls the process of communication by claiming rather blithely, "I am responsible for the company's communications; I am not really responsible for its economics."[13] Toscani appeals in this case to the moral high ground, one that he suggests is untarnished by the commercial context that informs the deep structure of his job. Should we assume that Benetton's market research in identifying target audiences has nothing to do with Toscani's creative endeavors? Or, perhaps, that Toscani has found a way to avoid linking his own corporate success to the rise of Benetton's name recognition in a global marketplace? Toscani is well aware of the relationship between representation and power, not to mention his own role in giving a new twist to the advertising of commodities as cultural signs in order to promote a particular system of exchange.

Post-Fordism and the Politics of Difference

> Capital has fallen in love with difference; advertising thrives on
> selling us things that will enhance our uniqueness and individuali-
> ty....From World Music to exotic holidays in Third-World locations,
> ethnic TV dinners to Peruvian knitted hats, cultural difference
> sells.[14]

In the world of international capital, difference is a contentious and
paradoxical concept. On the one hand, as individuals increasingly posi-
tion themselves within and across a variety of identities, needs, and
lifestyles, capital seizes upon such differences in order to create new mar-
kets and products. Ideas that hold the promise of producing social
criticism are insinuated into products in an attempt to subordinate the
dynamics of social struggle to the production of new lifestyles. On the
other hand, difference is also a dangerous marker of those historical,
political, social, and cultural borderlands where people who are consid-
ered the "Other" are often policed, excluded, and oppressed. Between
the dynamics of commodification and resistance, difference becomes
a site of conflict and struggle over bodies, desires, land, labor, and the
distribution of resources. It is within the space between conflict and
commercial appeal that difference carries with it the legacy of possible
disruption and political struggle as well as the possibility for colonizing
diverse markets. Within the logic of restructured global capital markets,
cultural differences have to be both acknowledged and depoliticized in
order to be contained. In a world riddled with conflicts over cultural,
ethnic, and racial differences, Benetton defines difference in cate-
gorical rather than relational terms and in doing so accentuates a
warmed-up diet of liberal pluralism and harmonious consensus.

Central to Benetton's celebration of cultural differences are the
dynamics of economic restructuring and its own rise from a local busi-
ness venture to a global marketing conglomerate. Benetton's commercial
success and the ideological legitimation upon which it constructs its
United Colors of Benetton worldview derives, in part, from its aggressive
adaptation to the shifting economic and cultural cartography of what
has been called post-Fordism.

Although post-Fordism is not an unproblematic term for designating
the changes that have taken place in manufacturing and retailing in
advanced industrial countries since 1950, it does focus attention on a
number of economic and ideological tendencies that alert us to the need

for new descriptions and analyses of the "shifting social and technical landscapes of modern industrial production regimes" that are refiguring the relationship between capital and everyday life.[15] Stuart Hall has succinctly described some of the most salient characteristics of post-Fordism:

> "Post-Fordism" is a [broad] term, suggesting a whole new epoch distinct from the era of mass production....[I]t covers at least some of the following characteristics: a shift to the new information "technologies"; more flexible, decentralized forms of labor process and work organization; decline of the old manufacturing base and the growth of the "sunrise," computer-based industries; the hiving off or contracting out of functions and services; a greater emphasis on choice and product differentiation, on marketing, packaging, and design, on the "targeting" of consumers by lifestyle, taste, ad culture rather than by the categories of social class; a decline in the proportion of the skilled, male, manual working class, the rise of the service and white-collar classes and the "feminization" of the work force; an economy dominated by the multinationals, with their new international division of labor and their greater autonomy from nation-state control; and the "globalization" of the new financial markets, linked by the communications revolution.[16]

Capitalizing on global shifts in the order of economic and cultural life, Benetton has seized upon post-Fordist production techniques and methods of retailing that integrate various aspects of production, design, distribution, and a flexible labor force into a single coordinated system. With great skill and ingenuity, Benetton uses its computerized planning systems, flexible production technology, and marketing resources to both forecast and respond immediately to consumer demands from all over the world. Once consumer orders from various Benetton retailers are tallied at the end of the day, they are sent to a centralized computer system that allows the orders to be filled within days. Benetton's concern with difference is in part rooted in the hard realities of a global market and its imperative to serve various consumer needs. But difference is more than just a feature of commerce; it is also about social movements, collective memories of resistance, and the struggle on the part of subordinate groups to reclaim their histories and collective voices. In response to the latter, Benetton has developed a representational politics in the service of a corporate narrative whose purpose is to harness difference as part of an ideology of promotion and political containment.

In this case, Benetton's post-Fordist economic policies are underwritten by a neoconservative political philosophy that supports minimum

state intervention in the world of commerce, accentuates privatization in the form of subcontracting, wages a full-fledged assault on unionized labor, and dramatically expands the service sector. While preaching the gospel of social responsibility, Benetton has become a "corporate model" for new post-Fordist production techniques in which workers are increasingly forced to take jobs with less security, benefits, and wages. In the new world of subcontracting, more and more "office and factory employees

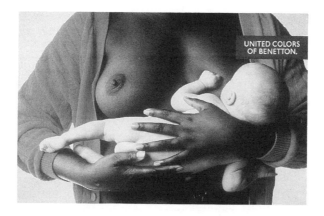

Breastfeeding
Oliviero Toscani for United Colors of Benetton

are getting transplanted overnight to a temporary or subcontracting nether world [in order] to save the mother company paperwork and cost."[17]

This assault on workers is coupled with a call for less state regulation of business. As a Senator in the Italian Parliament, Benetton has made it clear that he would promote a "lesser State presence in the economy" and apply the logic of business to the larger world of politics.[18] Within this scenario, Benetton's discourse of social justice appears transparently cynical next to its conglomerate building management practices, increasing use of temporary workers at the expense of a full-time, unionized workforce, and aggressive attempts to subordinate all aspects of political and cultural discourse to the logic of capital and commerce.[19]

The economic mandates of Benetton's post-Fordism are informed by an underlying ideological imperative: the need to contain potentially antagonistic cultural differences and an insurgent multiculturalism

through a representational politics that combines pluralism with a depoliticized appeal to world harmony and peace. This becomes more clear by recognizing that the politics of difference à la Benetton intersects diverse vectors of representation. Economically, the company's post-Fordist organizational structure acknowledges cultural difference as a vehicle for expanding its range of markets and goods; diversity in the commercial sense entails a move away from standardized markets and the intrusion of business into the postmodern world of plural identities. The representation of difference becomes a crucial component in a market-driven attempt to expand production of a variety of apparel for vastly different individuals, groups, and markets. Benetton's corporate ideology, therefore, bespeaks the need to construct representations that affirm differences, but at the same time deny their radical possibilities within a corporate ideology that speaks to global concerns. Difference in this sense poses the postmodern problem of maintaining the particularity of diverse groups while simultaneously unifying such differences within Benetton's concept of a "world without borders."

Benetton addresses this problem in both pedagogical and political terms. Pedagogically, it takes up the issue of difference through representations based on the conventions of fashion, style, and spectacle. Adapting its widely circulated magazine *Colors* to an MTV format, it uses the journal to focus on transnational topics such as music, sex, birth control, and a wide range of issues incorporating popular culture while simultaneously depoliticizing it. Popular culture, in this case, becomes the pedagogical vehicle through which Benetton addresses the everyday concerns of youth while at the same time blurring the lines between popular cultures of resistance and the culture of commerce and commercialization. Interspersed amid commentaries on music, pizza, national styles, condoms, rock stars, and the biographies of various Benetton executives, *Colors* parades young people from various racial and ethnic groups wearing Benetton apparel. In this context, difference is stripped of all social and political antagonisms and becomes a commercial symbol for what is youthfully chic, hip, and fashionable. At the same time, *Colors* appears to take its cue from the many concerns that inform the daily lives of teenagers all over the industrialized world.

Politically, Benetton develops a strategy of containment through advertising practices using journalistic photos that address consumers through stylized representations whose structuring principles are shock, sensationalism, and voyeurism. In these images, Benetton's motives are less concerned with selling particular products than with offering its

publicity mechanisms to diverse cultures as a unifying discourse for solving the great number of social problems that threaten to uproot difference from the discourses of harmony, consensus, and fashion.

Representations of Hopelessness

Many people have asked why we didn't include a text that would explain the image. But we preferred not to because we think the image is understandable by itself.[20]

I think to die is to die. This is a human situation, a human condition....But we know this death happened. This is the real thing, and the more real the thing is, the less people want to see it. It's always intrigued me why fake has been accepted and reality has been rejected. At Benetton, we are trying to create an awareness of issues. AIDS is one of today's major modern problems in the world, so I think we have to show something about it.[21]

In defense of the commercial use of sensational, journalistic photographs that include the aforementioned dying AIDS patient, a terrorist car bombing, and a black soldier with a gun strapped over his shoulder holding part of the skeletal remains of another human being, Benetton's spokespeople combine an assertion of universal values and experiences with the politics of realism. Arguing that such images serve as a vehicle for social change by calling attention to the real world, Benetton suggests that its advertising campaign is informed by a representational politics in which the "truth" of such images is guaranteed by their purchase on reality. From this perspective, "shocking" photos register rather than engage an alleged unmediated notion of the truth. This appeal to the unmediated "truth-effects" of photographic imagery is coupled with a claim to universal truths ("to die is to die") that serve to deny the historical, social, and political specificity of particular events. Ideologically, this suggests that the value of Benetton's photos reside in their self-referentiality, that is, their ability to reflect both the unique vision of the sponsor and their validation of a certain construction of reality. Suppressed in this discourse is an acknowledgment that the meaning of such photos resides in their functions within particular contexts.

Before discussing specific examples from Benetton's advertising campaign, I want to comment briefly on some of the structuring devices at work in the use of the photojournalistic images. All of Benetton's ads depend upon a double movement between decontextualization and recontextualization. To accomplish the former move, the photos militate

against a reading in which the context and content of the photo is historically and culturally situated. Overdetermined by the immediacy of the logic of the spectacle, Benetton's photos become suspended in what Stuart Ewen has called "memories of style."[22] That is, by dehistoricizing and decontextualizing the photos, Benetton attempts to render ideology innocent by blurring the conditions of production, circulation, and commodification that present such photos as unproblematically real and true. By denying specificity, Benetton suppresses the history of these images and, in doing so, limits the range of meanings that might be brought into play. At stake here is a denial of how shifting contexts give an image different meanings. Of course, the depoliticization that is at work here is not innocent. By failing to rupture the dominant ideological codes (i.e., racism, colonialism, sexism), which structure what I call Benetton's use of hyperventilating realism (a realism of sensationalism, shock, and spectacle), the ads simply register rather than challenge the dominant social relations reproduced in the photographs.

The viewer is afforded no sense of how the aesthetic of realism works to mask "the codes and structures which give photographs meaning as well as the historical contingencies (e.g., patriarchal structures which normalize notions of looking) which give such codes salience."[23] There is no sense here of how the operations of power inform the construction of social problems depicted in the Benetton ads, nor is there any recognition of the diverse struggles of resistance which attempt to challenge such problems. Within this aestheticization of politics, spectacle foregrounds our fascination with the hyperreal and positions the viewer within a visual moment that simply registers horror and shock without critically responding to it. Roland Barthes has referred to this form of representation as one that positions the viewer within the "immediacy of translation."[24] According to Barthes, this is a form of representational politics that functions as myth, because

> it abolishes the complexity of human acts, it gives them the simplicity of essences, it does away with all dialectics, with any going back beyond what is immediately visible, it organizes a world which is without contradictions because it is without depth, a world wide open and wallowing in the evident, it establishes a blissful clarity: things appear to mean something by themselves.[25]

Isolated from historical and social contexts, Benetton's images are stripped of their political possibilities and reduced to a spectacle of fascination, horror, and terror that appears to primarily privatize

the viewer's response to social events. That is, the form of address both reproduces dominant renderings of the image and translates the possibility of agency to the privatized act of buying goods rather than engaging forms of self and social determination. This process and its effects becomes clear in analyzing the ad in which AIDS patient David Kirby is portrayed on his deathbed surrounded by members of his grieving family.

As I noted above, this image involves a double movement. On the one hand, it suppresses the diverse lifestyles, struggles, and realities of individuals in various stages of living with AIDS. In doing so, the Kirby image reinforces dominant representations of people with AIDS, reproducing what Douglas Crimp, in another context, refers to as "what we have already been told or shown about people with AIDS: that they are ravaged, disfigured, and debilitated by the syndrome [and that] they are generally...desperate, but resigned to their inevitable deaths."[26] The appeal to an aesthetic of realism does little to disturb the social and ideological force of such inherited dominant representations. On the contrary, by not providing an analysis of representations of AIDS as a de facto death sentence, relying instead on the clichés enforced through dominant images and their social effects, the Benetton ad reproduces rather than challenges conventional representations that portray people with AIDS as helpless victims.

The politics at work in the Benetton photographs is also strikingly revealed in its use of photojournalistic images that are decontextualized from any meaningful historical and social context and then recontextualized through the addition of the United Colors of Benetton logo. In the first instance, the logo produces a representational "zone of comfort" confirming a playfulness which allows the viewer to displace any ethical or political understanding of the images contained in the Benetton ads. The logo serves largely to position the audience within a combination of realism and amusement. Public truths revealed in Benetton's images, regardless of how horrifying or threatening, are offered "as a kind of joke in which the reader is invited to participate (the 'joke' is how low can we go?), but its potential dangers are also pretty clear: today aliens from Mars kidnap joggers, yesterday Auschwitz didn't happen, tomorrow who cares what happens."[27] Of course, the "joke" here is that anything is for sale and social commitment is just another gimmick for selling goods. In this type of representational politics, critical engagement is rendered ineffective by turning the photo and its political referent into an advertisement. If the possibility of social criticism is suggested by the ad, this is

quickly dispelled by the insertion of the logo, which suggests that any complicity between the viewer and the event it depicts is merely ironic. The image ultimately references nothing more than a safe space where the logic of the commodity and the marketplace mobilize consumers' desires rather than struggles over social injustices and conflicts. In the case of the AIDS ad, the use of the Benetton logo juxtaposes human suffering and promotional culture so as to invite the viewer to position him or herself between the playfulness of commodification and an image of apocalypse rendering social change either ironic or unimaginable. This serves less to situate a critical viewer who can mediate social reality and its attendant problems than to subordinate this viewer to the demands and aesthetic of commerce. One consequence of such a position has been captured by Stuart Ewen: "By reducing all social issues to matters of perception, it is on the perceptual level that social issues are addressed. Instead of social change, there is image change. Brief shows of flexibility at the surface mask intransigence at the core."[28]

In the second instance, recontextualization appeals to an indeterminacy which suggests that such images can be negotiated by different individuals in multiple and varied ways. Hence, Benetton's claim that such photos generate diverse interpretations. While such an assumption rightly suggests that viewers always mediate and rewrite images in ways that differ from particular ideologies and histories, when unqualified it also overlooks how specific contexts privilege some readings over others. In other words, while individuals produce rather than merely receive meanings, the choices they make and the meanings they produce are not free-floating. Such meanings and mediations are, in part, formed within wider social and cultural determinations that propose a range of reading practices privileged within hierarchical relations of power. The reading of any text cannot be understood independently of the historical and social experiences which construct how audiences interpret other texts. It is this notion of reading formation that is totally missing from Benetton's defense of its endless images of death, pain, danger, and shock. Tony Bennett is helpful on this issue.

> The concept of reading formation...is an attempt to think context as a set of discursive and inter-textual determinations, operating on material and institutional supports, which bear in upon a text not just externally, from the outside in, but internally, shaping it in the historically concrete forms in which it is available as a text-to-be-read from the inside out.[29]

This point can be illustrated by examining two of Benetton's racially marked ads. The first depicts a black woman and a white baby. The second portrays two hands, one black, one white, handcuffed together. In the former ad, the viewer is presented with the torso of a robust black woman suckling a white baby. A crimson cableknit cardigan is pulled down over her shoulders to reveal her breasts. Her hands reveal traces of scar tissue, and her nails are trimmed short. This is not a traditional

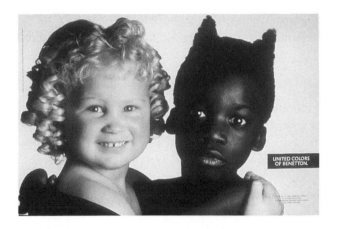

Angel/Devil
Oliviero Toscani for United Colors of Benetton

Benetton model. How might one decipher these potent, overdetermined set of signifiers? I say overdetermined in the double sense. First, the racial coding of the image is so overdetermined that it is difficult to imagine that this black women nursing a long, pale pink baby is the child's mother. Given the legacy of colonialism and racism that informs this image, I also believe that the photo privileges a range of dominant readings that suggest the ingrained racial stereotype of the black/slave/wet nurse or mammy.[30] Other than the logo, there are no signifiers in this photo which would threaten or rupture such an imperialist coding. It is precisely the absence of referents of resistance, rupture, and critique that allows the reader to be perfectly comfortable with such a configuration of race and class while at the same time accepting the image as nothing more than a "playful" ad.

In the second ad, there is a calculated and false equality at work in the image of black and white hands handcuffed together. Is the viewer in the

United States, England, France, or South Africa to believe that the black hand is the signifier of law, order, and justice? Or, given the legacy of white racism in all of these countries, is it more probable that the image, at least at the level of the unconscious, reproduces the racist assumption that social issues regarding crime, turmoil, and lawlessness are essentially a black problem? Restaging race relations in these terms exploits the racially charged tensions that underlie current racial formations in the Western industrial countries while simultaneously reducing the historical legacy of white supremacy to a representation of mere equality or symmetry. The emotionally charged landscape of race relations, in this instance, becomes another example of how social problems become "packaged" in order to "reinject the real into our lives as spectacle."[31]

Conclusion: Pedagogy and the Need for Critical Public Cultures

The new postmodern pedagogy of mass advertising poses a central challenge to the role cultural workers might play in deepening their politics through a broader understanding of how knowledge is produced, identities shaped, and values articulated as a pedagogical practice that takes place in multiple sites outside the traditional institution of schooling. The struggle over meaning is no longer one that can be confined to programs in educational institutions and their curricula. Moreover, the struggle over identity can no longer be seriously considered outside the politics of representation and the new formations of consumption. Culture is increasingly constituted by commerce, and the penetration of commodity culture into every facet of daily life has become the major axis of relations of exchange through which corporations actively produce new, increasingly effective forms of address.

There is more at stake here than advertising and commerce combining in the postmodern age to commodify through the ritualization of fashion that which has previously escaped its reach. More importantly, mass advertising has become the site of a representational politics that powerfully challenges our understanding of what constitutes pedagogy, the sites in which it takes place, and who speaks under what conditions through its authorizing agency. With the emergence of advertising as a global enterprise, we are witnessing a new form of violence against the public. By this I do not mean simply the intrusion of violence into designated public spheres as much as I am suggesting a "public whose essential predicate would be violence."[32] At the core of this violence are constituting principles that accentuate individualism and difference as central elements of the marketplace. Underlying this violence of the

public is a notion of the social bereft of ethics, social justice, and any viable notion of democratic public cultures. Put another way, mass advertising and its underlying corporate interests represent a new stage in an effort to abstract the notion of the public from the language of ethics, history, and democratic community.

The rearticulation and new intersection of advertising and commerce, on the one hand, and politics and representational pedagogy on the other, can be seen in the emergence of Benetton as one of the leading manufacturers and retailers of contemporary clothing. Benetton is important not only because of its marketing success, but also because it has taken a bold stance in attempting to use advertising as a forum to address highly charged social and political issues. Through its public statements and advertising campaigns, Benetton has brought a dangerously new dimension to corporate appropriation as a staple of postmodern aesthetics. Inviting the penetration of aesthetics into everyday life, Benetton has utilized less deterministic and more flexible approaches to design, technology, and styling. Such postmodern approaches to marketing and layout privilege contingency, plurality, and the poetics of the photographic image in an attempt to rewrite the relationship among aesthetics, commerce, and politics. Instead of depoliticizing or erasing images that vividly and, in some cases, shockingly depict social and political events, Benetton has attempted to redefine the link between commerce and politics by emphasizing both the politics of representation and the representation of politics. In the first instance, Benetton has appropriated for its advertising campaign actual news photos of social events that portray various calamities of the time. These include pictures of a duck covered with thick oil, a bloodied Mafia murder victim, depictions of child labor, and a terrorist car bombing. As part of a representation of politics, Benetton struggles to reposition itself less as a producer of commodities and market retailer than as a corporate voice for a particular definition of public morality, consensus, coherence, and community. This has been more recently revealed in an advertisement campaign which depicts Senator Luciano Benetton posing nude. The accompanying text urging people of wealth to give away their "old" clothes to charity. Benetton justifies the ad by arguing that "business has to go on for everybody. Rich people should buy new stuff and be pleased that others can profit from [their old clothes]."[33] Justice in this case is appropriated less to regulate the production of consumerism than to legitimate it.

This is not to suggest that the politics of consumption in its various

circuits of power constitutes an unadulterated form of domination. Such a view is often more monolithically defensive than dialectical and less interested in understanding the complex process by which people desire, choose, and act in everyday life than with shielding the guardians of high modernism, who have always despised popular culture for its vulgarity and association with the "masses."[34] What is at stake in the new intersection of commerce, advertising, and consumption is the very definition and survival of critical public cultures. I am referring here to those public spaces predicated on the multiplication of spheres of daily life where people can debate the meaning and consequences of public truths, inject a notion of moral responsibility into representational practices, and collectively struggle to change dominating relations of power. Central to my argument has been the assumption that these new forms of advertising and consumption do not deny politics, they simply appropriate it. This is a politics that "actively creates one version of the social," one that exists in harmony with market ideologies and initiatives.[35] Such a politics offers no resistance to a version of the social as largely a "democracy of images," a public media extravaganza in which politics is defined largely through the "consuming of images."[36]

Cultural workers need to reformulate the concept of resistance usually associated with these forms of colonization. Such a formulation has to begin with an analysis of how a postmodern pedagogy works by problematizing the intersection of power and representation in an ever-expanding democratization of images and culture. Representations in the postmodern world reach deeply into daily life, contributing to the increasing fragmentation and decentering of individual and collective subjects. Not only are the old categories of race, gender, sexuality, age, and class increasingly rewritten in highly differentiating and often divisive terms, but the space of the social is further destabilized through niche marketing which constructs identities around lifestyles, ethnicity, fashion, and a host of other commodified subject positions. Central here is the issue of how power has become an important cultural and ideological form, particularly within the discourse of difference and popular culture. Cultural workers need a new map for registering and understanding how power works to inscribe desires and identities and create multiple points of antagonism and struggle. Also in serious need of consideration is the creation of a new kind of pedagogical politics and pedagogy, organized through guiding narratives that link global and local social contexts, provide new articulations for engaging popular culture within rather than outside new technologies and regimes of

representation, and offer a moral language for expanding the struggle over democracy and citizenship to ever-widening spheres of daily life.

Clearly, more is at issue here than understanding how representations work to construct their own systems of meaning, social organizations, and cultural identifications. In part, cultural workers must investigate the new politics of commerce not merely as an economic issue, that is, as symptomatic of the new configurations of a post-Fordist world, but as a reaction to the emergence and "assertion of new ethnicities, problems of racism, problems of nationality, of law, of discrimination, and the assertion of particular communities."[37] Furthermore, this suggests reformulation of a politics and pedagogy of difference around an ethical discourse that challenges the ideological grounds and representations of commerce, but at the same time limits those public spheres it attempts to appropriate. If a politics of difference is to be linked not merely to registering "otherness," but identifying the conditions through which others become critical agents, the ethic of consumerism must be challenged by exposing its limits.

Cultural workers need to take up the challenge of teaching ourselves, students, and others to acknowledge our and their complicity in the discourse and practice of consumerism while at the same time bringing the hope mobilized by such practices to a principled and persistent crisis. This is not to invoke a vulgar critique of the real pleasures of buying nor to underestimate the diverse ways in which people negotiate the terrain of the market or reappropriate goods through resisting and oppositional practices. Rather these conditions require recognition of the political and pedagogical limits of consumerism, its often active involvement in creating new identities, and its ongoing assault on the notion of insurgent differences in a multicultural and multiracial democracy. Individual and collective agency is about more than buying goods, and social life in its most principled forms points beyond the logic of the market as a guiding principle. It is up to cultural workers and other progressive educators to address this challenge directly as part of a postmodern political and pedagogical challenge.

▨ Notes

I would like to thank Carol Becker for encouraging me to write this article, Roger Simon and Harvey Kaye for their support and advice, and Peter McLaren for his editorial help. I would also like to thank Michael

Hoechsmann for letting me read an early draft of a paper he is writing on Benetton pedagogy.

1. Michael Stevens, "Change the World, Buy a Sweater," *Chicago Tribune* (December 11, 1992), 33.
2. Benetton, *Spring/Summer 1992 Advertising Campaign* copy, 4.
3. Carol Squiers, "Violence at Benetton," *Artforum* (May 1992): 18–19.
4. On the issue of promotional culture, an excellent text is Andrew Warnick, *Promotional Culture* (Newbury Park: Sage Publications, 1991).
5. Noreen O'Leary, "Benetton's True Colors," *Adweek* (August 24, 1992), 28.
6. Benetton is not only publishing, with Ginko Press, a book entitled *United Colors of Benetton*, which "vividly displays the Benetton corporate philosophy," it is also publishing a book in 1994 entitled, *What's the Relationship between AIDS and Selling a Sweater?*, which chronicles various responses to the controversial Benetton ads. Both books appropriate the controversy over Benetton's ads in order to spread the company's name and generate profits. It seems that nothing is capable of existing outside of Benetton's high powered commercialism and drive for profits. Spike Lee is one of the most high profile celebraties to endorse Benetton's campaign. See the interview with Spike Lee, which was sponsored as an advertisement in "United Colors of Benetton," in *Rolling Stone* no. 643 (November 12, 1992): 1–5.
7. Ingrid Sischy, "Advertising Taboos: Talking to Luciano Benetton and Oliviero Toscani," *Interview* (April 1992): 69.
8. Quoted in Carol Squiers, "Violence at Benetton," 18.
9. Benetton, *Spring/Summer 1992 Advertising Campaign* copy, 2.
10. Andrew Warnick, *Promotional Culture*, 181.
11. Cited in Stuart Ewen, *All Consuming Images* (New York: Basic Books, 1988), 247.
12. Benetton, *Fall/Winter 1992 Advertising Campaign Literature*, 2.
13. Ingrid Sischy, "Advertising Taboos," 69.
14. Cited in Martin Davidson, *The Consumerist Manifesto* (New York: Routledge, 1992), 199.
15. Stuart Hall, "The Meaning of New Times," in Stuart Hall and Martin Jacques, eds., *New Times: The Changing Face of Politics in the 1990s* (London: Verso Press, 1990), 117.
16. Stuart Hall, "Brave New World," *Socialist Review* 91, no. 1 (January–March 1991): 57–58.
17. Clare Ansberry, "Workers are Forced to Take More and More Jobs with Fewer Benefits," *The Wall Street Journal* 84, no. 103 (March 11, 1993), 1. See also Robin Murray, "Benetton Britain: The New Economic Order," in Stuart Hall and Martin Jacques, *New Times*, 54–64.
18. Interview with Luciano Benetton in "News," an insert in *Colors* no. 3 (Fall/Winter 1992-93), 2.
19. For a succinct analysis of the relationship between post-Fordism and capitalism, see David Harvey, "Flexibility: Threat or Opportunity?," *Socialist Review* 91 no. 1 (January–March 1991): 65–75.
20. Luciano Benetton, quoted in Ingrid Sischy, "Advertising Taboos," 69.
21. Oliviero Toscani, quoted in Ingrid Sischy, "Advertising Taboos," 69.

22. Stuart Ewen, *All Consuming Images*, 248.
23. Abigail Solomon-Godeau, *Photography at the Dock* (Minneapolis: University of Minnesota Press, 1991), 145.
24. Roland Barthes, "Shock-Photos," in *The Eiffel Tower* (New York: Hill and Wang, 1979), 72.
25. Roland Barthes, *Mythologies* (New York: Noonday, 1972), 143.
26. Douglas Crimp, "Portraits of People with AIDS," in *Cultural Studies*, ed. Lawrence Grossberg et al (New York: Routledge, 1992), 118.
27. Dick Hebdige, "After the Masses," in Stuart Hall and Martin Jacques, *New Times*, 83.
28. Stuart Ewen, *All Consuming Images*, 264.
29. Tony Bennett, "Texts in History: The Determinations of Readings and Their Texts," in *Poststructuralism and the Question of History*, ed. Derek Atridge et. al. (Cambridge: Cambridge University Press, 1987), 72.
30. This issue of the legacy of racial representations and their affect on shaping cultural practices is analyzed in K. Sue Jewell, *From Mammy to Miss America and Beyond* (New York: Routledge, 1993).
31. Hal Foster, *Recodings: Art Spectacle, Cultural Politics* (Seattle: Bay Press, 1985), 6-7.
32. Andrew Payne and Tom Taylor, "Introduction: The Violence of the Public," *Public* no. 6 (1992): 10.
33. Sharon Waxman, "Benetton Laid Bare," *Miami Herald* February 8, 1993, C1.
34. On the dialectics of consumerism, see Mike Featherstone, *Consumer Culture and Postmodernism* (Newbury Park: Sage Publications, 1991), and Mica Nava, *Changing Cultures: Feminism, Youth and Consumerism* (Newbury Park: Sage Publications, 1992).
35. Dick Hebdige, *After the Masses*, 89.
36. I have taken this idea from the transcript of the television show, *The Public Mind* with Bill Moyers (New York: WNET Public Affairs Television, 1989), 14.
37. David Bennet and Terry Collits, "Homi Bhabha Interviewed by David Bennet and Terry Collits—The Postcolonial Critic," *Arena* no. 96 (Spring 1991): 47-48.

14

THE FREE ART AGREEMENT/EL TRATADO DE LIBRE CULTURA

Guillermo Gómez-Peña

▰▰▰ A Triptych of Broken Dreams

In 1992, the year of the much-touted *descubrimiento,* as the European community prepared for the grand opening of its borders Spain decided to break the "friendship treaties" that for two hundred years granted entry without visa to all Spanish-speaking citizens from Latin America. The Spanish immigration service began deporting Latinos (of color), along with the usual Arab and African *indeseables.* Why? Prime Minister Felipe Gonzalez, the legendary master negotiator of Latin American conflicts, was assigned the embarrassing role of gatekeeper for the new European economic community; and he assumed that role enthusiastically. In fact, he overdid it. Sadly, his triptych of dreams of grandeur, comprised by the Seville Expo, the Barcelona '92 Olympics, and the Comisión Quinto

Centenario, turned out to be sad abortions of ferocious capitalism and nothing more.

During an encounter between Spanish and Mexican artists that took place at the Universidad de la Rábida, in Palos de la Frontera, an important Spanish artist (who will remain nameless) stated, "We are lucky. Here we don't have the 'problem' of the *indios*. Spain [unlike Latin America] is not suffused with nostalgia for a past that no longer exists. [What past was he referring to? fascism?]. We are already a postmodern nation." Ironically, the amnesiac man had Arabic features. On my flight back to America, I wrote on a napkin: "When will Spain wake up from its colonial dream?"

Bush, Columbus, and Associates: Operation Transatlantic Storm

Visit the U.S. before the U.S. visits you!

—*Mexican T-shirt*

Ex-U.S. President Bush and his European sidekicks did everything possible to construct a *fin de siècle* mythology that could justify their post–Cold War excesses, and so the "New World Order" was manufactured. Operation Desert Storm and the Quinto Centenario were perhaps the two most expensive fiascos of the New World Order, Inc.

After so much quincentennial hoopla, Columbus ended up being a cheesy logo for friendly expansionism and free trade, and a bad actor in a couple of films. Like its ancient predecessor, the replica of the Santa Maria caravel was shipwrecked on its way to America. The poor Niña ended up in a Manhattan auction, after American Indian Movement activist Vernon Bellcourt "desecrated" it by throwing a pint of his own blood at its sail. The Japanese replicas didn't have any better luck. At every port they were welcomed by angry protesters. In Tampa, Florida, Indian performance activist Russell Means arrested Columbus (played by another bad actor) and put him in quarantine. In Minneapolis, Columbus was tried by historians and activists for eleven historical crimes against the indigenous population of the Caribbean and found guilty.

Remarkable counter-Columbus performances were staged everywhere we turned. A daring group of indigenous dancers from the Americas stormed the Seville cathedral in ceremonial outfits interrupting a pro-Columbus mass. Chicago artist Iñigo Manglano issued a limited edition of Columbus's illegal alien card. In San Diego, California, Chicano artists and *antropolocos* Richard Lou and Robert Sánchez unearthed the "remains of Columbus," a composite skeleton made out of animal bones.

They also dug up several papier maché "white mummies." They are currently asking museums of natural history to put them on permanent display. My compañera Coco Fusco and I lived for three-day periods in a golden cage as "undiscovered Amerindians" from the fictional island of Guatinau (Anglicization of "what now"). We were hand-fed by fake museum docents and taken to the bathroom on leashes. This "ethnographic" experiment was conducted at Columbus Plaza in Madrid, London's Covent Garden, the Smithsonian Institute in Washington, and the Australia Museum in Sydney, among other places.

All these performances, along with myriad books, films, art shows, and symposia, contributed to extinguishing the official Columbian bonfire and deporting the ghost of Columbus if not back to Europe, at least back to historical oblivion.

The New World Order, Inc.

In the theater of the New World Order, the Quincentennial brouhaha was intended to perform a political function similar to Operation Desert Storm: to divert the attention of the U.S. citizenry away from the acute national crises—an economy in shambles; racial and class conflicts escalating every minute; and the abrupt defunding of cultural, social, and educational institutions that serve people of color, women, gays, children, and the homeless. Bush and Columbus were cheered on by the war chants of psychotic skinheads, fundamentalist preachers, and rural white supremacists, backed by the panic rhetoric of far-right Repo-blicans, culminating in a wave of racial hatred that inundated the nation.

Out of this boiling context there emerged sleazy ideologues like Jesse Helms and Patrick Buchanan, who satanized and blacklisted artists investigating sexual difference and interracial conflicts. These "radical" artists suddenly became members of a national conspiracy to destroy American values and mythical representatives of what Vice President Dan Quayle characterized as a "hegemonic cultural elite."

Today, in the year 501 on the ante-"discovery" calendar, the New World Order has become a pathetic euphemism for generalized political and social turmoil both abroad and at home. Rappers, performance artists, and independent filmmakers warn us of the dangers of the end of the century. They speak of a dystopian U.S.A. where urban decay, crime, police brutality, homelessness, AIDS, and racial and sexual violence far exceed the social ills of the most troubled Third World countries. Incidents such as the L.A. insurrection are symptoms of what is yet to come.

We hope that the new president learns to listen carefully to the syncopated heartbeat of the end of the century. We hope that he realizes that the solution to this unprecedented crisis demands drastic reforms in the dysfunctional political and economic apparatus; for this reform to be effective, all the multiracial and multisexual communities that converge in this country must participate. We also hope that he understands the importance of the role of artists and intellectuals in this transition. This gringostroika project is as ambitious as that of Gorbachev. And the enemies and obstacles as formidable as those that defeated the Russian reformer.

The Fourth World and Other Utopian Cartographies

> When a writer writes, he/she creates his/her own nationality and culture.
> —*Native Canadian playwright*

I am a migrant performance artist. I travel from city to city, coast to coast, country to country, smuggling my work and the work and the ideas of my colleagues. I write in airplanes, trains, and cafés. I collaborate with artists from other communities and disciplines. I connect with groups who think like us and debate with others who disagree. Then I carry their ideas somewhere else.

I travel across a different America, a continent and a country that no longer matches the geopolitical outlines on the map. In my America, there exist other peoples, cities, and nations.

In my America, Québec seems closer to Latin America than to its Anglophone twin. When I am on the U.S. East Coast, I am also in the Caribbean. I call it Nuyo Rico or Cuba York. When I return to the Southwest, I am suddenly in Mexamerica, a vast conceptual nation that includes the Northern States of Mexico and overlaps with various Indian nations. When I visit Los Angeles or San Francisco, I am at the same time in Latin America and Asia. Los Angeles, like Mexico City, Tijuana, Miami, and New York, is practically a hybrid nation/city in itself. Here/there we all share the same space but we all are foreigners to one another. Here/there we all are potential border-crossers. We all have been uprooted in different degrees, but not everyone is aware of it.

Native Americans and Canadians who are not citizens of either the U.S. or Canada but of their Indian Nations remind us of the existence of other cartographies by challenging international law and marching every year into each others countries without papers. The valiant migrant

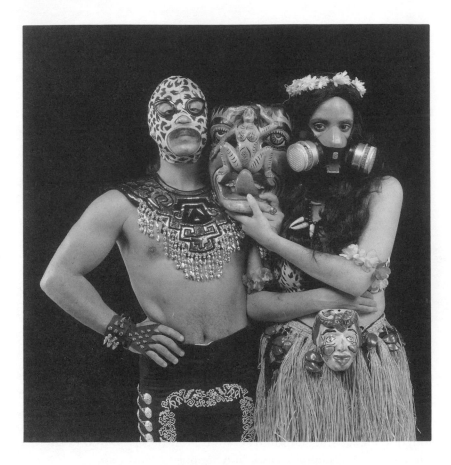

The Year of the White Bear (1992), Guillermo Gómez-Peña and Coco Fusco, performance

photo: Glen Halvorsen

workers remind us that human will is much stronger than international law. We can at least conceptually follow their example.

The job of the artist is to force open the matrix of reality to admit unsuspected possibilities. Artists and writers throughout the continent are currently involved in a project of redefinition of our continental topography. We imagine better maps. We imagine either a map of the Americas without borders, a map turned upside down, or one in which countries having different sizes and borders are organically drawn by geography and culture, not by the capricious fingers of economic domination. Congruent to this continental project, I try to imagine better maps.

I oppose the outdated fragmentation of the map of America with that of Arte-America, a continent made out of people, art, and ideas, not

countries; when I perform, this map becomes my conceptual stage.

I oppose the sinister cartography of the New World Order with that of the New World Border, a great trans-and intercontinental border zone in which no centers remain. It's all margins, meaning there are no "Others" left. Or, better said, the only true "Others" are those resisting fusion, *mestizaje*, and ongoing dialogue. In this utopian cartography, hybridity becomes the dominant culture; spanglish is the lingua franca, and monoculture becomes a culture of resistance practiced by stubborn Caucasian minorities.

I also oppose the old colonial categories of First World/Third World with the much more pertinent notion of the Fourth World, a conceptual place where the indigenous peoples meet with the deterritorialized peoples. The members of the Fourth World live between, around, and across various cultures and communities, and our identities are constantly being reshaped by this kaleidoscopic experience.

The Free Trade Agreement

If two becomes one, who is the one they become?
—*American pop song*

A North American Free Trade Agreement (NAFTA) has been signed by Canada, the U.S., and Mexico. Once it becomes law, we will be in the process of becoming the largest artificial economic community on the planet. In terms of geography and demographics, it will be much larger than the European Community or the fashionable Pacific Rim. From the myriad possibilities of Free Trade Agreements that could have been designed and implemented, the "neoliberal" version we have is not exactly an enlightened one. It is based on the fallacy that the market will take care of everything, avoiding the most basic social, labor, environmental, and cultural responsibilities.

There are a lot of burning questions that remain unanswered: Given the endemic lack of political and economic symmetry between the three countries, will Mexico become, as Chicana performance artist Yareli Arismendi stated in her performance *Penny Envy*, "the largest Indian reservation of the U.S.," or will it be treated as an equal by its bigger partners? Will the predatory Statue of Liberty devour the Virgin of Guadalupe, or are they merely going to dance a sweaty cumbia? Will Mexico become a toxic and cultural waste dump of the U.S. and Canada? Who will monitor the actions of the three governments? Given the exponential increase of American trash and media culture in Mexico,

what will happen to our indigenous traditions, social and cultural rites, languages, and national psyche? Will the future generations become hyphenated Mexican-Americans, brown skinned *gringos* and *Canochis* (upside down Chicanos)? And what about our Northern partners? Will they slowly become *Chicanadians, waspbacks,* and *Anglomalans?*

Whatever the answers are, NAFTA will profoundly affect our lives in many ways. Whether we like it or not, a new era has begun, and a new economic and cultural topography has been designed for the U.S. We must find our new place and role within this bizarre Federation of U.S. Republics.

▬▬ The Free Art Agreement

Nonaligned intellectuals and artists are talking about the need to create a structure parallel to NAFTA, a Free Art Agreement for the ongoing exchange of ideas and noncommercial art works, not just consumer goods and hollow dreams. Arts organizer Joe Lambert and journalist Marco Vinicio Gonzalez call this "a free idea zone." If formed, the tasks of this network of thinkers, artists, and arts organizations from Mexico, the U.S., Canada—and why not the Caribbean?—would consist of developing future models of multilateral cooperation, crosscultural dialogue, and interdisciplinary artistic collaboration.

Mexican and Caribbean cultures can offer the North their spiritual strength, political intelligence, and sense of humor in dealing with crises, as well as experience in fostering personal and community relations and the resourcefulness developed by their underfunded art-makers. In exchange, North American artists and intellectuals can offer the South more fluid notions of identity and their understanding of experimentation and new technologies. U.S. and Canadian artists of color, in particular, can offer Latin America a sophisticated discourse on race and gender. Through trilingual publications, radio, video, and performance collaborations, more complex and mutable concepts of "North American" cultures, nationalities, and identities can be conceived. These projects must take into consideration the multiple processes of diaspora, deterritorialization, hybridization, and "borderization" that our psyches, communities, and countries are presently undergoing.

Chicanos and other U.S. Latinos insist that it is fundamental that relationships of power and assumptions about privilege among participating artists, communities, and countries be addressed in the letter and spirit of this new trans-American contract. The border cannot possibly mean the same to a tourist as it does to an undocumented worker. To cross the

border from North to South has drastically different implications than to cross the same border from South to North. "Transculture" and hybridity have different connotations for a person of color than for an Anglo-European. People with social, racial, or economic privileges are more able to physically cross borders, but they have a much harder time understanding the invisible borders of culture and race. Though painful, these differences must be articulated fearlessly and with humor.

In the history of conflicts in the North/South dialogue and the debates around multiculturalism, American and European sympathizers have often performed involuntary colonialist roles. In their desire to help, they unknowingly become ventriloquists, impresarios, *flaneurs,* messiahs, or cultural transvestites. These forms of benign colonialism must be discussed openly, without accusing anyone. Their role in relation to us must finally be one of ongoing dialogue and a sincere sharing of power and resources. The Canadian artist Chris Creighton Kelly stated at the 1992 National Association of Artists Organizations conference that, in the nineties, "Anglos must finally go beyond tolerance, sacrifice, and moral reward. Their commitment to cultural equity must become a way of being in the world." In exchange, we have to acknowledge their efforts, slowly lower our guards, change the strident tone of our discourse, and begin another heroic project—that of forgiving and therefore healing our colonial and postcolonial wounds.

Global Transculture vs. Neonationalism

Today, wherever we turn, we witness a nasty wrestling match between a global consumer transculture and the resurgence of virulent ultranationalisms. Those in power insist that media, computer communications, and the global economy have already created a single borderless world community. They speak of "total culture" and "total television," a grandiose pseudo-internationalist world view à la CNN that creates the illusion of immediacy, simultaneity, and sameness, thus numbing our political will and homogenizing our identities. Through this lens, the entire world unfolds and changes in front of us, but nothing really matters. Variations on this official transculture can be found in contemporary world expos, like the one in Seville in 1992, which attempted unsuccessfully to deodorize the unpleasant smells of Spain's colonial history, and in Benetton-style multicultural art events like the French blockbuster exhibit *The Magicians of the Earth.*

This conflict is explicitly expressed in contemporary art and popular culture. L.A. poet Rubén Martinez warns us of the hype of "free trade

art," a *fin de siècle* initiative promoted by major cultural institutions in the three NAFTA countries. The objective: to use art as conservative diplomacy and as a means to create a conflict-free image of a country for the purpose of seducing investors and promoting cultural tourism.

Free trade art is tricky. It promotes transculture and celebrates the border, but for the wrong reasons. Despite their crosscultural rhetoric, the FTArt impresarios are unwilling to engage in a politicized dialogue with Chicanos and U.S. artists of color. Rather, they bypass the border zone, with its mine fields of race and gender and its political complexities, and deal directly with what they perceive as "the center" (New York, Los Angeles, Paris, or Mexico City). Unfortunately they ignore the fact that today, in 1993, culture has been completely decentralized and the old centers are being recolonized by the margins. In Mexico, those colonized artists and art impresarios who benefit from this sudden interest in crosscultural exchange must understand that this interest is the result of twenty-five years of Chicano/Latino activism and not just a gift from U.S. and Canadian liberals.

On the opposite side of "total culture" and "free trade art," a new essentialist culture is emerging that once again advocates ethnic and gender separatism. In reaction to transculture imposed from above, we see a ferocious quest for cultural autonomy, "bio-regional identity," and "traditional values." This tendency to overstate difference and the unwillingness to change or exchange, comes from communities in turmoil, who, as an antidote to the present confusion, have chosen to retreat to the fictional womb of their own history. From the secessionist rock movements in Europe to Afrocentric rap, from the nineties feminism of the Women's Action Coalition to the *movimiento mexicanista* in Mexico City, our communities are also retrenching in a fundamentalist stance.

We know why: The end of the century breeds *horror vacui*; multiculturalism has soured, racism and sexism still run amok, and crises have become the spinal cord of everyone's existence. But there has to be a better alternative to the obvious choice between neonationalisms and a homogenized global culture, a grassroots cultural response that understands the importance of crossing borders and establishing crosscultural alliances.

The Advantages and Risks of the Hybrid Model

I wish to propose a third alternative: the hybrid—a cultural, political, aesthetic, and sexual hybrid. The hybrid is crossracial, polylinguistic, and

multicontexual. From a disadvantaged position, the hybrid expropriates elements from all sides to create more open and fluid systems. This figure is from the grassroots yet experimental, radical but not static or dogmatic. The hybrid fuses "low" and "high" art, the indigenous and the high tech, the problematic notions of self and other, the liquid entities of North and South.

An ability to understand the hybrid nature of culture develops out of the experience of dealing with a dominant culture from the outside. The artist who understands hybridity in this way can be at the same time an insider and an outsider, a citizen of multiple communities, an expert in border crossings. He/she performs multiple roles in multiple contexts. At times he/she can operate as a crosscultural diplomat, a *coyote* (smuggler of ideas), or a media pirate. At other times he/she assumes the role of nomadic chronicler, cultural reinterpreter, or political trickster. He/she speaks from more than one perspective, to more than one community, about more than one reality. His/her job is to trespass, bridge, interconnect, translate, remap, and redefine.

The presence of the hybrid denounces the faults, prejudices, and fears produced by the self-proclaimed center. It reminds us that we are not the product of just one culture—that we have multiple identities; we contain a multiplicity of voices and selves, some of which may be contradictory. It tells us that there is nothing wrong with contradiction and fragmentation.

The growing recognition of the hybrid threatens the very *raison d'être* of any monoculture. Perhaps the main obstacle facing the hybrid is the ongoing distrust of both the new official transculture and the separatist cultures of resistance. And the main risk of the hybrid model is that, precisely because of its elasticity and open nature, it can be appropriated by anyone to mean practically anything. Since the essence of its borders is oscillation, these boundaries can be conveniently repositioned anywhere to include or exclude different peoples and communities. Eventually, even the official transculture will use the hybrid to baptize transnational festivals, boring academic conferences, and glossy publications. Then, once again, we will have to look for another paradigm to explain the new complexities of the times.

Ecocide and Ecoracism

The damage that corporations, armies, and government bureaucracies have done to the Earth, its flora and fauna, and indigenous peoples—a major chapter in the Columbian legacy—has reached apocalyptic

proportions. Animal species are disappearing for good. Scary man-made weather changes take place wherever we turn. It's either too cold or too hot. Either it hasn't rained for a long time or it's raining too much. Psychotic tornadoes and record-breaking hurricanes punish our coastal cities. The sinister legacies of Chernobyl, the Exxon Valdes, and the Baghdad genocide are taking their toll. The food and water we consume have been contaminated to an unimaginable degree. To live on this planet nowadays requires facing the daily threats of smog, ozone, acid rain, thermal inversions, and poisoning by pesticides. And there is no place to hide.

Without doubt, ecology must be incorporated in the social and cultural agendas of the nineties. But the ecological movements must begin to understand their interconnection with other social issues. They must finally realize that ecocide also means ecoracism and culturecide, since the dumping of chemical wastes and the ransacking of nature in search of profitable resources often takes place in other countries or at the expense of the urban or rural habitants of disempowered communities whose entire culture depends on the ecosystems where they live. When a sacred site is desecrated because the government wants to exploit the minerals or the oil lying underneath or when yuppies and the police evict people of color from their own original neighborhoods, we are talking about the same problem. Ecocide equals culturecide. Pesticides, for example, affect both the food we all eat and the health and culture of the migrant workers that harvest it. Respect for ecology necessarily implies respect for human rights and for other cultures and lifestyles. If we demand respect for Mother Earth or the oceans, we must also respect Tonantzin and Yemaya, the religions that venerate them, the art that represents them, and the people that carve their effigies. It's all or nothing.

The Columbian Legacy of Divisiveness

> To wake up here already means to be an accomplice of all this destruction.
>
> —*Argentine rock song*

It won't cut it anymore to pretend that the enemy is always outside. The separatist, sexist, and racist tendencies that we condemn others for perpetrating also exist within our own communities and within our own individual selves. Likewise, the art world is a dysfunctional family—a microuniverse reflecting the larger society. We can't continue to hide

behind the pretext that "straight, white men" or the all-purpose "domi-
nant culture" are the source of all our problems. We must now have the
courage to turn our gaze inward and begin to raise the touchy issues that
most of us avoided in the past decade.

Men of color are active protagonists in the history of sexism, and
Anglo-American women share the blame in the history of racism. We
must accept this with valor and dignity. African Americans and Afro-
Caribbeans have a hard time getting along. U.S.-born Latinos and Latin
Americans do not fully understand one another. Despite our cultural
similarities, we are separated by intricate invisible borders. Third World
feminists and American feminists still haven't reached a basic agreement
regarding priorities and strategies. The "boys clubs" of the sixties and
seventies can hardly be in the same room with the multiracial and multi-
sexual artists of the eighties and nineties. The embittered veterans resent
the irreverence of the youth and the intensity and directness of the
women artists and intellectuals. In fact, most straight men are still irri-
tated when sexism is mentioned. My lover has consistently pointed out
the hypocrisy of my hiding behind ethnicity to avoid gender issues.

The borders keep multiplying. Artists and academicians rarely talk to
one another. So called "community artists" and politicized artists work-
ing in major institutions still see one another as enemies, not as allies
working on different fronts. "Successful" artists are perceived as "co-
opted," and those who venture into theory are seen as elitist and not
"organic" in relation to their communities. Both Anglo liberals and
essentialists of color are still immersed in Byzantine debates about who
is "authentic" and who isn't. Politicized artists who favor hybridity and
crosscultural collaboration are viewed with distrust by all sides.

Well-meaning liberals often commit an insidious form of racism. They
have learned the correct terminology to not offend us, but they remain
unwilling to give up control and stop running the show. When called on
their benign bigotry, they suddenly become monsters. Many white mul-
ticulturalists are currently experiencing an acute case of "compassion
fatigue." They are either bailing out for good or retrenching to pre-mul-
ticultural stances. Tired of being rejected and scolded by people of color,
their thin commitment to cultural equity evaporates in front of our very
eyes.

In the decade of the nineties, our communities are ferociously divided
by gender, race, class, and age. An abyss—not a borderline—separates us
from our children, our teenagers, and our elders. The Columbian legacy
of divisiveness is more present than ever. This is contemporary America,

a land of such diversity that no one tolerates difference, a land of such bizarre eclecticism that everyone must know one's place. Here, artists and activists spend more time competing for attention and funding than establishing coalitions with other individuals and groups.

Chicano theoretician Tomás Ybarra-Frausto suggests that in the decade of the nineties we must resist all attempts at intercultural warfare. I completely subscribe to his call. In order to begin the great project of racial, gender, and generational reconciliation, we must sign a temporary peace treaty. Perhaps the key here is the recognition that we all are partially guilty and that most of us are partially disenfranchised. At least among ourselves, like at a family reunion, we must face these issues frontally but with respect, without indicting anyone, without calling names. Our cultural institutions can perform an important role: They can function as laboratories to develop and test new models of collaboration and "free zones" for intercultural dialogue.

Dysfunctional Communities

Our "ethnic" communities have changed dramatically in the past ten years: Our neighborhoods have become much more multiracial and impoverished. The new middle class has flown to the suburbs. Our families, schools, and community centers are falling apart. Interracial violence, homelessness, AIDS, and drugs have increased exponentially. And our outdated social theories have been rendered inadequate by these changes. Artists and activists have become foreigners and exiles in our own communities.

Despite the fact that in the nineties the word "community" has taken on myriad meanings (most of which are open-ended and ever-changing), some people still utilize the demagogic banner of a mythical and unified community to infuse their actions with moral substance. They attack and exclude others who express different views on racial identity, sexuality, and aesthetics: "I represent my community. He/she doesn't." "His community doesn't back him anymore." "This art is not community-based." And so on. This self-righteous BS must stop. Not only does it widen already existing divisions, but it provides the media and dominant institutions with confirmations of their stereotypes: We, the people of color, simply can't get along. Under the current fog of confusion, something is clear: We must rediscover our communities in turmoil, redefine our problematic relationship to them, and find new ways to serve them.

The art world, too, is a particularly strange community. It has no elders or children. The elders are ignored and the children are seen as a

nuisance. This fact is a microscopic expression of the dehumanization of the larger society. Latino leaders insist that everything we think and do in the future must be shared with other generations. We must invite our elders, teenagers, and young children to the table and reconnect with them, for they can remind us of the truly important things in life. We must bridge this grave generational gap and make sure that when we leave the table others will take our place.

The case of the distrustful teenagers is particularly sensitive. They rightfully believe we are partially responsible for the dangerous world they are inheriting. They see us as wordy, inefficient, and intransigent; they have a point. We must learn to accept responsibility and seek more effective languages to communicate with them. The teenagers have tremendous things to teach us: They have fewer hang-ups about race and gender; they are much more at ease with crisis and hybridity; and they understand our cities and neighborhoods better than we do. Surely, if there is an art form that truly speaks for the present crisis of our communities, this form is rap.

The Great Collaborative Project

> The people from the South are coming to save us.
> —*Lesli Marmon Silko*

The indigenous philosophies of the Americas remind us that everything is interconnected, all destructive and divisive forces have the same source, all struggles for the respect of life in all its variants lead in the same direction. The great project of reconstruction and reconciliation must be, above all, a collaborative one, and all disenfranchised communities must take part in it. We all need to begin sharing our secrets, skills, strategies, and infrastructures.

The indigenous communities can teach us more enlightened ways to produce food and medicine without continuing to destroy the air and the land. The new Latin and Asian immigrants can make our cities walkable and livable again. They can also teach us how to respect our children and elderly people, since their familial structures are much stronger than ours. The artists and writers of color can help us understand the extraordinary racial and cultural topography of contemporary America. The radical intellectuals can monitor the behavior of our governments with regard to human rights and environmental standards. Politicized women can teach us to organize more democratically and to develop more humanitarian political systems. And the gay and lesbian

communities can show us how to reclaim our bodies as sites for pleasure and celebration.

It's about time that politicians and corporate moguls begin to take note: No effective solution to the multiple crises that afflict contemporary society can be implemented without the consent, consensus, and direct participation of each of these overlapping communities. My colleagues and I politely ask you to join in.

Please forgive my incommensurable arrogance.

▰▰▰▰ Notes

This text is an attempt to weave into a somewhat coherent tapestry, the various anxieties and debates brewing in the alternative art worlds. Like my previous texts, it will appear in different versions, formats, and contexts throughout 1993–94. As I have stated before, I don't believe in copyright. Ideas belong to the civilian population that generates them. I am particularly thankful to Martha Gever, Coco Fusco, Amalia Mesa-Bains, Joe Lambert, Marco Vinicio Gonzalez, and Sal Salerno for informing, inspiring, and challenging the ideas presented in this document. Responses and comments from readers and colleagues will be incorporated in the next draft.

DISSED AND DISCONNECTED
Notes on Present Ills and Future Dreams

B. Ruby Rich

Traditional art in its traditional institution has of course to be given its reasonable place. Moreover, as we have seen, new work will then appear within the sustained traditional institutions. But what is hardest to realize is that even traditional art changes when its audiences change, and that in the making of new art changing audiences are always a significant factor....If we take seriously the idea of making art, as practice and as works, more accessible to more people, we have to accept and indeed welcome the fact that as part of these changes there will also be changes in the arts themselves. Nobody who knows the history of the arts need fear these changes. Indeed there is much more, from the record, to fear when art is locked in to courts and academies, or when, at the opposite extreme, artists are pushed by neglect into isolation and there is no flow between them and a wide and diverse public.

—Raymond Williams, *The Politics of Modernism*

Courts and academies. Neglect and isolation. Williams is not describing any hypothetical or mythical time in this 1981 lecture, prophetic as it may have turned out to be. The roots of our current artistic crisis were already clear and present in his mind and society (the U.K. in the early days of Thatcher). Today, art and culture occupy equally contradictory, even more contested, positions in the United States.

Most of our operative notions of art and artists are inherited remnants of nineteenth-century romanticism. Hardly anyone has succumbed to the need to remake these shards into a definition to fit today's very different needs and circumstances (except, of course, those artists who see their mission as linked to their communities, about which more later).

Instead, there persists an image of the artist as rebel, renegade, or non-conformist—identities which mitigate against any role being created for the artist as citizen, or even neighbor, of any specific city, nation, or global moment. The artist has become a figure out of time, navigating a postmodern course with nothing more advanced than a century-old compass. Never mind that the equipment no longer suits. Such a role no longer describes either the artist or the functionaries, power brokers, customers, admirers, and commodities that constitute today's art world, which in turn is itself fixed within a similar anachronism of purpose and identity, as though some sacred aura still suffused its all too secular manifestations in the late twentieth century.

The problem is not wholly the artist's, of course, nor germane only to the art world. In the absence of any coherent arts policy, the place of "the arts" within contemporary U.S. society has been perennially unclear. In the last decade, official postures of neglect gave way to famously contested and divisive debates, usually from a standpoint of morality legislated variously by the government, the right, the Church, or specific communities (antipornography feminists, antihomophobia queers) combating allegedly injurious representations. This essay, then, represents a breath taken in the midst of a conversation, offering up images frozen by a VCR momentarily fixed on "pause." It is a breath meant as a contribution to an ongoing though often interrupted dialogue which, once reengaged, faces as imperative the examination and reconsideration of the status of arts and artists in the U.S. Only once we understand fully the predicament in which we find ourselves in the present can we face the harder tasks of assessing the past and not merely imagining but designing a future.

Retrospection: Past Hits and Misses

In many countries of the world, and certainly in the European and Latin American countries I know best, the arts form a part of a national identity and a key foundation for building a sense of the collective whole and claiming a place at the world table. (In addition, of course, there is usually a component of what used to be called "cultural anti-imperialism" that seeks support for the arts of each country as a bulwark against the mass consumption of "foreign" Hollywood-or multinational-conglomerate culture, especially movies, music, and television.) In countries as diverse as Canada, Mexico, Portugal, or Uruguay, the development of painting, film, or literature is a source of national pride and a potential source of import dollars, investment, or enhanced tourism—as well as a

guarantee of cultural survival. Artists and writers are taken seriously, assigned government posts, or alternately, sent into exile and even shot at—the fate of Argentine filmmaker Fernando Solanas when he assailed President Menem's cultural policy as corrupt.[1] It is through the arts that a nation's cultural heritage can be passed on to a new generation. And because factors of language, geography, and economics constrain most countries' ability to replicate their own image internationally with anything approaching the universality that imperial power—economic or military—endows, the arts take pride of place. It is through the arts that influence can be exercised.

The U.S. commitment to capitalism, especially pronounced in the Bush-Reagan years, has always made such arguments difficult if not impossible for artists, arts organizations, arts patrons/enthusiasts. How to convince a country that the arts deserve support when the free market is supposed to be the ultimate arbiter of such a judgment? Only in the thirties, when the Depression forced new strategies to mend the rupture in the U.S. economy, was there a solution that momentarily addressed the need for subsidizing artists and was able to generate a philosophy of renegotiated national values that permitted such a subsidy to enjoy widespread support. Unfortunately, the Works Project Administration was short-lived, not only a casualty of success in a recovering economy but also one of the many victims of the anticommunist hysteria that swept postwar America.[2] To this day, the WPA remains a grand exception to the U.S. neglect of arts policies, philosophies, or strategies.

In 1960, when Nelson Rockefeller, then Governor of New York State, approved a half-million dollar appropriation for a provisional arts body mandated to distribute funding to arts activities throughout the state, he initiated an era of U.S. public subsidy of the arts that has continued to this day despite the inherent weakness of its enabling philosophy. Although Rockefeller was a Republican, the notion of publicly subsidizing the arts attracted bipartisan support in New York from the beginning: from Republicans, because it could shift the burden of philanthropy from wealthy individuals to the state and help keep "high art" (opera, ballet, symphony orchestras, museums) economically viable, and from Democrats, because it could democratize the arts. The latter strategy meant bringing the arts to, as well as fostering them within, diverse regions and populations long lacking voices or images of their own, with an emphasis in recent years on the most visible marker of such intentions, the so-called folk arts.

John F. and Jackie Kennedy made support of the arts fashionable (even though, by today's standards, their approach was Eurocentrism, francophilia to the max) and first brought the idea of supporting the arts into the modern embrace of federal policy. Lyndon Johnson included the arts in his Great Society expansionism, the soft-core version of the War on Poverty and in 1965 signed the original legislation for a National Council for the Arts and Humanities, which soon gave rise to the National Endowments. Nelson Rockefeller, when he became vice president, cast the National Endowment for the Arts in the image of the New York State Council on the Arts and brought New Yorker Nancy Hanks down to Washington to shape it.

But it was also under Johnson and Nixon that the kind of bifurcated social hostilities that have been so characteristic of the eighties really flourished, posed as opposite sides of a real war imported to the domestic front, that is, the Vietnam War era's schematic model of patriotism versus treason, morality versus immorality. Here we find early inklings of still-current ideological positions that veer off in numerous contradictory directions: suspicions of the dangerous contagion of degenerate "countercultural" arts, belief in the superiority of the artist and philistinism of the public, or, alternately, a utopian view of the engaged artist and an aware public working toward a common goal, grounded in a shared culture.

The late sixties and early seventies marked the beginnings of an oppositional establishment in the arts. Alternative spaces were formed, alternative audiences cultivated, alternative aesthetics developed: During the years 1968 to 1970 in New York State alone, a total of one hundred seventy-three "grassroots arts groups and theatre companies" came into being.[3] Political movements of the sixties and seventies opened space for enhanced participation. The Black Power movements, civil rights struggles, the Puerto Rican and Chicano *movimientos*, feminist consciousness-raising and agitating, equal-opportunity legislation, all provoked artistic corollaries and inspired new forms of aesthetic invention. In the seventies, the arts began to diversify and the spectrum of nonprofit organizations that are so taken for granted today as "the field" was first established.

In the eighties and early nineties, however, triumphant capitalist logic began to undermine even the arts subsidy ideal. Not only did the arts come under political attack from a right-wing phalanx in need of a quick fix—the boom industry of anticommunism had disappeared overnight, and it needed a new target to facilitate its post-Cold War ideological

conversion schemes[4]—but the always vague commitment to some sort of public funding began, almost imperceptibly, to unravel. Free market logic reigned with a vengeance: If it deserves support, then it gets support (from private galleries, buyers with bucks, Hollywood studios, blue chip or endowed museums, corporations); if not, then it must not deserve it. As a result, artists and all those who wanted an art reflective of their and others' realities, problems, aspirations, or fantasies have been left chronically on the defensive, on the outside looking in.

But the situation isn't simple, nor was it ever. Artists may have been championed at times, but they were always suspect, even before Reagan-Bush. While Abstract Expressionism was being exported around the world to showcase American freedom of expression (and implicitly to condemn Soviet totalitarianism), individual Abstract Expressionist artists were being targeted and their patriotism called into question. The WPA was subsidized at the same time that individual artists in its employ were denounced as pinkos. Gabriel García Márquez's books became bestsellers in the U.S. at the same time that he was unable to enter the country, all visa applications denied due to his name's appearance on the enemies list used by the custodians of entry and only laid to rest in the nineties.

The situation for art in the Reagan-Bush years was quite complex, a square with four sides, dividing up the conflicting but never mutually exclusive aspects of art's relationship to societies and politics. The four sides? Censorship. Fame and fashion. Bull market. Invisibility. Only the first and third commanded a discourse of their own in the contrary domains of political revenge and marketplace reward, but they are integrally linked to the second and fourth, and all four must be considered together if the nature of arts in the nineties is to be accurately forecast.

The eighties was an era of empowerment for artists and arts organizations: Their work was taken seriously enough to be attacked again after a hiatus of some twenty years (during which time a species of benign neglect had prevailed whereby despite underfunding, self-sacrifice and box office ingenuity allowed a dozen flowers to bloom). Franklin Furnace. Artists' Space. Robert Mapplethorpe. The School of the Art Institute of Chicago. The late mayor in women's underwear. The flag piece. Jesus Christ in piss. The NEA Four. Marlon Riggs's *Tongues Untied.* Todd Haynes's *Poison.* There is no space to restage the details here and no need, since others have done so at much greater length already.[5] Suffice it to say that artists, particularly those dealing with photography, film, or performance, were demonized and fashioned into symbolic

essences, stand-ins for "an enemy within."

It's helpful to keep in mind that the defunding of some of these artists (by a federal bureaucracy already short on funds, impoverished compared to its coffers of a decade or two ago) and the political attacks on others were taking place at the same time that Salman Rushdie was condemned to death by Iran's head ayatollah. Is "censorship" sufficiently wide an umbrella to apply to both of them? The U.S. artists did not go into hiding, exile, or eclipse. On the contrary, many achieved instant fame, a steady or escalated career path, enhanced bookings in many cases, and sometimes even enlarged artistic reputations.[6] Indeed, the political condemnation of certain U.S. artists, performers, and film/videomakers would seem to have inadvertently created an alternate career path. Just as "controversy" has been long recognized by film publicists as a route to maximum box office grosses, in these cases the "censorship" charge has balanced disadvantage with advantage. Muzzle voices with a megaphone: that's how censorship and controversy, fame and fortune, have combined into a single championship race.

Parallel to the governmental attacks and the art world's defensive counterattacks running alongside them has been the steady progress of what in the eighties amounted to a bull market for art as commodity. When immorality was charged, it was rarely Eric Fischl or Julian Schnabel at the end of the gunsight. In an odd marriage of pragmatism and market savvy, only artists outside the magic circle of the big-time collections were likely to be targeted. Few of those on the inside seemed to have any interest in art as an oppositional practice.[7] Following customs honored since the days of royalty (which preceded those of royalties, the semantic play merely underlining art's shift into commodification), these artists were usually busy identifying with their patrons, enhancing their own class status, building up their bank accounts, and moving out of the old neighborhood. "Artist" became a profession, like "lawyer" or "architect," that provided considerable recompense in return for highly valued services and extended to its practitioners the same class privileges assumed by their clients.

Thus, just as one sector of beleaguered artists was engaged in battle with political forces over their symbolic power (and, sometimes, their very survival), another sector left the battlefield in favor of a purely professionalized identity devoid of conflict. It should be emphasized, then, that when one speaks of the arts being under attack in the eighties, only the *nonprofit* art world is at issue.

That leaves the final category: invisibility. The word alone suggests the

difficulty of coming to terms with it. But perhaps a quotation from the great Uruguayan writer Eduardo Galleano might suggest a starting point:

> There has been much discussion of direct forms of censorship....But indirect censorship functions more subtly; it is no less real for being less apparent....What is the nature of this censorship which does not declare itself? It resides in the fact that the boat does not sail because there is no water in the sea; if only 5 percent of the Latin American population can buy refrigerators, what percentage can buy books? And what percentage can read them, feel a need for them, absorb their influence?[8]

In the U.S., such discussions of socially constructed cultural inequity tend to stay mired (when they occur at all) in an idealistic but unpracticed utopianism, lacking in sufficient concrete praxis to anchor debate. It is useful, therefore, to borrow Galleano's terms to uncover the myopia with which "censorship" as a category of punitive suppression has been applied—by definition, only to those already holding a position of recognition. It was only those artists already funded by the National Endowment for the Arts or the Corporation for Public Broadcasting, already programmed by public television or nationally prominent alternative spaces, already dignified with retrospectives or other support, that could be anointed with the Purple Heart of "censorship" in the first place. Just such myopia explains why the organizing against censorship that went on nationally in the late eighties was overwhelmingly white and middle-class: It was only these groups, in general, that had the sense of entitlement necessary to galvanize outrage at its withdrawal. Simply put, members of other groups felt that they were already the victims of an ongoing censorship that hid under the less formal banner of exclusion and was never protested.[9]

The wounded self-interest that propelled many white, middle-class artists and the institutions that served them into an outburst of political activism was a missing component for many other artists and community-based institutions—and for the many inner city and immigrant communities lacking bases of support for either their artists or institutions. Here are the artists who are "censored" because they have never been allowed to come into being—to receive training, to imagine such careers, to enter the intimidating structures that can produce such identities and such vocations. In a time of job cutbacks and public-education curtailment, the care and feeding of "other" artists has suffered: They simply fail to materialize in the numbers necessary to make the arts a

genuine reflection of this society. And just as problematic is the fate of the artists who have emerged from ethnic-specific or class-constrained communities, who enter an art world uninterested in their origins or influences. They often encounter hostility to their vernaculars along with a paradoxical insistence that they join the ranks in order to claim professional status.

Myopia could be found, too, in the standard by which artistic obstacles were considered to constitute "censorship." Given the overall infantilization of the artist in U.S. society, it comes as no surprise that the favored oppressor, virtually to the exclusion of any other, was the government.[10] As a result, when censorship arose in other quarters, there was little acknowledgment or support forthcoming. Notable in this regard was an incident involving Isaac Julien, the British filmmaker and director of *Looking for Langston,* an inquiry into the life (and homosexuality) of the legendary Harlem Renaissance writer Langston Hughes, who found his work censored by the Langston Hughes estate through the device of withholding copyright permission.[11] As a result, the film had to be reedited for U.S. release—but was nevertheless censored further at its debut at the 1989 New York Film Festival, due to renewed threats of an injunction by the estate if certain contested passages were not suppressed on the soundtrack. Ironically, then, the body of Langston Hughes appeared on screen, miming his poem, his voice silenced. Yet there was no picket line outside, no protests, no mainstream media coverage: The "censorship" had come from within the black community, not from Washington, and like all black-on-black crime, it never seriously disturbed the surface of white art politics.

▰▰▰ The Politics of the Art World: Recollections of Conflict and Contradiction

Gimme an "a." A! Gimme an "r." R! Gimme a "t." T! What does it spell? A-R-T! Say it again: ART, ART, ART! Art is part of the community, but what part, and which community? When one famous nonprofit film theater found itself suddenly imperiled by possible demolition, it was suggested they contact their local community board to organize—but they had no idea what district they were in, nor who represented them. The arts have rarely been part of any political landscape as a player, and rarely reach out until attacked. What is art, anyway, and who wants it, and why? Is it an object or a right? A commodity, or a state of grace?[12]

For more than a decade, I worked as a bureaucrat for a state arts agency, a mole in the belly of the beast. In my capacity as director of the film program (and later the electronic media, too) for the New York

State Council on the Arts, I traveled around the state's urban, suburban, and rural territories to consult with the council's real and imagined constituencies. In the early eighties when budgets were still growing, I traveled to drum up business and carry out my mission: to foster the development and growth of a nonprofit film and video culture throughout the state that reflected its diverse populations. By the time I left my post, with state funding for the arts cut by half, my job had become damage control: reassuring populaces that the council wouldn't abandon them completely, trying to brainstorm alternative resources (virtually nonexistent as local economies, too, collapsed) and working to maintain a film-media presence as multiarts groups initiated the program cutbacks they needed to stay alive.

During these years, especially in the growth period of the early eighties, my travels were an education in how arts function within communities. I met with one volunteer film group between their stints at the county fair. I went to see another that listed a nurse (male) and a vintner among their members and met with me in a local restaurant because they had no office. I learned that the biggest factor in film attendance in the North Country was weather, not choice of films: a single storm could knock out the best programming, as audiences might travel up to fifty miles for an average show. I met with black theater groups in upstate cities that didn't want to apply to the council at all because they didn't want "welfare." (I applauded their threadbare self-sufficiency while pointing out that the Metropolitan Opera didn't share their fears.)

I also met with the boards of directors of new arts centers in countless towns and small or midsize cities that hoped to tap into tourism dollars and build community identities through the arts. In virtually every case, the motivation to establish such a center was inextricably and obviously linked to class mobility: In the absence of a multiplicity of hierarchical signifiers, the arts offered a way to distinguish oneself as a member of the discerning, art-loving "upper" echelon. In this sense, the arts council became a source of outside "nonprofit" capital, providing not factories or hotels but something equally valuable if less tangible: enhanced local privilege. It was the big city bureaucrat who got to play the role of eternal populist, pushing groups to reach out to "minority" communities in their areas, to publicize programs beyond a small circle, to expand programming beyond a narrow range of Eurofilm titles cribbed from the *New York Times* or *New Yorker* to which they subscribed. Art may have been scapegoated as radical in the pages of the *Congressional Record*, but the arts interests in small town America knew that the arts could be a loyal player

in the status quo, too.

At the same time, the arts could offer a route out of the status quo. In the early eighties, the council funded the first feature by a young black filmmaker with one student film to his credit. *She's Gotta Have It* became a monster hit, and Spike Lee became famous overnight. Soon after, I found myself in Syracuse, New York, at a high school Career Day at the Community Folk Art Gallery, a small black arts center (originally established as a "ghetto arts" facility in the late sixties). Pushed by its director to talk to the students, I asked about their career plans. Specifically, did anyone want to be a film director? Scores of hands went up—in a center that hadn't even been able to maintain film exhibition in its community before—with voices asking whether I really knew Spike. His commercial success had more effect on the film aspirations of black youngsters in the U.S. than all the nonprofit arts programs combined. Paradoxically, though, he achieved his success through the established R&D route of nonprofit film activity.

The worlds of inner city teenagers, of Spike Lee's commercial career, of the arts center boards of directors, of the small town merchant class, all have little in common with each other apart from their shared peripheral relationship to that sphere that goes by the name of The Art World. This "art world" exists in identifiable geographic locales and identifiable buildings—the Getty, MOCA, the Stedelijk, the Pompidou Center, key streets in Frankfurt or Brussels or Soho, the Venice or São Paulo Bienale—easily catalogued in the pages of *Artforum, Art in America,* or *Flash Art.* In each city, the world enshrined in the galleries and museums is as distant from the outlying towns and populaces as the instances just included in my New York examples; at the same time, of course, the art worlds stationed there are linked to each other transnationally, sharing the values, goals, status, and economies that distinguish them so clearly from their respective local environments.

The actual values of these art world(s) pass largely unnoticed, free of interrogation. On the rare occasion when forces or influences do originate outside its hothouse environs, the art world usually acts as though the origins were internal anyway. When postmodernism became the fashion, few voices pointed out that its strategies of pastiche, appropriation, and hybridity were precisely those of subcultural and Third World survival strategies, folk art, and artistic production; rather, with the term in place, the aesthetics were whitewashed and annexed, maintaining rather than dissolving the barriers between these disparate worlds.

The art world rallies around its own when attacked. For me, one of the

most profound and tragic examples of this was the loyalty that protected the famed minimalist sculptor Carl Andre with silence when he was indicted for the murder of his wife, my friend Ana Mendieta, the pioneering Cuban American artist who died in 1985.[13] The assistant district attorney in charge of the prosecution, Elizabeth Lederer, contended that the only times she had confronted such obstacles to gathering information were cases concerned with the Mafia. Andre's ultimate acquittal for lack of sufficient evidence quieted neither rumors nor ghosts. On the other hand, his powerful art world friends' concerted efforts to boost his reputation and revive his career have been successful enough that the opening of the downtown Guggenheim in 1992 included his work in its premiere show. But the ghosts could not be banished: WAC (Women Artists Coalition) forces demonstrated on opening night with signs, T-shirts, and calling cards, all proclaiming: "Carl Andre is at the Guggenheim. Where is Ana Mendieta? *Donde está Ana Mendieta?*" The death of Ana Mendieta remains a rare instance of an art world split, wherein more marginalized voices (particularly feminists and artists of color) have staked out opposition to mainstream, entrenched art interests. Further, attention to Ana has grown as time has passed, including considerations of the Cuban roots of her artistic vision.

There are other examples, equally contentious if less fatal. The most famous case focused entirely on the art itself.[14] Richard Serra was commissioned to design a sculpture for the plaza of the Federal Building in lower Manhattan. *Tilted Arc* was installed in 1981, its huge rusting hulk bifurcating a plaza long used as a site of political protest as well as a main pedestrian thoroughfare. Although the plaza was a mere few blocks east and south of Soho and Tribeca, *the* art neighborhoods of New York City, it was located in a district entirely populated by salaried workers, civil service lifers, shops purveying cheap goods for these workers, courthouses, and so on—in other words, a typical working-class and lower-middle-class environment with little or no preexisting contact with or conduit to the art world or its interests.

Up went the minimalist sculpture, praised for the precise placement that managed to redefine fundamentally the architecture of Federal Plaza. Not everyone was impressed, however. A petition to remove the sculpture was signed by 1300 workers, a significantly large number considering that most workers felt powerless and thought that its removal would be impossible.[15] But the terms of public art were being disputed at that time, and the debate over *Tilted Arc* became a central feature in that debate.

Public funding for "public art" in the U.S. began, typically enough, as "value free" funding, with no clear philosophy in place. It was assumed that the same standards that governed gallery shows or museum acquisitions (formal art world standards) could simply be exported to the city streets. However, this artistic vernacular was a private, not a public, one. The aesthetic codes governing such sculptures were not known by the general public, nor did these public installations allow for any gallery-to-street translation. Thus, the resulting sculptures were judged by the neighborhood less according to sculpture's unfamiliar aesthetics than by the more familiar codes of architectural or storefront custom. According to the latter, the Serra sculpture was quickly labeled, in street terms, an "eyesore." Many people hated the extra steps involved in detouring around it on their brief lunch hours or hurried deliveries, or resented the sheer physical audacity of its colonizing presence in "their" square.

The two worlds of art and wage labor intersected in three days of hearings on whether the sculpture should be removed. Both sides argued in terms of conflicting aesthetic standards. The removal team argued community standards, that old bat that is inevitably swung against difference; they also tried to argue aesthetic failure, but lacked the credentials to carry that one off. The art defense team argued the trump cards of censorship and freedom of expression. Drawing on history, they cited the philistinism of public standards and incidences of public opinion vanquished by the later triumph of the artist's vision. Nevertheless, the local Government Service Administration judge William Diamond ruled against the art interests in favor of the local workforce. On March 15, 1989, some eight years after its construction, *Tilted Arc* was removed.

The issues raised by the *Tilted Arc* case, however, could not be removed as easily as the sculpture itself. What exactly did it mean to argue freedom of expression or censorship in this case of conflicting values? Since any opposition to any artwork can be stereotyped as "censorship," it is hard to imagine how an objection to any work could ever receive the support of the art world itself. Also, is such a stance appropriate? If values could be defined, then perhaps some works of art would be seen as lying outside their range and therefore not deserving of automatic support.

Even in instances that merit support, the defense might at least be trimmed like a sail meeting the wind. When a retrospective of Robert Mapplethorpe's photographs became a target of conservative Republican wrath and was canceled from the exhibition schedule of the Corcoran Museum, the art world came through with support and even—

when the same show's opening at Cincinatti's Contemporary Art Center led to a court case on obscenity charges—with expert testimony. However, in the entire debate over the Mapplethorpe photographs, couldn't someone have dropped the charade of defending these photos as worthy solely on the basis of their intrinsic formal composition and admitted, up front, that these were inherently transgressive works dedicated to shattering taboo, works valued precisely for that thrill of shock, works fully conscious of the outrage likely to attend any migration outside their intended subcultural audience? Contemporary arguments should at least acknowledge the desire to transgress that's obvious in so much work and defend that impulse as itself a worthy one, part of a noble artistic tradition with a name—*épater la bourgeoisie*—instead of claiming this transgression as normative and then, by default, blaming an inferior public for not being hip enough to get the punch line.

Unlike other professions the arts occupy a special, anomalous position in our society. Practitioners aren't licensed. Its members are entirely self-declared and self-anointed, lacking any visible signs of status or ordination, devoid of licenses or union cards. The field lacks even the most minimal forms of regulation (the only exceptions, true to market forces and value preservation, involve theft or forgery). In the medical profession, standards are enforced by the threat of malpractice, in law by disbarment, in journalism by libel suits.[16] Landlords get liability insurance to protect their property. Product manufacturers worry about personal injury suits. Such forms of regulation, whether applied from within or without, however minimal, provide a framework of responsibility, however imperfect, that suggests to the public a contract of trust.

Although the romantic legacy of the art world mitigates against any such institutionalized forms of redress, such systems of regulation are not unimaginable and could easily be as useful to artists as to the public. Public forums could be held on controversial issues. An ombudsman structure could be established to handle situations of conflict or distress, mediating between contradictory aesthetic discourses or values. Certainly there is room for mediation outside the zones of politics and business that still dominate all debates about these issues, creating a vacuum most often filled by the press. There is one exception, however, to this moral and ideological vacuum: one territory resembling solid ground—the principle of freedom of expression. Erected on the foundation of the First Amendment, this has been at the heart of every major arts defense. But in a free market economy, what does freedom of expression signify? Perhaps laissez-faire aesthetics, the triumph of

individualism, in essence nothing more grandiose than the survival of the fittest, an Ayn Rand scenario rehashed for the cultural sector.

From the Individual to the Community and Back

Individualism is a tricky concept, at best, subject to appropriation in any number of conflicting directions. Advocates of social authority often lean rightward, while advocates of individual autonomy lean in all different directions, from Tiananmen Square to Ross Perot, from right to left to corporate.

In the contemporary U.S., the art world's model of individualism mimics the social Darwinism that holds sway in the larger body politic. Surely other stances could be initiated, other forms of ego investment and aesthetic transcendence envisioned. The change of administration in the White House has brought an uncharacteristic optimism (however brief) to the United States, despite the very real causes for pessimism both nationally and internationally. The White House has changed not only from Republican to Democratic, but generationally. The global paradigm has changed from communist/capitalist to something much harder to define but which is beginning to look like capitalist/fundamentalist-nationalist.

It is precisely at such a painful, troubled, yet potentially inspiring and empowering time that the arts have much to offer, if only artists are up to the challenge. Perhaps this is a time when other models might be imagined. If Western fantasies of the artist are indeed founded on the outmoded platform of romantic individualism, then it's perhaps useful to remember the relativism of that position and the lack of inevitability attending the paradigm.

> Not all cultures socialize autonomy or redundantly confirm the right of the individual to projects of personal expression, to a body, mind, and room of one's own. To members of sociocentric organic cultures the concept of the autonomous individual, free to choose and mind his or her own business, must feel alien, a bizarre idea cutting the self off from the interdependent whole, dooming it to a life of isolation and loneliness....It is also sobering to reflect on the psychic costs, the existential penalties of our egocentrism, our autonomous individualism. There are costs to having no larger framework within which to locate the self.
>
> —Richard A. Shweder, *Thinking Through Cultures: Epeditions in Cultural Psychology*

Shweder's appeal to life in "organic" or "sociocentric" cultures is an attractive one, even if its wistfulness marks it indelibly as the expression of an outsider peering in at the society so admired. His comparison between our own individualistic "Western" society and the "organic wholeness" of the "East" seems designed to evoke the very qualities missing in the debates and conflicts traced in this piece so far—a sense of shared community, interdependency with others, a sense of belonging within a society which he regards as a "regulated" universe.[17] Of course, without knowing more of Shweder's sense of this shared universe, it would be impossible to guess whether normative patriarchal or other property-based models of authority have been displaced or merely replicated in his model. Nevertheless, his suggestion that autonomous individualism has limits and may carry its problems along as a precondition of its very hegemony deserves serious consideration. In such a universe, presumably, even the art world could articulate a sense of values by which its works and behaviors could be modulated and measured. Echoing this suggested critique of U.S. society, philosopher and theologian Cornel West has spoken of the "existential emptiness" of U.S. society, similarly pinpointing the "excessive preoccupation with isolated personal interests and atomistic individual concerns."[18] The weakness of the social fabric in the U.S. is a cause for concern to anyone worried about the psychic health of the nation.

The late Audre Lorde once wrote, in moving terms, of a different kind of interpersonal relationship possible in our own society, not terribly removed from Shweder's rather idealist crosscultural model. Hers is perhaps more realistic, since she suggests the preconditions that would enable such a model of interdependency in a society that allows for individualism.

> Within the interdependence of mutual (nondominant) differences lies that security which enables us to descend into the chaos of knowledge and return with true visions of our future, along with the concomitant power to effect those changes which can bring that future into being....Without community there is no liberation, only the most vulnerable and temporary armistice between an individual and her oppression. But community must not mean a shedding of our differences, nor the pathetic pretense that these differences do not exist.[19]

For artists in the nineties, it seems to me that the route hypothesized by Shweder and outlined (in word as well as deed) by Lorde is the only

possible means for healing the rifts between artists and the larger societies with which they seek to communicate. Similarly, Toni Cade Bambara has described what she calls "the authenticating audience" in an attempt to imagine the sort of communion by which a filmmaker, writer, or artist might communicate productively with a true community, however constituted.[20]

How to go to the well and return refreshed? The thread of connection must be restored. Artists can produce work, not solely in the splendid isolation of the individual ego (though it is there, surely, that the spark of the work takes hold) but in the call-and-response connection that links each one to some sort of community, however literal or geographic, symbolic or delineated—that might be a community whence the force of the work might arise or be inspired, whereto the finished work might return, to be taken in, replenish, exult, or chastise. The artist must be bicultural. Most artists were not born into the art world, weren't raised in galleries or weaned on performances. Everyone comes from somewhere, aspires to be somewhere else (or back *there* again, a lost Eden regained). When artists emerge from identifiable communities or the energies generated by particular historic moments, the power of that connection can be immense. At the same time, when artists are truly bicultural, then conflicts inevitably arise, if not for them then for the institutions and communities they bring into contact.

An interesting example of such a conflict, far different in cause and consequence from the *Tilted Arc* dispute, transpired in Texas in 1991. The Chicana artist Carmen Lomas Garza was accorded a traveling retrospective of her work, *Pedacito de mi Corazon* (*A Little Piece of My Heart*), organized by the Laguna Gloria Art Museum in Austin. The show featured dozens and dozens of the drawings, etchings, and paintings inspired by her childhood in Kingsville, Texas. Redolent of Chicano cultural life in the fifties and sixties, her images are filtered through an artistic vocabulary forged out of folk art motifs and the political ideals of the Chicano movement of twenty years ago. It's a rich and fanciful history, full of family and tradition, as entitled to normative status as any *Ozzie and Harriet* rerun or Norman Rockwell portrait. However, when the show traveled to the El Paso Museum of Art, events took an unusual turn.

The story broke in the *El Paso Herald-Post* with the headline: "Museum President Embarrassed."[21] Interviewed for a feature on the exhibition's success (with museum attendance up from twenty-five to one hundred people a day), the new president of the board (which functioned effec-

tively as a board for the museum) expressed his embarrassment over the show. Asked to respond, Lomas Garza got to renegotiate her own relationship to white Texas: "There is a strain of racism in that attitude, which also is a form of censorship. I'm not threatened by it. I think it's sad." Burton Patterson, the president, had forgotten something: He was representing a public museum, not a private institution, despite the importance of his cronies' money. A new association, the Friends of the El Paso Museum of Art, was formed to protest his statements and increase support for the museum's director, Betty Duval Reese, who had staged the exhibition and opened the museum more fully to its communities. The Hispanic Chamber of Commerce called for Burton's resignation. In one of the few art debates involving a unified community of color, the city of El Paso responded by ending the Association's thirty-year reign over the museum and appointing a new board made up, in part, by those who had mobilized in Lomas Garza's defense. The city officials saw in her treatment a reflection of the powerlessness of their own situation and discovered, in the process—the artist's response and the community's actions—a source of expanded power and authority born from the ashes of past abuse.

There is no longer any single, unitary art world to which we can or must pledge allegiance. That's the good news. The bad news is that the arrival of heterogeneity has already set off its own backlash. Even the most desultory observer, randomly scanning the popular and art press in the early spring of 1993, could not have failed to notice the vitriolic attacks on the Whitney Museum's Biennial exhibition.[22] Granted that such a feeding frenzy has become de rigeur in recent years, what was new in the first Biennial to unfold in the post–Cold War period was the focus on the perceived domination of the show by artists of color, on the collectivity and coherence of artistic selection, and on the threat of antipleasure posed by an exhibition that rejected the studio arts in favor of more deconstructed, performative, or celluloid/electronic strategies.

Despite the media's fears and propensities, some of the best work of this last decade of the twentieth century is precisely the work that articulates a sense of connection and seeks to bring aesthetic contributions to existing concerns, campaigns, or constituencies (and vice versa).[23] Work that connects artist to community and back must be *syncretic* work, work that marshals differing vernaculars under a sign of mutuality, work that can move beyond hybridity as an aesthetic to hybridity as a process. One of the strongest forces in the New World has been the religions built from pieces of Catholicism, native indigenous faiths, and African rituals.

Practices like the *santeria* found in Cuban and Puerto Rican communities and the *macumba* or *candomblé* practiced in Brazil—even Catholicism itself as practiced in its Mexican or Peruvian incarnations—are known as syncretic religions for their ability to fuse old tribal powers with modern religious practices and personal needs into a dynamic, powerful, and evolutionary system. The strength of such a syncretism is available for artists in the U.S. today, offering a model for strength and accommodation without assimilation, charting a route out of the cul-de-sac of postmodernism and the crisis of paralysis precipitated by the collapse of Cold War binaries.

This appeal for a syncretic practice is no utopian call to arms, no instructive blueprint for an unconstructable future. No, the building is already underway. The traces are already visible, already in motion.

Hollis Sigler, headquartered in a modest house in the near rural suburbs of Chicago, continues a lifelong series of paintings of landscapes and domestic dramas, despite the cancer diagnosis that has changed her life. The bright colors, fanciful dramas, and primitive landscapes of her faux-naïf work remain the same. They continue the iconography and style she developed back in the early seventies, when she rejected the painterly techniques of the star art student in favor of a vernacular more compatible with emotional truths, positioning her work solidly within the feminist art movements of the time. It is only careful attention that yields a view of the texts—on cancer statistics, women's survival rates, personal anecdotes—that Sigler has introduced into the wooden spacers between picture and frame, texts that invade the "body" of the painting as surely as cancer has invaded her body and millions of other women's bodies. Sigler's words connect her to an invisible but powerfully present community of women battling cancer, all "walking in the ghosts of our grandmothers" as one of her titles suggests. Her statistics come from their lives, her grief from their deaths, her survival from these painterly representations. Though her work today appears in mainstream art venues, its soul is still intimately linked to a collectivity of cultural strength and survival.

Filmmaker Marco Williams got his hands on a camera and dedicated years to charting the life of his mother and the other women of his extended family of single mothers and runaway dads. His documentary is perfectly aware of white society's media images of the black family and of the stereotypical racism that drives those images and ideas. And it is precisely the context of the black family's invisibility that makes his documentary so eye-opening. His story is deeply personal, yet it resonates

across communities, collectivizing its narrative into a sort of matriarchal moral tale, refusing mainstream society's self-interested statistics, the boss man's studies, and journalistic standards of mock objectivity, in favor of lived experience and a thoroughly subjective position.

Sadie Benning, meanwhile, was passing her adolescence in her bedroom, making videotapes that chart an unprecedented portrait of the artist as a young dyke, making them for less money than one can imagine and meeting up with other Bad Girls and Riot Grrrls in concerts, zines, and high school hang-outs across the country. With a distributor at the age of seventeen, a Museum of Modern Art retrospective at eighteen, by the age of twenty Benning had become a magnet for the young lesbian sensibility, even as she fled her own fame and went on the road in search of community. Indeed, her videotapes have become a tool in the construction of an unprecedented lesbian community. Syncretically visionary, Benning has an artist's eye and a young dyke's soul, leading to work that travels effortlessly between bars and museums and shatters genre boundaries in an effort to make connections. She assumes her right to sit at multiple tables and find a place set in welcome, and by so assuming, finds it so.

In East Harlem, Pepón Osorio makes sculptural objects and installations, creating a bridge between the tragedies of daily life for the Puerto Ricans of *el barrio* and the transformative powers of art. When he staged the opening of his retrospective at the Museo del Barrio in New York, the members of the Volki club turn out in force with their customized, decorated Volkswagen bugs, blurring the line between the gallery and the highway, the inside and the outside of El Museo. His work brings the luminous beauty and transcendence of art in touch with the painful, tragic authenticity of the streets, reminding us of art's ability if not always responsibility to offer a mode of healing to its supplicants.

Osorio's piece in the 1993 Whitney Biennial, *The Scene of the Crime: What Crime?*, communicates an immensely powerful message of community under siege in its staging of a murder scene within the over-the-top typicality of a *barrio* apartment. It's a syncretic installation that combines kitsch and realism into a new, self-conscious, virtually kitsch 'n' sink aesthetic. The change of venue inevitably has changed the response to the work, recontextualizing Osorio's lifelong commitments under the sign of an institutional event and allowing critical misreadings to emerge: it was *The Scene of the Crime* that was chosen by some art director or editor to illustrate the *New York Times*' claims for the show's aesthetic shortcomings. A shock as great as that of the museum president's statements in El

Paso, such a scapegoating of Osorio is a reminder that art constructs its audiences as surely as the reverse and that, by refusing to leave his community at the door upon entering the museum, Osorio has run smack into the limits of tolerance in one arena of the art world.

These limits have been illuminated for a moment by the beam of his aesthetic flashlight, revealing conflicts that are more often hidden or erased by mechanisms of quiet exclusion. No secret, though, to those artists navigating the bicultural shoals of various art worlds, crossing over between specific communities of origin or connection and the mainstream art world. Crossover, though, has been a general feature of cultural and subcultural life in the eighties and nineties, whether the commercial version of rap or the guerrilla version of tagging and piecing (graffiti to the uninitiated). Hip-hop culture has spawned music, clothing, clubs, a whole lifestyle. There has always been a tradition of community invention and cultural crossover. The Harlem Renaissance flourished as an arts movement because it took a whole community along with it. In the early days, when it had a broad audience, so did jazz. So, too, did movements around Chicano art or feminist culture, black film or contemporary cultural responses to AIDS. In every case, the kind of attention and demand generated by the community's response to the work propelled the artists forward even as they reached beyond it, increasing the power of their creations and stimulating an audience (sometimes, a market) well beyond its original focus. Call and response, at a collective level, in a cultural chord, has frequently spawned movements that redefined the arts of their moments.[24]

A Call for a Prophetic Aesthetics

> Prophetic thought and action is preservative in that it tries to keep alive certain elements of a tradition bequeathed to us from the past and revolutionary in that it attempts to project a vision and inspire a praxis which fundamentally transforms the prevailing status quo in light of the best of the tradition and the flawed yet significant achievements of the present order.
>
> —Cornel West, *Prophetic Fragments*

While "prophetic religion" is most often interpreted to mean "liberation theology," here Cornel West is speaking of an explicitly Afro-American prophetic thought centered within the black Baptist Church. He locates such a religious practice within a U.S. context he describes as spiritually barren, obsessed with consumption and facile stimulation, prone to

titillation and intensity. His task as a theologian, however daunting, is not wholly irrelevant to that of artists today, who confront an identical context of production and reception. The arts can offer a secular form of transcendence, an aesthetic healing of cultural abscesses, a formalist solution to socictal disequilibrium. Such achievements are well within the grasp of the arts and easily compatible with any cultural mission. But the arts are as prone to "despair, dogmatisms, and oppressions" as the degraded religious forms he seeks to assess.[25] Only with a thorough reinscription of the artist and the arts into American society will miracles of transcendence or healing be effected or even attempted.

Following West's lead, then, we could begin to imagine new aesthetic strategies that could build productively on notions already advanced of hybridity, crossover, syncretism. A new strategy of prophetic aesthetics could link artists, arts institutions, and communities in a sphere of shared and mutually reinforcing interests that could strengthen lives as well as careers. But perhaps aesthetics is too narrow a term, as the necessities and implications of such a radical repositioning move quickly off the canvas, out of the frame, into the realm of structural and infrastructural change—for artists, audiences, arts institutions, and the sociopolitical context within which all of us must operate.

An arts sector driven by prophetic aesthetics and values might organize itself differently, for starters. Perhaps museums would open evenings instead of just school hours so that working people could go there. Perhaps the free days that most museums make available as a salve to their public mission could be moved from weekdays to weekends, so that families could escape the television set and make a trip to an arts institution together. Maybe the corporations that fund the big exhibitions would like to adveitise free admission days on MTV or the home shopping network or the local radio station. Maybe outreach for the "ethnic" shows that do get scheduled at galleries and museums could cross racial borders in its publicity, too, and recognize that people have to learn about each other if we're to be able to cohabit the inner cities of this nation in peace. Perhaps the smaller galleries and satellite spaces that breed new work could get the support they need to enrich their own communities and provide artists with meaningful alternative venues.

But once stated, even these changes sound minor, new riffs on a tune rather than any fundamental change in rhythm or instrumentation. Perhaps the President of the United States sitting in office in the early nineties could do for the arts what he has promised to do for education and health. Why not revive a form of the WPA for the nineties, with

young people recruited for a sort of Culture Corps, traveling not to foreign lands but working to enrich the inner cities—where culture remains a major industry, as vital a part of the landscape as farming is to rural areas or manufacturing to smaller towns? Why not fashion new art forms for a new era, drawing on sampling techniques in music to find visual, sculptural, or cinematic corollaries for diverse community narratives, hopes, and fears? Why not develop public access cable channels into electronic town meetings, on-air soap boxes to express views—on the arts, prospective public arts commissions, and so on, as well as other civic concerns?

Why not broaden the notion of arts spaces beyond the old apartheid system of art world galleries versus community arts centers? The San Francisco airport puts arts exhibitions in its terminals. Why not the bus stations, too? Japan puts art exhibitions in its department stores. Why not Macy's? Why not Toys 'R' Us? Chic restaurants install local artists' works. Why not Burger King, too? Change of venue need not be just a legal term. It might equally be used to fit artists to communities and aesthetics to viewers.

For any such renegotiations to work, however, there would have to be a massive overhaul of kinship systems and reward structures so that less established artists weren't assigned to less valued arenas. Imagine a world, then, in which it would do as much for an artist's career to show in a fast food restaurant as in a bank. Where a composer would feel as inspired and satisfied writing a piece for a high school orchestra as for a symphony orchestra. Where artists of color, whether first-generation or fifth-generation, would assume major museums to be appropriate venues for their work, would assume both curatorial interest—for any show, not special shows—and would assume their friends and families would be likely to venture inside without terror or fear of humiliation.

Why not learn from the singularly most successful piece of public art in the second half of the twentieth century, Maya Lin's Vietnam Veterans Memorial, that managed to fashion a rigorously modernist aesthetic vocabulary into a democratic, inclusive, and easily accessible work of art for a broad public? It's an ideal example of what a "prophetic aesthetics" could contribute. But such aesthetic gestures need not be monumental. Many are ephemeral. When artist Barbara Kruger wanted to contribute a poster to a national abortion rights march in 1992, she tried unsuccessfully to go through "appropriate channels" to get the sponsoring organization's permission and figure out how to work with the coalition sponsoring the march. Eventually, Kruger just produced the poster with

her own money and resources and plastered it all over New York City to solicit participation in the event. Similarly, when a group of artists commissioned to install a storefront window exhibition on art and AIDS for the New Museum came up with a slogan they had no idea that "silence = death" would quickly migrate out of the museum to become a rallying cry for a political movement. Such examples are intensely political ones. But a prophetic aesthetics could take many shapes and forms to meet the needs of its practitioners and communities of interest. Sculptor Mel Edwards, for example, makes pieces that resonate with the horrors of slavery, yet his work is nonnarrative, nonrepresentational, virtually nonverbal. The chains, wood, and iron—the materials of his work—speak for him eloquently enough.

What is important now is not a purity of ideology, not an orthodoxy set on erecting rules for followers, but a generosity of purpose that is prepared to encompass fully the sorts of differences that Audre Lorde long championed. What is clear is that the old models are not working, not in society as a whole, certainly not in the art world(s) either. With generosity and optimism and a commitment both of selves and resources, we have a chance to fashion the worst crisis of the arts in the twentieth century into the greatest flowering of the arts—at least by the time the twenty-first century comes along.

� Notes

1. My story on the Solanas attack appeared as "Tangles Argentina," in *The Village Voice,* July 24, 1991, p. 64, after his case was publicized by Amnesty International.
2. For an illuminating chronicle of how the arts were scapegoated as anti-communist in this period, and how the U.S. government's export of Abstract Expressionism could transpire simultaneously, see Eva Cockcroft, "Abstract Expressionism, Art of the Cold War," *Artforum* 11, no. 10 (June 1974), 39–41.
3. See the annual report for the New York State Council on the Arts fiscal year 1969–1970. Figures taken from the Executive Director's Statement, p. 113.
4. I have written elsewhere of my contention that the right wing simply reversed the letters of two acronyms, converting the CP (Communist Party) into PC (Politically Correct) to preserve its own political power and base of support when its external enemy disappeared.
5. See the three main books already published on this era: *Culture Wars: Documents from the Recent Controversies in the Arts,* ed. Richard Bolton (New York: New Press, 1992); Steven C. Dubin, *Arresting Images: Impolitic Art and*

Uncivil Actions (New York: Routledge, Chapman and Hall, 1992; Marjorie Heins, *Sex, Sin, and Blasphemy: A Guide to America's Censorship Wars* (New York: New Press, 1993). See also Carol Becker's exemplary essay on the key Chicago incidents, "Private Fantasies Shape Public Events: And Public Events Invade and Shape Our Dreams," *Art in the Public Interest*, ed. Arlene Raven (Ann Arbor: UMI Research Press, 1988).

6. Notoriety doesn't always guarantee success, to be sure, but those who stayed within their own established sectors tended to profit from the attention.

7. Of course, there were exceptions: Hans Haacke, Leon Golub, Barbara Kruger, and Gran Fury among them.

8. Eduardo Galleano, "In Defense of the Word," *Days and Nights of Love and War* (New York: Monthly Review Press, 1983), translated by Bobbye S. Ortiz.

9. This is largely an anecdotal and observation-based deduction on my part. But it was confirmed by incidents like a speech by Tony Whitfield, then manning the cultural desk in the Manhattan Borough President's office, at the Media Alliance conference held at Cornell University in 1990. Whitfield spoke of his distress at attending a press conference to protest censorship in the arts at the Public Theatre, where he was the only person in attendance who was not white.

10. The artistic attachment to victimization at the hands of government was such a dominant paradigm that throughout the eighties the stalwart First Amendment principles of the New York State Council on the Arts were never acknowledged or saluted, while attacks on freedom of expression at the National Endowment for the Arts drew consistent press.

11. For details, including excerpts from interviews with both Julien and estate executor George Bass, see Catherine Saalfield, "Overstepping the Bounds of Propriety: Film Offends Lanston Hughes Estate," *The Independent Film and Video Monthly* 13, no. 1 (January/February 1990): 5–8.

12. Opinions vary, of course, as to the meaning and importance of the arts. There's Quentin Crisp's assessment: "Culture, you know, is anything too boring to be regarded as entertainment." (Lance Loud, "Queen for a Lifetime," *The Advocate*, August 10, 1993. More soberly, an opinion poll conducted in October 1992 by Research and Forecasts, Inc., for the National Cultural Alliance reported that, of the 1,059 adults interviewed, 87 percent said that the arts were life-enriching—but 57 percent said that the arts and humanities played only a minor role in their lives as a whole, and 41 percent said they had little to do with their daily lives. Clearly, there is a crisis of separation afflicting the arts and their potential audiences, while at the same time the belief in art's powers is an enduring sign of optimism.

13. See B. Ruby Rich, "The Screaming Silence," *Village Voice* (September 23, 1986), 23; "The Case of Carl Andre," *Mirabella* (September, 1990), 126–128; and Robert Katz, *Naked by the Window: The Fatal Marriage of Carl Andre and Ana Mendieta* (New York: Atlantic Monthly Press, 1990).

14. For original documents, definitive chronologies, hearing proceedings, and Richard Serra's perspective on the sculpture and surrounding events, see

Clara Weyergraf-Serra and Martha Buskirk, *The Destruction of Tilted Arc: Documenta* (Cambridge: MIT Press, 1991). For an art world view of public art in general and the issues it raises, see *Art and the Public Sphere*, ed. W. J. T. Mitchell (Chicago: The University of Chicago Press, 1992).

15. This figure is taken from Peter Schjeldahl's euology, "Arc Brevis" in *7 Days* (March 29, 1989). For a Serra-positive view of the debates, there's no better record than Shu-Lea Cheang's videotape *Tilted Arc*, made with Paper Tiger Television at the time of the hearings.

16. I hasten to admit, though, that these institutions of redress have usually been intrinsically conservative, used as intruments of retaliation most often against those who might otherwise be considered the victims whom such instruments were meant to protect.

17. Richard A. Shweder, *Thinking Through Cultures: Expeditions in Cultural Psychology* (Cambridge and London: Harvard University Press, 1991), 154–155. Obviously I am taking this observation out of the context of his overall study of U.S. versus Indian cultures.

 This notion of regulation, of course, is a dangerous one in an increasingly corporatized world in which civil liberties, privacy, and "minority" rights are downgraded in favor of government or corporate interests. Women, in particular, have little to gain historically from regulation. On the other hand, the savings and loan fraud is one of thousands of examples of the equally present dangers of underregulation.

18. Cornel West, *Prophetic Fragments* (Grand Rapids and Trenton: William B. Eerdmans Publishing Company and Africa World Press, 1988), ix.

19. Audre Lorde, *Sister Outsider* (New York: The Crossing Press, 1984), 111.

20. For more on this concept, see my essay, "The Authenticating Goldfish," in the catalogue for the 1993 Whitney Biennial (New York: Whitney Museum of American Art, 1993).

21. Details and quotations can be found in the following newspaper articles, with headlines that easily tell the progression of events: Robbie Farley-Villalobos, "Artist's Political Struggle Opens Museum," *El Paso Herald-Post*, December 19, 1991, 3; Robbie Farley-Villalobos, "Museum President Embarrassed," *El Paso Herald-Post*, January 25, 1992, 1; Joe Old, "Let's Support Diverse Museum" (op-ed), *El Paso Herald-Post*, January 30, 1992; Robert Nelson, "Art Museum Finds Lots of New Friends," *El Paso Times*, "Borderland" section, Feb. 9, 1992, B1. Thanks to Carmen Lomas Garza for calling the incident to my attention.

22. The viciousness of the attacks was particularly intense and explicitly grounded in the show's inclusiveness. Michael Kimmelman's review "At the Whitney, Sound, Fury, and Not Much Else," in the *New York Times*, April 26, 1993, read in part: "The show implies that anyone who disagrees with what is on view is morally suspect—as if the people who go to the Whitney are so witless and backward that they need to be told that sexual abuse and racism and violence are bad."

23. By this, I do not mean merely the same narrow range of concerns played and replayed throughout the eighties, when the innocent observer might

have been forgiven for deducing that sexual expression was the *only* problem confronting Americans in a time of repression and recession. In general, I fear that the reactions to the reactionaries overshadowed all other equally meaningful work.

24. Many other artists could be mentioned here if space permitted an extended analysis. Figures such as Cherríe Moraga, Juan Sanchez, Nancy Spero, and Carrie Mae Weems come immediately to mind.

25. Cornel West, *Prophetic Fragments*, 49.

INDEX

CONTRIBUTORS

Kathy Acker's twelve novels include *Great Expectations, Don Quixote, Empire of the Senseless,* and *Blood and Guts in Highschool.* Her writings have been translated into eight different languages, including Japanese and Czech. She also wrote the screenplay for the film *Variety* and the libretto for the opera *The Birth of a Poet* (music by Peter Gordon, sets by David Salle, directed by Richard Foreman). She works regularly as a journalist, has taught at the San Francisco Art Institute, and is currently teaching at the University of California, San Diego.

Carol Becker is a writer, cultural critic and author of *The Invisible Drama: Women and the Anxiety of Change,* which has been translated into seven languages. She is currently Professor of Liberal Arts and Acting Dean of the School of the Art Institute of Chicago.

Page duBois is Professor of Classics and Comparative Literature at the University of California, San Diego. She has authored three books on the subject of women, slavery, democracy, and antiquity: *Centaurs and Amazons, Sowing the Body,* and *Torture and Truth.*

Michael Eric Dyson, a professor of American Civilization and Afro-American Studies at Brown University, is author of *Reflecting Black: African-American Cultural Criticism* (University of Minnesota Press, 1993). He is currently at work on two books: one an anthology entitled *Malcolm X: A Critical Reader,* and the other entitled *Boys to Men: Black Males in America.*

Felipe Ehrenberg is a a multimedia artist and neologist who exhibits internationally. In 1992 he culminated a multi-faceted oeuvre called *Past Imperfect,* which deals with the encounter between America and Europe, as well as Africa. He has received several awards, foremost among them the Roque Dalton Medal for his work following the Salvadoran earthquake, a Guggenheim Fellowship, a Fullbright Lecturing Award, and Mexico's CNCA Grant for Mature Artists. Ehrenberg has three grown children and is married to Lourdes Hernandez-Fuentes.

Elizam Escobar is a Puerto Rican painter and writer imprisoned in the U.S. since 1980 for his participation in the struggle for the independence of Puerto Rico. His artwork has been exhibited widely, and his writings have appeared in various art and cultural journals.

Coco Fusco is a writer, curator, and media artist. Her articles have appeared in such publications as *The Village Voice, The Nation, Art in America,* and *High Performance.* Her writings have also appeared in several anthologies, and she has curated many film and video exhibitions. She began her collaborative work with Guillermo Gómez-Peña in 1989. They have performed in New York, Barcelona, Sydney, Chicago, Portland, and Washington, D.C.

Henry A. Giroux holds the Waterbury Chair Professorship in Secondary Education at Penn State University. He has written numerous of articles and books on education, pedagogy, and cultural studies. His most recent books include *Border Crossings, Living Dangerously*, and *Between Borders: Pedagogy and Politics in Cultural Studies*.

Guillermo Gómez-Peña is a writer and experimental artist who was born in Mexico City and came to the United States in 1978. Since then, he has been exploring border issues, crosscultural identity, and U.S.-Latino cultural relations with the use of multiple media: journalism, performance, radio art, video, bilingual poetry, and installation art. He was a founding member of the Border Arts Workshop/Taller de Arte Fronterizo and a contributor to the National Radio program *Crossroads* and currently serves as a contributing editor to *High Performance* magazine and *The Drama Review*.

Eva Hauser studied at Prague University and worked as a microbiologist before becoming a professional writer and editor. She is the author of a feminist science fiction novel, *Cvokyne* (*The Madwoman*, 1992), and a collection of science fiction stories. From 1990 to 1992 she was assistant editor of the science fiction magazine *Ikarie*. Her work has appeared in English in *Everywoman, Women: A Cultural Review*, and various science fiction magazines.

Ewa Kuryluk is a Polish artist, fiction writer, teacher, critic, and art historian who has been living in New York since 1982. She is esteemed for her books on Salome and Saint Veronica. Her art work has been exhibited internationally and is documented in *Ewa Kuryluk: Cloth Works, 1978-1987*. Her novel *Century 21* was published in 1993.

Njabulo S. Ndebele is a South African writer, cultural critic, and professor of African literature. He is Vice-Chancellor designate of the University of the North and President of the Congress of South African Writers. His major publications are the award winning collection *Fools and Other Stories, Rediscovery of the Ordinary*, and *Bonolo and the Peach Tree*.

B. Ruby Rich is a cultural critic who contributes regularly to such publications as *Mirabella, Sight and Sound, GLQ: A Journal of Lesbian and Gay Studies*, and *The Village Voice*. She is completing a collection of her writings, *Projections: Essays on Women, Film and Sexuality*. Since leaving her post as Director of the Electronic Media and Film Program of the New York State Council on the Arts, she has served as a visiting professor at the New School for Social Research and the University of California, Berkeley.

Martha Rosler is an artist working primarily with photography, video, and installation. She writes occasionally about art and cultural criticism and teaches media and critical studies at Rutgers University, where she is Director of Graduate Studies in Visual Art. Her project on homelessness and housing, held in New York in 1989, is documented in *If You Lived Here: The City in Art, Theory, and Social Activism*. Her current video projects include *Hidden Histories*, a series of interviews with native Americans in Seattle, Washington.

Ahmad Sadri is assistant professor of sociology and anthropology at Lake Forest College. His book *Max Weber's Sociology of Intellectuals* was published by Oxford University Press in 1992. He is currently doing research on the role of Iranian intellectuals in defining the political culture of Iran.